To scan :)

...and for Tereza and Paolo

Transcendent Spirit: The Orphans of Uganda

Douglas Menuez: Author, Photographer
Copyright: © 2007 Douglas Menuez
First Edition

Library of Congress Cataloging-in-Publication Data
Menuez, Douglas.
Transcendent spirit: the orphans of Uganda / Douglas Menuez.
p. cm.
ISBN 978-0-8253-0585-6 (alk. paper)
1. Orphans — Services for — Uganda. 2. Children of AIDS
patients — Uganda — Pictorial works. 3. Dancers — Uganda — Pictorial
works. 4. Dance companies — Uganda.I. Title.

HV1347.M46 2007
362.73096761--dc22
2007028328

Published in the United States by Beaufort Books, New York
www.beaufortbooks.com

Distributed by Midpoint Trade Books, New York
www.midpointtradebooks.com
Printed in Canada

www.menuez.com
10 9 8 7 6 5 4 3 2 1

This book is dedicated to the children of Uganda.

It was made possible with the generous support of

Macy's West

in conjunction with their 25th annual Macy's Passport event.

Profits from this book will be used to help orphans in Uganda.

Preface

Transcendent Spirit documents the lives of an exceptional group of 20 Ugandan orphans who tour the United States every two years as a dance troupe. These tours have brought awareness not only to their own personal plight, but also to the continuing onslaught of HIV/AIDS in Uganda and most of southern Africa. These US tours also raise money to buy food, clothing, shelter and education for more than 700 orphans at two Ugandan orphanages. Many of these orphans have earned scholarships to attend college in the United States. When they complete their education, they return home to help rebuild their country. This kind of successful grass-roots program is a shining light of hope for all of Africa.

This project began when I was asked by Larry Hashbarger, Director of Special Productions for Macy's West, if I would be interested in documenting the dance tour as part of the Macy's Passport program. For 25 years, Larry; Bette McKenzie, Vice President of Public Relations; and the Macy's West team have produced this yearly fashion fundraiser which has raised $25 million for HIV/AIDS-related causes — a stunning achievement. Larry then introduced me to Alexis Hefley, the self-effacing, iron-willed founder of Children of Uganda and Empower African Children, who arranged our journey through Uganda. Our goal was to create a book that would directly support fundraising for the orphans, and by doing so, would also celebrate the 25th anniversary of the Macy's Passport program.

I began shooting Children of Uganda's dance performances in the New York area toward the end of the troupe's 2006 tour. I was immediately electrified. The children radiate an almost aggressive rapture when they dance, and night after night, I saw jaded American audiences rise to their feet for standing ovations. These audiences knew they were seeing an extraordinary performance. But there was also something deeper that pierced their hearts — an instinctive recognition of the power of the human spirit to renew itself in the face of adversity. Onstage, the children gathered their creative energy, and through an explosion of dance, they manifested utter transcendence over the unspeakable

hardships they suffered during the course of their young lives. It was a gift and a privilege to watch them perform.

Later, I met the children and heard the numbing details of their tragic lives. I was amazed to find them so optimistic, so driven and so focused on the future. As a photojournalist, I've documented many stories of appalling human catastrophe over the years, but I had never seen such a joyful and vital response. I quickly realized that in order to make photographs that could even begin to provide an understanding of these children, I would have to travel to Uganda with them and trace their personal stories. The question that drove me was: How did these children find the strength to overcome such impossible odds with such dignity and grace? And so the journey began.

In addition to relentless regional warfare, famine, drought, ethnic genocide, corrupt dictatorships, lack of education, lack of clean water and overall poverty, much of sub-Saharan Africa during the last three decades has endured the massive devastation wrought by HIV/AIDS. This scourge has created 12.6 million orphans across the continent. In Uganda alone where 40 years of continuous warfare has increased the misery, there are an estimated 2.4 million orphans of AIDS and war.

The conclusion one forms in Africa is that we must choose faith over despair. We must believe that life has meaning. We must believe that we can create meaning in our own lives by virtue of our actions. And we must believe that our actions can create positive meaning in the lives of others. That is what the orphans of Uganda taught me. They have chosen faith over despair, and in the process, they turned tragic lives into lives of meaning.

The orphans of Uganda also taught me to live fully every single day — a throwaway aphorism that these children invest with profound meaning. As they turn away from their own painful past and seize the moment, these children radiate beams of joy. They are luminescent. They rise up and live, and against the odds, they find a way to express their creative natures. And this gives hope to all of us.

— *Douglas Menuez*

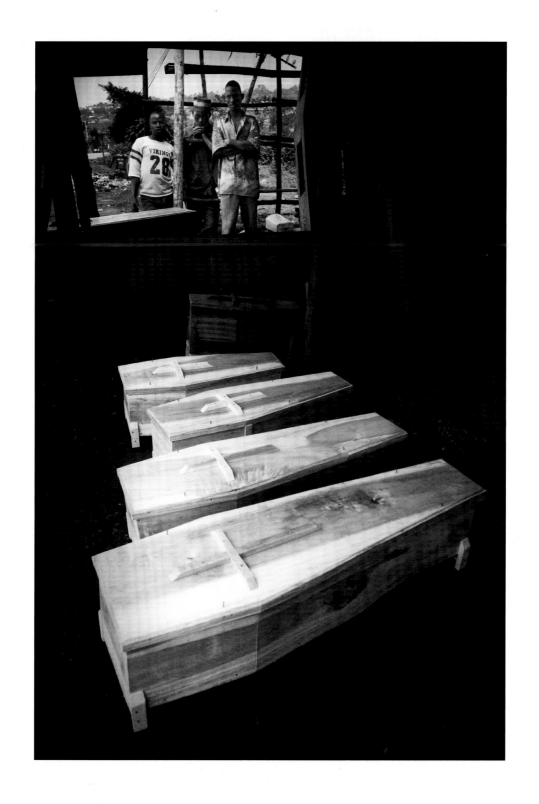

TRANSCENDENT SPIRIT:
THE ORPHANS of UGANDA

INTRODUCTION
DAME ELIZABETH TAYLOR

EXECUTIVE PRODUCER
DAVID ELLIOT COHEN

TEXT
RACHEL SCHEIER

PHOTOGRAPHS
DOUGLAS MENUEZ

BEAUFORT
BOOKS

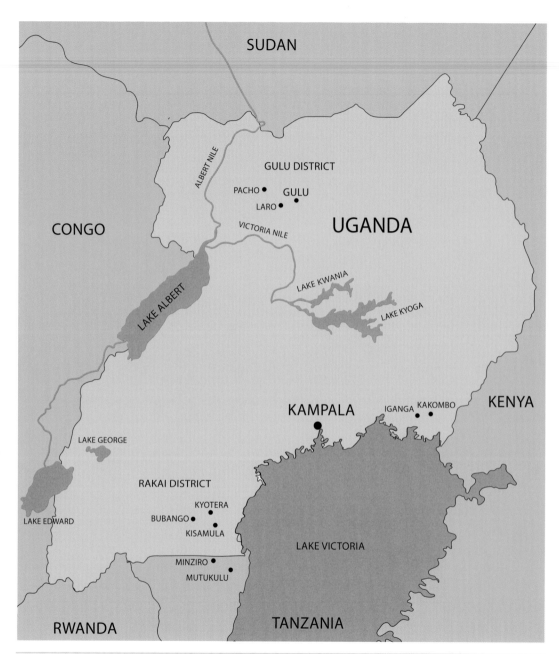

SUDAN

CONGO

UGANDA

GULU DISTRICT

ALBERT NILE

PACHO ● ● GULU

LARO ●

VICTORIA NILE

LAKE ALBERT

LAKE KWANIA

LAKE KYOGA

KAMPALA ● IGANGA ● ● KAKOMBO KENYA

LAKE GEORGE

RAKAI DISTRICT

LAKE EDWARD

KYOTERA
BUBANGO ● ●
KISAMULA ●

MINZIRO ●
MUTUKULU

LAKE VICTORIA

RWANDA TANZANIA

Transcendent Spirit comprises photographs made in Uganda and the US. The above map references the various locations where the photographs in Uganda were made. Beginning with daily life in the orphanages in Kampala and Rakai, the book follows six children as they journey the length and breadth of the country to visit their various homes, some in neighborhoods in Kampala and some in villages out in the countryside. They traveled far to the North, to Gulu, in rebel territory, to find a father's grave at the site of a brutal 1998 massacre, then to the South and across the border into Tanzania to where a brother and sister were reunited, then to the East, almost to Kenya. The book closes with images from the children's triumphant dance tour of the US in 2006.

Contents

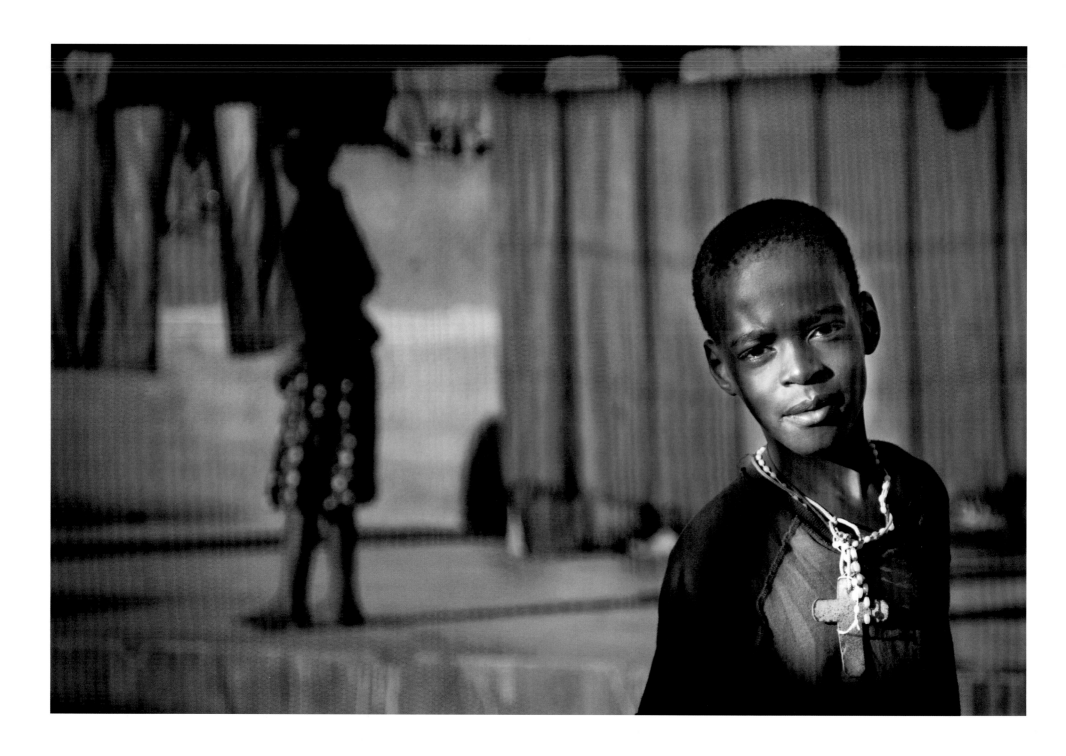

Dame Elizabeth Taylor

This remarkable book celebrates the strength and stories of children who have been orphaned by AIDS in Uganda. In 2000, I met the incredible young people featured in *Transcendent Spirit* when this Ugandan dance troupe performed at the annual Macy's Passport event, an AIDS fundraiser for which I am Founding Chair. Everyone present was electrified by their performance, moved by their spirits and inspired by their life stories.

In the beautiful country of Uganda, as in so many African nations, AIDS is the leading cause of death, killing nearly 200 people each day. Over two million Ugandan children under the age of 15 have lost one or both parents to this monstrous disease. This great loss has forever changed the face of Uganda, the face of Africa and the face of the world.

The stories featured in *Transcendent Spirit* illuminate the smallest fraction of Uganda's heartbreaking history with HIV/AIDS. I believe you will be moved by the magnificent photographs by Doug Menuez as much as I have been. It is through his caring lens that we see the children and experience their courage, joy and innate beauty. This book brings these young lives into sharp focus, and we must never look away.

The children within these pages are a testament to the power of the human heart. They are true warriors in this battle, and we owe them a debt of gratitude for their inspiration and courage. In the war against HIV/AIDS, education, prevention, treatment and hope are powerful weapons, and each must be deployed in the fight. It is only through collaborative and comprehensive efforts that we will counteract current trends and change the pandemic's trajectory.

While progress has been made in combating the transmission of the disease, we must not rest until HIV/AIDS is a distant, tragic memory. We must join forces now with organizations that protect, defend and nurture these children, such as Empower African Children, the current parent organization of the Ugandan children featured in *Transcendent Spirit*. This powerful book will support their continued creativity.

We must recommit ourselves to the global fight against this pandemic. It is our duty to prevent, treat, and ultimately defeat HIV/AIDS in Uganda and in our world.

— *Dame Elizabeth Taylor*

Left: A young resident of the Children of Uganda home in Kiwanga. About seventy percent of Uganda's orphans are victims of AIDS – more than one million children. Others are from families torn apart by the long-running bloody rebellion on Uganda's border with Sudan and those affected by severe poverty.

Kiwanga & Rakai Orphanages

"There were times when my only thoughts were: Where am I going to sleep? What am I going to eat? What am I going to do when I grow up?"

— *Peter Kasule*

Young residents of the homes for orphaned children in Kiwanga and the Rakai district of Uganda awaken each morning promptly at five in dormitory-issue metal bunk beds surrounded by graying mosquito nets. Their days are dictated by strict routine: school, prayer, chores. Meals are mostly beans and *posho* (maize meal) or mugs of steaming porridge. Occasionally, as night falls, a pick up soccer game or dance rehearsal is held.

It would seem an austere existence to a Western child. But what you hear more than anything else from the young people who live at these homes is that they are thankful. They consider themselves the lucky ones.

Uganda was the first country in Africa to feel the full impact of the AIDS epidemic, which emerged in the fishing villages and along the trucking routes in the southwestern part of the country in the late 1970s. By the early 1990s, one-third of all adults in Kampala, Uganda's capital city, were estimated to be HIV positive. Ugandans who lived through the time remember weeks in which they attended half a dozen funerals. The disease seemed to

strike people in the prime of life: from gardeners to doctors and professors and — above all — parents.

Uganda, a country about the size of Oregon, is home to 28 million people. Over the last 20 years, more than 2.4 million children have been orphaned by HIV/AIDS, a civil war that has ravaged the northern part of the country, and the consequences of severe poverty.

Despite some very successful government initiatives, Ugandan children have largely relied on acts of striking generosity by aunts, grandfathers and sympathetic neighbors to care for these children. But the traditional extended family safety net in Uganda has been stretched beyond its limits. Many orphans end up as street children in the cities or live desperate existences in rural villages.

By the early 1990s, international organizations and committed individuals sought to meet the overwhelming needs of Uganda's children. It was against this backdrop that Alexis Hefley, a banker from San Antonio, Texas, first traveled to Uganda in 1993. She came at the invitation of Uganda's First Lady, Janet Museveni, to work on orphan-related

Right: Dusk falls over the main courtyard at the orphanage in Rakai district. It was in the fishing villages of Rakai in southwestern Uganda that the AIDS epidemic first emerged some three decades ago.

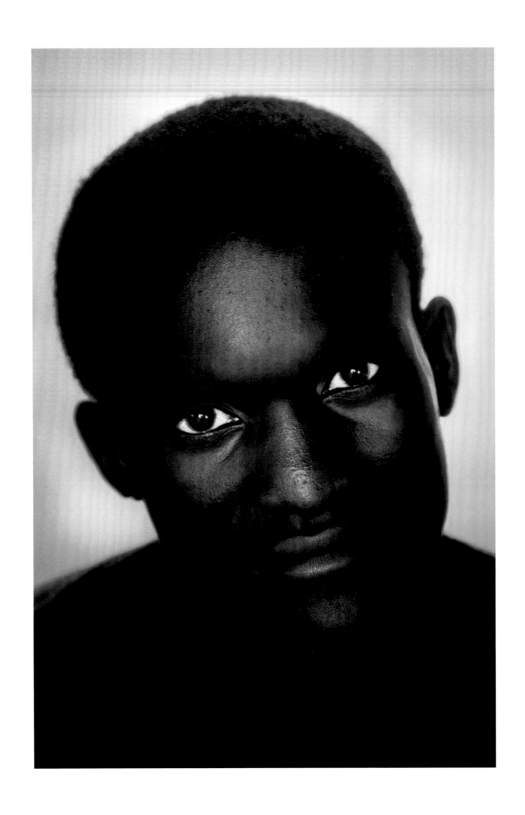

projects. Alexis was introduced to Sister Rose Muyinza. The Ugandan nun cared for some 120 orphans and AIDS victims at the Daughters of Charity orphanage, a peeling old colonial building in downtown Kampala that lacked running water and electricity. The Ugandan capital was still reeling from two decades of tyranny and civil war; buildings were riddled with bullet holes. Enormous maribu storks fed on garbage on the streets.

To earn money for food, medicines, clothing and school fees, the children at the Daughters of Charity home did whatever they could. They catered meals and made and sold crafts. They set up a makeshift shop stall and sold staples like sugar, matoke, soda, beer, cigarettes and baggies of local gin to passing soldiers and truckers. The children also performed traditional dances and songs at weddings, parties and, of course, funerals.

"These children were struggling to create a future for themselves," says Hefley. "I looked at my own life and thought, I've had so many second chances." She continues, "I was awestruck by what these children could do if they were given a second chance."

Partnering with the Daughters of Charity and a master teacher who had worked with a well-known local troupe in Kampala, Hefley decided to train a troupe that would tour internationally to raise awareness and monies to support the orphanages in Uganda.

"The arts have survived in Uganda and throughout all of Africa though borders may have moved and country names changed," explains Peter Kasule, now the Artistic Director of Spirit of Uganda. "Dance, music, and storytelling record our histories and instill values. They help raise children, celebrate milestones, provide assurance, dispense justice, proclaim beliefs and sustain societies. They are our teacher and tool of survival."

In 1995, with seed money from a few private donors, Alexis founded the Uganda Children's Charity Foundation, a non-profit organization dedicated to helping Uganda's orphaned and vulnerable children. The Children of Uganda's biennial US tours soon became a major source of income and a powerful public face of the AIDS crisis in Uganda. By 2006, UCCF was directly supporting more than 700 children in two homes in Kiwanga, which lies a few kilometers outside of Kampala, and in Rakai, the district in the southern part of the country that was first and hardest hit by AIDS. UCCF also sponsored grass-roots community programs for HIV-positive mothers and disabled children. A US Scholarship program enabled eight children to complete college degrees from such leading US institutions as Tufts, Pepperdine and Boston College.

What does this all mean for the generation of Ugandans coming of age now? The greatest challenge is access to higher education and jobs. Fourteen million children — 50% of Uganda's population — are younger than 15. Secondary schooling, including vocational training, must be paid for at costs between $300 and $1,500 per year. The average Ugandan lives on less than one US dollar per day, and only 15% of primary school graduates can afford secondary school.

What happens in the next decade is crucial says Hefley, who left UCCF in 2006 to start a new organization, Empower African Children. Although the number of new AIDS victims continues to decline, the legacy of the 30-year HIV scourge will affect Uganda for generations to come.

The word, "orphanage" is largely avoided because of the stigma associated with it, but the Kiwanga and Rakai homes provide all available support for these children: food, clothing, shelter, medical care, and primary school level education for younger residents. Older children may continue to live at these residences but often attend secondary and vocational boarding schools.

Upon "graduating" from the homes, the children are given a mattress, a saucepan and a few other items to start them out into the world. Abel Mwebembezi, UCCF's country director, says some alumni have become secretaries, mechanics, engineers, and accountants. These students reveal the tremendous potential waiting to be developed here.

Asked what might have become of them on their own, the children usually shrug or shake their heads. Perhaps they might have ended up on the street, they say, begging for change, sniffing glue, or worse. Instead, now they have a chance for a better life. Still, there is something missing, said Mwebembezi. "Much as we give them food and education and we try to give them love, we know they've lost their mothers and fathers," he said. "We can't replace them."

Left: Geofrey Nakalanga, 18, left home when he was 10. He was invited to live at the Kiwanga home when he was 16 after a friend learned that he could play traditional Ugandan musical instruments. He toured the US in 2004 and 2006.

Right: Sweeping the chapel at dawn at the Kiwanga home. Children rise at five each day for morning prayers. They make their beds, do chores and begin the school day promptly at seven. **Following pages: (Left)** Children at both orphanages are taught strict discipline and modesty. Girls and boys wear their hair cut short and do their laundry by hand. **(Right)** Noeline Nabasezi waits in line for a shower.

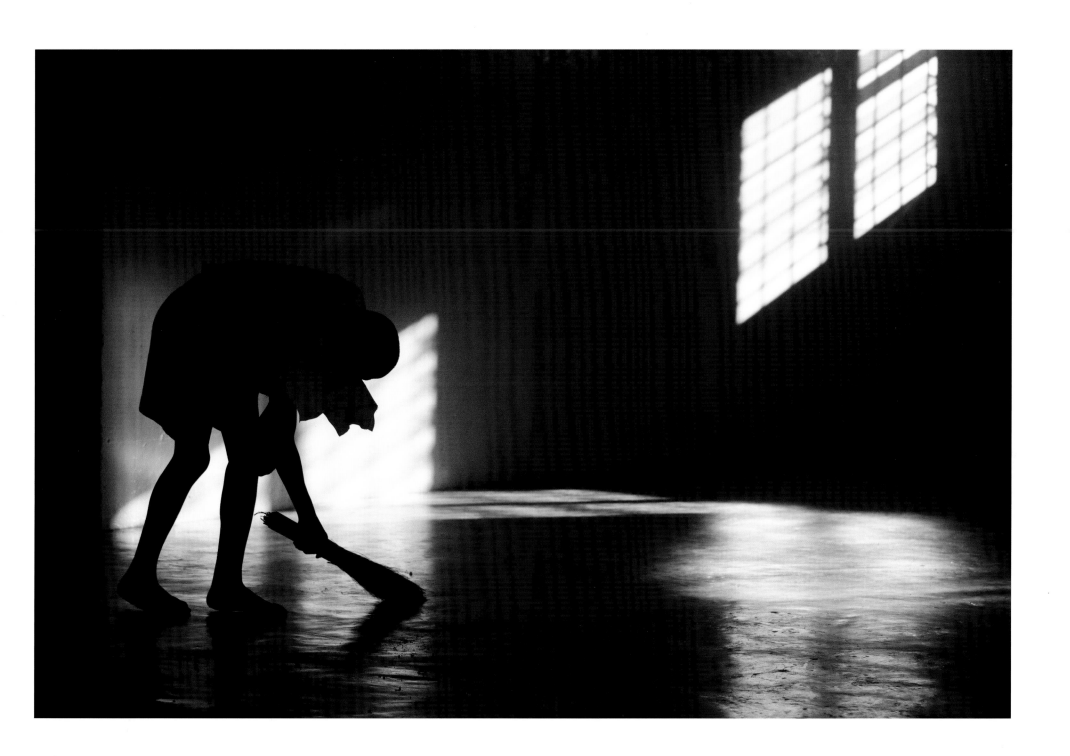

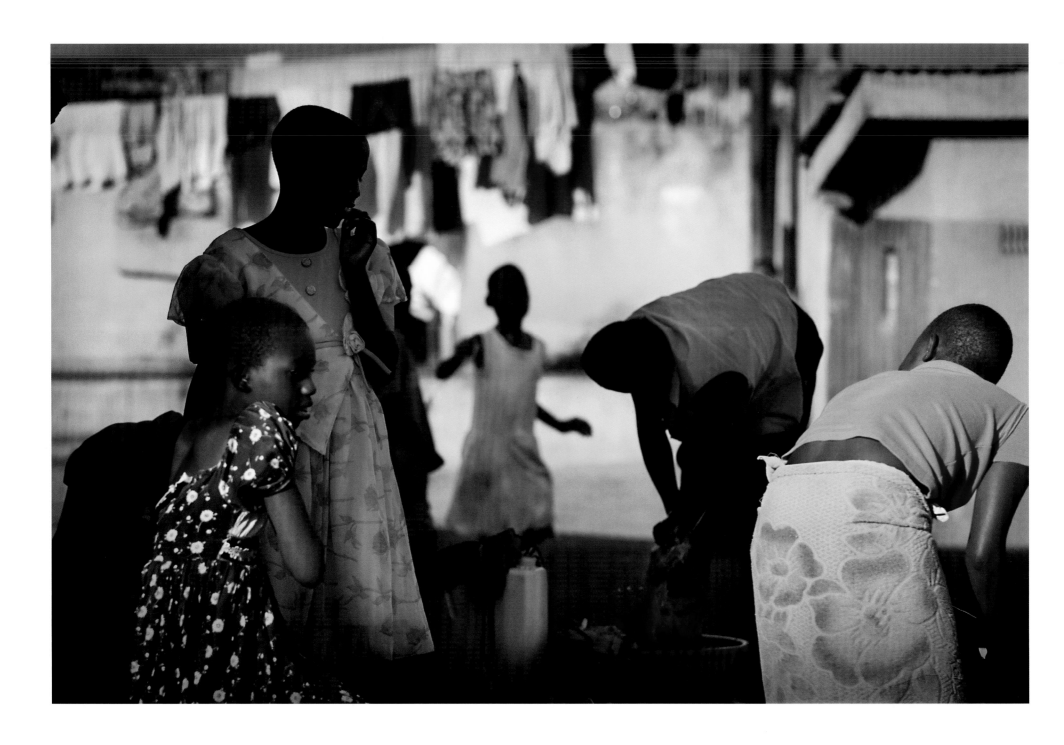

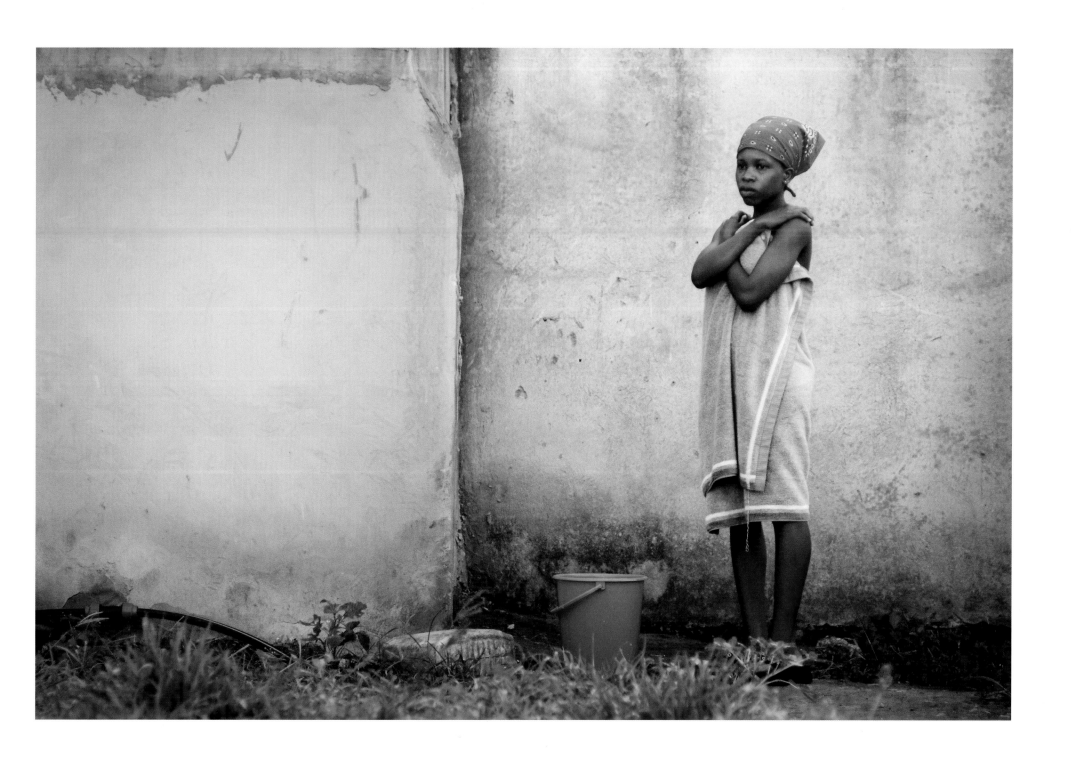

Right: Rakai students wait to take part in dance classes and, possibly, a chance to try out for the dance troupe that tours the US.

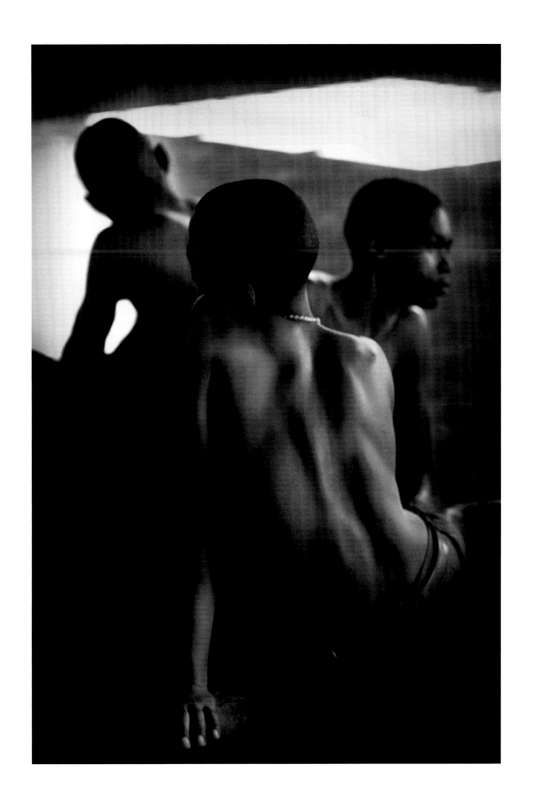

Right: Primary school children at Rakai home usually eat *posho* (maize meal porridge) and beans for lunch. The children line up with their tin plates to get their servings, then are allowed to sit where they like to eat and talk with their friends.

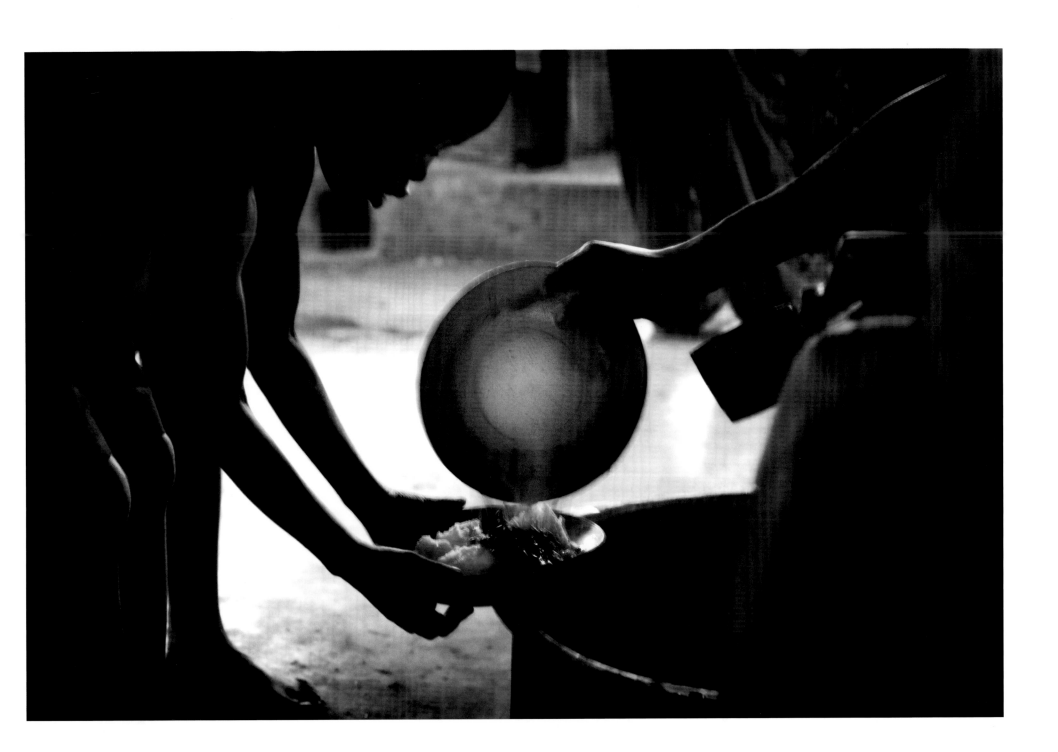

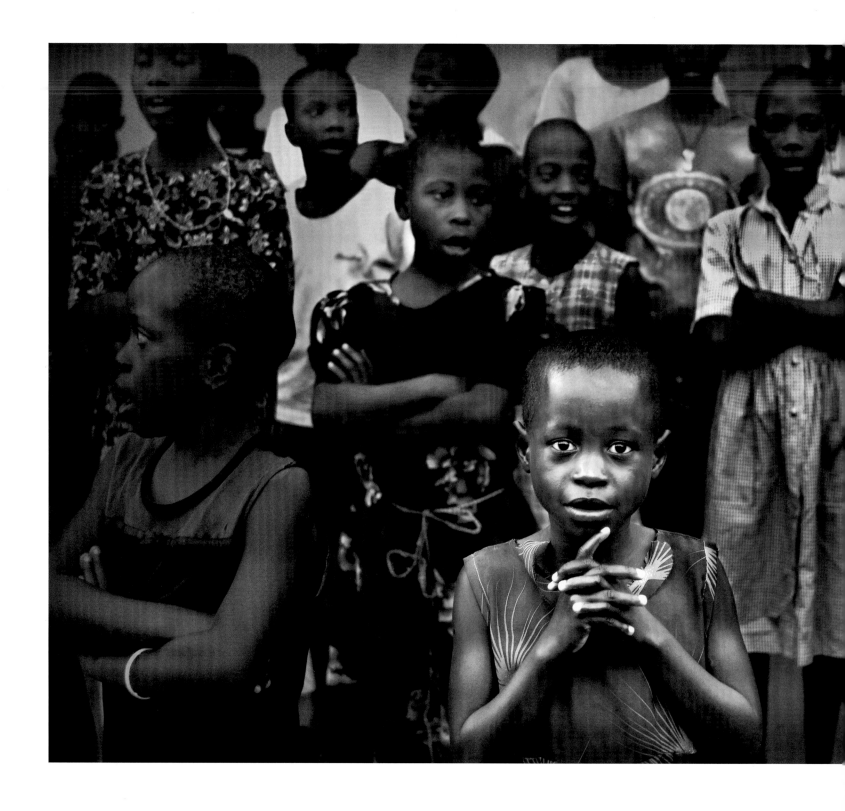

Left: Children at the orphanages gather for singing and evening prayers.

Right: Lunch at the Kiwanga home in Kampala is a much stricter affair than the Rakai home. The staff serves the same porridge, but the children all eat in one lunchroom in strict silence overseen by house mothers.

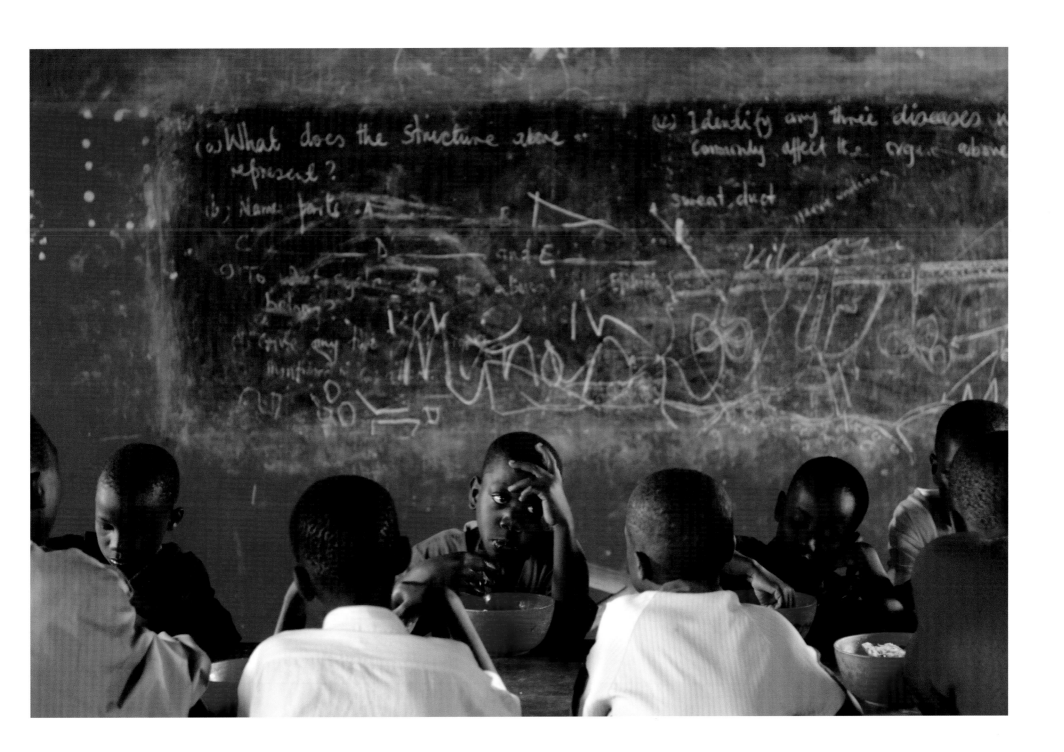

"People think, 'these are children who have lost their parents. They have had so many problems,' — but then they see us perform. They see the joy and the smiles we carry... People learn that life goes on."

—*Francis Lubuulwa*

Right: One of the lead dancers on the US tour, Francis Lubuulwa, 18, seated, lost his father to AIDS in 1997. But the disease still carries a deep stigma in Africa, and no one ever told him why his father got sick. He has never asked his mother about her HIV status. "Maybe I feel afraid to know, afraid of more sad news," he said. The children at the homes say they are most thankful for their friends. "When I first came to the orphanage, I was very lonely, but then I got to know people and it was OK," said one girl. "It was nice to wake up and have someone to say good morning to." Francis is pictured with his friend Moses Kaggwa.

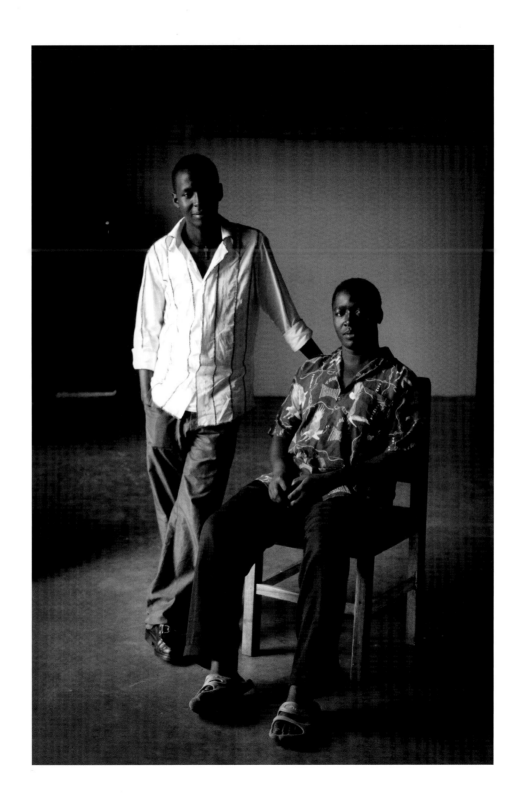

Right: Sunday afternoon is a time for sports and relaxation at the Kiwanga home.

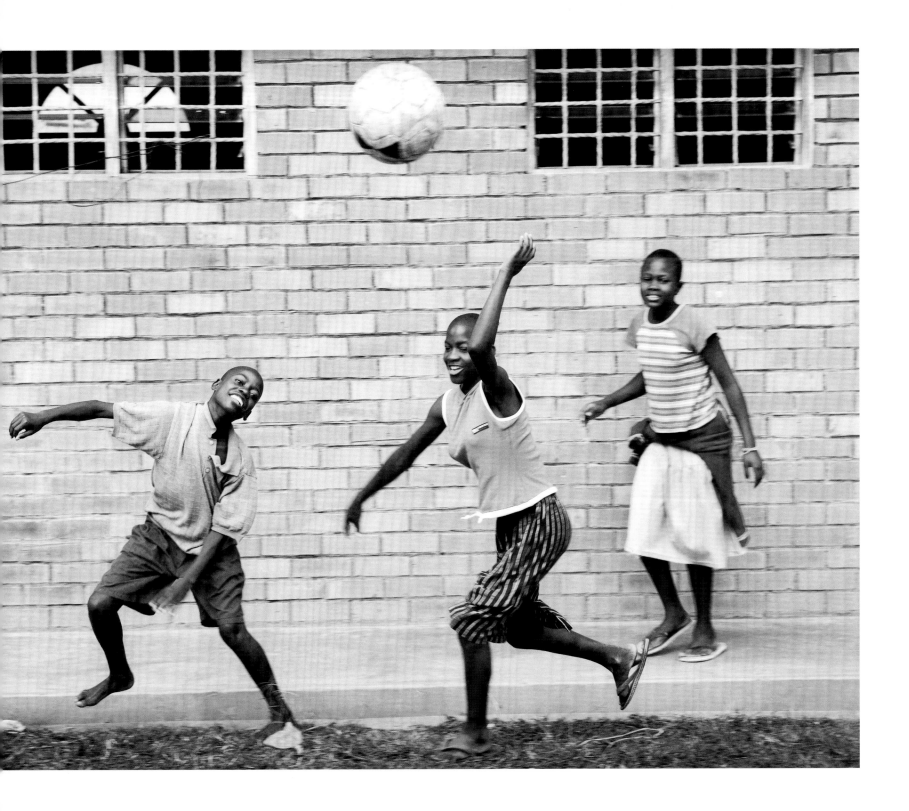

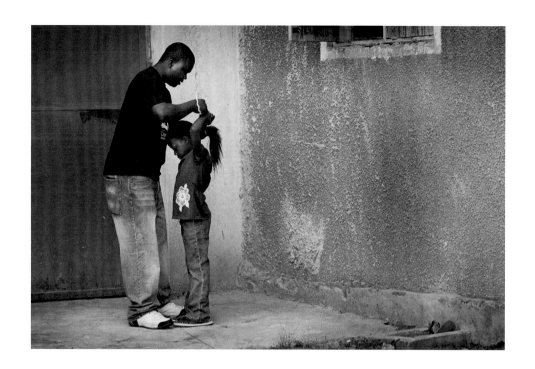

Above and Right: The children at the homes describe themselves as part of a family rather than as orphans. **Following pages: (Left)** Children gather in the courtyard for a school assembly. **(Right)** A science class at the Rakai Primary School. The Daughters of Charity orphanage and primary school in Rakai were originally built in 1993 when AIDS deaths in the area peaked. Today the expanded campus also serves approximately 150 needy children from nearby villages whose parents cannot afford to pay school fees.

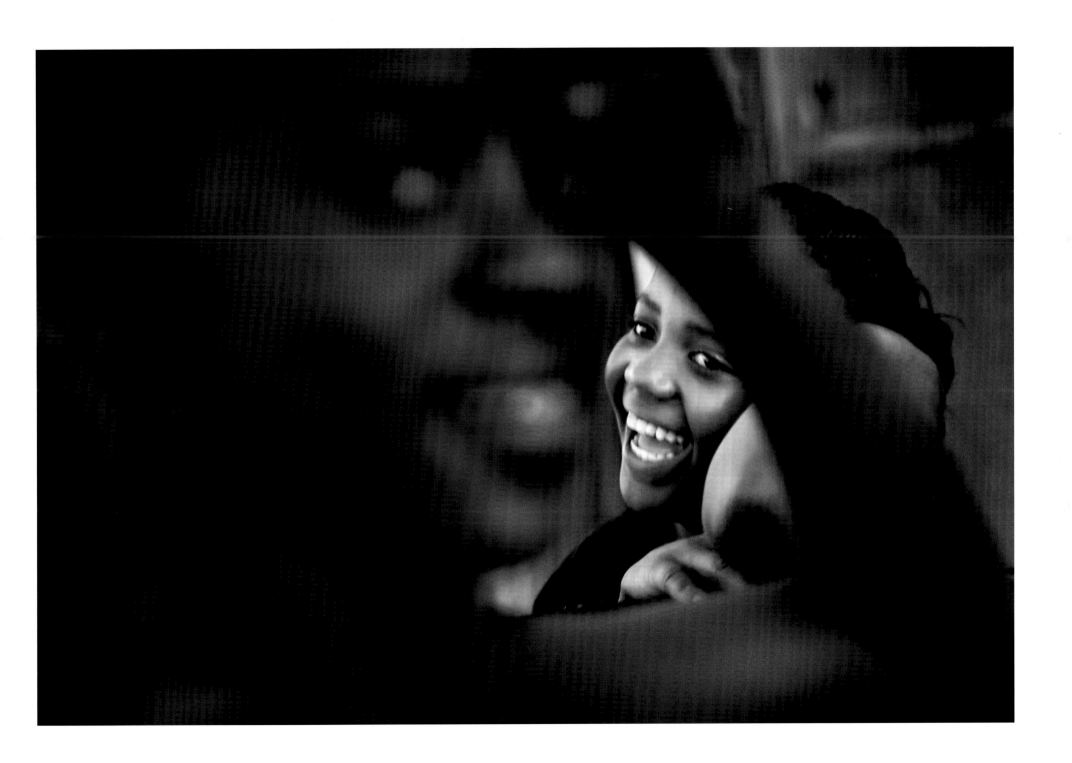

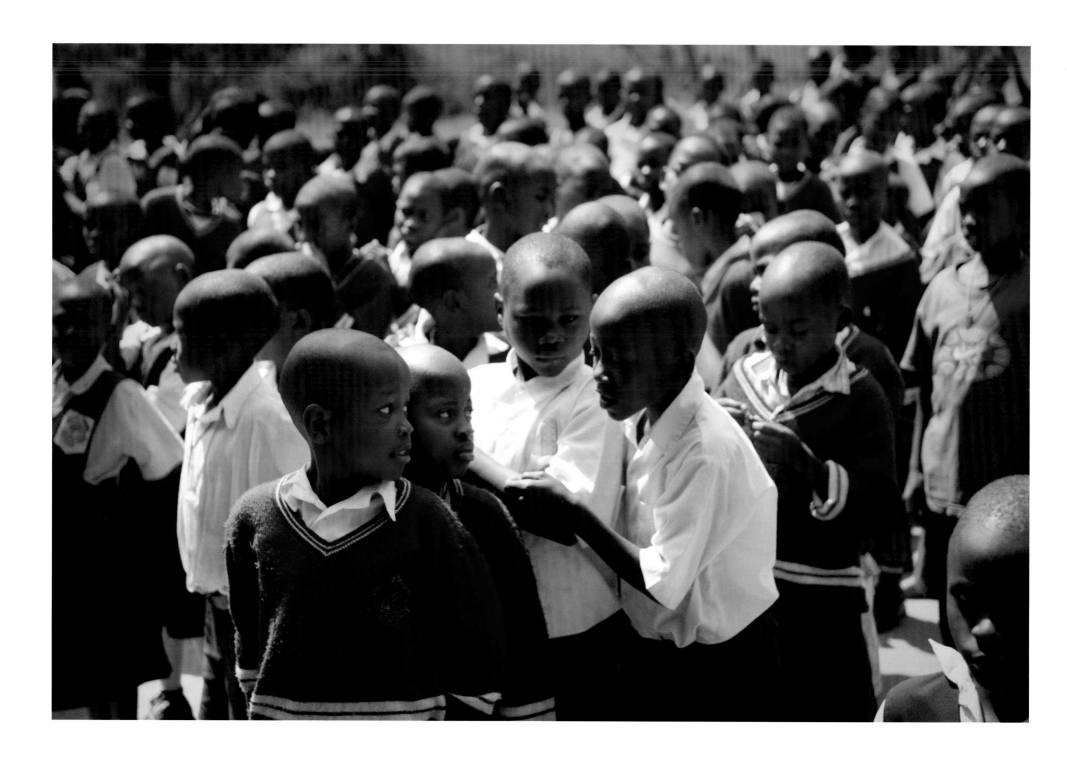

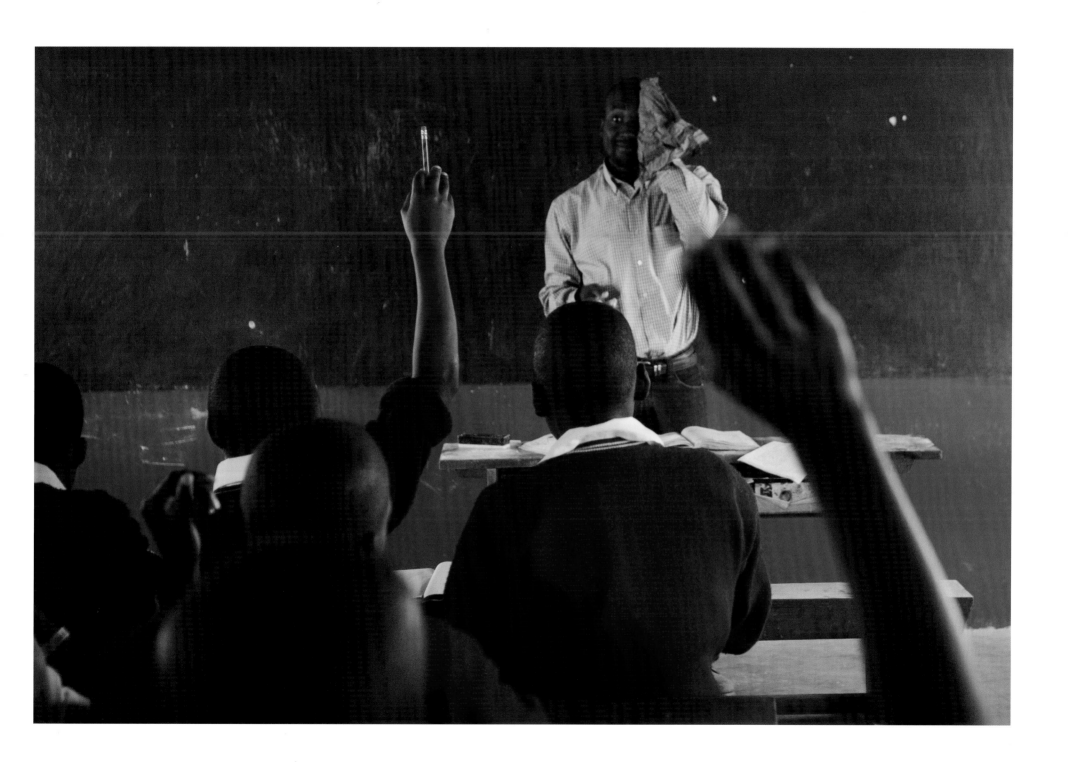

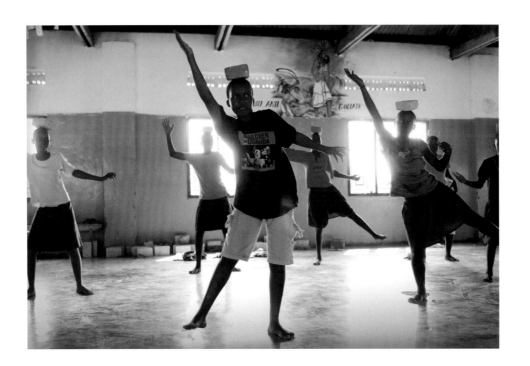

Above: Young girls who hope to join the tour first learn to balance heavy bricks on their heads. **Right:** Peter Kasule lived at the Daughters of Charity home in Kampala for seven years after the death of his parents and was a US Scholarship high school and college student. Now the artistic director of the dance troupe, Kasule likes to mix African dance and music with Western forms. He not only choreographs the troupe's acclaimed performances, but also serves as master of ceremonies.

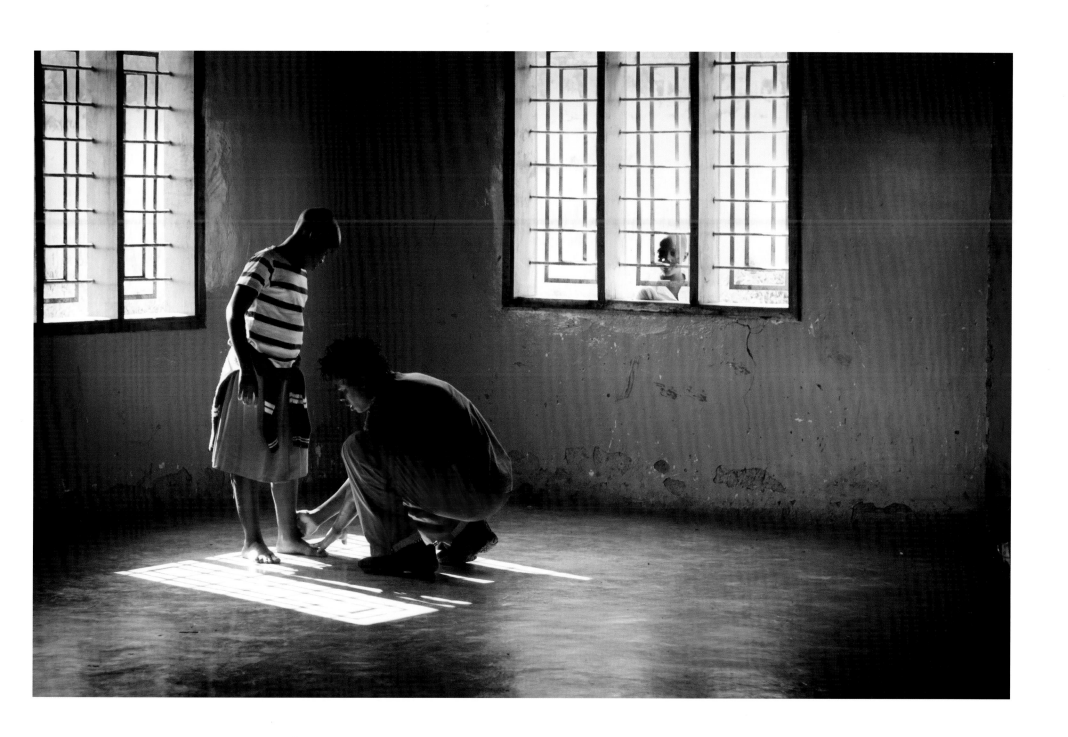

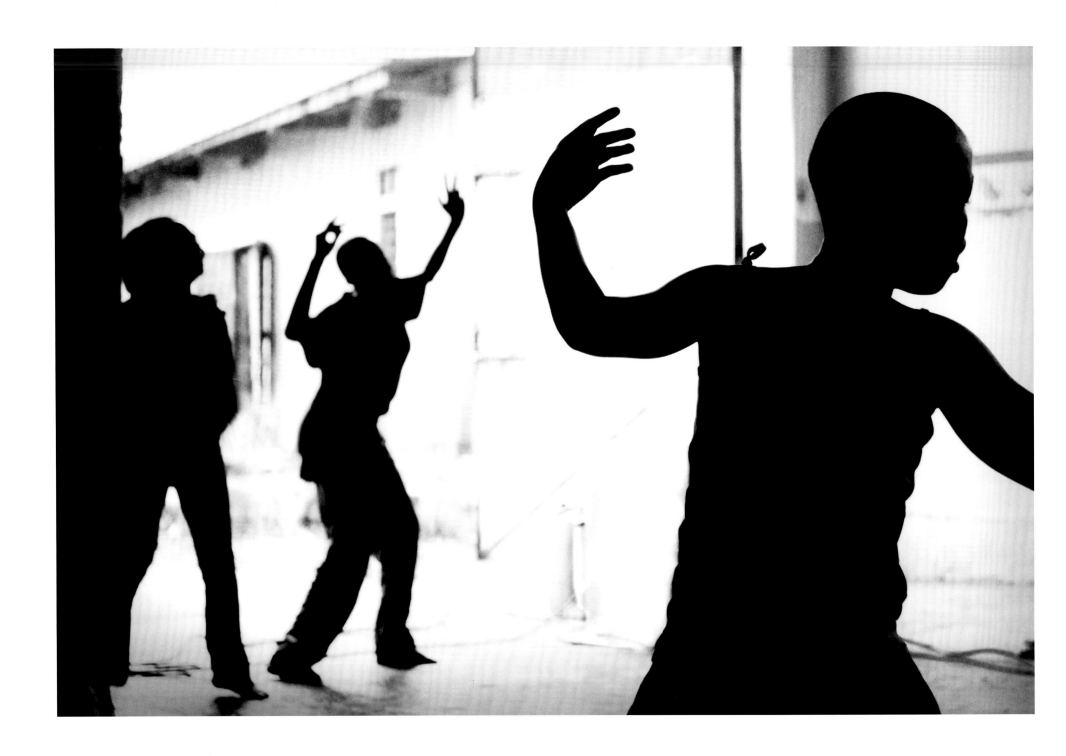

"I was about six when my mother died... I thought maybe she was just sleeping. I didn't know people died. People were crying and I said, 'What's wrong?' But then I realized she was dead. I was so sad for a long time because I was so close to my mom."

—*Betty Nakato*

Left: At the Kiwanga home the children spend hours each day training and learning dances. Every child is given a chance to try out for the dance troupe, but only about two dozen of the most talented and hardworking kids are chosen to go on tour. "There are those who really love it passionately, and those are the ones who really rise to the top," said Alexis Hefley.

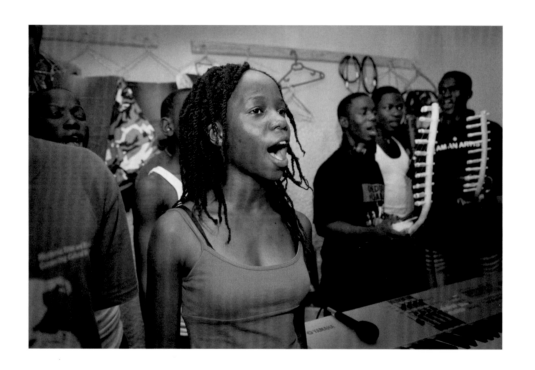

Above: Betty Nakato, 16, one of the touring dancers, sings with her fellow performers during a rehearsal for a recording Peter Kasule produced. Betty's entire family died of AIDS. **Right:** Six-year-old Miriam Namala was a star of the most recent US tour with her featured solo during the *Titi Katitila* dance she rehearses here. The dance comes from the Bunyoro-Kitara people who celebrate one of the many extraordinary birds found in eastern Uganda. The lyrics say the titi katitila always sleeps better after seeing a friend.

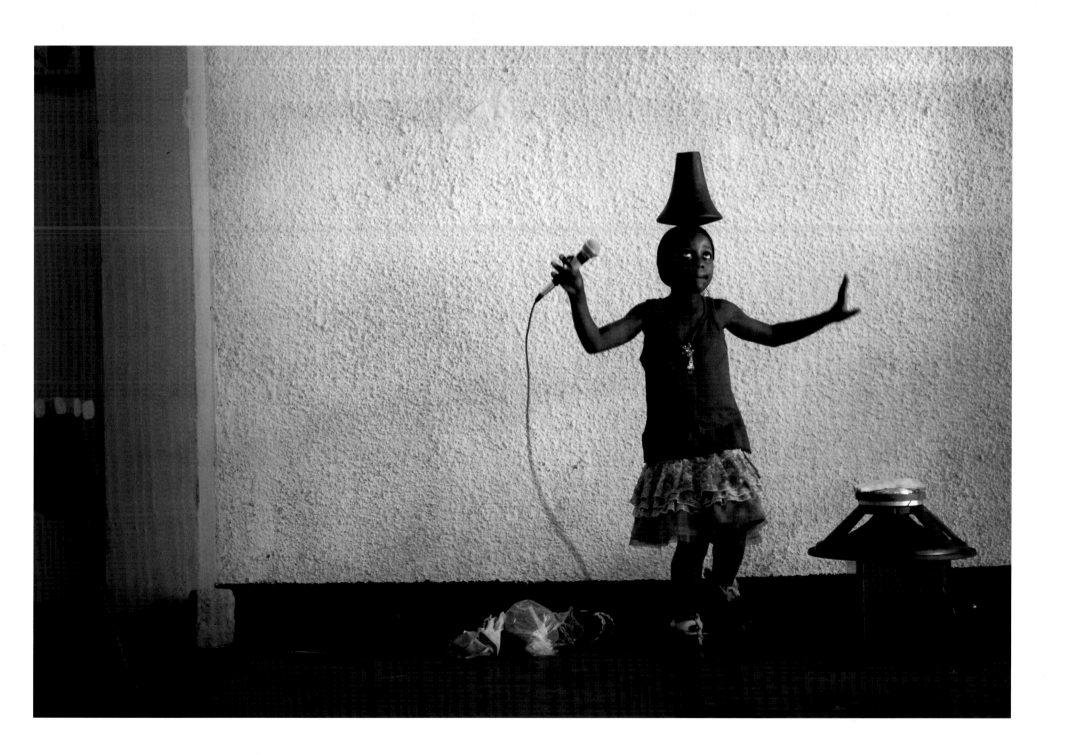

Right: Children relax in their dormitory after lunch.

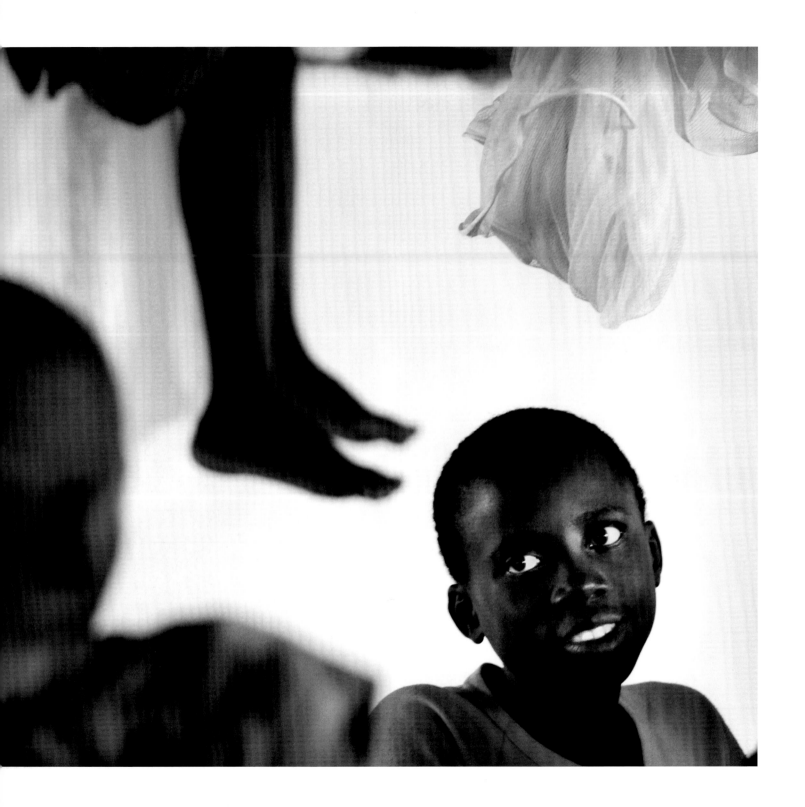

Right: The women in Geofrey Nakalanga's family sing and ululate to welcome him back to his home village of Kakombo in eastern Uganda. Geofrey is one of 18 children from the same biological mother who is now deceased. He presents each of his father's three other wives with a bunch of *matoke* (green bananas, the Ugandan staple) and five kilos of sugar. Then a feast is served in his honor. Geofrey, who plans to attend college to study business, is the pride of the family.

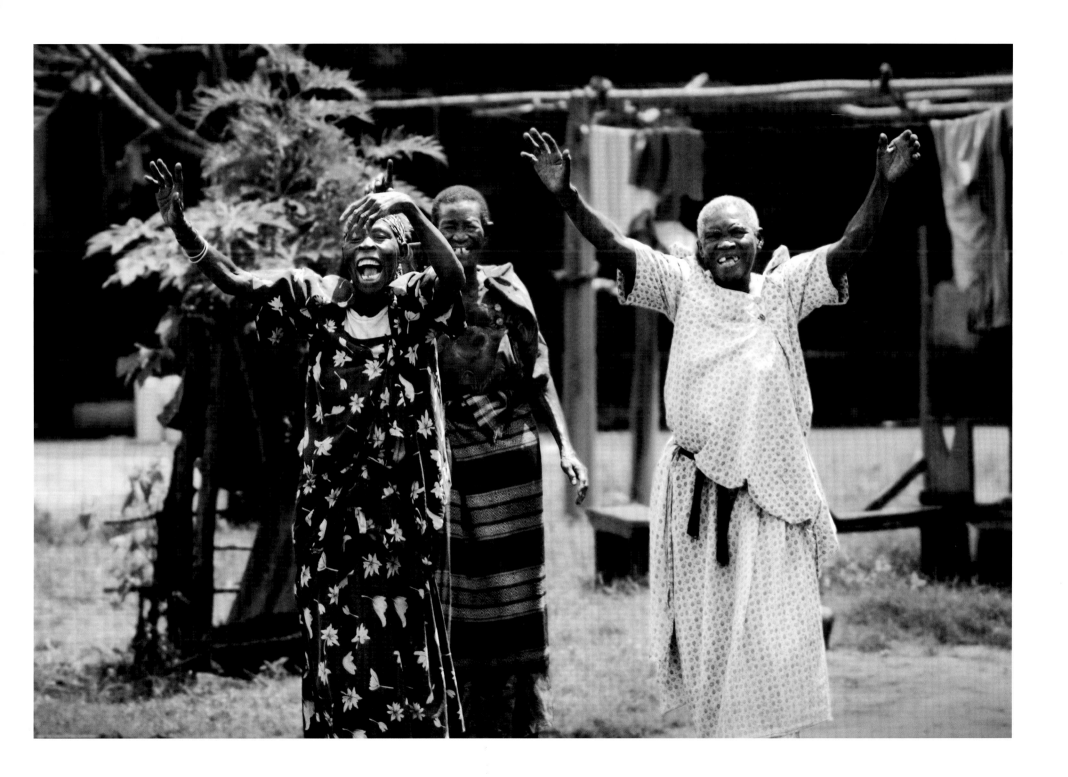

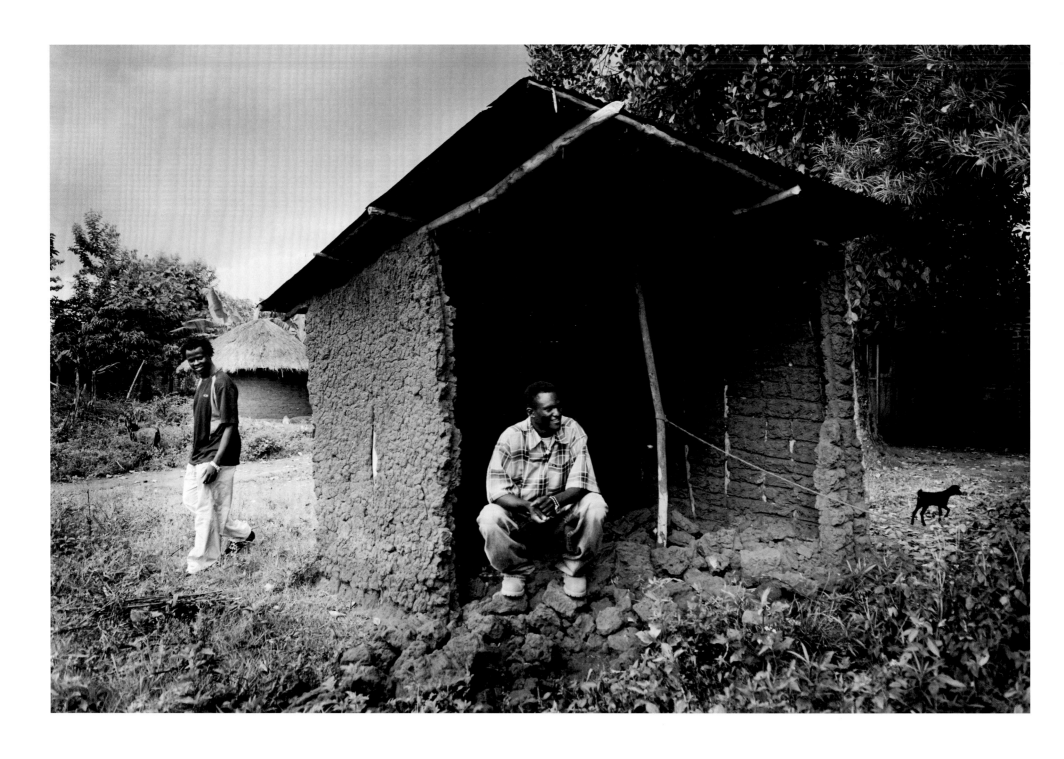

"When I reached ten years of age, I had to leave home. That is when I built my own little house of brick in our village and began to work selling fish."

—*Geofrey Nakalanga*

Left: Geofrey Nakalanga and Peter Kasule visit the mud brick house Geofrey built for himself when he left his impoverished family. His mother subsequently died. Geofrey was welcomed into the Kiwanga home, which nurtured his musical talent and provided the support he needed to continue his secondary schooling.

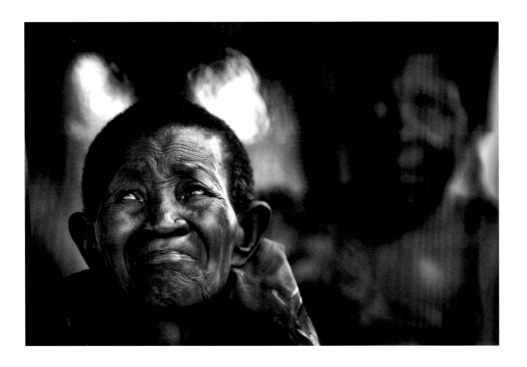

Above: Geofrey's aunts listen as he describes America and the recent US tour. **Right:** Geofrey's clan has lived in this village as long as anyone can remember, and his great-grandfather is buried nearby. **Following pages:** Children stroll to the street market to buy meat and supplies near the Kiwanga home.

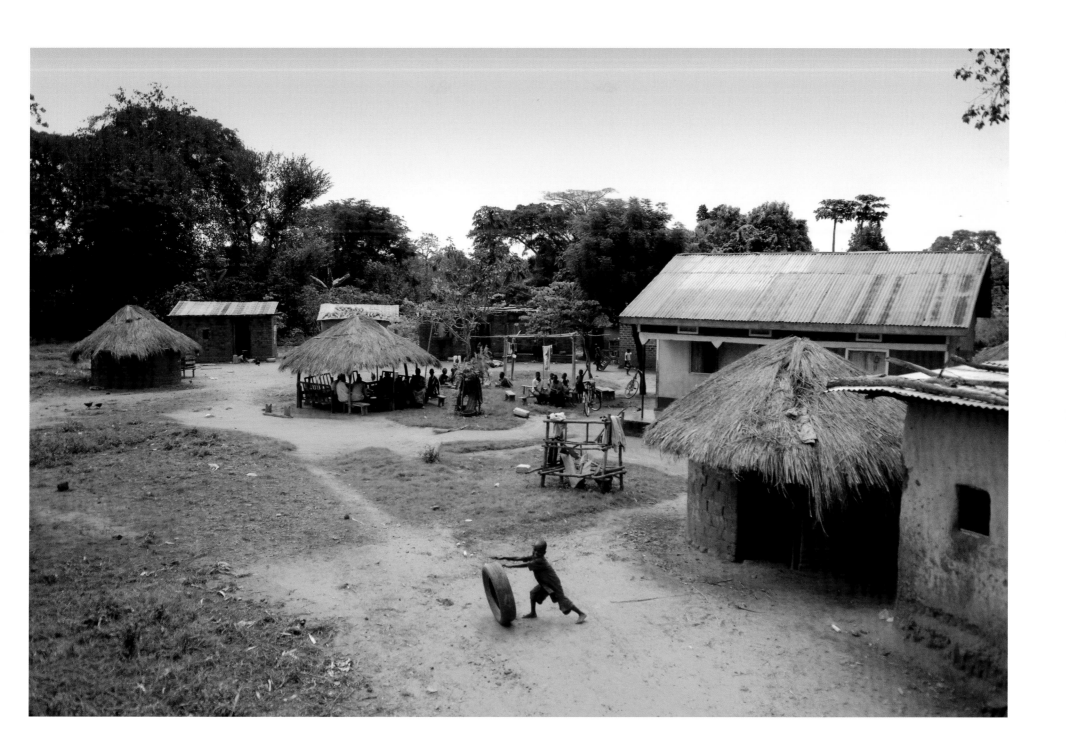

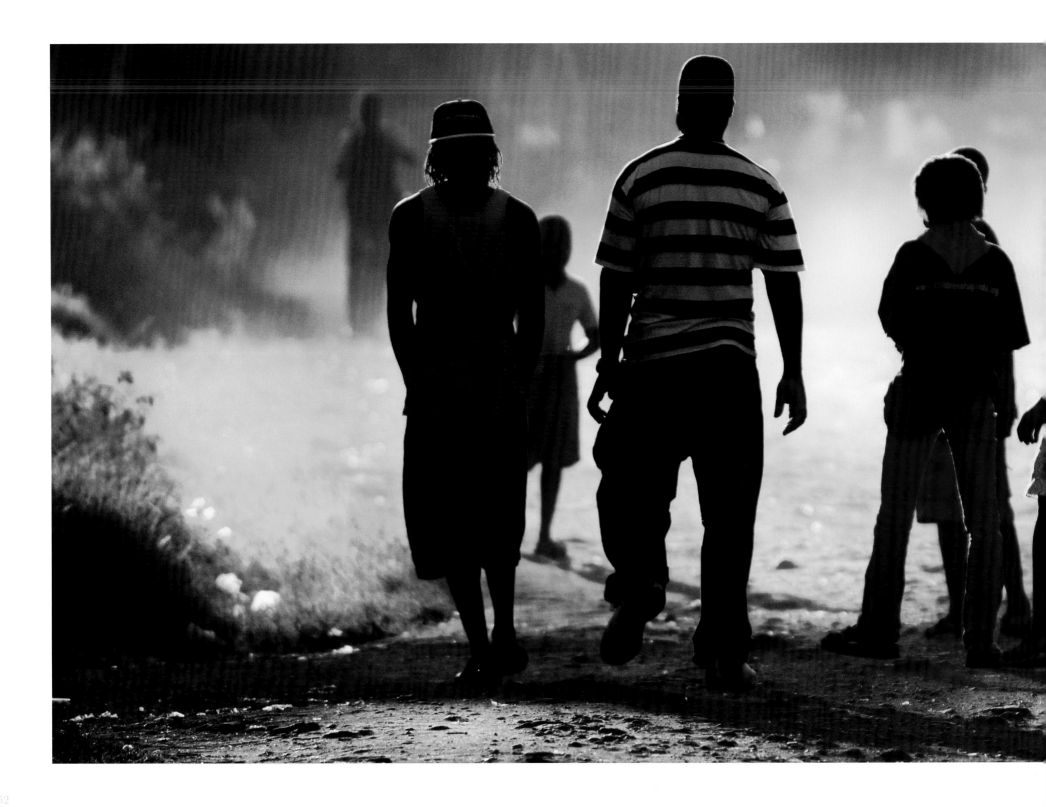

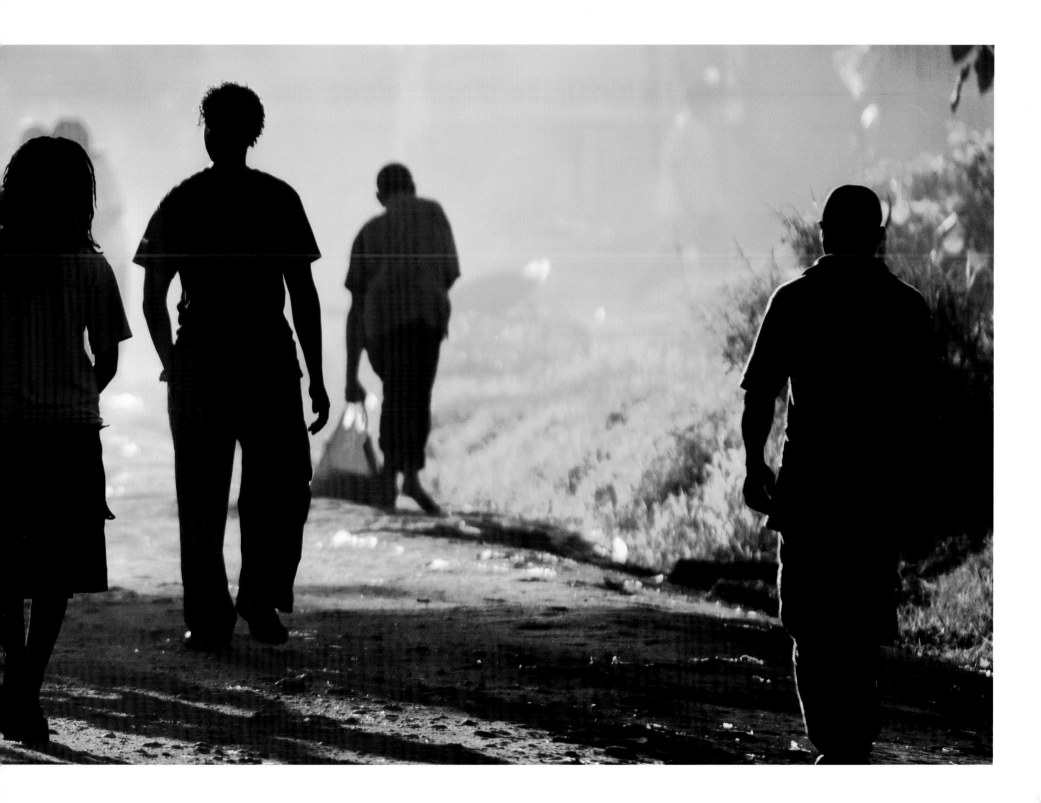

Brian

"Every day, I would think of my dad and wish he would come for me."

—*Brian Odong*

On the night of March 2, 1998, rebels from the Lord's Resistance Army crept into the tiny Ugandan village of Pacho. They hacked 11 people to death with machetes and burned their huts to the ground. Thirty-eight children were orphaned. Among them, little Brian Odong.

The LRA, a murderous insurgent group that has terrorized northern Uganda for more than two decades, is most infamous for kidnapping village children and transforming them into child soldiers and sex slaves. Brian, then five, and the other children of Pacho were spared that night only because they were sleeping on the floor of a school several kilometers away when the rebels attacked — a safety practice known locally as "night commuting."

Right: Brian (left) rehearses with other dancers at the Kiwanga home. At first, he was very lonely at the orphanage, but eventually, he made friends. "Then they told me we were going to America." He said, "I was so happy."

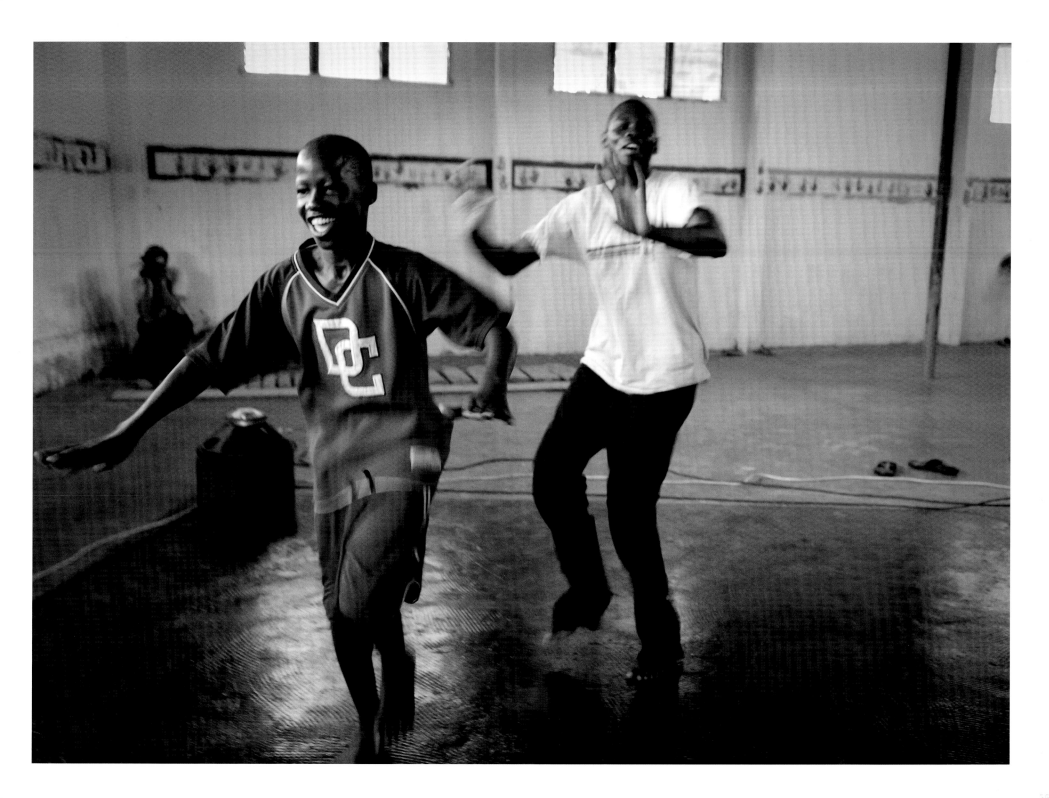

Brian and his older brother, Nicholas, got news of the attack as they walked back to the village the next morning. Brian's mother died when he was an infant, so he was particularly dependent upon his father. Brian and Nicholas watched with horror that day as their father and the other victims of the LRA attack were hurriedly buried in shallow graves.

Brian's uncle survived the attack but could not afford to care for the orphaned children. He appealed to an army major he knew for help, and a few months later, Brian and Nicholas were packed into taxis and driven to orphanages in Kampala. Brian was eventually sent to the Daughters of Charity home in Kiwanga. Initially, he was very lonely there. He spoke only Acholi, a different language from Ugandans in the capital, and almost no English. "Every day, I would think of my dad and wish he would come for me." One day, someone saw Brian dancing and singing to a song on the radio and noticed he was musically talented. Brian began to train for the dance troupe, and his English gradually improved. He made friends. In 2006, Brian performed with the troupe on its US tour. He says his favorite subject in school is history, and he wants to be a social studies teacher someday.

Brian was 13 when he and his brother Nicholas returned home for the first time, hoping to find their father's grave. The two boys were overjoyed to see their relatives, including two long lost older brothers who had stayed behind in the north. They laughed together and ate greens and millet bread, the staple food of the Acholi.

That summer, the newspapers in Uganda were full of headlines promising peace talks with the rebel leaders. But locals warned that the area was still very dangerous and it was not safe for children to sleep in their villages. So, like the fateful night when they lost their father, Brian and Nicholas would once again have to trek to the nearby town of Gulu to sleep. But before they left, soldiers escorted the brothers several kilometers through the tall grass to the place where their village once stood. Their father's grave had nearly disappeared into the bush, but they somehow managed to find it. "I will never forget him," Brian said quietly. "My dad is part of my heart."

Right: When they journeyed back to rebel territory in northern Uganda for the first time in 2006, Brian and Nicholas brought their cousin, 18-year-old George Okot. George was kidnapped by the LRA and made into "a boy soldier," but he escaped.

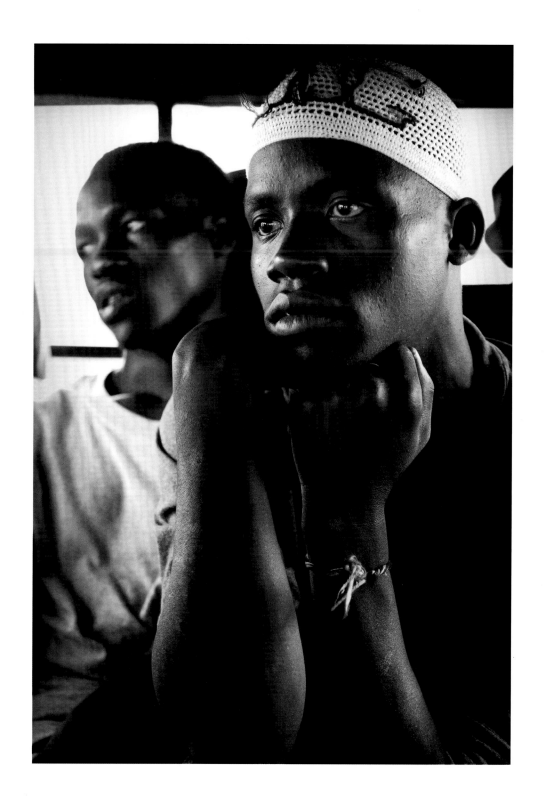

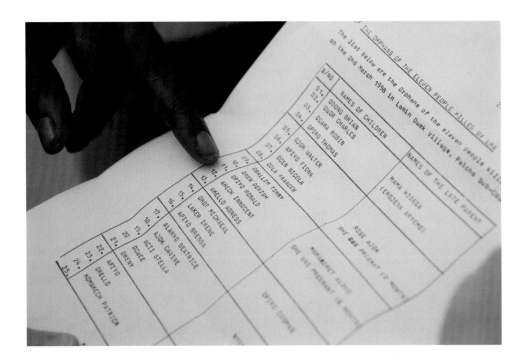

Above: A government document shows the names of orphans who survived the attack. Brian Odong's name is right at the top. **Right:** Brian's uncle, Justine Kidega, center, was among the few survivors of the 1998 Lord's Resistance Army massacre in Pacho, northern Uganda. Kidega hid in the bush when rebels struck and watched as they hacked his relatives to death and burned the compound to the ground. Later, he brought the newly orphaned children to an army major and pleaded for help. "I had no money or food to feed them," he said. Justine buried his wife next to Brian's father and offered to help guide the boys to the gravesite at the abandoned village.

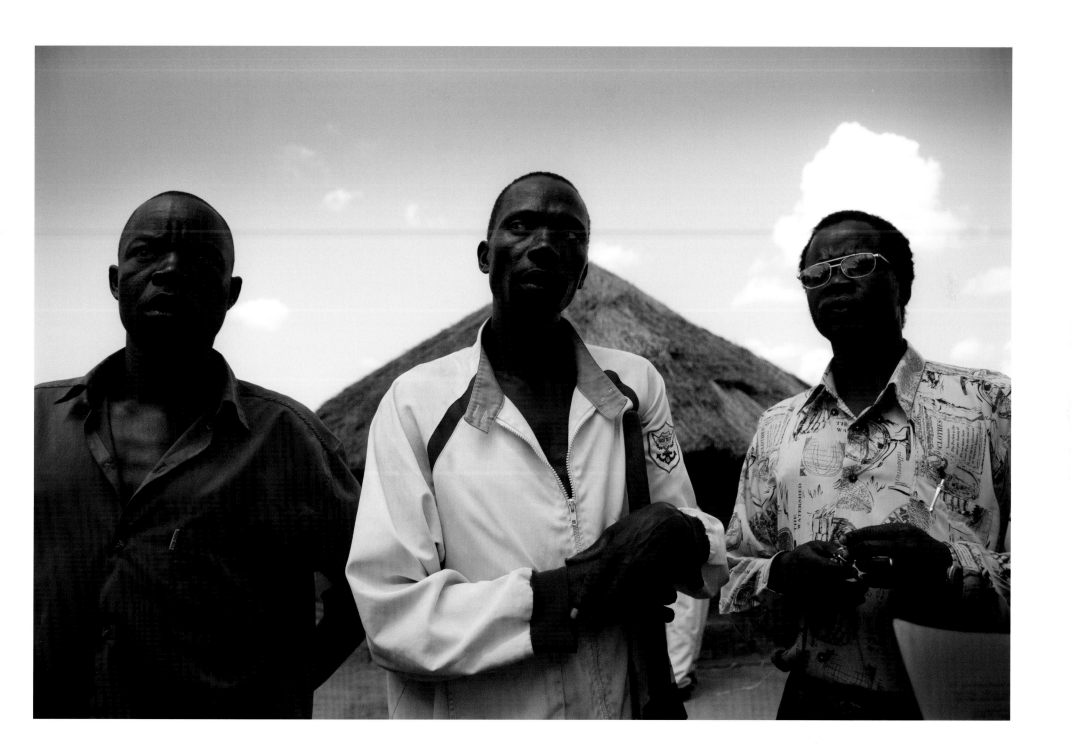

Right: In July 2006, Brian follows government soldiers into the bush to find his father's grave. They hiked for an hour in the midday African sun to find the site of the 1998 massacre where Brian's father died. At first, the soldiers tried to block their way, saying rebels were active in the area and that it was too dangerous, but eventually they agreed to escort the group and protect them.

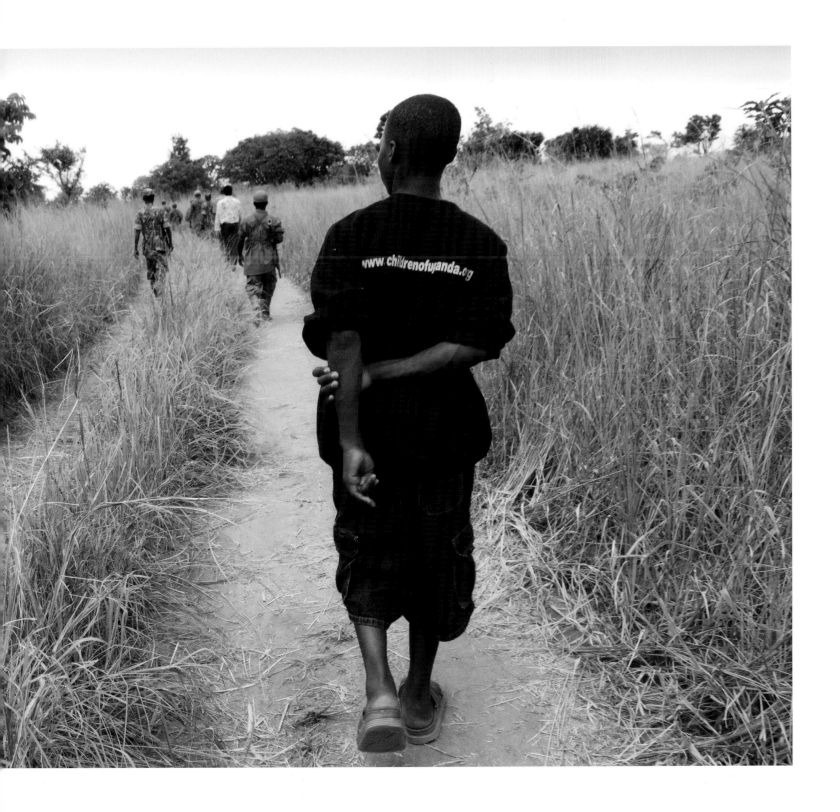

They watched with horror that day as Brian's father and the other victims were hurriedly buried in shallow graves.

Right: Brian, his cousin and village elders cut through the brush to find the spot where the victims of the Pacho massacre were buried eight years before. The graves had nearly disappeared into the bush.

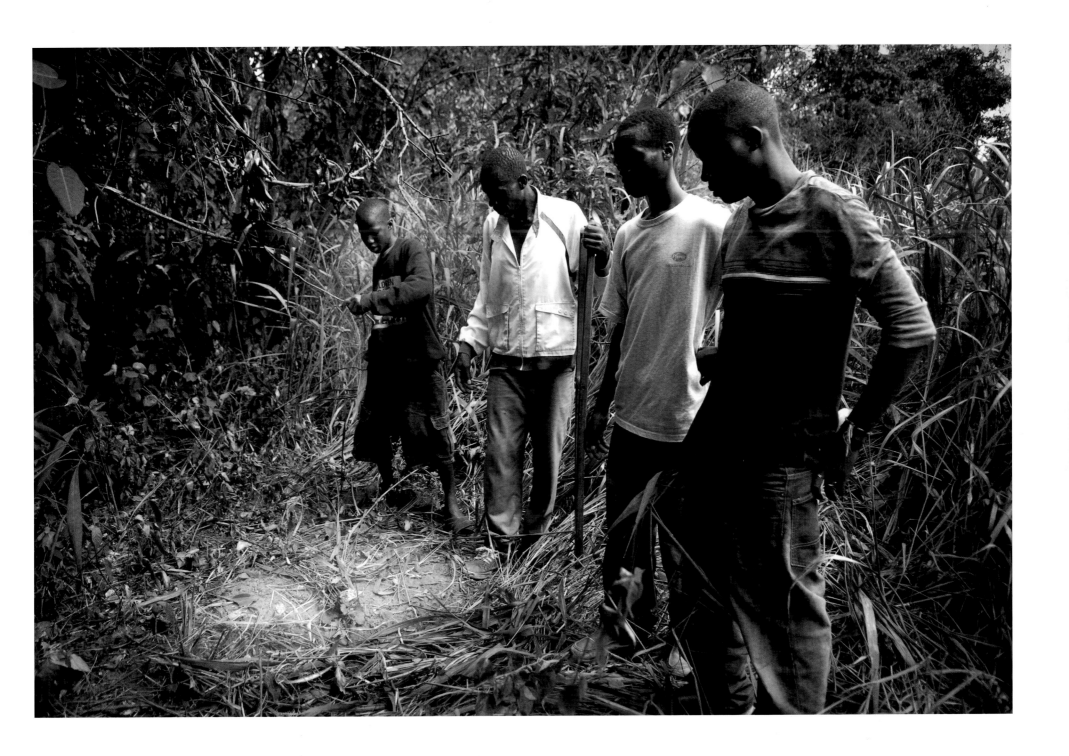

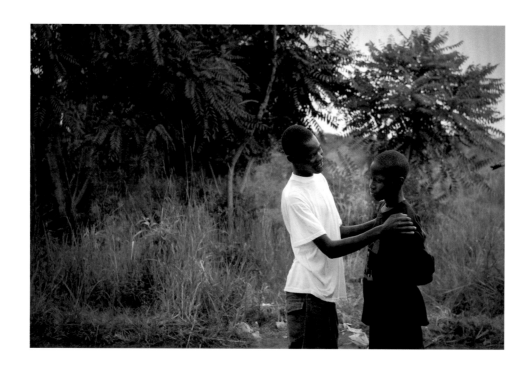

Above and Right: Aside from seeing his father's grave, Brian hoped he would also find the older brothers he had not seen since 1999. They had stayed in rebel territory, growing up as "night commuters." After driving around, stopping and asking at various villages, the group finally stopped at a roadside bar. There, incredibly, both brothers just walked out of the bush. It was a sweet reunion with Mark, above, and his eldest brother Acire Mugisha.

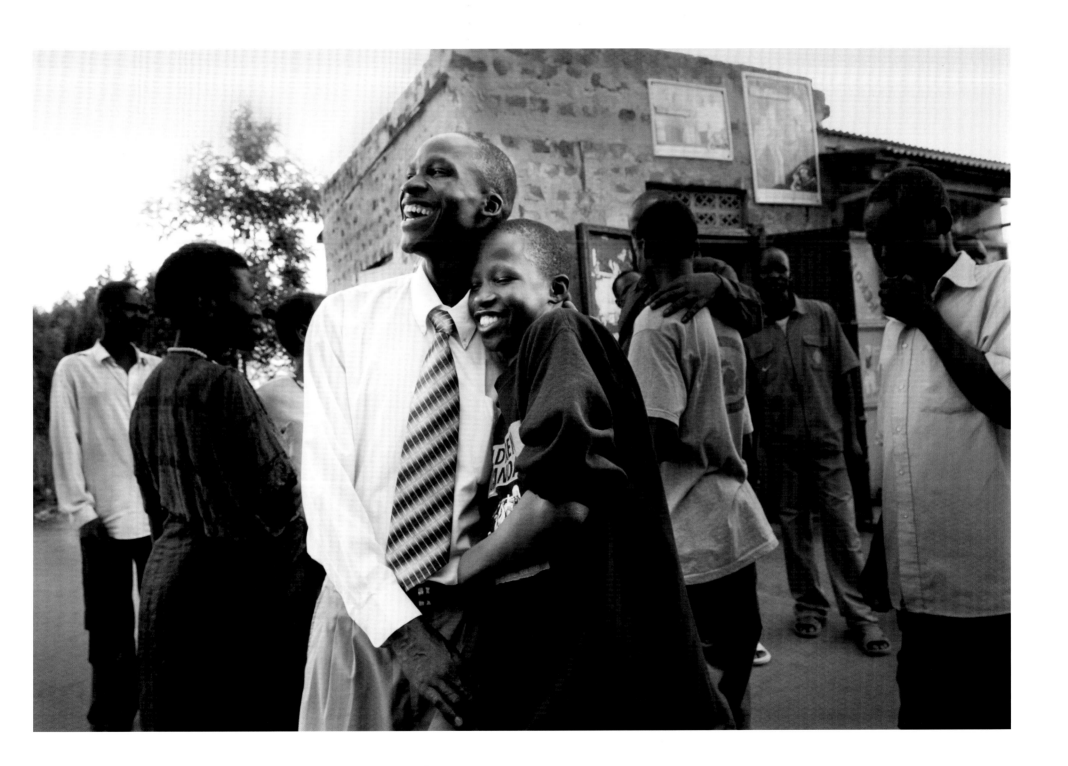

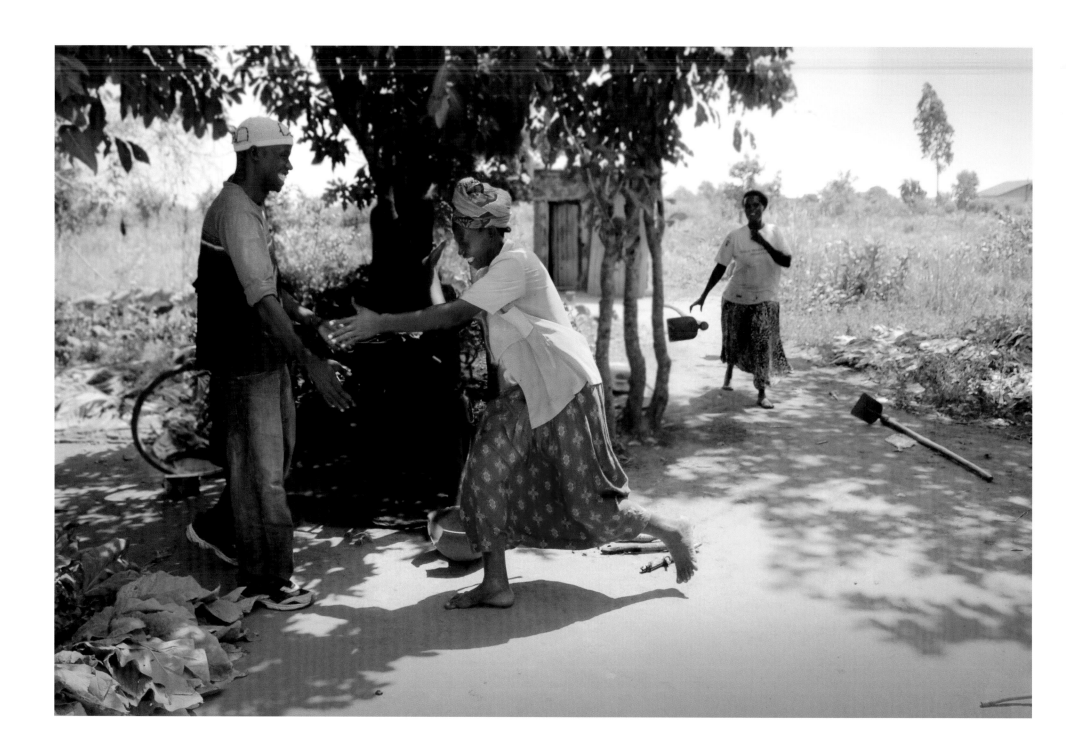

Left: Brian's cousin, George Okot greets his "auntie," another survivor of the 1998 massacre.

Teddy

"We don't talk about AIDS. All I know is it's a disease that cuts people, and then they die."

—*Teddy Namuddu*

All Teddy Namuddu remembers of her father is a framed photo of him that hung above the dining table when she was small.

Back before he got sick, Teddy's father was a tailor. He supported his eight children by sewing men's suits and children's school uniforms. The family lived together in a tin-roofed house with two rooms in a dusty neighborhood on the outskirts of Kampala.

But when Teddy was still a baby, her father was struck by the long fevers and diarrhea that were all too familiar to Ugandans. Within two years, he died of AIDS. For a while, Teddy's mother, Annette Najjembe, struggled to feed her children by working odd jobs. She sold pancakes by the roadside and used her late husband's old sewing machine to repair second-hand clothes. But she couldn't make enough, and she knew that soon her own health would start to fail since a test revealed that she was also infected with HIV.

Right: Teddy sits by her mother's side during a rare visit to her childhood home. Annette says her pride in her daughter's accomplishments helps to make up for the losses she has suffered.

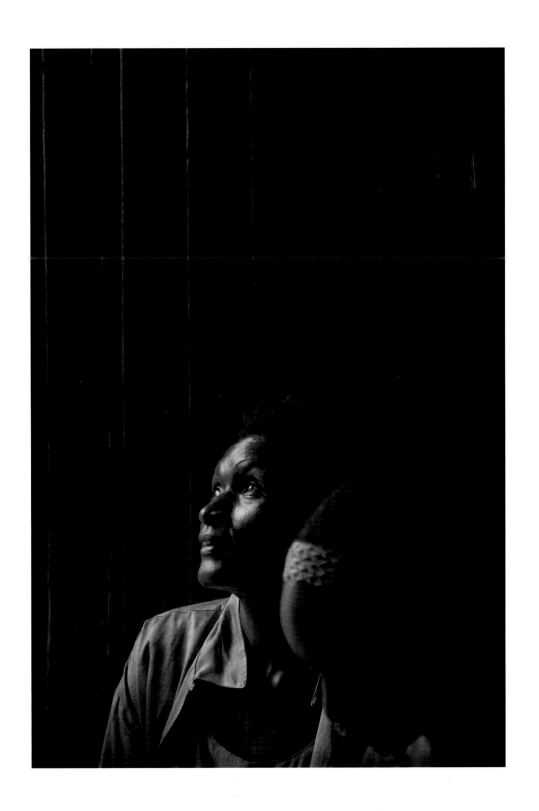

Teddy was just a toddler when she went to live at the Kiwanga home. The people at the orphanage were kind to her she said, and the food was good. But what she loved best were the dance classes. She was just three when she began touring with the troupe.

Teddy, now 10, visits her mother on holidays and some weekends. On a visit to her mother's house in June 2006, Teddy found her mother still working as a seamstress. Annette's eyes brimmed with tears of pride for her daughter as they quietly spoke together. She listened as Teddy described how she danced in America to rapt audiences. Teddy is also a top student at Taibah Junior School.

"I am so thankful," said Annette, who said she took AIDS drugs for a while, but they made her feel weak, so she stopped. Annette visits a hospital in Kampala when she has a high fever or a bad cough. She has never discussed her HIV status with her children. "We don't talk about AIDS," says Teddy. "All I know is it's a disease that cuts people, and then they die."

Right: Peter Kasule helps carry donated food to Teddy's mother, brother and sister.

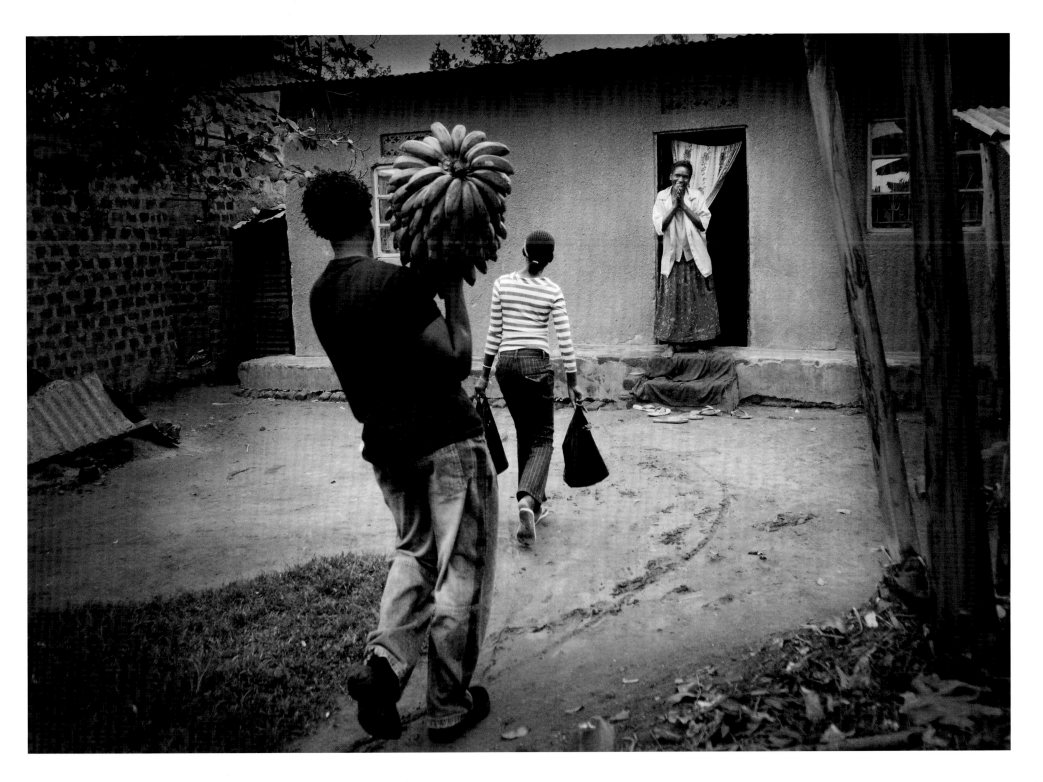

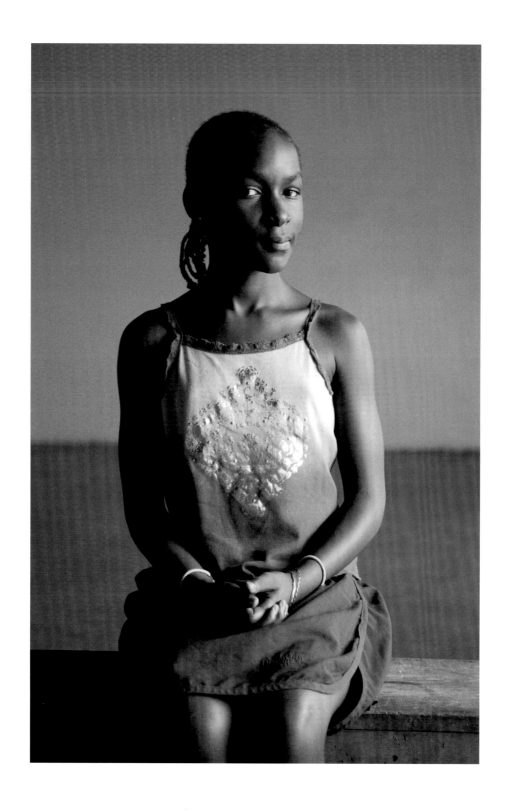

"My dad died when I was three...I don't remember him. There was a framed photo of him above the table where we ate."

—Teddy Namuddu

Left: Teddy returns to the Kiwanga home after the long tour in the US.

73

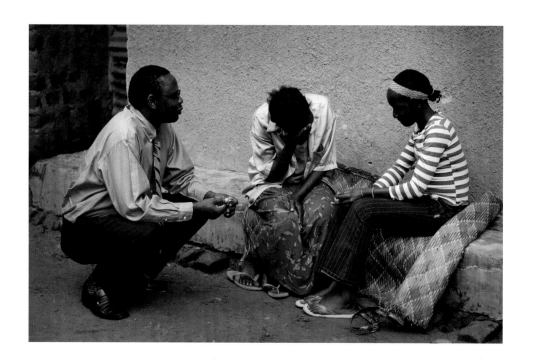

Above: Abel Mwebembezi tries to persuade Teddy's mother Annette to continue taking her AIDS medication. She stopped taking the drugs because they had unpleasant side effects. **Right:** Annette shows her children the medicine that made her feel too sick to work. Antiretroviral drugs that effectively prolong the lives of people infected with HIV are now available to Ugandans who could not previously afford them. But AIDS education in many areas is weak, and many Africans are suspicious of the drugs.

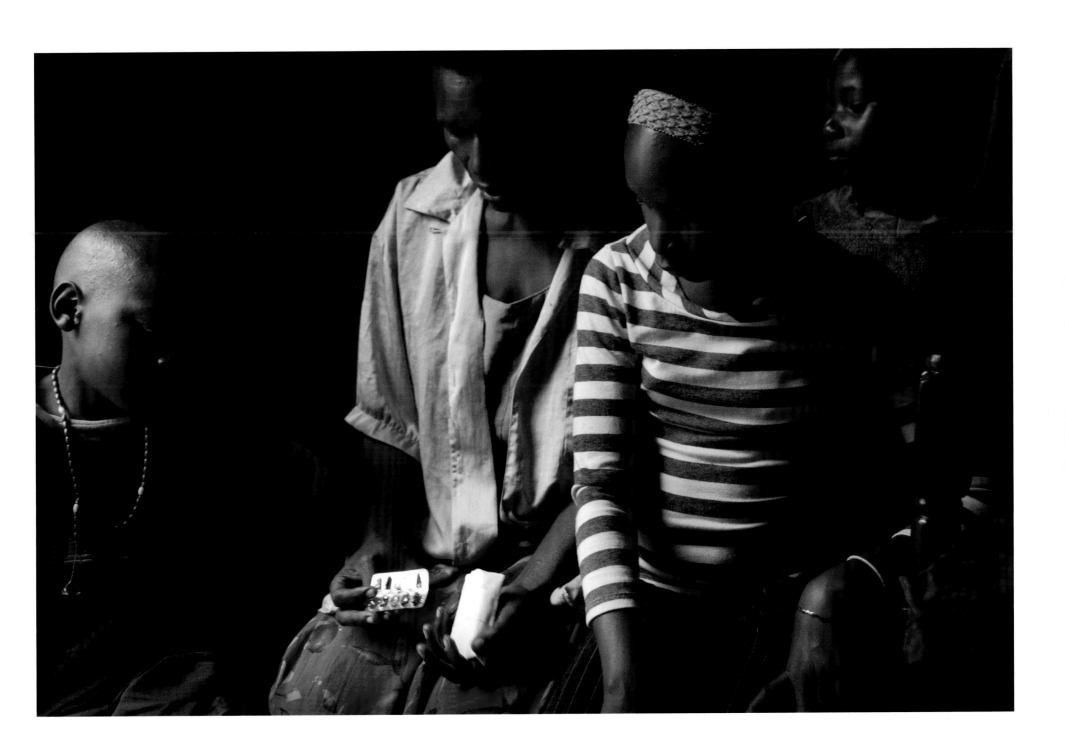

Peter

The truck was waiting for Peter Kasule one day when he got home from school. It was white, license plate UPW 110. It was filled with frightened children like him.

Peter's sister told him they were going to an orphanage in Kampala. "I don't want to go," Peter said. He was nine. He had never been out of Kyotera, a bustling border town in the district of Rakai in southwestern Uganda. In the 1980s, fishing villages on the nearby shores of Lake Victoria had recorded the country's first deaths from a strange new disease the locals called "Slim." By the 1990s, AIDS had killed so many people in the region that survivors assumed it could only be witchcraft.

Among the dead were Peter's parents. He lost his mother first in 1989. He was already living at the orphanage in Kampala when the news reached him three years later that his father had also succumbed. He wasn't able to go to the funeral.

The Daughters of Charity orphanage was founded by a dynamic Ugandan nun, Sister Rose Muyinza, to care for AIDS orphans, war orphans and those who simply had no one. When Peter arrived in 1990, the home was in a decrepit old colonial building in downtown Kampala. He and the other children began performing traditional African music and dance as a means to make extra money. In 1996, Peter was a performer in the dance troupe's maiden tour to the US. He was invited to return as a US Scholarship student, completed his high school education in Texas, and graduated with a B.F.A. in music technology from the College of Santa Fe.

His time abroad has inspired him to combine traditional African rhythms with Western musical forms like jazz and classical. Peter now leads Empower African Children's artistic initiatives and training programs including the Spirit of Uganda troupe. Peter

Right: In 2006, Peter Kasule finally made the journey to a mountaintop in Tanzania, where his father is buried. He placed stones on the grave, completing the last rites a Ugandan son must perform.

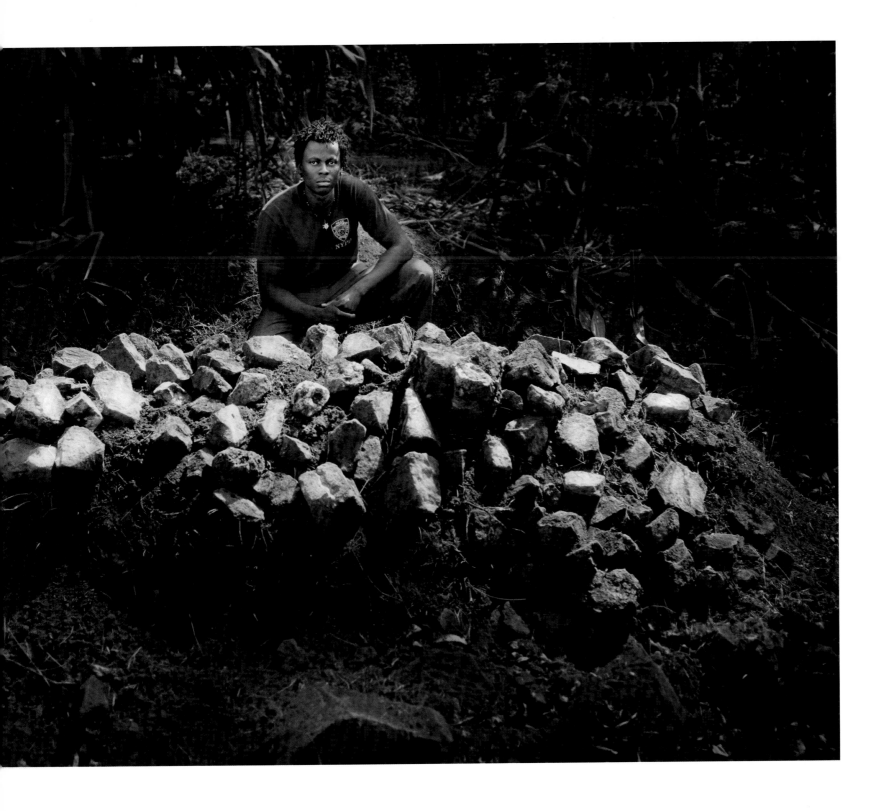

researches, creates, arranges and rehearses all repertory and serves as Master of Ceremonies. He directs the company's video and music recordings, leads master classes on tour and is an articulate speaker and advocate in lectures and panel discussions. Peter believes that he and the children who tour embody the power of the human spirit. As ambassadors for an entire continent, bearing an important message of pride and hope, "We show people there is another side to Africa than just hardship and problems," he says. He has purchased a small plot of land and plans to live, teach and create his work in Uganda. "I believe I can make a difference here."

In June, 2006, when he was 26, Peter returned to Uganda during the school break. He was busy traveling between the orphanages in Kiwanga and Rakai, scouting the homes for talent. But he also took a more personal trip that summer, back to Kyotera, where as a boy he had once sold pancakes and fish by the roadside. A few kilometers outside of town, he arrived at his mother's village, where aunts and cousins ran from their huts to welcome him home.

The next morning, he got up at dawn. He crossed the border into Tanzania and arrived in the village of Chembale, his father's birthplace. It was here that Frederic Kawempe Kasule had once worked as a teacher and a minister, preaching in a modest church atop a grassy hill. It was here that Peter's father was buried. Fifteen years after his death, Peter finally made the journey to pay his respects at his father's grave. He placed stones on the grave, completing the traditional last rites a son must perform for his father. "It brings some kind of peace," he said.

Right: Peter in the abandoned church where his father once preached. Peter remembers carrying stones to help build the foundation as a small boy.

"I was blinded by poverty, anger, fear and grief. One day a stranger held my hand and lifted me to a higher ground."

—Peter Kasule

Right: On their trip to Tanzania, Peter and his sister Mary Nakitto, 31, are surprised and welcomed by another sister, 29-year-old Josephine Namirembe, who lives nearby with her four children. Josephine also went to the orphanage in Kampala with her brothers and sisters after their mother's death, but she later returned and settled in their father's village in Tanzania. Peter had not seen her for 20 years.

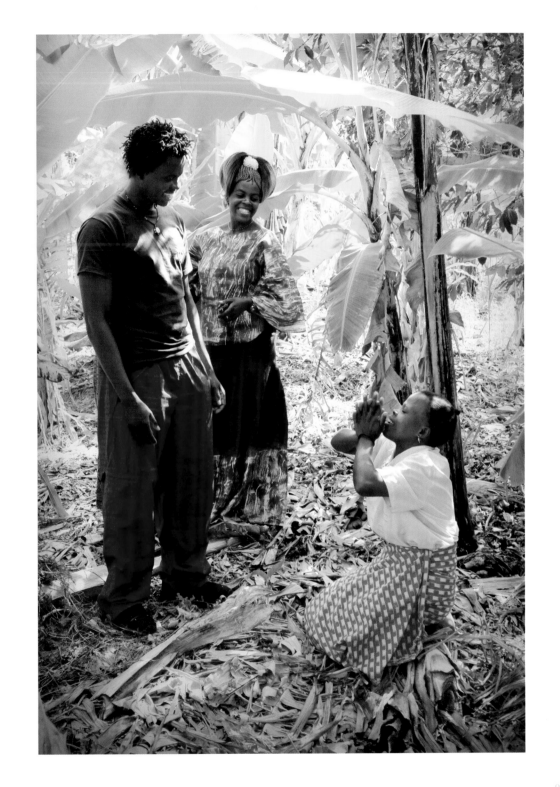

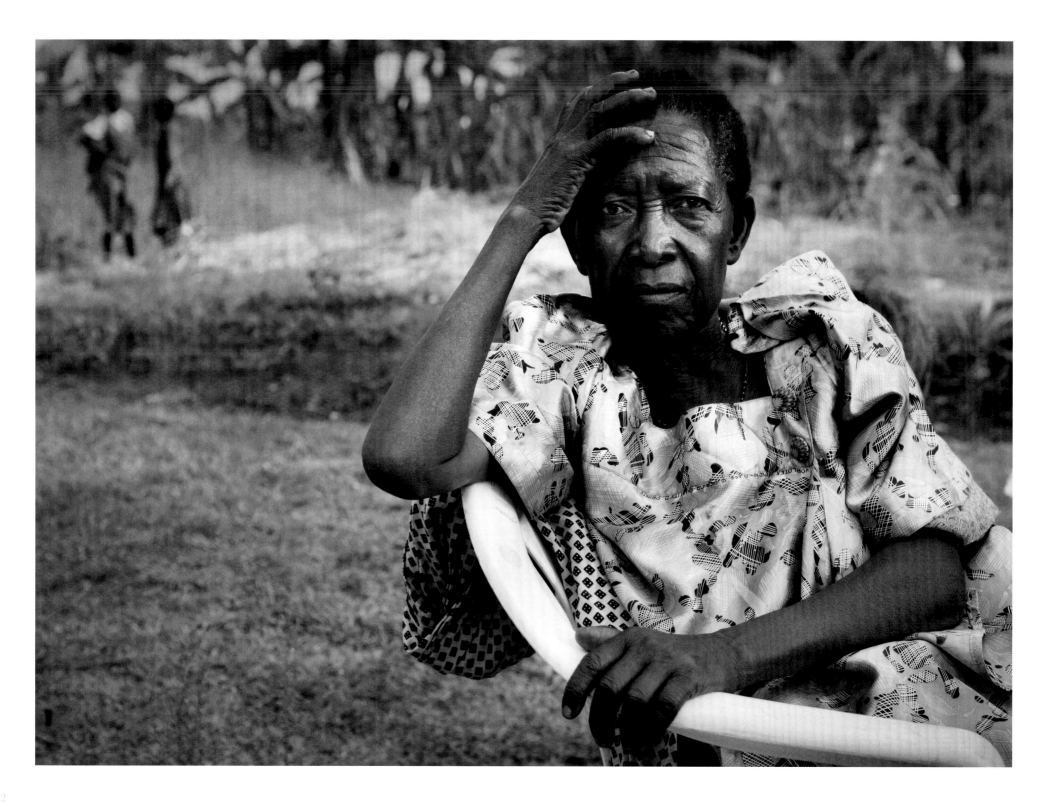

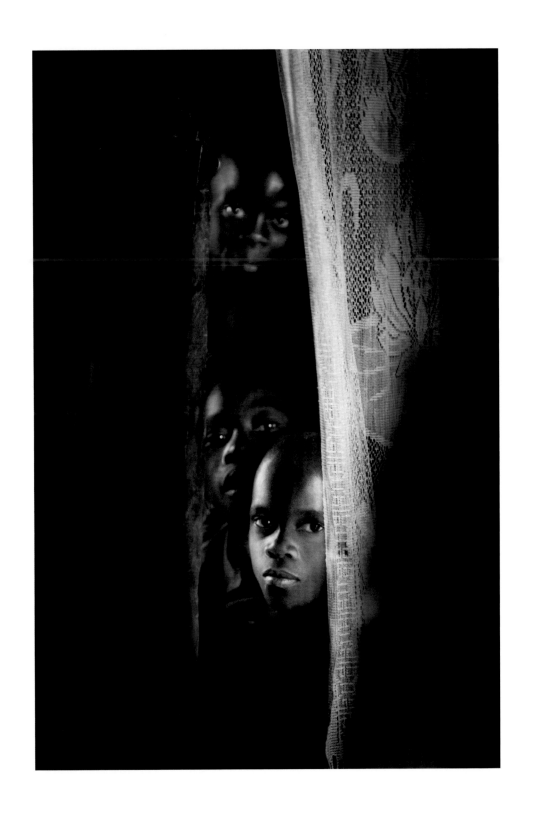

"When you think hope is gone, that is when you need to look farther than where your eyes can see."

—Peter Kasule

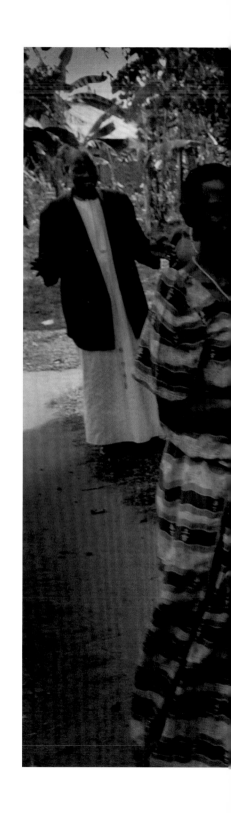

Previous pages: Peter's Aunt Thereza rests during the party while Peter's sister Josephine and her children wait respectfully for Peter behind a curtain in their mud-walled home. **Right:** On his way to visit his father's grave, Peter makes a rare visit to relatives in Rakai where his grandmother leaps into his arms to welcome him. The family prepares a feast in his honor.

84

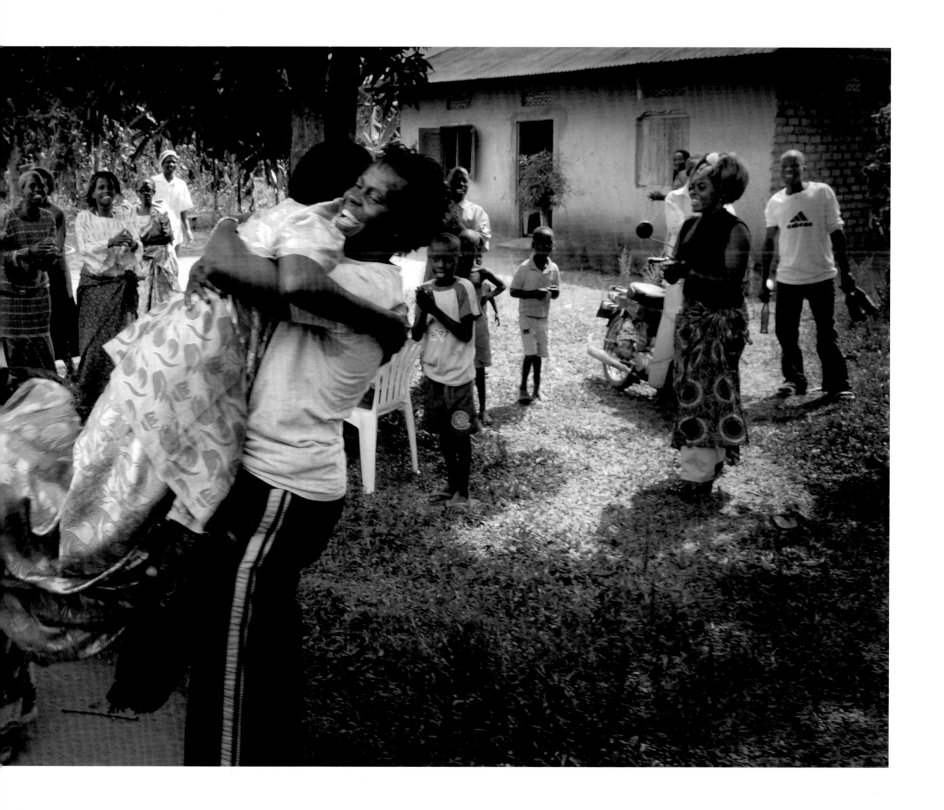

Ronald

Sixteen-year-old Ronald Kyambadde woke up several hours before dawn to get in line at Mulago Hospital by six. By nine, there were perhaps 100 children waiting quietly behind him to see a doctor, all of them HIV positive. Of the one million people infected with the AIDS virus in Uganda, 100,000 are under 14. Virtually all of them caught the virus from their mothers, who were HIV positive at the time of their birth.

Ronald had been a frail, sickly child when he arrived at the orphanage in Kiwanga six years ago. An uncle explained that both the boy's parents had died of AIDS but that he could not afford to care for him. And Ronald's health was already failing. During that first year at the orphanage, he had frequent fevers and his skin was covered with sores. Staff members at the home soon confirmed what everyone suspected: Ronald had the same deadly virus that had killed his parents.

But gradually, Ronald improved at the home, where he ate regular meals and got medical care. A doctor started him on antiretroviral drugs funded by a clinic at Mulago Hospital that subsidizes HIV care with monies from private corporations and the US and Ugandan governments.

Ronald gained weight and his skin looked normal again. In 2006, thanks to a private sponsor, he started attending a boarding school in Jinja, a town about an hour's drive east of the capital. He loved the new school. On holidays, he returned to Kiwanga full of news about his new friends.

But the morning Ronald woke up early to wait in line at the hospital, he got bad news. At ten o'clock, he was finally let in to see the doctor who told him that his immune system was weakening and that he would have to start a new, stronger course of medicine that required refrigeration. Ronald's new boarding school, which he loved so much, didn't have refrigerators. So Ronald would have to return to school in Kiwanga the following term.

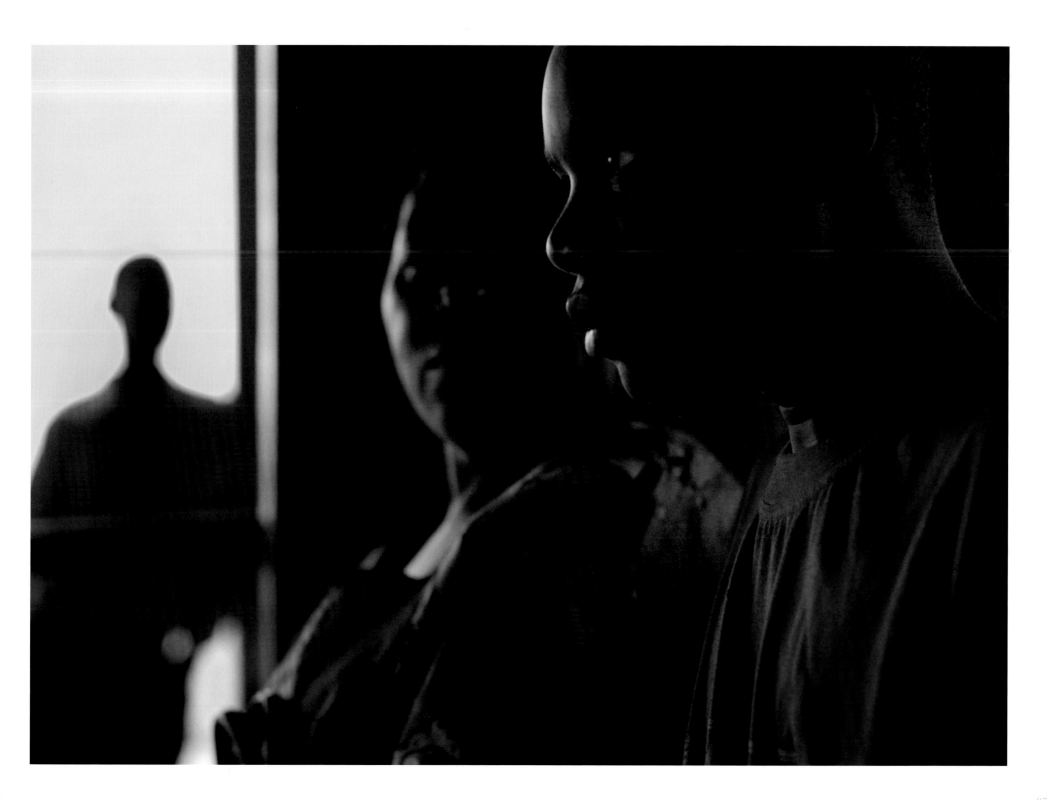

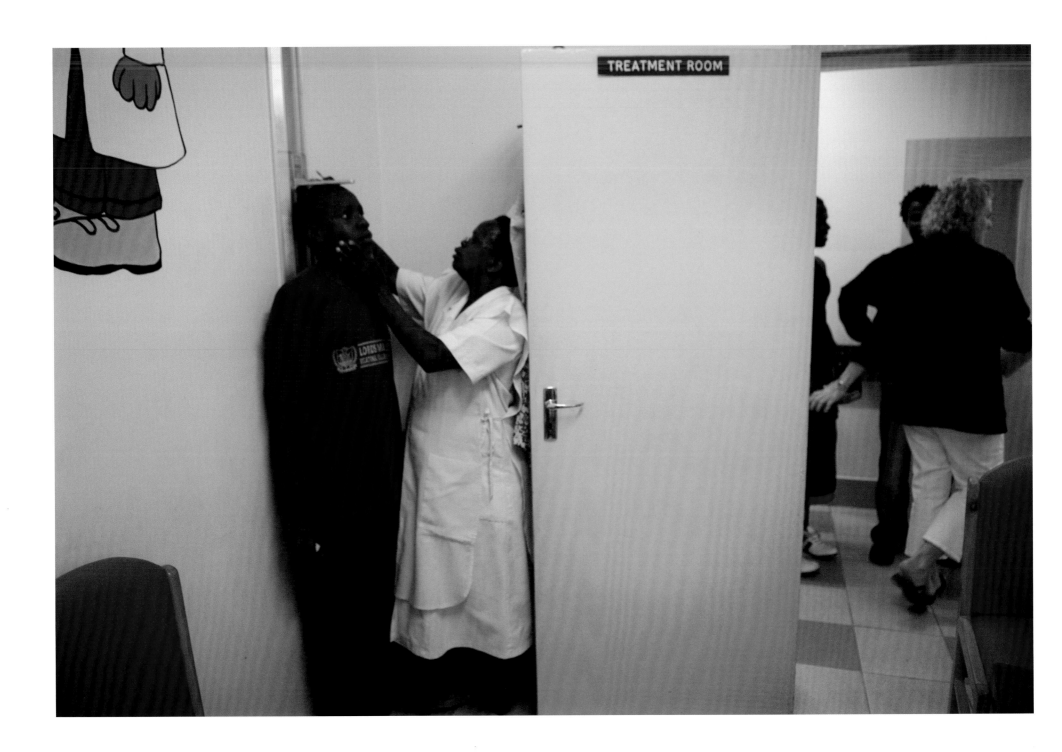

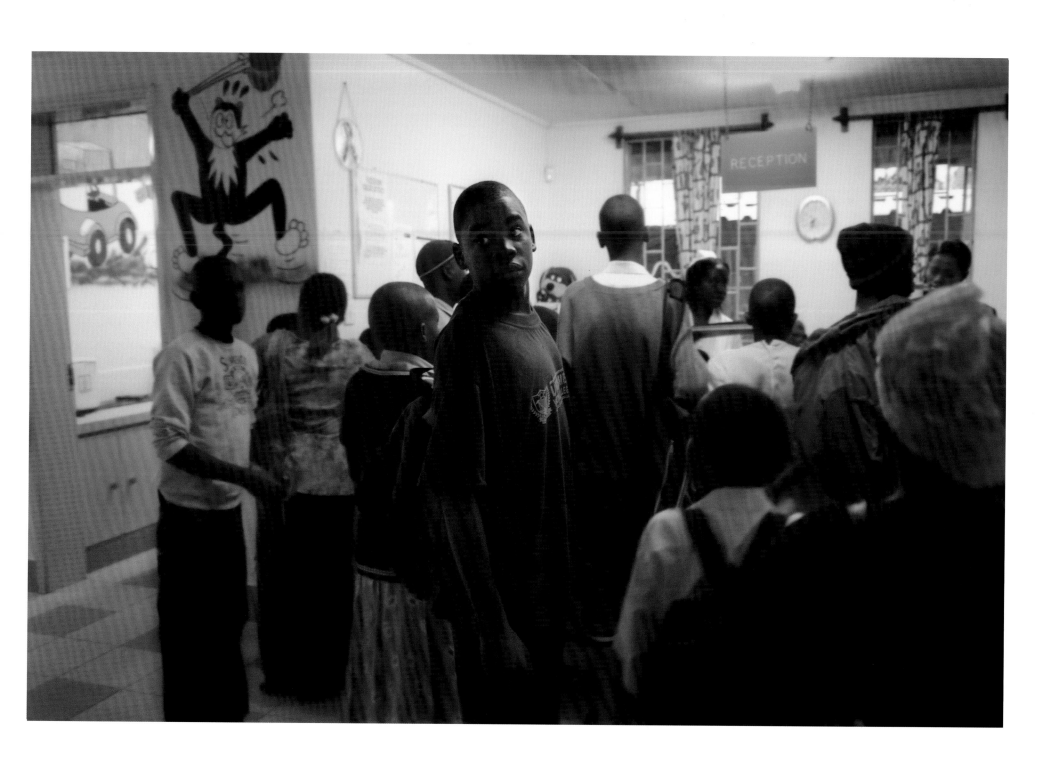

"I threw them away. I did not want anyone to see me taking them."

—*Ronald Kyambadde, explaining to the doctor what happened to his AIDS medications.*

Right: After a four-hour wait, Ronald sees the doctor. He reveals why his immune system is weakening, admitting that he is not consistently taking his antiretroviral drugs. Ronald says he thought the drugs might make him sicker.

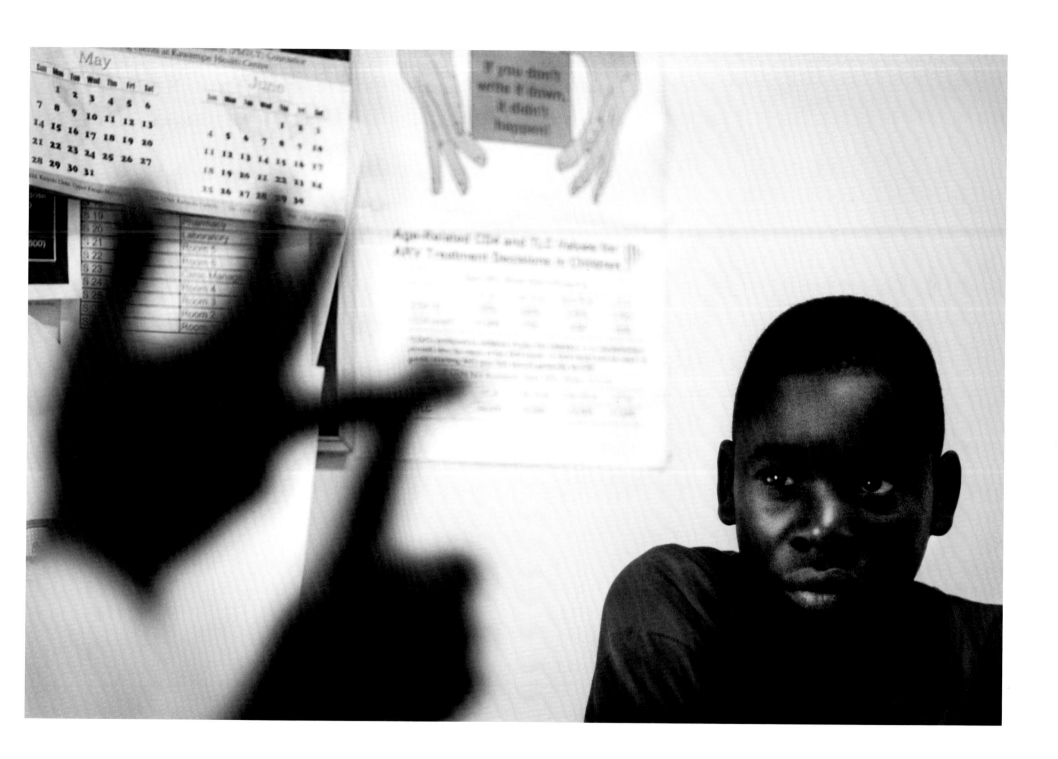

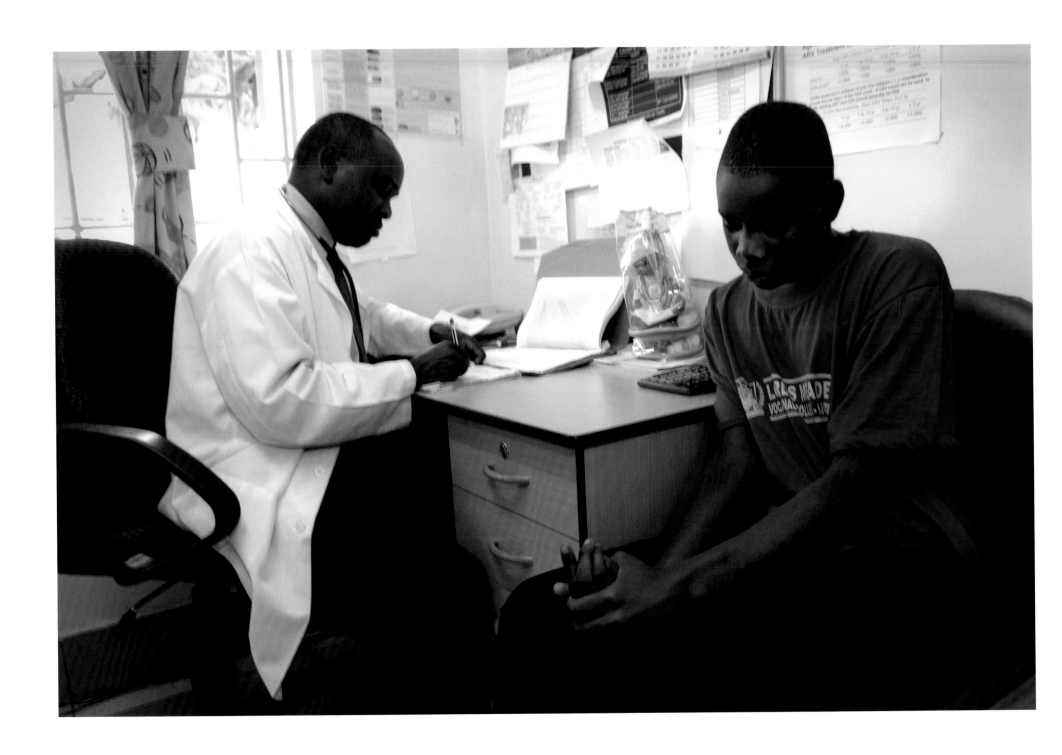

Above: All children carry a "book" that documents their medical history. **Left:** After running tests and reviewing his case, the doctor prescribes a new regimen of AIDS drugs he hopes will strengthen the boy's immune system. But the drugs require refrigeration, which means that Ronald will have to leave his new boarding school. Ronald is very shy and has had a hard time making friends.

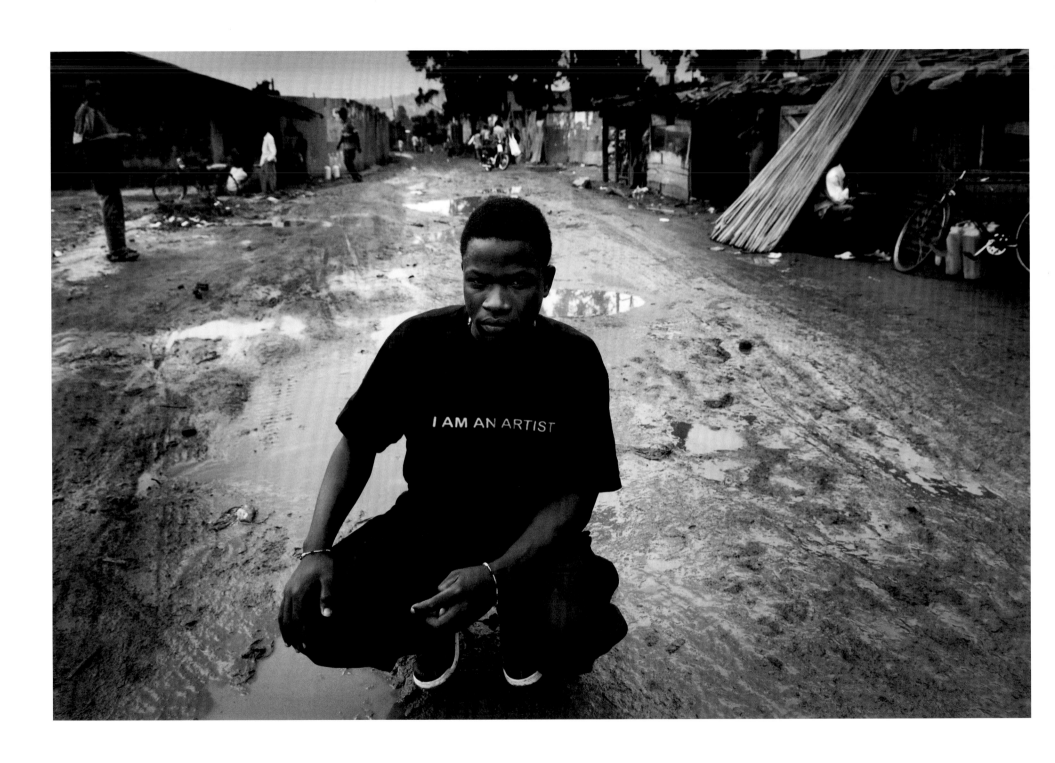

Bernard

"When I was twelve, my mother left us. I said, 'Please come back, we are your children.'"

—*Bernard Sserwanga*

Before she left her children, Bernard Sserwanga's mother taught them the *Bakisimba*, the ancient royal dance of the Baganda, Uganda's central tribe.

Bernard was born in the mid-1980s, when Uganda was suffering the aftermath of Idi Amin's brutal regime. The capital city was crumbling and violent. Staples like sugar and cooking oil were hard to find. His mother earned a living by selling steamed plantains and goat meat in the central market. But she was also a talented traditional dancer, and on weekends, she would leave the slum where they lived to perform at weddings and parties. Sometimes she would sneak cake home to give to the boys.

Left: Bernard in Katwe, a rough-and-tumble neighborhood of metalworkers and storefronts on the outskirts of Kampala. He once lived in a room there with his mother and two brothers.

The family lived in Katwe, a crowded neighborhood full of makeshift shops and open sewers. Bernard's father, who was also a dancer, drummer and singer, abandoned them when Bernard was three. Bernard and his two younger brothers stayed in a one-room storefront where a single light bulb dangled from the ceiling. They ate leftover market food their mother brought home, if there was any. They put down mats on the floor at night to sleep. When it rained, the room flooded and the boys had to sleep outside on the muddy ground.

When Bernard was 12, his mother disappeared. She packed all her belongings, said she was going on a trip and never returned. Bernard believes that providing food, shelter and education for her sons was simply too difficult for his mother. He has spoken to her only once since she left, about a year later when she called on the telephone. "I said, 'Please come back. We are your children,' but she said she couldn't."

At first, Bernard and his brothers stayed in their room in Katwe, surviving on the kindness of neighbors and their own wits. Their mother had left them with one skill: They could dance. They performed at parties and in city squares — wherever they could. One day, a teacher and leader of a well-known traditional troupe in Kampala saw Bernard dance and helped move him to the home in Kiwanga. In 2000, Bernard went on tour to the United States for the first time.

Every now and then, especially when he dances the *Bakisimba*, Bernard still thinks of his mother. But he says he no longer wants her to come home. "Now I am a man, and I have to be grown up and help myself," he says.

Right: Samuel Mowonge, a Katwe tailor, fed and protected Bernard and his brothers after their mother left them. Now he makes drum covers and costumes for Spirit of Uganda. **Following pages:** Bernard shows his intensity during rehearsal at Kiwanga. Members of the troupe receive extra food and special treats when they are training. Bernard also trains some of the younger dancers at Kiwanga. The older, more experienced members of the dance troupe help the younger ones and act as mentors.

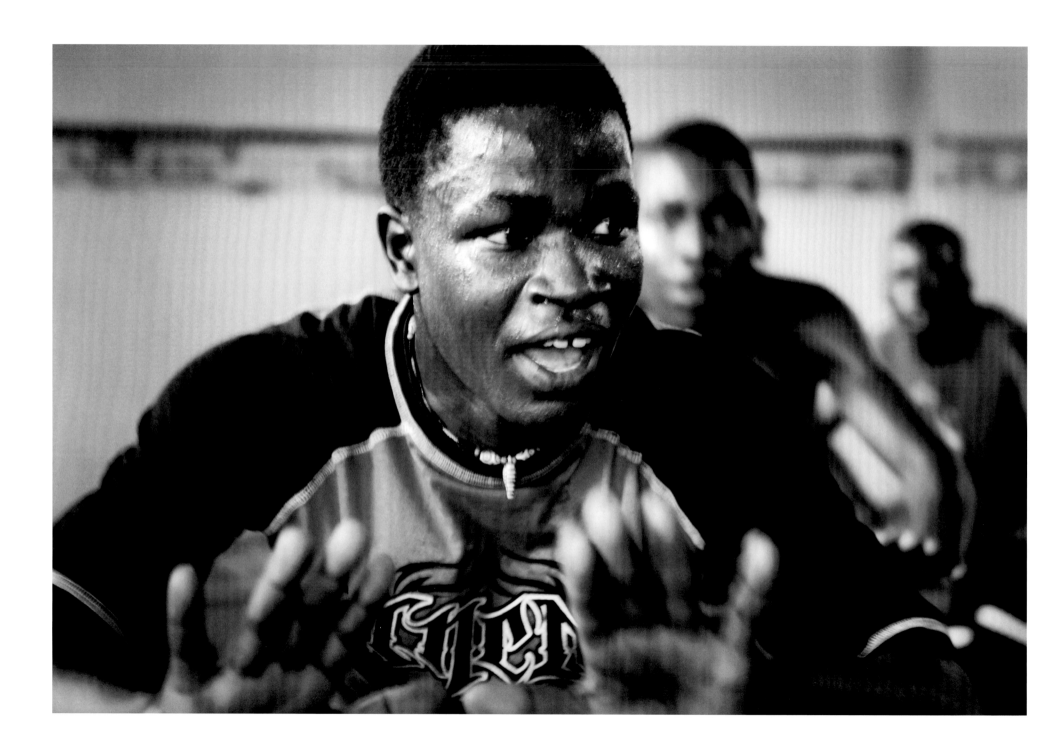

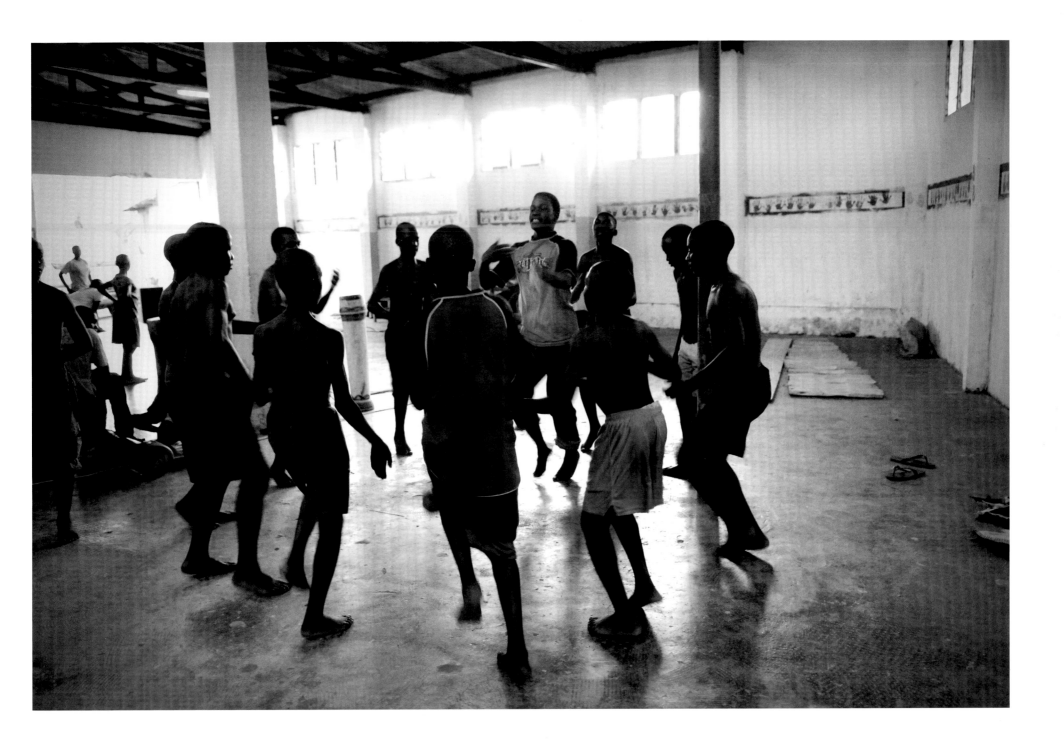

"Now I am a man, and I have to be grown up and help myself."

—*Bernard Sserwanga*

Right: After the US tour, Bernard and his fellow dancers are immediately back at work rehearsing and training new dancers for the next tour.

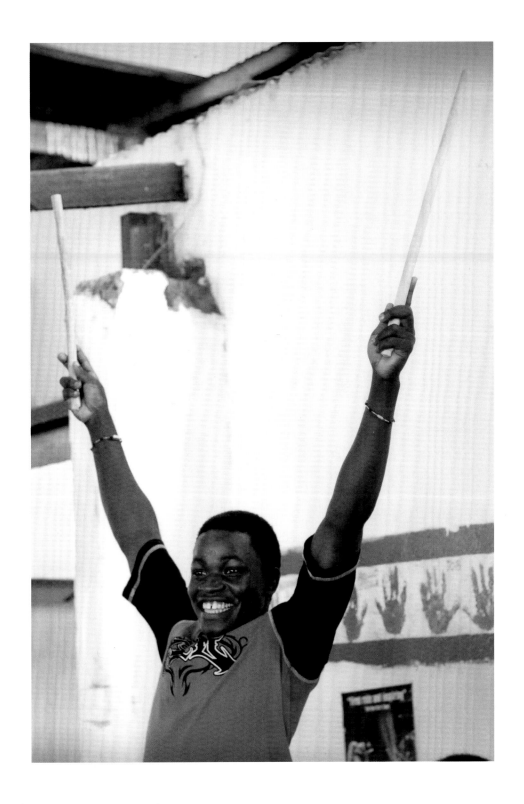

Zaina

"The most special thing about me? That I am alive."

—*Zaina Nakato*

Zaina Nakato lost her parents before she was old enough to talk. Most of her aunts and uncles followed. When she was nine, an older sister brought her to live at the Daughters of Charity orphanage in Rakai. A year later, Zaina learned that her sister was dead too.

The tragedy of Zaina's family is not unique, particularly in the region of southwestern Uganda near the Tanzania border. In the mid 1980s, doctors from Kampala traveled there to investigate what the locals assumed was a curse. For several years, people had been falling sick with the same awful wasting symptoms and dying mysterious deaths.

Right: Zaina is pensive during a rare visit home to the town of Mutukula on the Uganda Tanzania border. Like many families in the area, Zaina's was decimated by AIDS. One of her few surviving relatives is her uncle, Hajji Ntambazi Habib, a very strict man who was Zaina's guardian after the rest of her family died of AIDS.

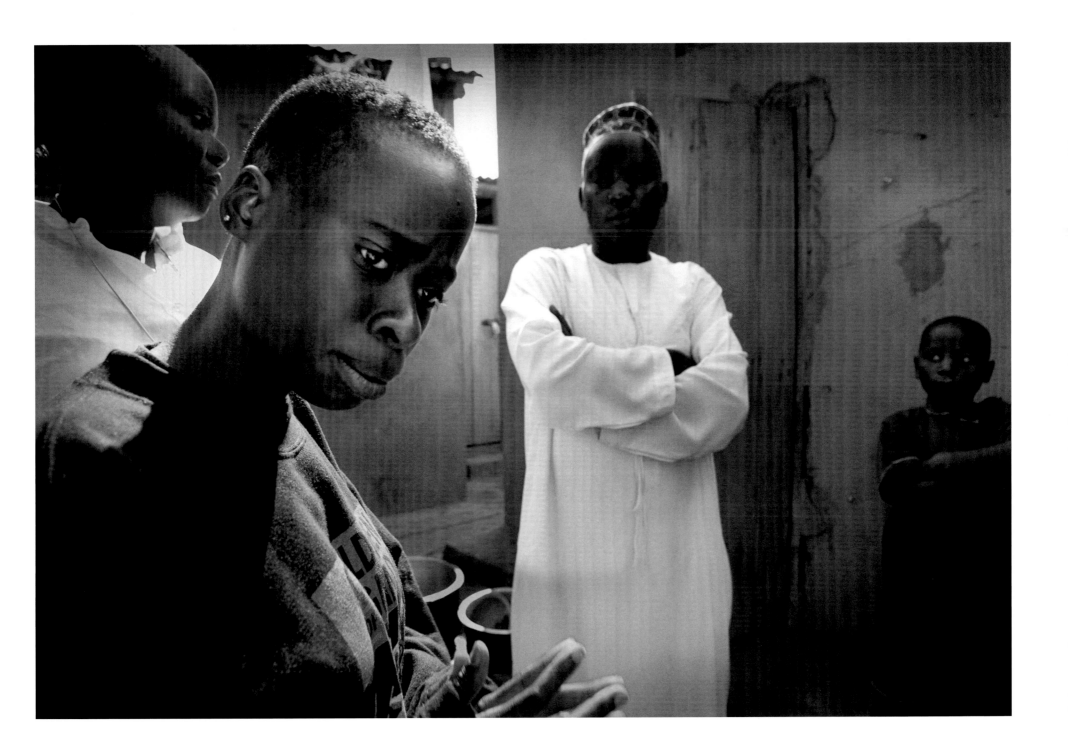

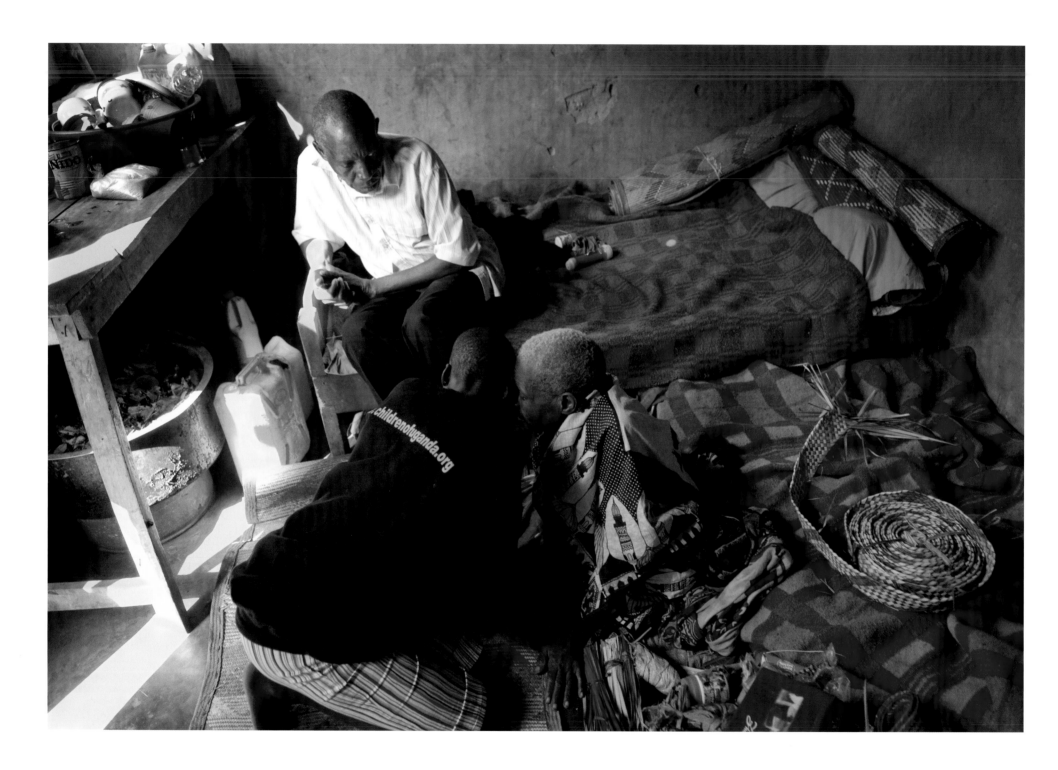

It soon became clear that this was somehow the same disease that was killing gay men in the United States. But here no men, women or children were spared. By the time scientists in the West had come up with a name for the new syndrome, AIDS had cut deadly swathes through many African families like Zaina's.

The home in Rakai opened in 1993 in response to the overwhelming number of children in the area who had lost their parents and had no one else with the means to care for them. Today, there are an estimated one million AIDS orphans living in Uganda. Zaina, 16, who traveled on the US tour in 2006, considers herself fortunate. "I am a happy, nice looking girl, able to read, write, talk to many people in more than one language, and I can also stand and talk in any community despite the hardships I have gone through. I am looking ahead. As the saying goes: 'In life what matters is where you are going to, not where you are coming from.' "

Left: Zaina leans close to hear Hajjad Sayawa, her *ja ja* (grandmother) during a brief visit to her old hometown of Mutukula on the Uganda Tanzania border. Of Sayawa's five children, three have died of AIDS. **Following pages: (Left)** A young boy watches Zaina and staff from Rakai as they stop for provisions on the road south to Tanzania. **(Right)** Zaina's expression shows the strain of remembering the past while Deborah Nakiduuli, director of the Rakai orphanage and Zaina's aunt use their cell phones to try to find Zaina's uncle.

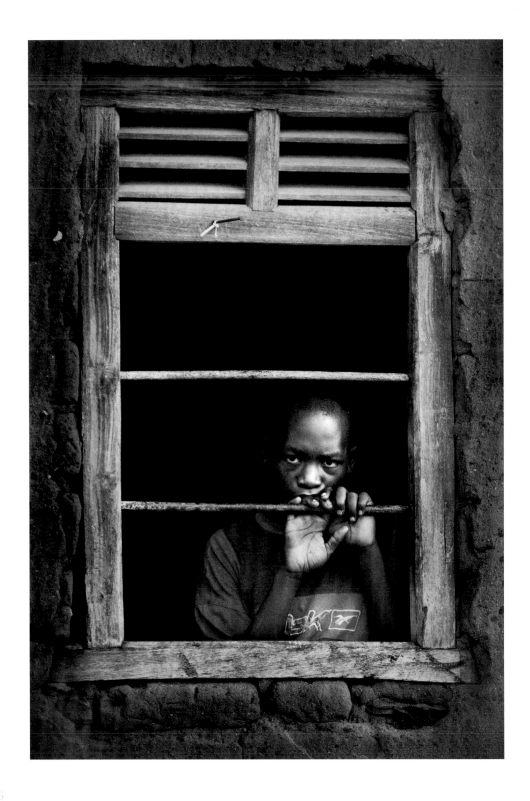

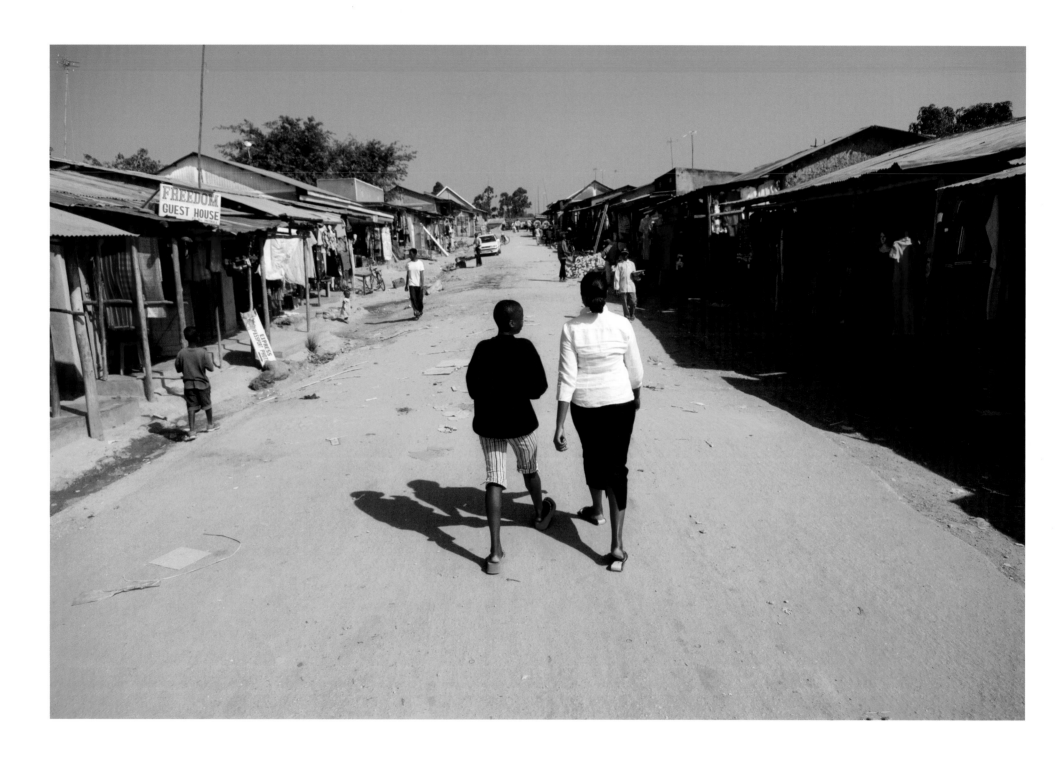

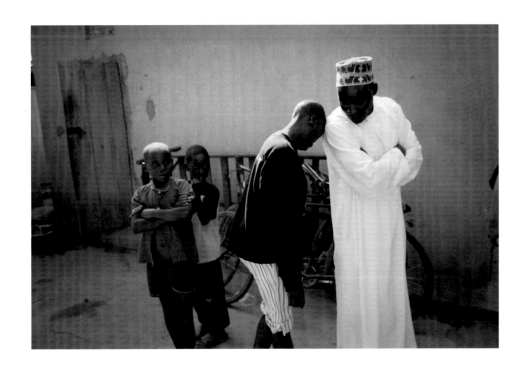

Left: Zaina and a staff member from the Rakai orphanage walk through the main merchant district of Mutukula. Traders, truckers and other transient workers who passed through border towns like this one helped fuel the rapid spread of HIV through many regions of Africa in the 1980s. **Above:** Zaina shares a tender moment with her uncle. **Following pages:** Sugar cane fields on the road to Rakai.

The US Tour

"Dancing for us is a way out. It's our escape."

—*Peter Kasule*

Originally envisioned as a means of raising funds and awareness for the orphanages in Rakai and Kiwanga, the children's first US tour in 1996 played primarily to community centers, churches and schools. Now their venues include some of the nation's leading performing arts centers and engagements at the White House, the World Bank, the Grammys, and Late Night with David Letterman, "Invigorating the stage with that elusive thing called joy," said the *New York Times*.

Under the direction of Peter Kasule, a member of the first troupe to tour America, twenty of the most talented children supported by Alexis Hefley's new organization,

Empower African Children, will continue to tour the USA biennially beginning in 2008 as Spirit of Uganda. The new troupe continues to explore the history, legends and beliefs of East Africa and introduces some of the dynamic music and dance forms that are being created now.

Many of the young performers believe that in addition to the intricate choreography and infectious drumbeats, Western audiences love the stories told by every dance. One 16-year-old dancer, Betty Nakato, put it this way: "Maybe we are teaching people that if something bad happens to you, you should not think it's the end of life. I have this belief that if you have life and hope, that anything can happen."

In 2006, the young dancers performed for more than 100,000 people. As well as preserving and introducing American audiences to Ugandan music and dance, these young ambassadors raise awareness about the global AIDS crisis and are thriving examples of what is possible when potential is recognized and supported.

Right: The children hold nothing back during a dress rehearsal before a show at the Joyce Theater in New York. Zaam Nandyose, 16, is rehearsing a dance called *Ekitaguriro*, which belongs to the nomadic Banyankole people of western Uganda. The Banyankole are sometimes ribbed by their countrymen for their great devotion to their herds of cattle. This dance praises the long-horned cows of Ankole and Rwanda – found nowhere else on earth. The dancers imitate the sounds, rhythms, and the movements of the graceful cows. This piece features the omukuri, a flute used to herd the cattle.

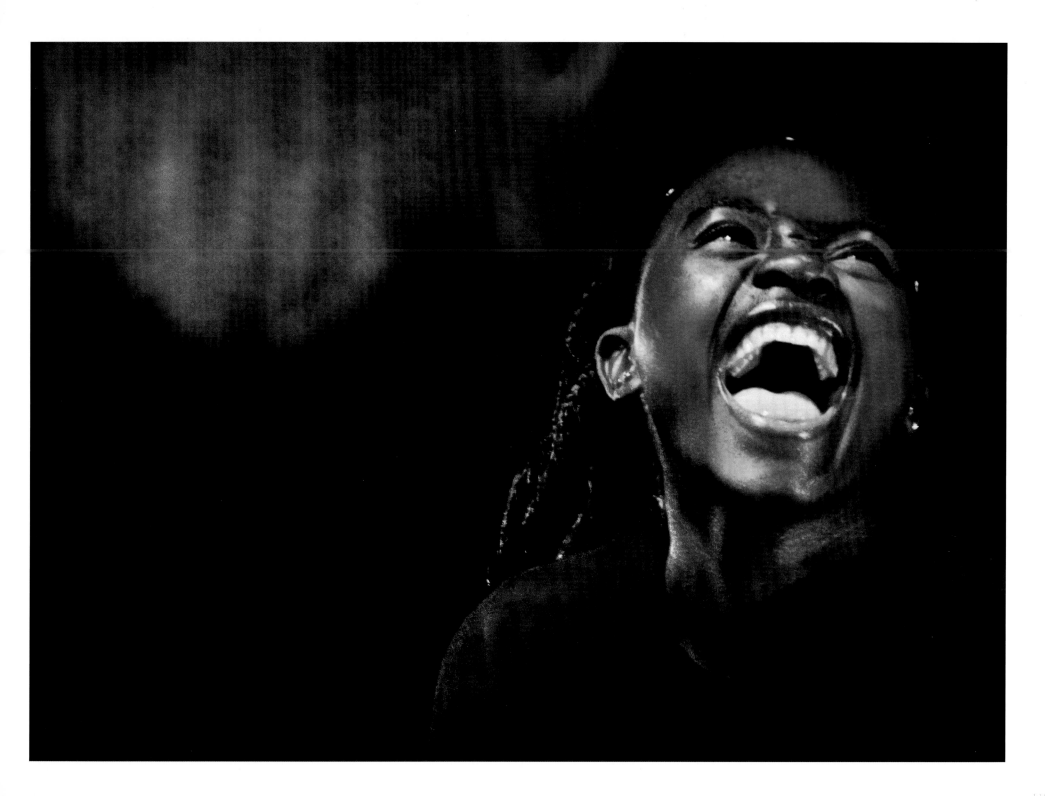

Right: Patrick Nyakojo, Brian Odong and Francis Kalule enjoy some down time at their hotel before one of the last shows they will perform on their four-month 2006 tour.

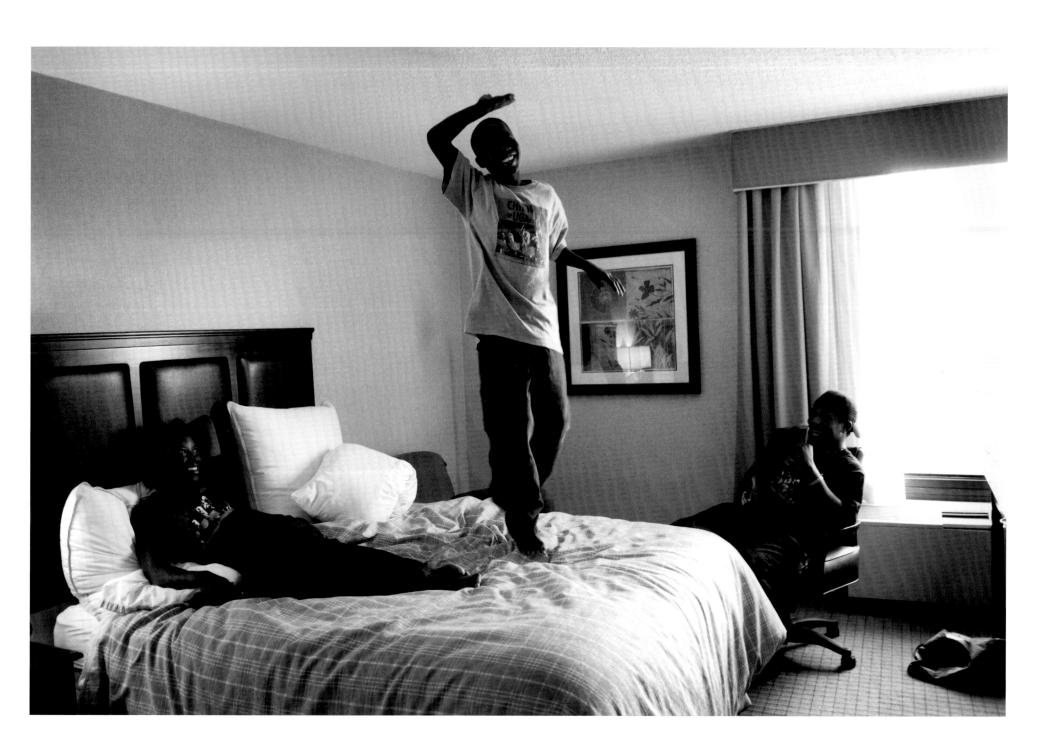

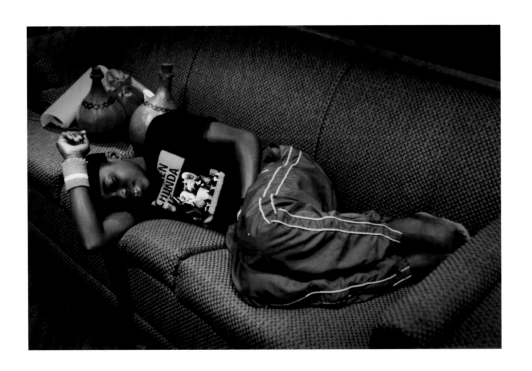

Above: Munawiru Jengo, 13, rests before the show. On stage, he is ecstatic. **Right:** Bernard Sserwanga
and Patrick Nyakojo dressing for a rehearsal.

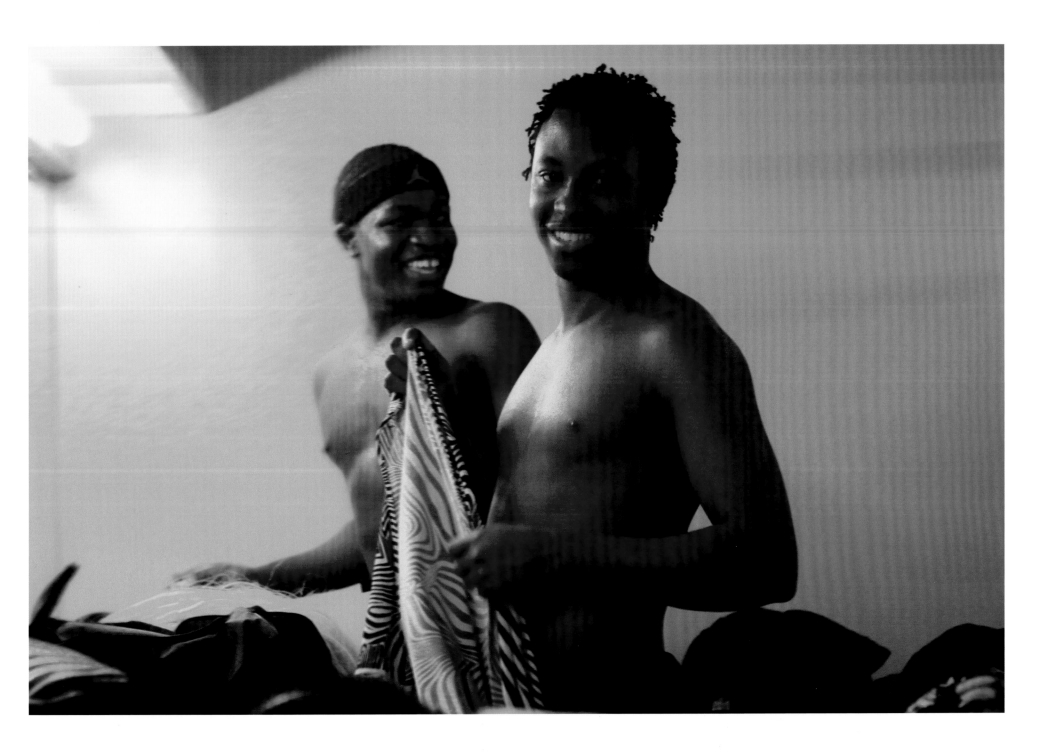

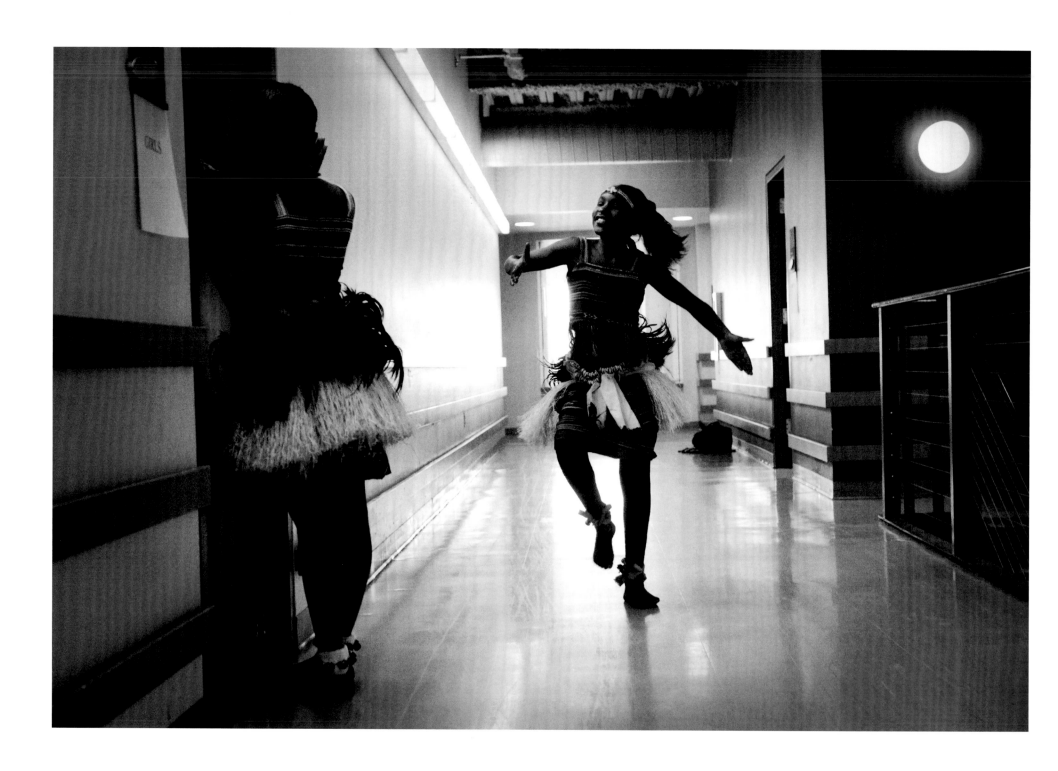

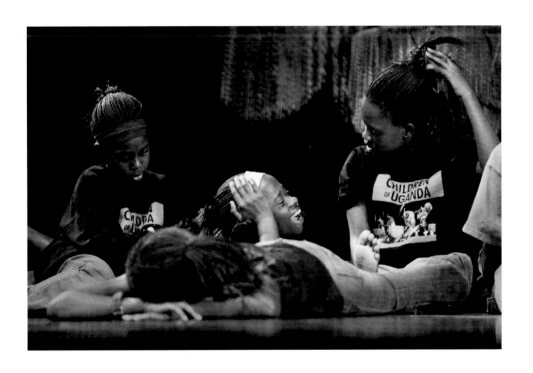

Above: Waiting for the rehearsal to begin, Miriam Namala, 6, Zaina, and Noeline Nabasezi, 14. Even after months of travel and dozens of performances, Peter puts the troupe through complete rehearsals and dress rehearsals at each new venue. **Left:** Teddy Namuddu having fun and warming up in the hallway before a show. Her costume is for a dance called *Ding Ding*. This piece comes from the Acholi people in the northern part of Uganda who are highly regarded for their dark complexions and tall stature. Girls developing into young women perform this high-energy dance, with its engaging melodies and intense, syncopated rhythms. **Following pages:** Brian Aine, 14, gets ready for a show.

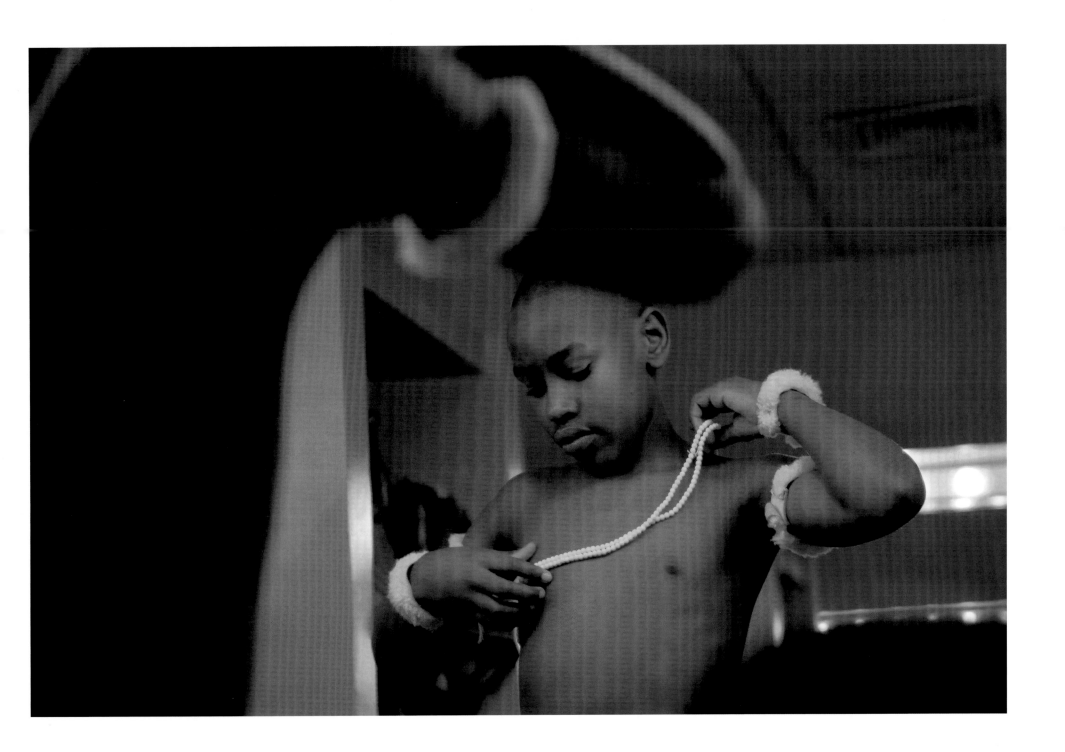

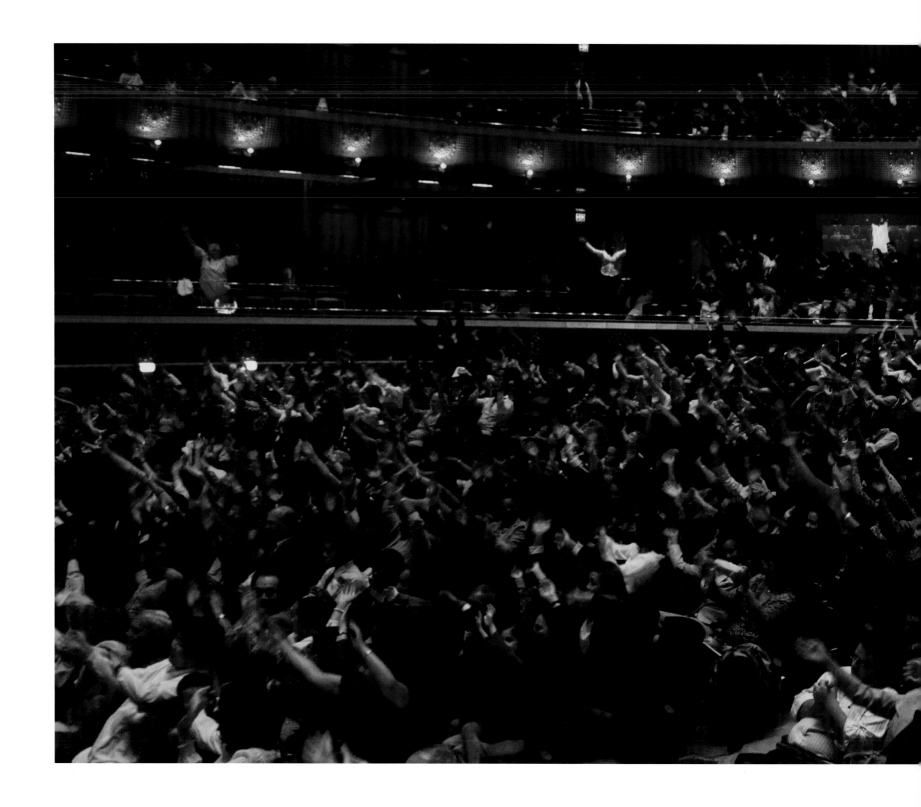

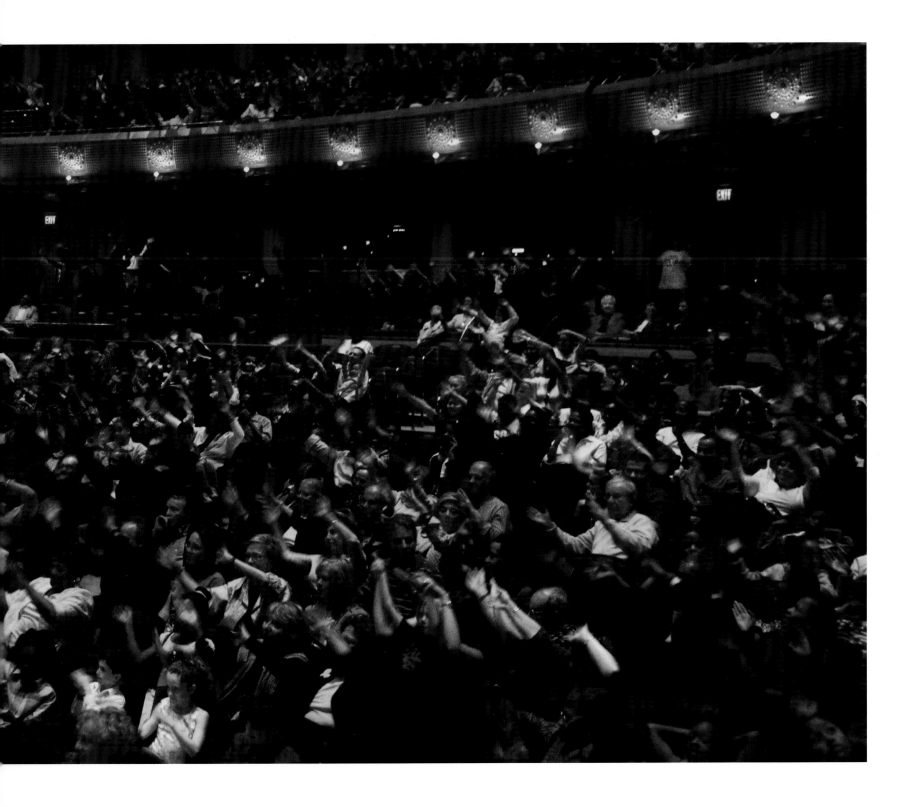

Preceding pages: As house lights go up during a performance the crowd is fully enjoying the show. **Right:** The boys showcase their skills in *Ngoma Ya Ukaguzi* a piece that features rhythms from northern Tanzania. Dramatic precision drumming is a big part of the show and once done only by men, but Peter has created a crowd-pleasing section of the show with young girls drumming as well. Drums are an integral part of traditional Ugandan music. Each drum is carefully handmade to produce a specific pitch, depending on the frame size and the type of hide. For example, the main drum, the Bakisimba, is made from the skin of a female cow.

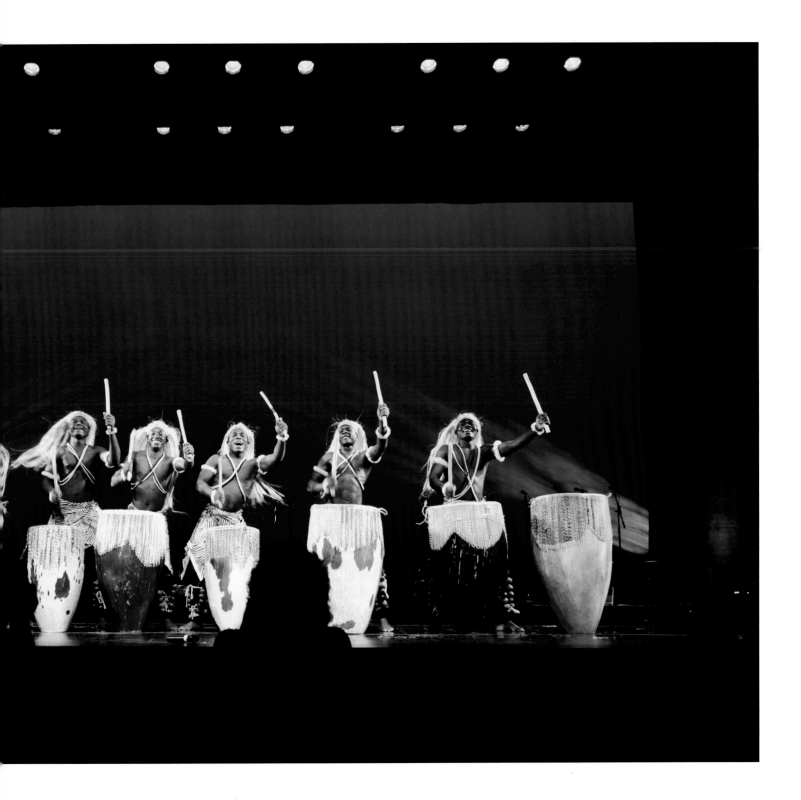

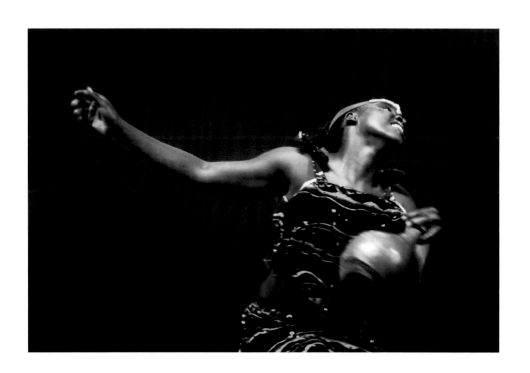

Above and Right: What starts with new students carefully learning to balance bricks on their heads, ends two years later with stunning, dance and stagecraft. Prossy Namaganda, 18, performs *Kanyonza* where the girls balance clay pots on their heads while performing intricate and fast moving choreography. The dance highlights the grace and talent of the performers and the lyrics praise women from three different Ugandan regions: Ankole in the west, the Swahili-speaking people of the east, and the Acholi of the north.

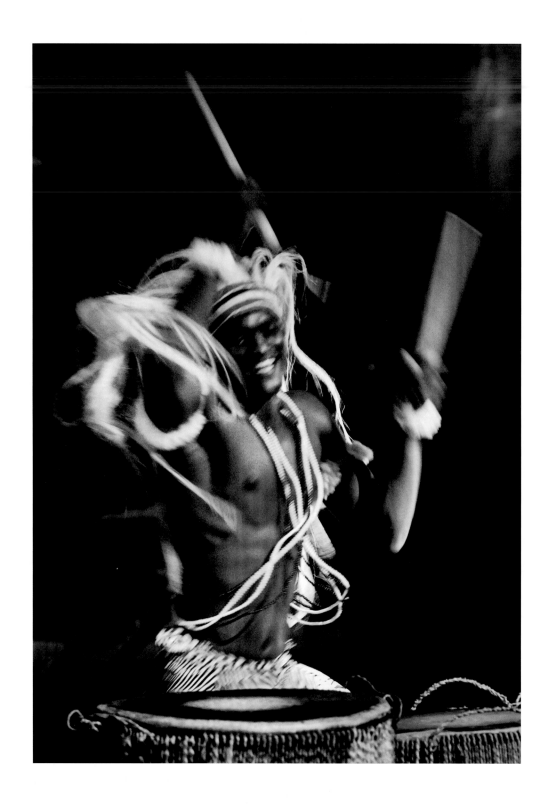

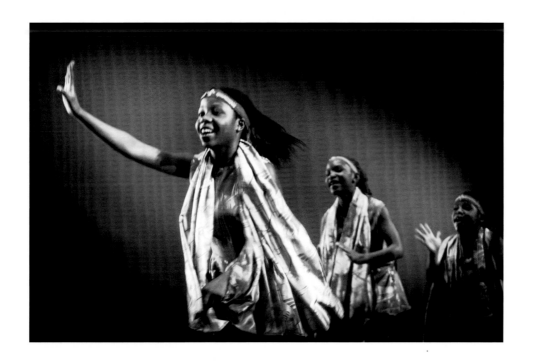

Above: Betty Nakato, 16, Teddy Namuddu,13, and Miriam Namala, 6, during the *Ekitaguriro* dance. **Left:** Geofrey Nakalanga loses himself in his drumming. **Following pages:** Peter Kasule and Miriam Namala on stage in *Titi Katitila* at Newark's Prudential Hall at New Jersey Performing Arts Center.

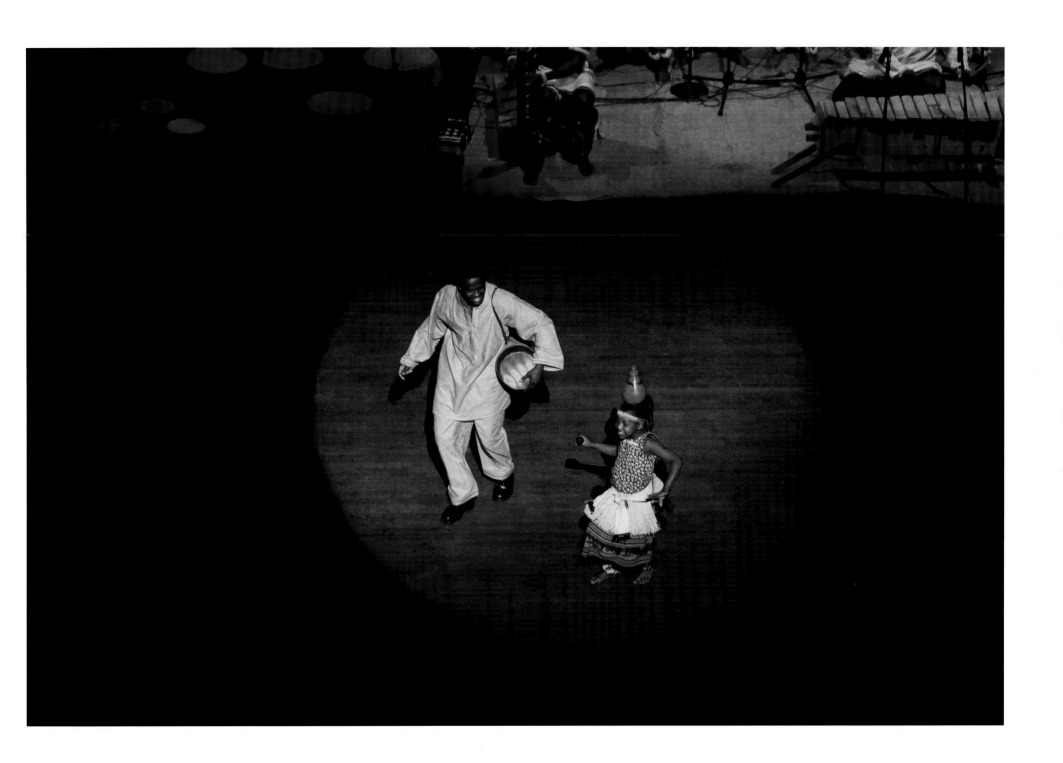

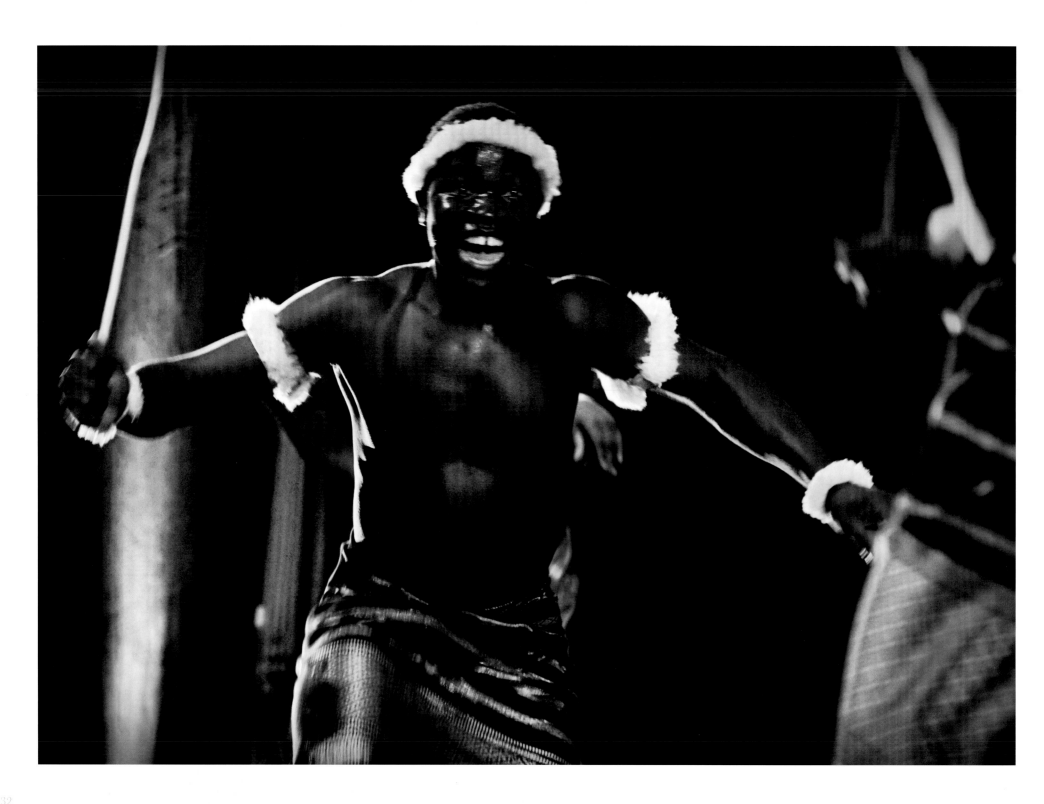

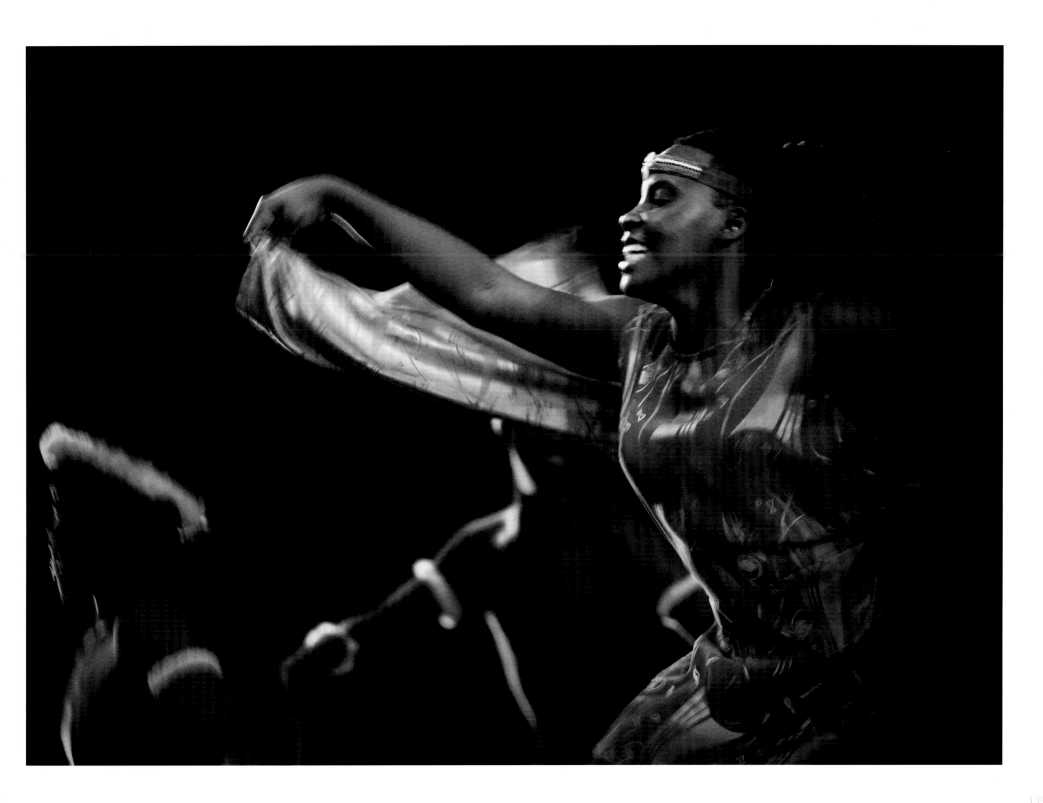

Preceding pages and Right: Bernard Sserwanga races across the stage with the boys to meet the girls led by Prossy Namaganda, 18. Dancer, Francis Lubuulwa, 17, after the show said "People think, these are children who have lost their parents; they have had so many problems. But then they see us perform and tell us how wonderful it is. They see the joy and smiles we carry on stage. People learn from us that life goes on."

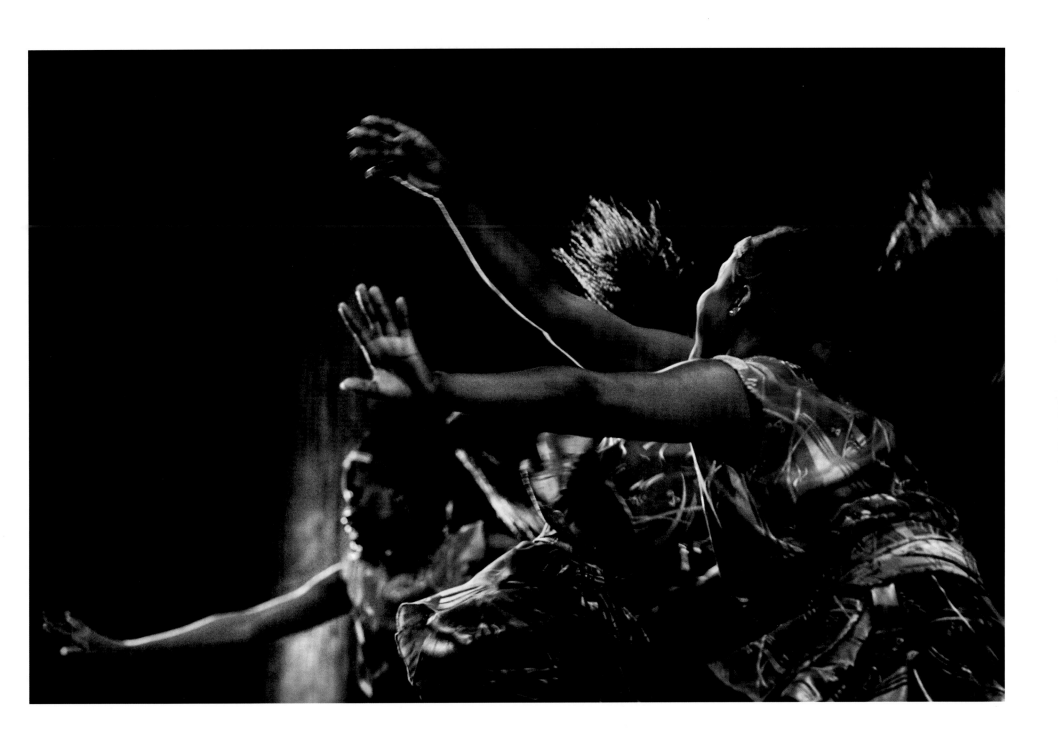

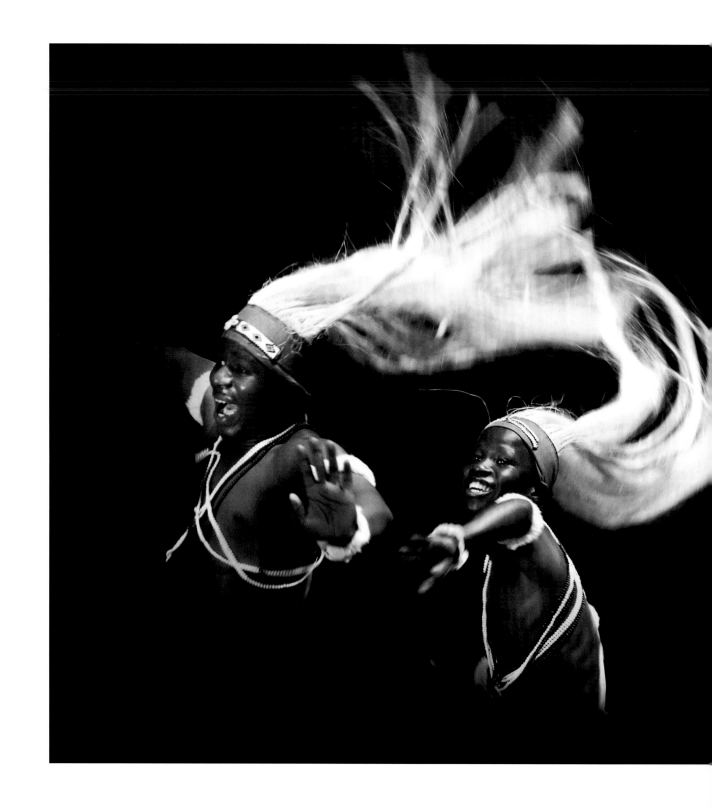

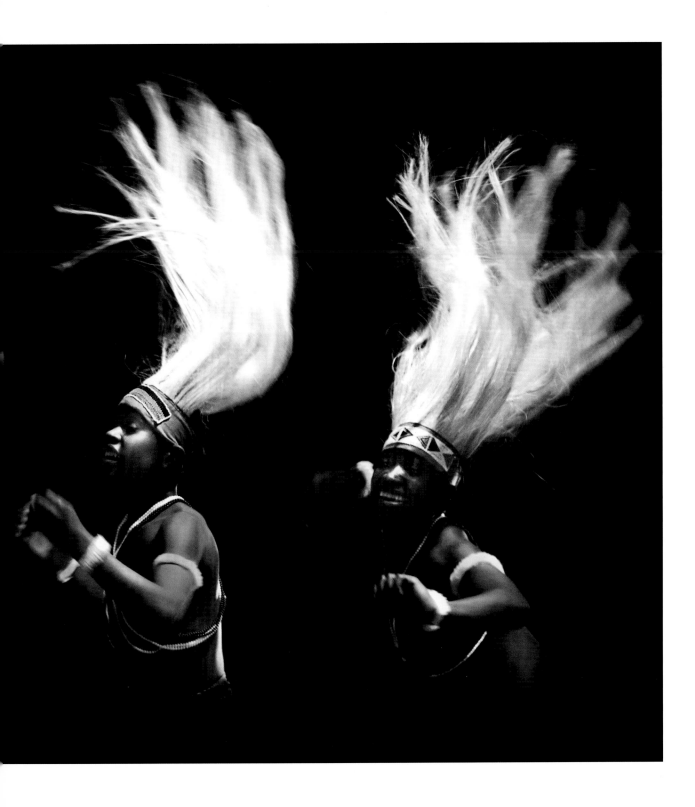

"We show people there is another side to Africa than just hardship and problems."

—Bernard Sserwanga

The beautiful theaters where the dancers perform can sometimes present a jarring contrast to the brutal conditions these dancers suffered in Uganda. Yet to spend time with these children is to learn important lessons about the power of persistence in the face of adversity. The dancers view their performance in these theaters as the triumphant culmination of a long journey from extreme poverty to artistic celebration.

Impassioned cultural messengers and articulate advocates for AIDS awareness and prevention, they show what is possible when potential is recognized and realized. At home and abroad, they demonstrate the power of art and education. They bring us the good news from Africa.

Preceding pages: Francis Kalule, Brian Odong, Brian Aine and Patrick Nyakojo perform the *Kinyarwanda* dance named for the Rwandan language. It features the Rwemeza drums of the Banyarwanda royalty, played to announce the king's entrance to the court. **Right:** Prudential Hall at Newark's New Jersey Performing Arts Center. **Following pages:** The rolling hills of Kampala at dawn.

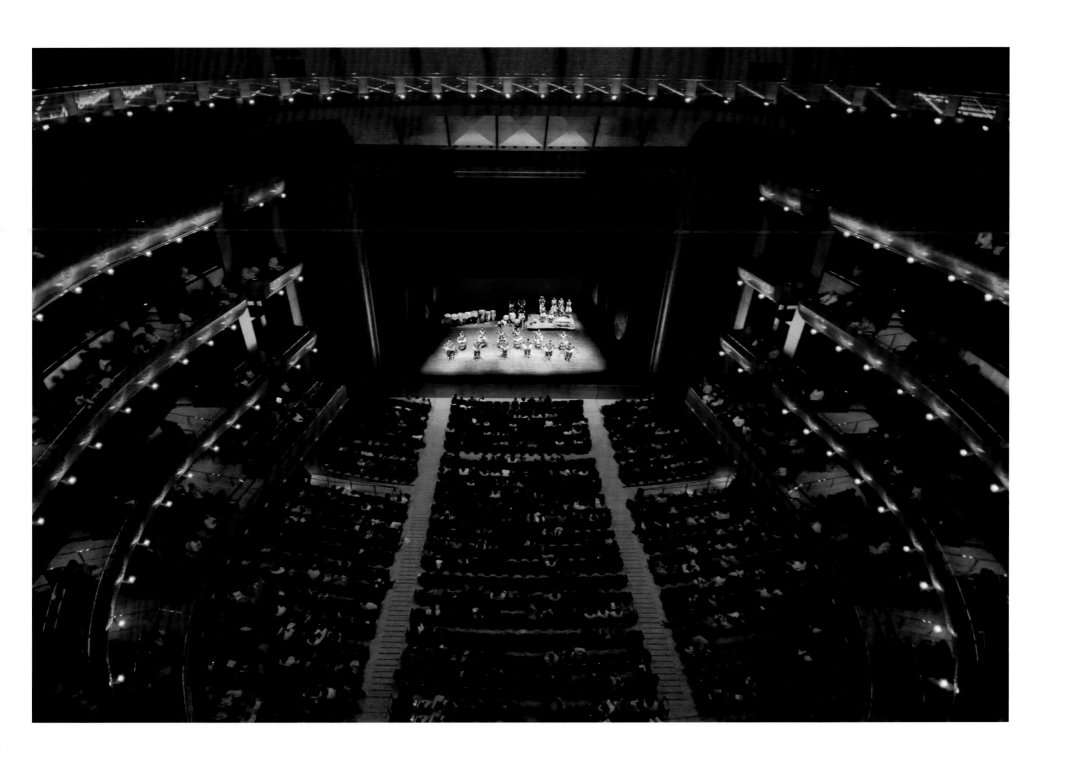

COU & EAC FOUNDER Alexis Hefley

A story of transformation

Leaving behind a banking career, I first traveled to Uganda in 1993 at the invitation of First Lady Janet Museveni to help with orphan-related projects. Soon after arriving, I met and began working with Sr. Rose Muyinza at the Daughters of Charity orphanage in Kampala. One of my tasks was to look after women in the last stages of AIDS who were also living there. Sr. Rose had taken them in so that they wouldn't be alone as they died. Some of the older children also helped them cope with the day-to-day struggles they faced. "When one person is in trouble, we are all in trouble," she would say, and I wondered how she found the courage.

An 18-year old who had grown up in the orphanage and then run away, returned, desperately seeking help. The virus had completely taken over her body. Powerless, bitter and full of anger, she had large patches of wounds behind her knees, under her breasts and armpits that would break open when she tried to stand. I prayed that Sr. Rose wouldn't assign her to me. She had a stench about her, and it was hard to be in the same room.

I began to think about how lonely I would be if no one wanted to touch me, be near me, or talk to me. When I looked inside myself, I saw shame and fear; I prayed for the courage to face her and myself. I was charged with taking her for treatment to the clinic and to a village doctor to be treated with herbs. Too weak to walk, I often carried her to and from the car. Gradually, I became friends with this young woman and as I embraced her — all of who she was and would never be, I was overwhelmed. She showed me mercy, grace in its purest form. Then and there, I made a commitment to help secure a better future for Uganda's children.

I returned to the US to found Uganda Children's Charity Foundation and directed that organization for ten years. What quickly became apparent was how central dance, music, and story telling were to the lives of these vulnerable children, orphaned by AIDS and civil war. UCCF began producing performances by the children in the US in 1996, visiting schools and churches in order to raise awareness — to help others see the face of Uganda's crises in human terms, not just the numbing statistics.

The impact was overwhelming for audiences and for the children themselves. Their emotional, high-energy performances provided potent proof of the transformative power of art and a vivid reminder of how impoverished our own culture would be without the songs, dances and stories of Africa.

By 2006, Children of Uganda's national tours directly supported more than 700 children and the communities in which they lived. The schedule expanded to include

Right: Alexis Hefley has spent 14 years working with Ugandan orphans and is a passionate advocate for the children. She makes it a point to learn the name of every child, and when she visits the Kiwanga home, they flock to her side.

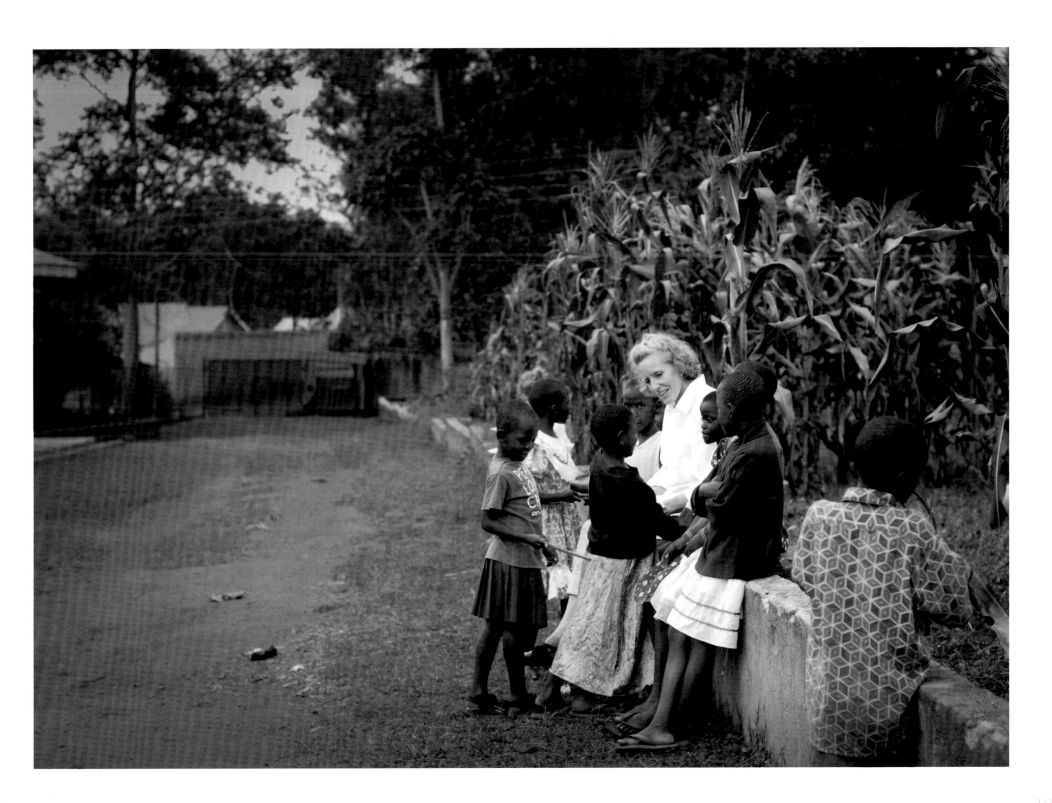

large theaters and leading dance venues, garnering national media attention. Critically acclaimed from coast to coast, these performances significantly contributed to raising AIDS awareness in the US and enriched the lives of so many children.

War, poverty and AIDS know no borders. In 2006, I launched a new organization, Empower African Children to address the complex challenges that the next generation of Ugandans and their peers in the region face.

Empower African Children's strategy centers on providing a globally-competitive and dynamic education with arts, health care and technology at its core. We are now in the process of building a unique secondary school in Uganda with professional recording, technology and performance facilities to serve as an important resource for the region. A US college level scholarship program makes it possible for some of Africa's most talented students to deepen their education so that they may return to their home countries and fully contribute to the social welfare and economic growth of their communities.

For so many children in Africa the harsh realities of daily survival rob them of the ability to envision a different future — for themselves or their societies. The children pictured here manifest the resilience of the human spirit and thrillingly illustrate what is possible when potential is realized through dedicated and professional support.

Right: Residents of the Kiwanga home, Zaina Nakato and Dorothy Nabuule, rush to welcome Alexis back to Uganda. Working with the children has become her life's passion, she says.

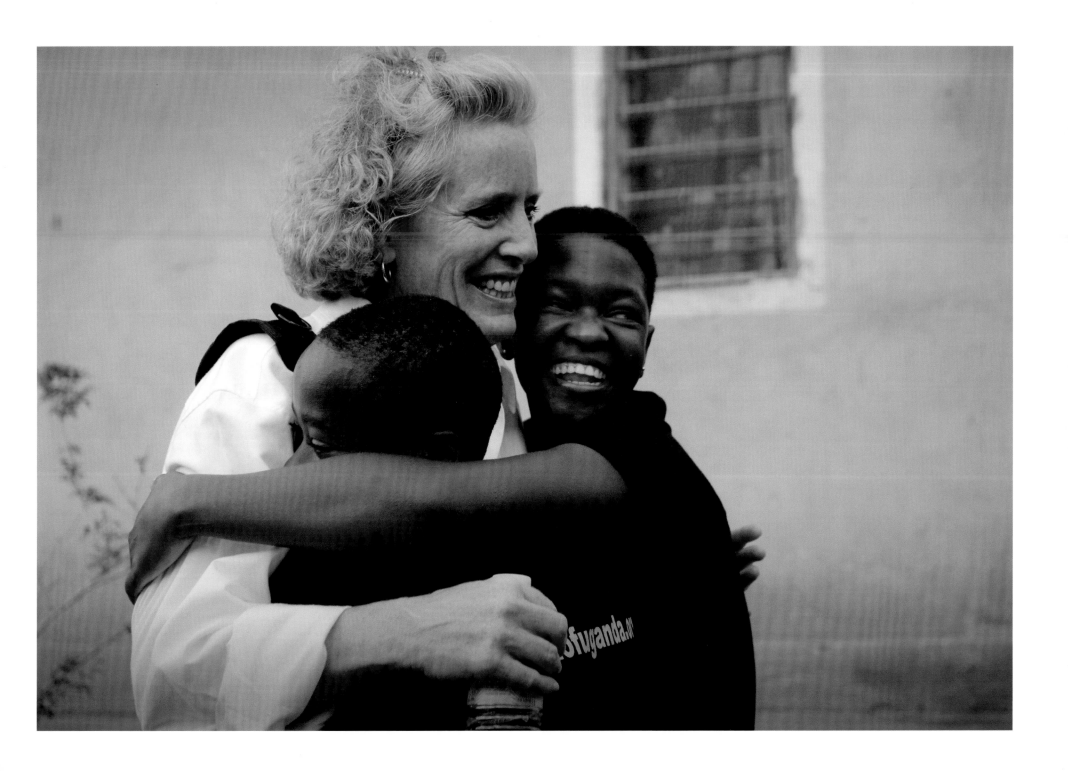

The Macy's Passport Story

To understand Macy's connection with The Orphans of Uganda, one must first understand the history of Macy's Passport and its commitment to the fight against HIV/AIDS. Now in its 25th year, Macy's Passport is the result of fashion and compassion joining forces for the common good. One of the best-loved fashion theatre events in America, it's also the one with the biggest heart.

It all began in 1980, when Macy's presented "GQ Live," a men's fashion show featuring American designers in the employee cafeteria of Macy's San Francisco. The initial audience totaled 300 people, which was good enough to ensure that the following year, an "American Designers" show was held in front of an enthusiastic crowd in Union Square.

Creative wheels started to turn and the vision grew. More than 2,000 supporters attended the 1983 show, making it official: Macy's Passport was a hit!

In 1987, Hollywood legend and AIDS activist Dame Elizabeth Taylor made her debut appearance at Macy's Passport, elevating the show to a new level. One year later, the show stepped up again. Macy's, in a pivotal and pioneering move, turned Passport into a benefit for six Bay Area AIDS agencies, thereby becoming one of the first companies in the United States to recognize the need for AIDS fundraising and to shine a light on the intensity of the pandemic.

By 1992, Macy's Passport hit its stride with the 10th Anniversary show featuring supermodels Claudia Schiffer and Christy Turlington on the runway. Swatch, one of the show's sponsors, released a limited-edition watch designed by Vivienne Westwood, sales of which helped triple what Macy's Passport had previously raised. All told, $250,000 was donated to the San Francisco AIDS Foundation and the Shanti Project.

By the mid-90s, Macy's Passport was known as a unique and powerful fashion fundraiser. With its reputation spreading far outside of San Francisco, the show went on the road and became an annual event in both San Francisco and Los Angeles.

Building yearly on its success, in 1996, with help from Founding Chair Dame Elizabeth Taylor and basketball star and HIV/AIDS activist Earvin "Magic" Johnson, Macy's Passport raised a record-breaking $1.5 million. Hollywood embraced the event, and over the years, the celebrities who've graced the stage read like the "A list": Sharon Stone, Annette Bening, Tyra Banks, Macy Gray, Cindy Crawford, Tina Turner, Will Smith, Liza Minnelli, k.d. lang, Jennifer Lopez, Sean Combs and Mary J. Blige. The best and the brightest names from the world of fashion have also taken Macy's Passport to their hearts, with Calvin Klein, Kenneth Cole, Marc Jacobs and Michael Kors lending their talents. Every year Macy's Passport shined causing audience members to wonder how the show could possibly top itself....

But top itself it did! In 2000, when Macy's first saw this talented musical dance group of Ugandan orphans, they immediately invited them to perform at that year's Passport show. It was an obvious and natural partnership to all those involved with Passport. As orphans of AIDS, these young people knew first-hand of the devastation caused by the pandemic; as gifted performers, they understood the talent and presence necessary to capture the stage. With their performance at Macy's Passport, the children electrified the crowd, demonstrating the power of the human spirit to transcend adversity and ultimately gain victory over this terrible disease.

Now commemorating its 25th anniversary, Macy's Passport in 2007 will surpass $25 million raised for the HIV/AIDS organizations that serve our local communities. In addition, Macy's has underwritten the creation of this beautiful book of photography by Douglas Menuez. It explores the lives and stories of the Ugandan orphans including Peter Kasule, originally a young performer and now Artistic Director of Spirit of Uganda and introduces Alexis Hefley, an extraordinary American who saw their potential and dedicated her life to helping them realize it. It is our hope that this book will increase committed awareness of the global impact of HIV/AIDS.

It is in the spirit of Macy's Passport that we continue our mission of AIDS fundraising on a worldwide stage. Through the stories of these children and millions more like them, we are challenged to do more. Macy's is truly grateful to be part of such a profoundly important endeavor. We salute all those who have the vision, courage and compassion to make a positive difference in the world and thus change the future of HIV/AIDS.

Right: Dame Elizabeth Taylor congratulates the Children of Uganda dancers after a performance at Macy's Passport.

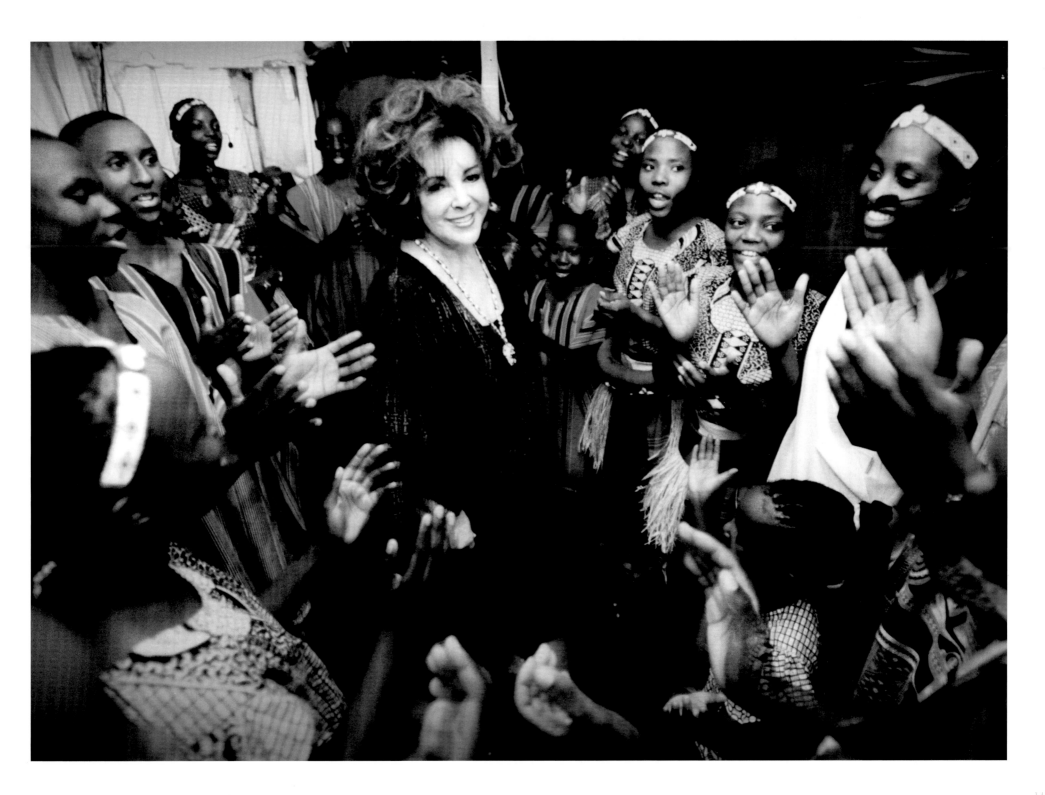

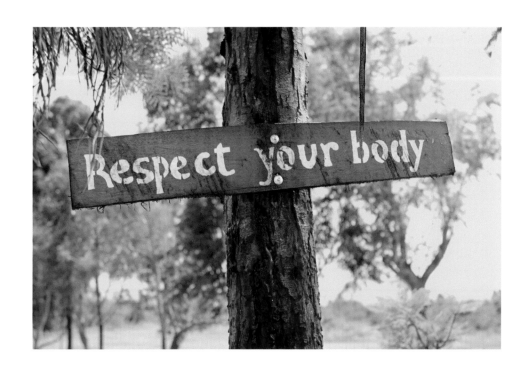

Acknowledgments

MACY'S WEST

Chairman and CEO
Robert L. Mettler

President and COO
Dan Edelman

**Vice Chairman and
Director of Stores**
Rudy Borneo

**Louis Meunier
and the Public
Relations Team**
Bette McKenzie
Larry Hashbarger
Laura C. Heffron
Anita Jaffe
Milinda Martin
Patrick Smith
Laura Townsend
Lavina Wong
Ali Hartman
Nicha Kittitanaphan
David Miranda
Natalie Smith

**Bill Bigler
and the Fashion
Office Team**

**Michael Wirkkala
and the Finance Team**
Rosi Gaitan-Blandino

**Wendy Schmidt
and the Legal Team**
Carl Goldberg

**Sheila Field
and the Marketing & Sales
Promotion Team**
Lia Battaglia-Perez
Beverly Y. da Silva

LaTonya Lawson
Vicky Ness

**Liz Hauer
and the Store
Planning Team**
Mary Ryan Duffy
Kathie Urbiztondo

**James Bellante
and the Visual
Merchandising Team**

For more information, go to:
CHILDREN OF UGANDA
www.childrenofuganda.org

**EMPOWER AFRICAN
CHILDREN**
www.empowerafricanchildren.org

2006 US TOUR PERFORMERS
Brian Aine
Munawiru Jengo
Francis Kalule
Simon Peter Kiranda
Jacob Kiwanuka
Francis Lubuulwa
Peter Mugga
Noeline Nabesezi
Dorothy Nabuule
Geofrey Nakalanga
Rose Kokumbya
Betty Nakato
Zainabu Nakato
Veronica Nakatudde
Prossy Namaganda
Miriam Namala
Teddy Namuddu
Zaam Nandyose
Lukia Nantale
Patrick Nyakojo
Brian Odong,
Bernard Sserwanga

Special thanks to:

Laure Ames
Sonni & Teddy Aribiah
Michael Ash
Margot Atwell
Anna Marie Bakker
Susan Baraz
Lori Barra
Carolyn Bechtol
Gene Blumberg
Karen Blessen
Lisa Booth
Miriam Burke
Cherry Burnett
Margaret Camp
Paris Chong
Hobson and Robin Crow
Pat Davies
Gaurav Dhillon
Colin Drake
Catherine Easley
Henry Eisenson
Betulia & Anders Per Ericksson
Jennifer Erwitt
Quentin Faust
Hossein Farmani
Catherine Fernandez
Tom Fetter
Joel Fineberg
Bahram Foroughi
Barry Friedman, Innerworkings
Greg Friedman
Robert Friedman
Joe Gelchion
Martin Gisborne
William Gladstone, Waterside
 Productions
Carl Goldberg
Joan Gordon
Magda & Knut Goshol
Dudley & Beverly Hafner

Tony & Janet Hall
Kathryn Hanley
Darrell Harris
Larry Hashbarger
Henry Heflich
Alexis Hefley
Andrew Herkovic
Eileen Hudnell
Lauren Jack
Monua Janah Memorial Foundation
The Joyce Theater
Jon Kamen
David Kasata
Agnes Kasule
Gyavira Kasule
Peter Kasule
Jane Kembabazi
Judge Jim Kerr
Pat Kirby
Scott Kline
Sara Krueger
Andrews Kurth LLP
MAC AIDS Fund
Donna Malouf
Stephen Malouf
Bill & Nancy Maloy
Sarah Mbabazi
Ken & Mary McLeod
Barry Menuez & Jean Venable
Jane Menuez & Armando Santana
Julia Menuez
Ross Menuez & Keetja Allard
Stephanie Menuez
Tereza & Paolo Menuez
Ann Mills
Susan Moore
John David & Leslie Moritz
Karen Mullarkey
First Lady Janet Museveni
Sr. Rose Muyinza
Teddy Namirembe
Ana Neitzel

David Nelson
Prudential Hall at New Jersey
Performing Arts Center
Melissa Overmyer
Jana & Max Panconesi
Kirk Paulsen
Judi Mc Phail
Jeremy & Jamie Phillips
Scott & Cathy Phillips
Assunta Pisani
Karen Raley
Serena Van Rensselaer
Garrett Rice
Betty Richardson
Gabriel Rinaldi
"Maggie,"
Michael & Jodi Robins
Rollins and Bitsy Rubsamen
Ming Russell, Waterside Productions
Arthur Sainer
George & Cynthia Scofield
Matt Seminara
Laureen Seeger
William Shuford
Lucas da Silva, Universal
 Art Gallery
Rick Smolan, Against All Odds
Marshall Sollender
Surj Soni, Soni Law Firm
Robin Stavisky
St. Michael and All Angels Church
Dennis Stock & Susan Richards
Mary Jane Treloar & Arthur Sainer
James & Isabel Turner
Pamela Vachon
Deirdre Valente
Alan Flamenhaft
Andrew & Schenley Walker
Debra Weiss
Tom & Elise Wilkes
Patrick Yoacel
Kim Young

PRODUCTION

Executive Producer:
David Elliot Cohen

Text and Reporting:
Rachel Scheier

Design/Production:
Brooke Merrill Tinney,
 Dweller ByThe Stream Bindery
Pauline Neuwirth,
 Neuwirth &Associates

Mapmaker: Chris Palome

Retouching:
Jessica Mahady, Sheri Manson

Proofing/Editing:
Marilyn McHugh

Photo Assistants:
Joe Puhy, Jr. and Joshua Dick

Studio Manager:
Robert Englebright

Digital Fine Art Paper:
Wayne Connelly, Innova Art Ltd.

Travel:
Anette Ayala, The Agency
Moses, Pearl of Africa

*This book was shot using Nikon
digital cameras. Apple Aperture
was used to import, edit and
process the raw files.*

Douglas Menuez represented by:
Michael Ash/Radical Media
212.462.1500
www.radicalmedia.com
www.menuez.com

Naturally Peninsula
Chocolate
Flavours

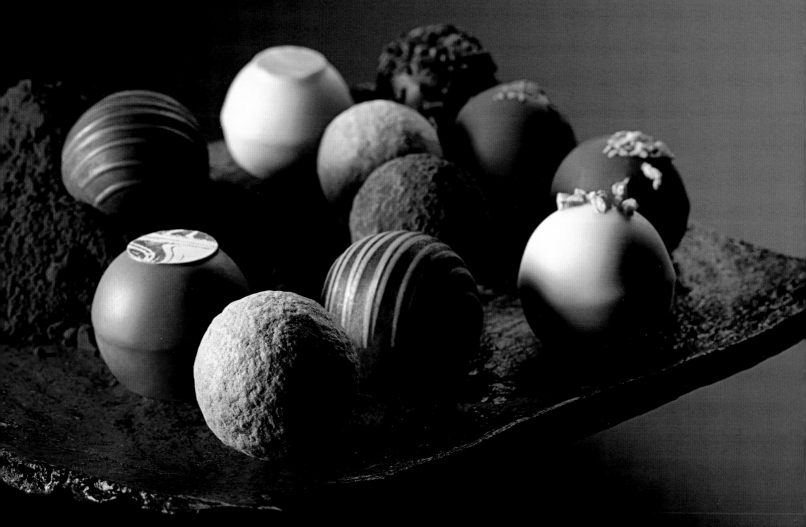

PENINSULA
MERCHANDISING LIMITED

Contents

Foreword

Of all the flavours in the world, none elicit passion as chocolate does. Touted by many as the most sensual of foods, it earned its reputation as the "food of the gods" more than 3,000 years ago when the ancient Mayan and Aztec civilisations used it as a ceremonial drink of worship.

Since then its production has often remained shrouded in mystery – seen by many as the domain of expert chocolatiers. Today it has reached cult status; we talk of chocolate connoisseurs, artisanal makers, and single-origin growers. To understand chocolate in our modern age is to understand luxury.

Naturally Peninsula – Chocolate Flavours is the third cookbook to emerge from the kitchens of the nine Peninsula hotels throughout Asia and the USA. The cookbook is again a true reflection of The Peninsula's commitment to the finer things in life.

Many people cook savoury food, if for nothing else than to feed themselves on a daily basis. However, when it comes to cooking desserts and sweets for family, friends and oneself, there is always an element of indulgence, a recognition that life is to be enjoyed.

Throughout these pages, The Peninsula's expert chefs have demonstrated the highest commitment to quality. Where necessary, they have been very specific about the cocoa percentage of each chocolate ingredient. Wherever possible, follow their guidelines, as they will yield the best results.

Experiencing new taste sensations is one of the highlights of international travel. Staying at The Peninsula Hotels helps guests make the most of new places by introducing them to new dining experiences.

With these recipes, you will discover how The Peninsula's chefs have used chocolate as an inspiration for many of their most memorable dishes.

With this book, you will be able to bring home with you the ultimate travel memento – the chance to recreate and enjoy every single delicious mouthful.

The Peninsula Hotels

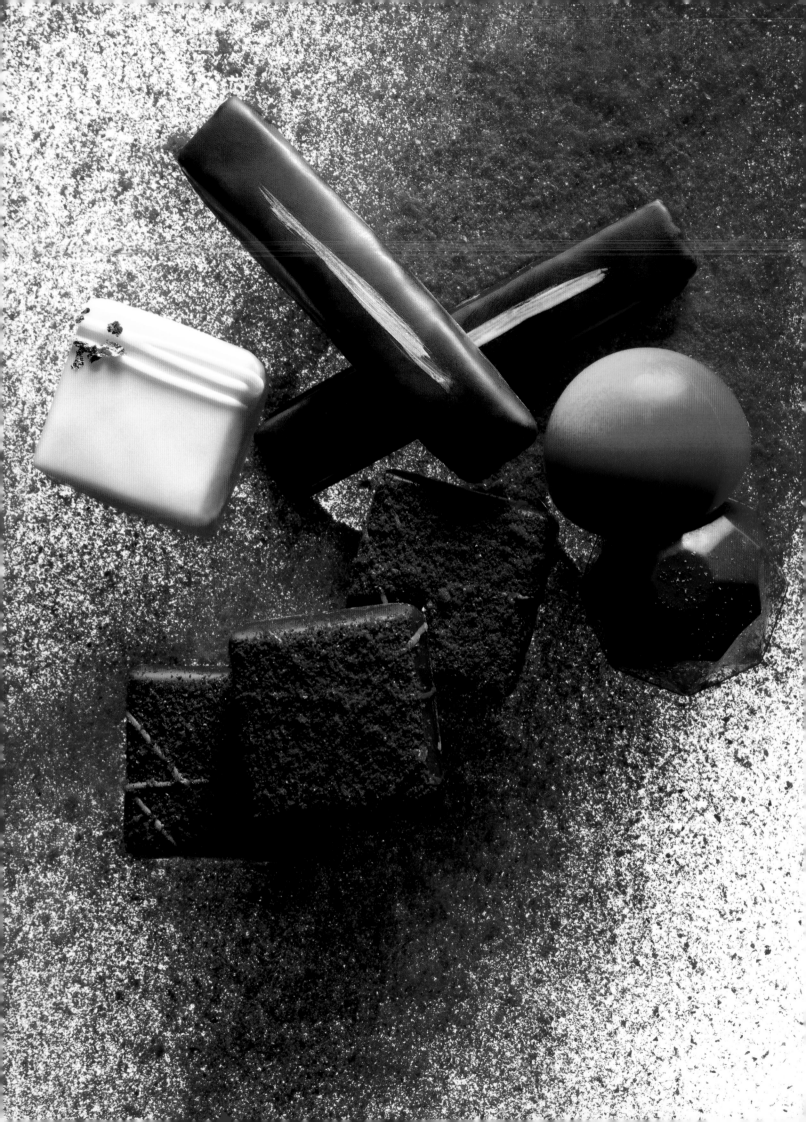

Introduction

Revered for over three millennia, chocolate is as instantly recognisable as it is universally liked. Superlatives abound as to its taste, although preferred methods of consumption differ. There are those who fondle the chocolate in their mouth, allowing the taste to unfold with a sublime, majestic inevitability. Others bite straight through and submit their mouth to a stunning explosion of flavour.

Regardless of how you enjoy your chocolate, there is no dispute that for much of its history, chocolate has been one of life's simplest pleasures. It offered easy choices: plain or with almonds? Milk or dark?

Now, from many perspectives, chocolate is viewed as a far more complex food.

Fine chocolate now shares the status of wine and cheese: connoisseurs have learned to taste differences among producers and even among cacao growers, with single-plantation and single-origin chocolates emerging from many cacao-growing regions.

The Peninsula Hotels has always understood the importance of luxury, elegance and indulgence. Our award-winning chefs have been at the forefront of the chocolate revolution, respectful of its origins, yet keen to promote its diversity as a flavour. Throughout these pages you will find chocolate paired with traditional favourites such as cream, mint, cinnamon and coffee as well as the more avant-garde chilli, saffron, basil and sake.

Naturally Peninsula – Chocolate Flavours captures the imagination and talent of the chefs, distilling chocolate into 81 recipes that will enable you to recreate the hotels' hallmark chocolate experiences at home.

Working with chocolate is often shrouded in mystique. The Peninsula chefs believe that while creating good food takes time, it doesn't necessarily mean that good recipes must be time-consuming or difficult. A beautiful meal is a reflection of the cook's love of cooking, and is about taking the time to think about what you want to cook, recognising the seasons, enjoying shopping for beautiful produce and finally, experiencing the wonderful feeling you get when sitting down and enjoying good food with great friends and loved ones.

In recognition that people are at different stages of their culinary journey, *Naturally Peninsula – Chocolate Flavours* includes recipes for all levels of expertise. From working techniques and step-by-step instructions for the artisanal chocolatier to gourmand basics for children, the full gamut of chocolate's capability is covered.

The Peninsula's aim in creating this exquisite collection of recipes was to show you that chocolate can be as much a pleasure to work with as it is a pleasure to eat. We are sure you will agree. Enjoy!

Food of the Gods:
The History of Chocolate

It is hard to pin down exactly when chocolate was born. What is clear is that it was cherished from the start.

Most historians believe the secret of the cacao (pronounced: kah KOW) tree was unlocked 2,000 years ago in the tropical rainforests of Latin America.

The Mayan and Aztec civilisations discovered the seeds of the tree could be ground into a powder and mixed with spices to make a bitter, frothy drink. They believed the bean had magical, even divine, properties, and used it in sacred rituals.

The Aztec word for this drink was *xocoatl*, the origin of the word 'chocolate'. The Latin name for the cacao tree, *Theobroma cacao*, means 'food of the gods'.

In the 16th century, the Spanish conquered Mexico and brought the seeds back to Europe as the spoils of war. Finding the drink bitter, the Spanish mixed it with sugar and cinnamon and introduced the concept of drinking it hot.

By the 17th century, chocolate was a fashionable drink throughout Europe, believed to have nutritious, medicinal and even aphrodisiacal qualities. It remained largely a privilege of the rich until the Industrial Revolution helped to create a solid form of chocolate and made mass production possible. For the first time in its history, chocolate became affordable to the general public.

Throughout the 18th and 19th centuries a steady stream of technological inventions gave chocolate the texture and aroma we know today.

In the 20th century, the word "chocolate" expanded to include a range of affordable treats with more sugar, milk and additives than actual cocoa in them, often made from the hardiest but least flavourful of the bean varieties.

Most recently, artisan chocolate makers have gained prominence. Connoisseurs have learned to taste differences among producers and even among cacao growers, with single-plantation and single-origin chocolates emerging from Indonesia, Venezuela and the Côte d'Ivoire.

From Bean to Bar:
How Chocolate is Made

Cocoa trees flourish in hot, humid climates within 20 degrees of the equator. Their fruits ripen twice yearly, between November and January and then again between May and July. The fruit is a long pod with a thick shell. Inside, 30 to 50 seeds rest in a white, gelatinous pulp. Cocoa plantations

are notoriously labour-intensive. Farmers use age-old techniques to harvest the fruit and remove, ferment and dry the seeds. Fermenting the seeds neutralises their bitterness and is crucial to the final aroma and taste of the chocolate. Once dry, the seeds are poured into burlap sacks, ready for transport to a chocolate manufacturer.

Stage One: Roasting
Roasting intensifies the aroma and flavour of the bean. Depending upon the variety of bean, the seeds are roasted at 120°C to 150°C (250°F to 300°F) for anywhere between 30 minutes to 2 hours.

Stage Two: Cracking
After roasting, the shells of the cacao seed are brittle. Once the seeds are cool, machines are used to crack them open. Giant fans then blow away the empty husks. What remains are small shards of seeds known as cocoa nibs.

Stage Three: Grinding and Pressing
The nibs are milled to release the highly prized cocoa liquor. Some of this cocoa liquor is then put through a hydraulic press to squeeze out the cocoa butter. Once the cocoa butter is extracted, the remaining solid cocoa is pulverised into cocoa powder.

Stage Four: Blending
Manufacturers blend unpressed liquor with sugar and extra cocoa butter to form chocolate mass (or paste). When making milk chocolate, they also add powdered milk. The raw mixture of chocolate liquor, milk, sugar and cocoa butter is churned until it becomes a coarse, brown powder.

Stage Five: Refining
The raw mass is ground further using a series of rollers to create a silky powder.

Stage Six: Conching
A conche is a container filled with metal beads. Conching churns and agitates the refined chocolate paste at a temperature of 80°C (176°F) for up to 6 days (the length of the conching determines the smoothness and quality of the chocolate). The conching process reduces the cocoa and sugar particles to a size the tongue can't detect. This is why chocolate tastes so smooth.

Stage Seven: Tempering
The refined chocolate is cooled and warmed repeatedly in a process known as tempering. This gives chocolate its glossy sheen, and ensures that it will melt properly.

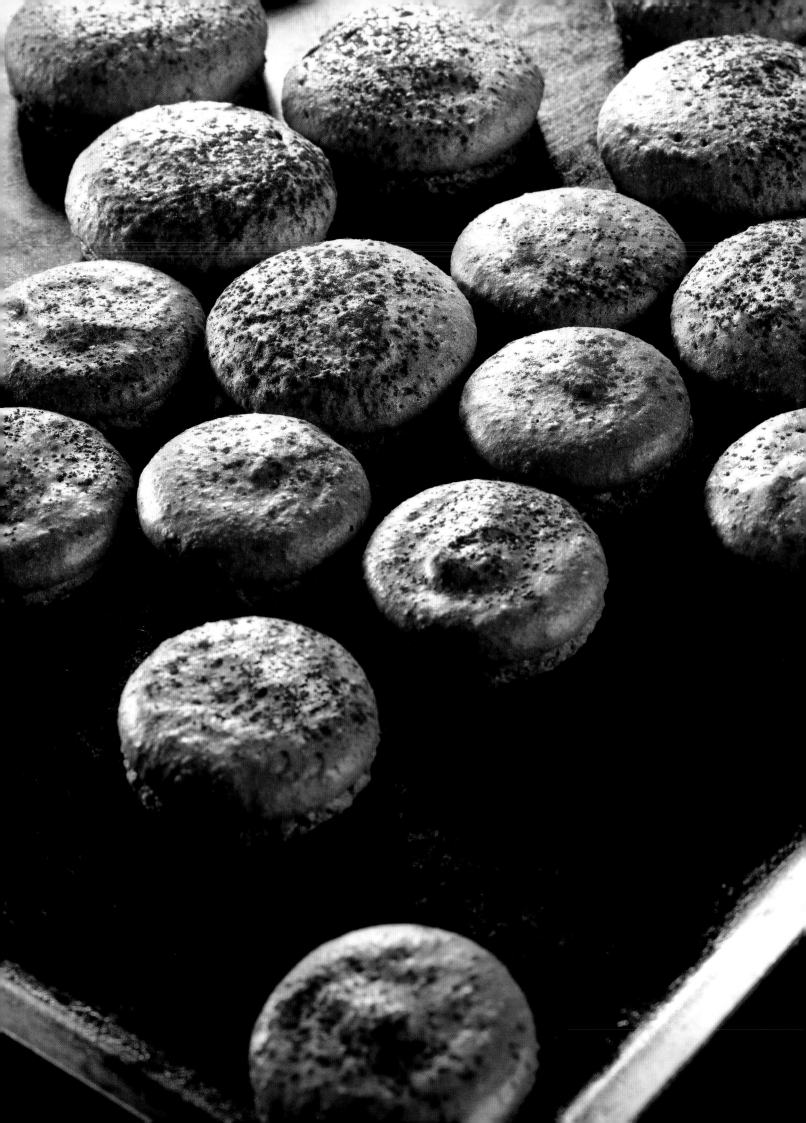

BONBONS AND PRALINES

For The Peninsula's artisanal chocolatiers, pralines and bonbons are the jewels in their production crown. Petite pieces of heaven, exemplifying the chef's creative impulses.

Velvety smooth couverture encases each creation, while the chocolate fillings span a plethora of taste sensations. The Pistachio-Cherry Praline is tart and nutty, with flavours and textures that meld beautifully. The Basil-Lemon Bonbon is citrusy and woody, chewy and sweet. Juxtaposed with the immaculate shine of the moulded and dipped chocolates are the equally delicious hand-formed truffles and chocolate-coated nuts.

Each morsel is melt-in-the-mouth perfection, spoiling you for choice.

Citrus Bonbon

Makes: 84 pieces
Preparation time: 1 hour
Cooking time: 1 hour
Refrigeration time: 12 hours

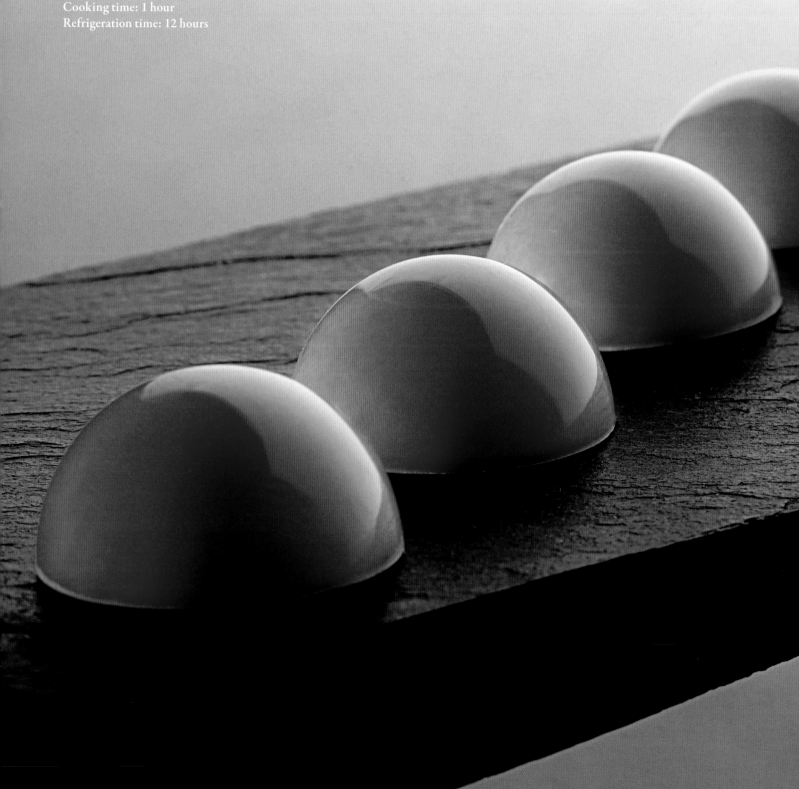

CITRUS JELLY

80 ml (2½ fl oz) lime juice

170 ml (6 fl oz) orange juice

½ vanilla pod

126 gm (4½ oz) caster sugar

2 tsp pectin, yellow

Place the lime and orange juices and the opened vanilla pod in a saucepan and heat.

In a separate bowl mix the sugar and pectin.

Pour the sugar and pectin into the heated juice.

Boil the liquid until it reaches 103°C (217.4°F).

Remove the saucepan from the heat and remove the vanilla pod. Gently mix the liquid with a flexible spatula.

Pour the liquid into a separate bowl and cover it with plastic wrap. Leave it to cool in the refrigerator overnight.

CITRUS GANACHE

35 ml (1⅙ fl oz) lemon juice

80 ml (2½ fl oz) orange juice

70 ml (2½ fl oz) heavy cream, 38%, fresh

12 gm (⅓ oz) glucose

125 gm (4½ oz) dark chocolate, 53%

62 gm (2⅕ oz) milk chocolate, 37%

8 ml (⅓ fl oz) Grand Marnier liqueur

13 gm (½ oz) honey

62 gm (2⅕ oz) butter, soft

Place the juices in a saucepan and bring them to the boil. Reduce the liquid to 70 ml (2½ fl oz). Set aside.

In a separate saucepan bring the cream and glucose to the boil.

Place the chocolates in a bowl and pour the glucose mixture over them.

Bring the 70 ml of juice back to the boil. Pour this into the chocolate and cream mixture.

Stir the mixture with a flexible plastic spatula until the chocolate is melted.

Add the Grand Marnier and honey to the chocolate mixture.

Once it has reached 35°C (95°F), add the butter and mix until it is a smooth and shiny ganache.

Spoon the ganache into a piping bag and set aside.

CHOCOLATE MOULD

600 gm (1¼ lb) white chocolate, tempered†

Cast† 4 moulds (yielding 21 pieces per mould) with tempered white chocolate.

Chef's tip: Spray the moulds with orange-coloured cocoa butter† for decoration; spray only one side of the mould.

ASSEMBLY

Once the chocolate in the moulds starts to set, spoon the citrus jelly into a piping bag and pipe approximately half of each shell with jelly.

Pipe the ganache on top of the citrus jelly and place in the refrigerator to set.

Once the filling has set, close† the moulds with a layer of tempered white chocolate.

† See Kitchen Techniques

Basil-Lemon Bonbon

Makes: 70 pieces
Preparation time: 1½ hours
Cooking time: 1 hour
Refrigeration time: 12 hours

21 gm (⅔ oz) fresh basil leaves

150 ml (5⅓ fl oz) lemon juice

190 gm (6⅓ oz) dark chocolate, 53%

143 gm (5 oz) milk chocolate, 37%

20 gm (⅔ oz) trimoline

40 ml (1⅓ fl oz) heavy cream, 38%, fresh

15 gm (½ oz) lemon zest

40 gm (1⅓ oz) butter, soft

200 gm (7 oz) dark chocolate, 64%, tempered[†]

Prepare a square frame 20 cm (7½ inch) in length by 1 cm (½ inch) in height on a non-stick baking mat[†].

Use an immersion (stick) blender to blend the basil and a little of the lemon juice into a paste.

Place the remaining lemon juice in a saucepan and bring to the boil. Mix in the basil paste.

Place the chocolates and trimoline in a bowl and pour the lemon juice through a sieve over the chocolates. Use a spoon to press down on the sieve to squeeze out all the juice.

Place the cream and lemon zest in a separate saucepan. Bring them to the boil.

Pour the cream mixture through a sieve onto the chocolate mixture.

Mix well with a flexible plastic spatula.

While mixing, constantly check the temperature of the chocolate. Once it reaches 35°C (95°F), add the butter.

Pour the ganache into the pre-prepared frame and spread smoothly.

Leave overnight in the refrigerator to set.

The next day, remove the frame and spread a very thin layer of the tempered dark chocolate on top of the ganache.

Once the chocolate has hardened, turn the ganache over and remove the baking mat.

Repeat the process and apply a very thin layer of tempered chocolate to the other side of the ganache. Allow the chocolate to set.

Cut into 6½ cm (2½ inch) by ½ cm (¼ inch) rectangular bars.

Dip[†] the bars in tempered dark chocolate.

GARNISH

Using a small paintbrush, decorate each bar with a stroke of green cocoa butter.

† See Kitchen Techniques

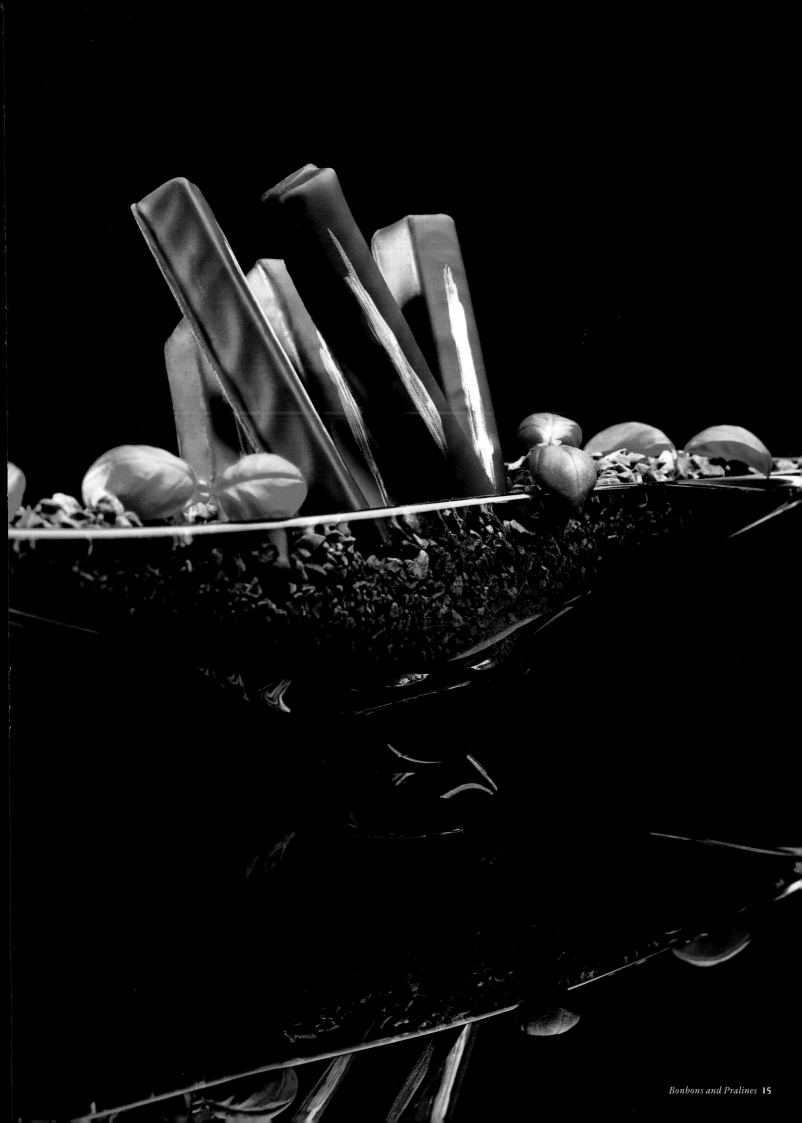

Orange Bar

Makes: 20 pieces
Preparation time: 1 hour
Cooking time: 1 hour
Refrigeration time: 12 hours

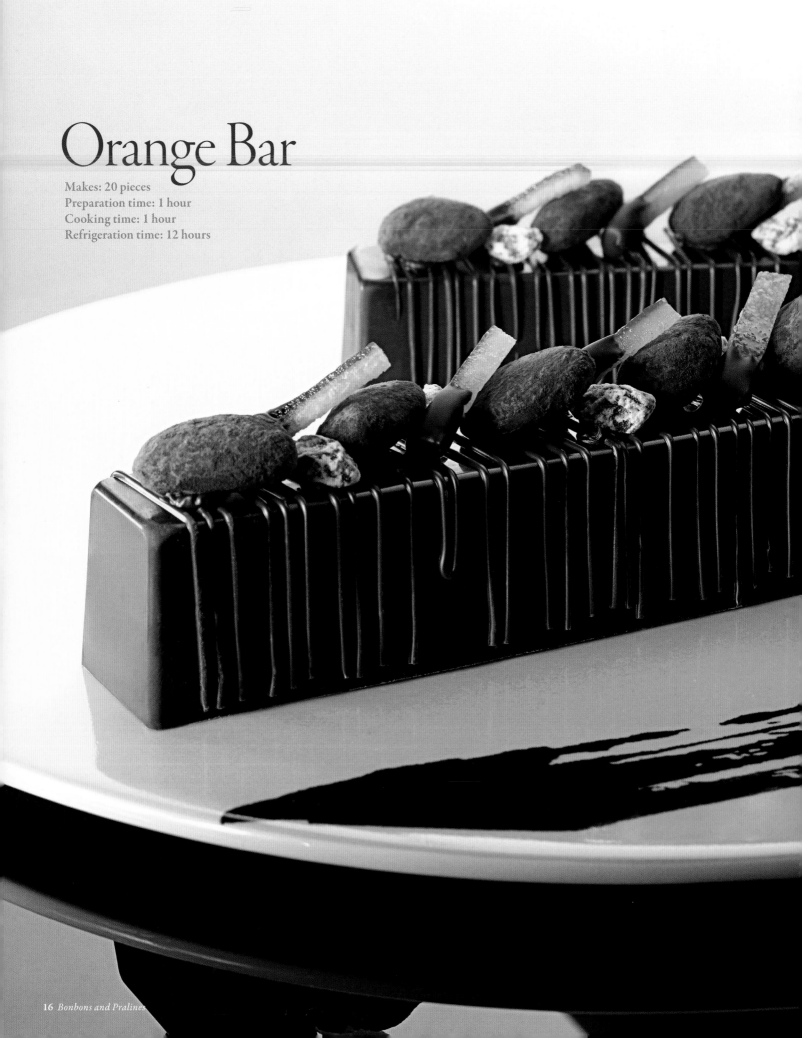

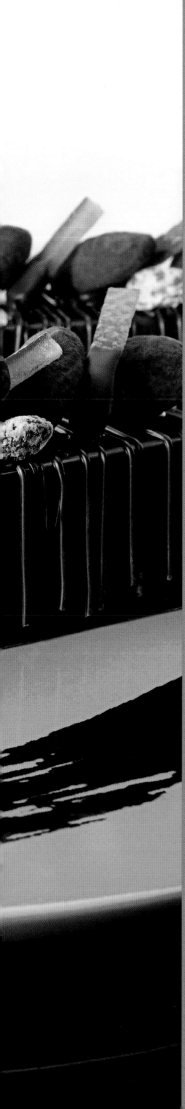

ALMOND GANACHE

240 ml (7⅔ fl oz) heavy cream, 38%, fresh
120 ml (4⅓ fl oz) milk
55 gm (2 oz) almonds, pre-roasted and peeled
50 gm (1¾ oz) trimoline
450 gm (16 oz) milk chocolate, 40%
60 gm (2⅙ oz) butter, unsalted

Pour the cream and milk into a saucepan and bring to a simmer.

Place the pre-roasted and peeled almonds in a food processor. Add the cream and milk mixture and process until smooth. Leave the mixture overnight in a refrigerator (no cooler than 18°C).

The next day, strain the mixture into a saucepan, add the trimoline and sugar, and bring to a simmer.

Gradually add the chocolate and emulsify.

Take off the heat, then add the butter and mix with a stick (immersion) blender.

ORANGE GANACHE

210 ml (7 fl oz) heavy cream, 38%, fresh
200 gm (6½ oz) trimoline
550 gm (1⅕ lb) dark chocolate, 70%
35 gm (1⅙ oz) butter, unsalted
100 ml (3⅓ fl oz) Grand Marnier liqueur
1 tsp orange peel, grated
110 gm (4 oz) orange jam

Place the cream and trimoline in a saucepan and bring to a simmer.

Gradually add the chocolate and emulsify with a whisk.

Take the saucepan off the heat and add the butter, Grand Marnier and orange jam. Mix the ingredients with a stick blender.

Gently stir in the grated orange peel. Set aside.

ORANGE SABLÉ

150 gm (5⅓ oz) butter, unsalted
70 gm (2½ oz) icing sugar
20 gm (⅔ oz) egg
220 gm (7¾ oz) all-purpose flour
1 tsp orange peel, grated

Preheat the oven to 170°C (338°F).

Place the softened butter and icing sugar in a mixing bowl and mix together.

Gradually add the egg.

Add the all-purpose flour and the grated orange peel. Mix well until it becomes a dough.

Remove the dough from the bowl and knead together on a lightly floured surface.

Roll the dough to a 5 mm (¼ inch) thickness and place it on a baking tray lined with baking paper.

Bake in the preheated oven for 25 minutes.

Remove from the oven and allow to cool.

ASSEMBLY

8 gm (¼ oz) orange confit, store-bought
70 gm (2½ oz) dark chocolate, 66%, tempered†

For each bar, prepare a rectangular frame 18 cm (7½ inch) long by 2.5 cm (1 inch) wide by 3 cm (1¼ inch) high on a non-stick baking mat†.

Cut the sablé to the appropriate size and place it at the bottom of the frame.

Pour in the orange ganache to cover the sablé. The layer of orange ganache should be approximately 1.5 cm (⅗ inch) thick.

Pour the almond ganache on top of the orange ganache. The layer of almond ganache should be approximately 1.5 cm (⅗ inch) thick.

Sprinkle with orange confit.

Place the frame in the refrigerator overnight, at approximately 18°C (64.4°F).

The next day, remove the frame and coat† the bar with the tempered† chocolate.

Allow the bar to cool and set.

GARNISH

2½ tsp candied orange peel, store-bought
2½ tsp sugared pistachios
20 gm (⅔ oz) almonds
70 gm (2⅓ oz) dark chocolate, 66%, tempered†

Decorate each bar with piped tempered chocolate, then garnish with almonds, pistachios and orange peel, using a tiny amount of tempered chocolate to attach them. For best results, delicately rest the decorations on the bar before the tempered chocolate has fully set – this will allow them to stick.

† See Kitchen Techniques

Crunchy Macadamia Nuts

Makes: Approximately 100 pieces
Preparation time: 30 minutes
Cooking time: 45 minutes

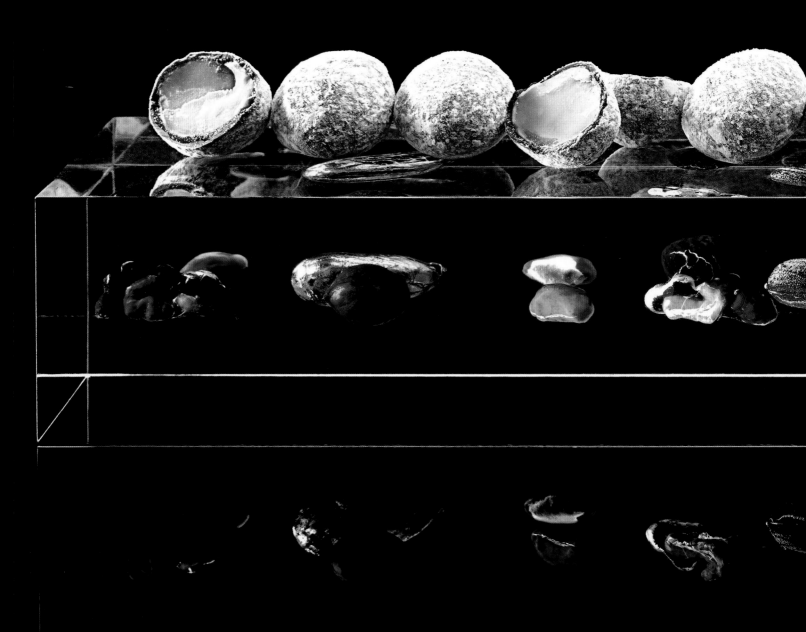

150 gm (5⅓ oz) macadamia nuts

20 ml (⅔ fl oz) water

75 gm (2½ oz) caster sugar

10 gm (⅓ oz) butter

150 gm (5⅓ oz) dark chocolate, 64%

75 gm (2½ oz) icing sugar

Roast the macadamia nuts in the oven at 160°C (325°F) for 10 minutes. Allow them to cool.

Place the water and sugar in a saucepan and heat to 110°C (230°F).

Add the macadamia nuts and caramelise them slowly.

Once the nuts are well coated in caramel, add the butter – this helps to separate the nuts. Spread the nuts on a baking tray lined with baking paper and allow them to cool.

Separate the nuts and place them in a bowl.

Temper† the dark chocolate.

Pour a fifth of the chocolate into the bowl of nuts. Move the bowl around so that the chocolate coats the nuts.

Allow the chocolate to start crystallising on each nut. It is important to keep the nuts moving so they don't stick together.

Repeat this 4 more times (using a fifth of the chocolate each time) so the nuts develop a thick coating of dark chocolate.

When finished coating, place the nuts on a baking tray lined with baking paper and allow to set. Just before the chocolate is fully set, dust the nuts with icing sugar. Roll the nuts to ensure they are evenly coated.

Chef's tip: You can use this recipe for all kinds of nuts.

† See Kitchen Techniques

Makes: 70 pieces
Preparation time: 2 hours
Cooking time: 1 hour
Refrigeration time: 12 hours

Pistachio-Cherry Praline

CHERRY JELLY

100 gm (3½ oz) cherry purée

33 ml (1 fl oz) apple juice

22 gm (⅔ oz) caster sugar

1 tsp pectin, yellow

26 gm (⅚ oz) glucose

120 gm (4½ oz) caster sugar

1 tsp citric acid

1 tsp water

Prepare a square frame 20 cm (7½ inch) in length by 1 cm (½ inch) in height on a non-stick baking mat†.

Place the cherry purée and juice into a 14 cm (5½ inch) saucepan.

In a separate bowl, mix the pectin with the 22 gm (⅔ oz) of sugar.

Heat the cherry purée and juice.

Add the pectin mixture.

Add the glucose.

Bring to the boil and add the 120 gm (4½ oz) of sugar.

Boil until the liquid reaches 107°C (224.6°F), occasionally stirring so that the mixture doesn't stick to the bottom of the pan.

Mix the citric acid with water (1:1) and incorporate into the cherry mixture by hand.

Pour the jelly into the frame to cover the base.

PISTACHIO PRALINE

160 gm (5⅔ oz) pistachios

50 ml (1¾ fl oz) water

160 gm (5⅔ oz) caster sugar

⅓ vanilla pod

27 gm (1 oz) cocoa butter

27 gm (1 oz) milk chocolate, 43%

18 gm (⅔ oz) butter, soft

Prepare a praline‡ with the pistachios, water, sugar and vanilla pod (seeds scraped). Make sure the praline is well mixed using a food processor.

Leave the praline to rest until it reaches room temperature.

In a small saucepan, melt the cocoa butter with the chocolate; warm to 33°C (91.4°F).

Add the butter to the chocolate mix.

Add the praline into the chocolate mix, incorporating well.

ASSEMBLY

Gently pour the praline mix into the frame†, on top of the cherry jelly.

Place the frame in the refrigerator to set overnight.

The next day, remove the frame and spread a thin layer of tempered‡ chocolate over the pistachio praline.

After the chocolate is set, turn the praline over and remove the baking mat.

Cut the filling into 2 cm (1 inch) squares.

Coat‡ the squares with tempered dark chocolate.

GARNISH

Decorate the pralines with red and green chocolate stripes, using store-bought icing tubes.

† See Kitchen Techniques
‡ See Basic Recipes

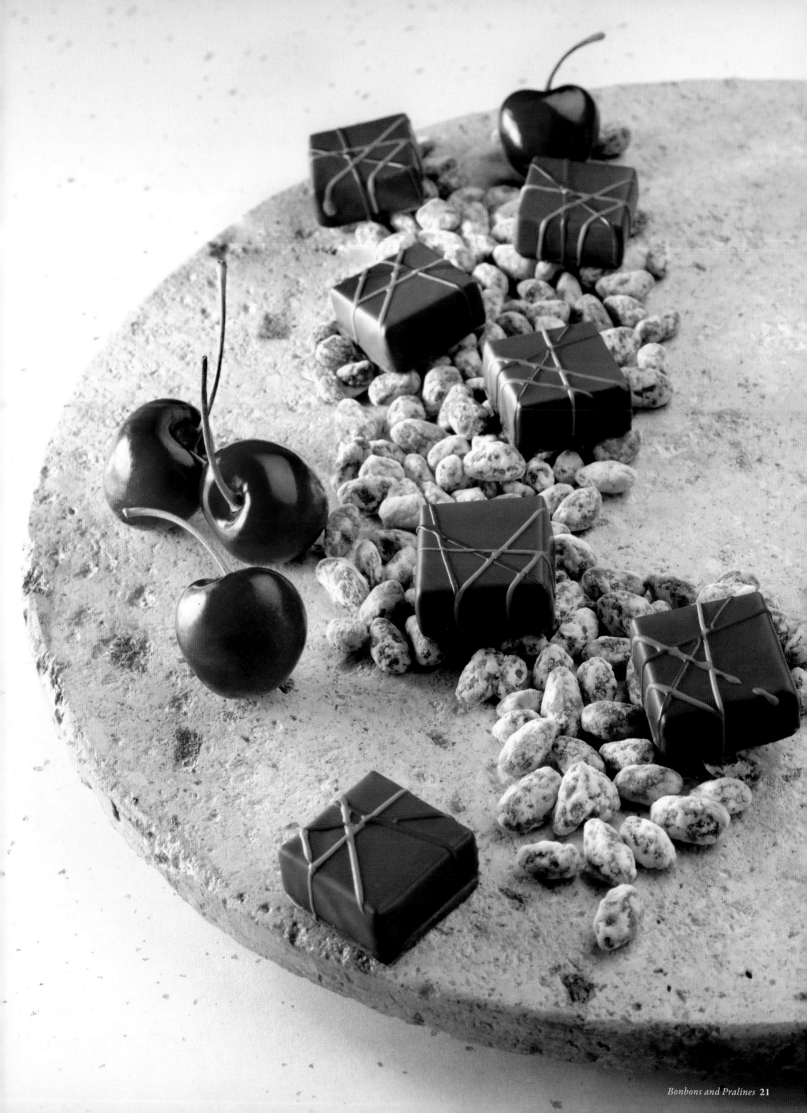

Caramel-Espresso Bonbon

Makes: 42 pieces
Preparation time: 30 minutes
Cooking time: 20 minutes

125 ml (4½ fl oz) heavy cream, 38%, fresh

1 vanilla pod

1 tsp coffee extract (or ½ shot fresh espresso)

240 gm (8½ oz) milk chocolate, 34%

40 gm (1½ oz) cocoa butter

700 gm (1½ lb) milk chocolate, 43%, tempered[†]

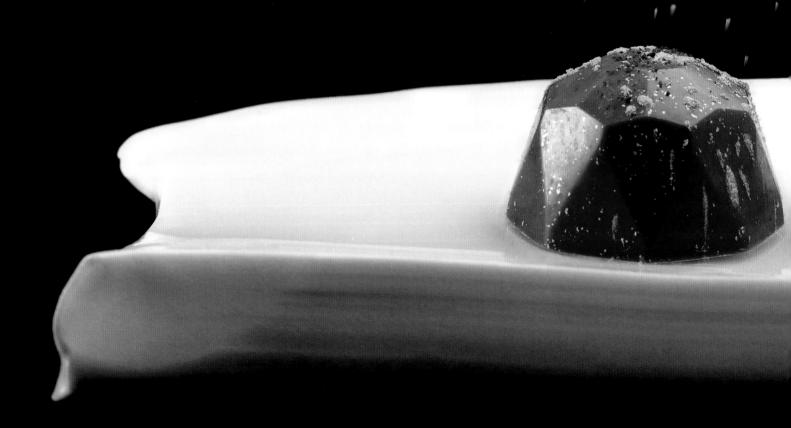

Slice the vanilla pod longways through the centre and scrape out the seeds. Place the seeds and the cream in a saucepan and bring to the boil.

Place the 240 gm (8½ oz) of chocolate in a bowl and pour the cream over the chocolate.

Let the cream stand for 1 minute to allow the chocolate to melt.

Mix the cream and chocolate with a whisk until they combine and have a nice shine.

In a separate saucepan melt the cocoa butter.

Pour the cocoa butter into the chocolate mixture and mix together.

Use the 700 gm (1½ lb) of tempered chocolate to cast† the mould.

Spoon the ganache into a piping bag and pipe into the cast mould.

Seal† with tempered chocolate.

GARNISH†

Add a touch of ground espresso and a sprinkling of gold dust.

† See Kitchen Techniques

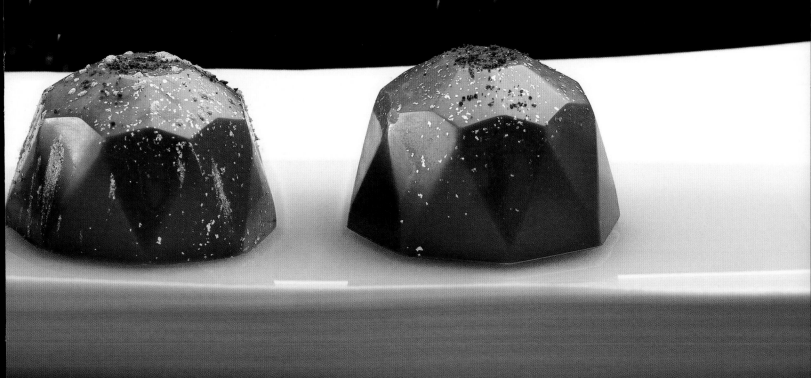

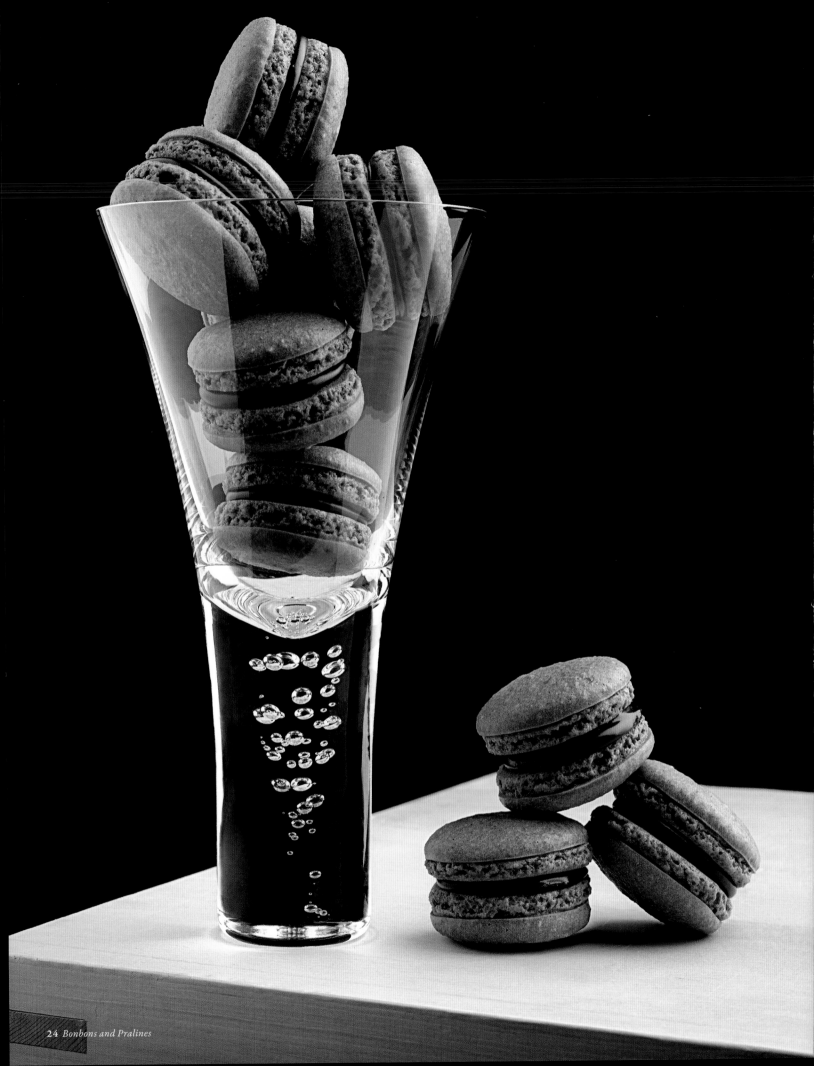

Makes: 60 pieces
Preparation time: 30 minutes for macaron shells,
15 minutes for the ganache
Cooking time: 8 minutes
Refrigeration time: 12 hours

Chocolate Macaron

MACARONS

125 gm (4½ oz) almond powder, sifted

125 gm (4½ oz) icing sugar, sifted

20 gm (⅔ oz) cocoa powder, sifted

100 gm (3½ oz) egg whites

115 gm (4 oz) caster sugar

A pinch of salt

50 ml (1¾ fl oz) water

1 tsp red colouring powder

Preheat the oven to 160°C (325°F).

Sift the almond powder, icing sugar and cocoa powder together.

Add 50 gm (2 oz) of the egg whites to the almond mixture and work to a paste. Set aside.

Place the caster sugar and the water in a saucepan and heat to a temperature of 118°C (244.4°F).

Place the remaining egg whites, salt and the red colouring powder in the bowl of a free-standing electric mixer and whip them together on a medium speed.

Slowly pour the hot syrup into the mixing bowl as the egg white mixture is being whipped.

Continue to whip the mixture until it cools to 50°C (122°F).

Take the almond paste (previously set aside) and fold through a third of the egg white mixture. Mix well. Repeat with the remaining two thirds, mixing in a third at a time. Continue until it is smooth and shiny.

Spoon the almond and egg white mixture into a piping bag. Pipe as desired on a baking tray lined with baking paper.

Chef's tip: To flatten the tops of the macarons after piping, gently tap the side of the baking tray. This will help the macaron shell flatten to a smooth surface.

Bake in the preheated oven for 8 minutes.

CHOCOLATE GANACHE

162 gm (5½ oz) dark chocolate, 53%

125 gm (4½ oz) dark chocolate, 70%

18 gm (⅔ oz) trimoline

200 ml (7 fl oz) heavy cream, 38%, fresh

1 vanilla pod

42 gm (1½ oz) butter, soft

Chop the chocolates and place them in a heatproof bowl. Add the trimoline.

Slice the vanilla pod longways through the centre and scrape out the seeds. Place the cream and the scraped vanilla pod in a saucepan and bring to the boil. Remove the pod.

Pour the hot cream in batches (3 to 4) over the chopped chocolate and trimoline.

Mix gently after each batch of cream is added.

At first, the ganache will look as though it has separated, but when thoroughly mixed with the cream, it will come together as a homogeneous mass.

Once the ganache reaches 35°C (95°F), incorporate the butter with a hand-held mixer.

Mix until the ganache is soft and shiny. Spoon the ganache into a piping bag.

ASSEMBLY

Pipe the ganache on half of the macaron shells – use the remaining shells to cover them.

The ganache will transfer a little moisture to the macaron. This makes the macaron soft on the inside and crunchy on the outside – just as it should be.

Refrigerate the macarons overnight.

Chef's tip: These macarons can be used as petits fours with coffee and tea, but are also nice as decoration for cakes and other pastry items. Macarons keep very well in the freezer.

Peach and Apricot Bonbon

Makes: 65 pieces
Preparation time: 2 days
Cooking time: 45 minutes

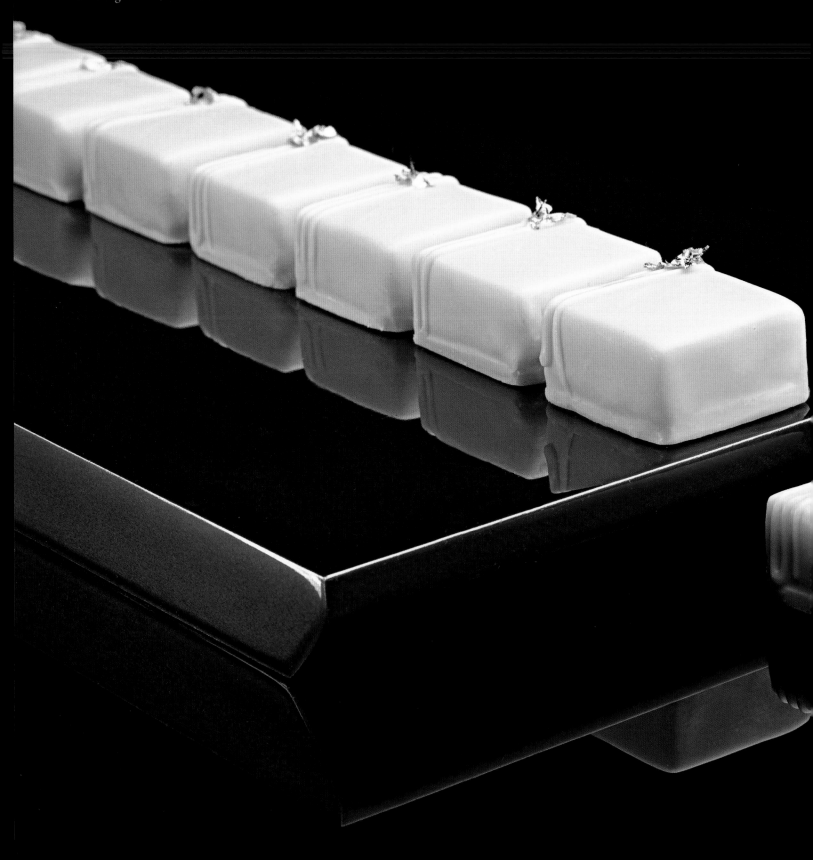

PEACH GANACHE

13 ml (½ fl oz) heavy cream, 38%, fresh

53 gm (1¾ oz) peach purée

20 gm (⅔ oz) invert sugar

150 gm (5⅓ oz) white chocolate, 38%

20 gm (⅔ oz) butter

3½ tsp peach liqueur

1 Tbsp peach paste

Prepare a 20 cm (7½ inch) square frame, 1 cm (½ inch) in height, on a non-stick baking mat†.

Place the heavy cream, peach purée and invert sugar in a saucepan and bring to a simmer. Gradually add in the chocolate and emulsify.

Add peach liqueur, peach paste and butter, mix with an immersion blender. Pour the ganache into the pre-prepared frame† and allow to rest overnight in a cool place.

APRICOT GANACHE

13 ml (½ fl oz) heavy cream, 38%, fresh

53 gm (1¾ oz) apricot purée

20 gm (⅔ oz) invert sugar

200 gm (10⅔ oz) white chocolate, 38%

20 gm (⅔ oz) butter

3½ tsp apricot liqueur

1 Tbsp apricot paste

Place the heavy cream, apricot purée and invert sugar in a saucepan. Over a medium heat, bring to a simmer. Gradually add chocolate and emulsify.

Add the apricot liqueur, apricot paste and butter and mix with an immersion blender.

ASSEMBLY

Pour the apricot ganache over the top of the peach ganache in the frame† and allow to rest overnight in a cool place.

Once the ganache has set, remove the frame and undercoat† a very thin layer of tempered† white chocolate on top of the ganache.

Once the chocolate has hardened, turn the ganache over and remove the baking mat.

Repeat the process and apply a very thin layer of tempered chocolate to the other side of the ganache. Allow the chocolate to set.

Cut the ganache into 2.5 cm (1 inch) square pieces.

Dip† in tempered white chocolate.

GARNISH

Decorate with gold leaf, placing it on the bonbons with a pair of tweezers. For best results, delicately rest the gold leaf on the bonbons before they are fully set – this will allow it to stick.

† See Kitchen Techniques

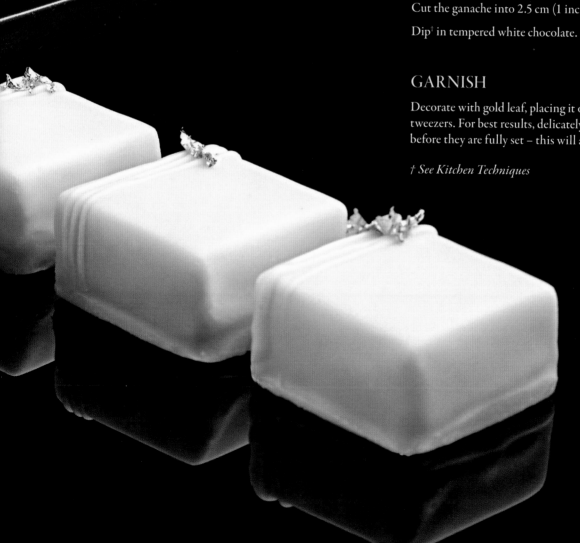

Makes: 75 pieces
Preparation time: 30 minutes
Cooking time: 1 hour
Refrigeration time: 15 minutes

Kumquat-Saffron Bonbon

SAFFRON CARAMEL

90 ml (3 fl oz) heavy cream, 38%, fresh

10 gm (⅓ oz) butter, salted

10 saffron threads

96 gm (3½ oz) caster sugar

Place the cream, salted butter and saffron in a saucepan and heat without boiling.

In a separate saucepan, caramelise the sugar.

Once the sugar is golden brown, add the hot cream little by little.

Mix well to ensure that the caramelised sugar is totally dissolved. Place back on the heat if necessary to dissolve the caramel.

Allow the caramel to cool. Set aside.

KUMQUAT GANACHE

150 gm (5⅓ oz) fresh kumquats

16 gm (½ oz) trimoline

220 gm (7 oz) milk chocolate, 37%

40 gm (1⅓ oz) dark chocolate, 70%

85 ml (2½ fl oz) milk

35 ml (1⅙ fl oz) orange juice

32 gm (1 oz) butter, soft

Purée the kumquats.

Place the chocolates and trimoline in a bowl.

Place the milk in a saucepan and bring to the boil over a medium heat.

Pour the milk over the chocolates and trimoline.

In a separate saucepan bring the orange juice and kumquat purée to the boil.

Pour the liquid through a sieve onto the chocolate mixture.

Mix by hand until the chocolate is melted. If it is not completely melted, place briefly in a microwave oven.

Once the chocolate mixture reaches 35°C (95°F), add the butter and mix until it is a smooth and shiny ganache.

Spoon the ganache into a piping bag and set aside.

ASSEMBLY

½ tsp yellow cocoa butter

½ tsp red cocoa butter

220 gm (7⅘ oz) milk chocolate, 43%, tempered[†]

Spray[†] one side of the mould with yellow-coloured cocoa butter and the other side with strawberry-red-coloured cocoa butter.

Cast[†] the mould with tempered chocolate.

Chef's tip: The type of mould can be changed.

Spoon the saffron caramel into a piping bag and pipe a small amount (approximately 2½ gm) into the cast mould.

Pipe the kumquat ganache, approximately 7.5 gm (⅓ oz) on top of the saffron caramel.

Place mould in the refrigerator for 15 minutes to set the filling.

Seal[†] with tempered chocolate.

† See Kitchen Techniques

Noisette Couture

Makes: 36 pieces
Preparation time: 2 hours
Cooking time: 1 hour
Resting time: 36 hours

265 gm (8½ oz) hazelnuts
45 ml (1½ fl oz) water
160 gm (5⅔ oz) caster sugar
⅓ vanilla pod
46 gm (1½ oz) dark chocolate, 60%, melted†
46 gm (1½ oz) cocoa butter, melted

Prepare a square frame 20 cm (7½ inch) in length by 1 cm (½ inch) in height on a non-stick baking mat†.

Make a hazelnut praline‡.

Allow the praline to cool to room temperature.

Chef's tip: The praline can be made a day ahead and left for 24 hours to cool to room temperature.

Mix the melted chocolate and cocoa butter. Once the mixture reaches 33°C (91.4°F),

gradually add the hazelnut praline, mixing well.

Pour the mixture into the prepared frame and spread smoothly.

Leave overnight in a cool storage area, approximately 15°C to 18°C (59°F to 64°F) to set. Do not cool the mixture in the refrigerator.

The next day, remove the frame and undercoat† the hazelnut mixture with a thin layer of tempered† milk chocolate.

Once the chocolate has set, turn the filling over and remove the baking mat.

Use a circular cutter, 3 cm (1⅙ inch) in diameter, to cut discs out of the praline.

Coat† the discs with tempered milk chocolate.

Before the chocolate is fully set, place a hard-plastic square on the top of each disc, corner in centre, to create a pattern. Once the chocolate has set, remove the plastic.

GARNISH

To finish, decorate each disc with a chocolate button‡, sticking it on with a tiny amount of tempered† chocolate.

† See Kitchen Techniques
‡ See Basic Recipes

Makes: 60 pieces
Preparation time: 40 minutes
Cooking time: 10 minutes
Refrigeration time: 12 hours

Jasmine Tea Bonbon

270 ml (9 fl oz) heavy whipping cream, 38%, fresh

42 gm (1⅓ oz) jasmine tea leaves

432 gm (15 oz) milk chocolate, 40%

66 gm (2⅙ oz) butter, room temperature

Place the cream and tea leaves in a saucepan and bring to the boil. Take the saucepan off the heat and allow the tea to infuse for 10 minutes.

Strain the tea from the cream and re-boil the cream.

Place the chocolate in a bowl and pour the hot cream over the chocolate.

Cut the butter into small cubes. Add the butter to the chocolate.

Use a hand-held beater to mix the chocolate, cream and butter until the ingredients are incorporated and the mixture is smooth.

Line a 10 cm (4 inch) square tray with plastic wrap and pour the ganache into the tray.

Leave the tray overnight in the refrigerator.

Cut the ganache into 2½ cm (1 inch) squares.

Dip the squares in tempered couverture†.

GARNISH

Garnish with tiny fragments of jasmine tea leaves, placing them on the bonbons with a pair of tweezers. For best results, delicately rest the tea leaves on each bonbon before it is fully set – this will allow them to stick.

† See Kitchen Techniques

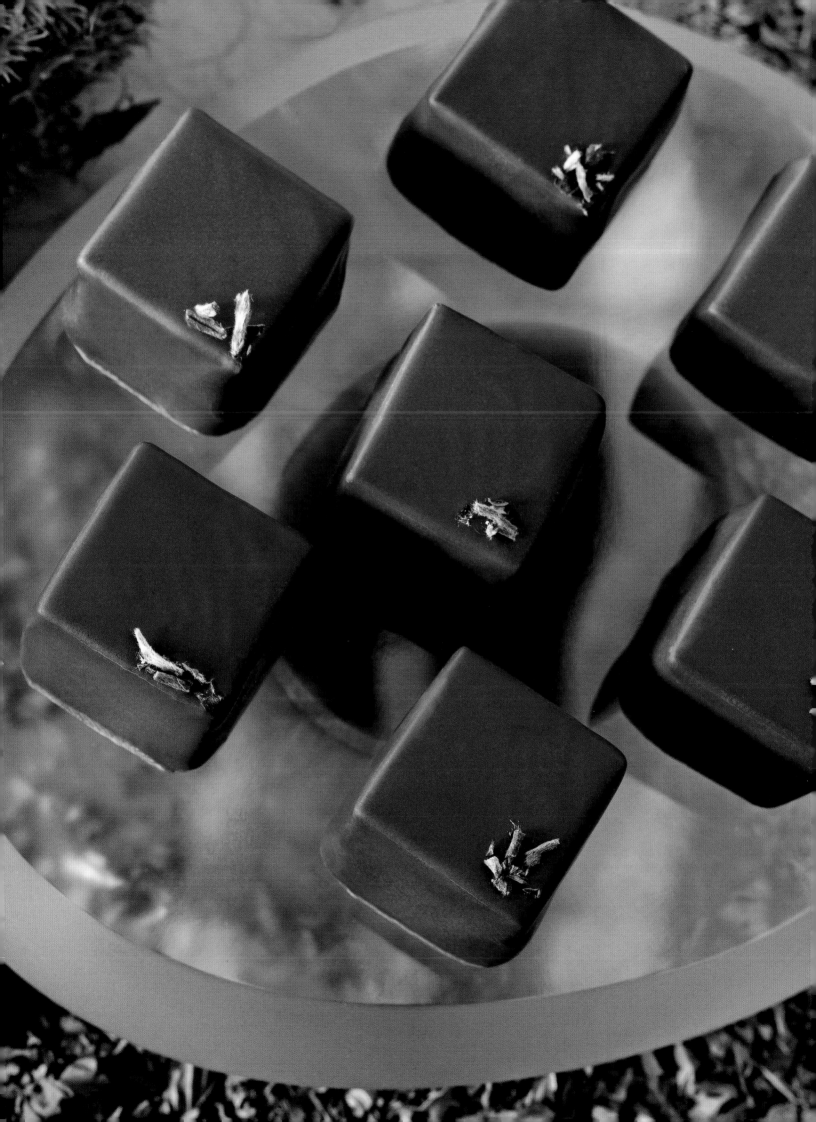

Makes: 120 pieces
Preparation time: 20 minutes
Cooking time: 1 hour
Freezing time: 1 hour

Coffee Truffle

40 ml (1½ fl oz) water
80 gm (3 oz) caster sugar
100 ml (3⅓ fl oz) glucose syrup
14 gm (½ oz) coffee, ground
100 ml (1⅓ fl oz) condensed milk
240 gm (8¾ oz) butter, soft
400 gm (14⅓ oz) milk chocolate, 35%
280 gm (10 oz) dark chocolate, 65%
55 gm (2 oz) cocoa powder

Note: Temperatures are very important in this recipe, particularly when mixing the butter and chocolate. When mixing the butter and syrup make sure the mixture stays at room temperature. The chocolate must remain at 33°C (91.4°F). If the butter is too cold when mixed with the chocolate, the chocolate will crystallise and there will be pieces of chocolate in the mixture. If the chocolate is too warm, it will melt the butter and the mixture will be too liquid.

Place the water, sugar and glucose syrup in a saucepan and heat to 110°C (230°F).

Add the ground coffee and condensed milk. Mix well. Allow the syrup to cool to room temperature. (This can be prepared a day ahead.)

Melt† the milk chocolate and allow it to cool to 33°C (91.4°F).

Place the butter in the bowl of a free-standing electric mixer and whip until creamy.

Add the syrup and continue to whip well.

Mix in the melted chocolate a third at a time.

When combined, spoon the mixture into a piping bag.

Using a 5 mm (¼ inch) nozzle, pipe the mixture in 3 cm (1¼ inch) pieces onto a baking tray lined with baking paper.

Place the baking tray in the freezer and allow the mixture to freeze.

Melt† the dark chocolate to 40°C (104°F). Dip the frozen truffles in the warm chocolate, remove with a fork and place in cocoa powder. Roll the truffles in the cocoa powder. Leave to defrost in the cocoa powder.

When defrosted, remove and shake the excess powder off.

† See Kitchen Techniques

CAKES AND PASTRIES

Chocolate cake elicits childlike enthusiasm from even the most composed of diners. Knowing this, The Peninsula's chefs have included sentimental classics – fudge brownies, marble cakes and chocolate crumbles – in this chapter. At the other end of the spectrum are more extravagant creations, from the low-lying, intensely rich Chocolate Three Ways to the light bounce and silkiness of the Chocolate Roulade. The classic pairing of chocolate and cinnamon has been given a modern makeover in the rich creamy Adamtan. Other chefs have subtly laced chocolate with spices, fruit or nuts. Be assured, however, that every cake and pastry included in this chapter is a wonderful showcase for good chocolate.

Makes: 6 servings
Preparation time: 1 hour 10 minutes
Cooking time: 1 hour
Freezing time: 6 hours

Rum and
Sultana Financier

CHOCOLATE CAKE

30 gm (1 oz) almonds, toasted and ground

45 gm (1½ oz) icing sugar

30 gm (1 oz) egg whites

60 gm (2 oz) heavy cream, 38%, fresh

11 gm (⅓ oz) cornstarch

1 tsp dark chocolate, 64%, melted[†]

30 gm (1 oz) dark raisins

Preheat the oven to 160°C (320°F).

Place the almonds, icing sugar, egg whites, cream and cornstarch in the bowl of a free-standing electric mixture and mix until combined.

Pour the melted chocolate into the almond mixture.

Pour the mixture into a greased circular cake tin 15½ cm (6 inch) in diameter.

Sprinkle the raisins over the top and bake in the preheated oven for 20 minutes.

Allow to cool on a cooling tray.

RUM MOUSSE

250 ml (9 fl oz) milk

250 gm (9 oz) heavy cream, 38%, fresh

½ vanilla pod

196 gm (7 oz) egg yolk

124 gm (4½ oz) caster sugar

2 sheets gelatine, dissolved in water

30 ml (1 fl oz) dark rum

190 gm (7 oz) heavy whipping cream, 38%, fresh

Place the milk, cream and vanilla pod in a saucepan and bring to the boil.

Place the egg yolks and sugar in a bowl.

Remove the saucepan from the heat and gradually pour the milk and cream mixture over the top of the egg yolks and sugar.

Whisk together.

Return the liquid to the saucepan, whisking continuously.

When the custard coats the back of a spoon remove from the heat and add the dissolved gelatine.

Place the custard in a bowl over ice and allow to cool.

Once the custard is cool, semi-whip the whipping cream and fold through the rum.

Reserve 100 ml (3 fl oz) of the combined rum and cream for the milk chocolate mousse.

Fold the remaining rum and cream through the custard.

MILK CHOCOLATE MOUSSE

183 gm (6 fl oz) milk chocolate

100 ml (3½ fl oz) reserved rum and cream

150 gm (5 fl oz) heavy whipping cream, 38%, fresh

Melt[†] the chocolate.

Take the reserved rum and cream from the rum mousse and whisk it together with the chocolate.

Semi-whip the whipping cream and fold it into the chocolate mixture.

ASSEMBLY

Spoon the rum mousse into a piping bag and pipe a layer of the mousse into a circular mould, 15½ cm (6 inch) in diameter.

Slice the cooled chocolate cake into two layers.

Place a layer of cake on top of the rum mousse and place it in the freezer for 3 hours.

Take the cake and rum mousse from the freezer and pour a thick layer of the milk chocolate mousse on top.

Place the second layer of the cake on top, and return the mould to the freezer for 3 hours.

GARNISH

100 gm (3½ oz) chocolate ganache[‡]

15 gm (½ oz) chocolate pearls, store-bought

1 curved white chocolate plate, store-bought

Once frozen, glaze the financier with chocolate ganache. Before the ganache is fully set, decorate with chocolate pearls and a white chocolate plate, placed in the centre of the cake.

Chef's tip: The white chocolate plate can be replaced by 3 white chocolate sticks[†].

† See Kitchen Techniques
‡ See Basic Recipes

Makes: 4 servings
Preparation time: 2 hours
Cooking time: 40 minutes
Refrigeration time: 6 hours

Chocolate Roulade

FLOURLESS CHOCOLATE SPONGE CAKE

120 gm (4⅓ oz) egg yolks

65 gm (2⅙ oz) caster sugar

80 gm (3 oz) dark chocolate, 70%

150 gm (5⅓ oz) caster sugar

65 gm (2⅙ oz) egg whites

Preheat the oven to 180°C (350°F).

Place the egg yolks and 65 gm (2⅙ oz) of sugar in the bowl of a free-standing electric mixer. Using the whisk attachment, whisk the egg yolks and sugar until well combined.

Melt† the chocolate.

Remove the bowl from the electric mixer and using a spatula, fold the melted chocolate into the egg mixture.

In a separate, clean bowl whisk the 150 gm (5⅓ oz) of sugar with the egg whites.

Fold the egg white mixture into the chocolate mixture.

Spread the mixture into a rectangular baking tray, 30 cm (11⅕ inch) by 40 cm (15½ inch) by 6 cm (3 inch), lined with baking paper.

Bake in the preheated oven for 8 minutes.

Remove from the oven and allow to cool.

CHOCOLATE MOUSSE

45 gm (1½ oz) eggs

30 gm (1 oz) egg yolks

50 gm (1⅓ oz) caster sugar

15 ml (½ fl oz) water

120 gm (4⅓ oz) dark chocolate, 70%

160 ml (5⅔ fl oz) heavy cream, 38%, fresh, whipped to soft peaks

Place the eggs and egg yolks in the bowl of a free-standing electric mixer. Using the whisk attachment, whisk well.

Place the sugar and water in a saucepan and heat to a temperature of 118°C (244.4°F).

Gradually pour the water over the eggs, while continuing to whisk. Keep whisking until the mixture has completely cooled.

Melt† the chocolate.

Incorporate one fifth of the whipped cream into the melted chocolate. Stir well.

Add the cooled whisked eggs and sugar to the chocolate, using a hand-held whisk.

Whisk in the remaining whipped cream.

Place the mousse in the refrigerator to chill.

Before use, gently stir the mixture to ensure it is smooth.

CHOCOLATE GANACHE

70 gm (2½ oz) chocolate ganache‡

ASSEMBLY

Place a baking sheet on top of the sponge cake, turn it over and remove the baking paper used for baking; trim the edges of the sponge cake to make a neat square.

Spread a very thin layer of the ganache over the sponge cake. Allow the ganache to set.

Spoon the chocolate mousse into a piping bag with a 1 cm (½ inch) nozzle.

Pipe a layer of mousse over the top of the ganache, leaving a 2½ cm (1 inch) border from the edge of the cake so that the mousse won't ooze out when the cake is rolled.

Place a rolling pin under the paper on one edge of the cake. Gently start to roll the cake over onto itself. Use the rolling pin to gradually move the paper from the cake as you roll.

Roll the cake as tightly as possible.

Place onto a parchment paper sheet and tighten with the rolling pin.

Ensure the roulade is evenly rounded.

Refrigerate to set.

GARNISH

Hazelnuts to garnish

Walnuts to garnish

Almonds to garnish

½ tsp gold leaf

3 chocolate plates, store-bought

3 chocolate macarons (see Chocolate Macaron, pg 24)

Use the leftover ganache and spread it over the rolled roulade.

Use a piece of paper or plastic to make it smooth and straight.

Use a blowtorch or hot air blower to make the ganache shiny. Decorate with homemade macarons, chocolate plates, nuts and gold leaf.

† See Kitchen Techniques
‡ See Basic Recipes

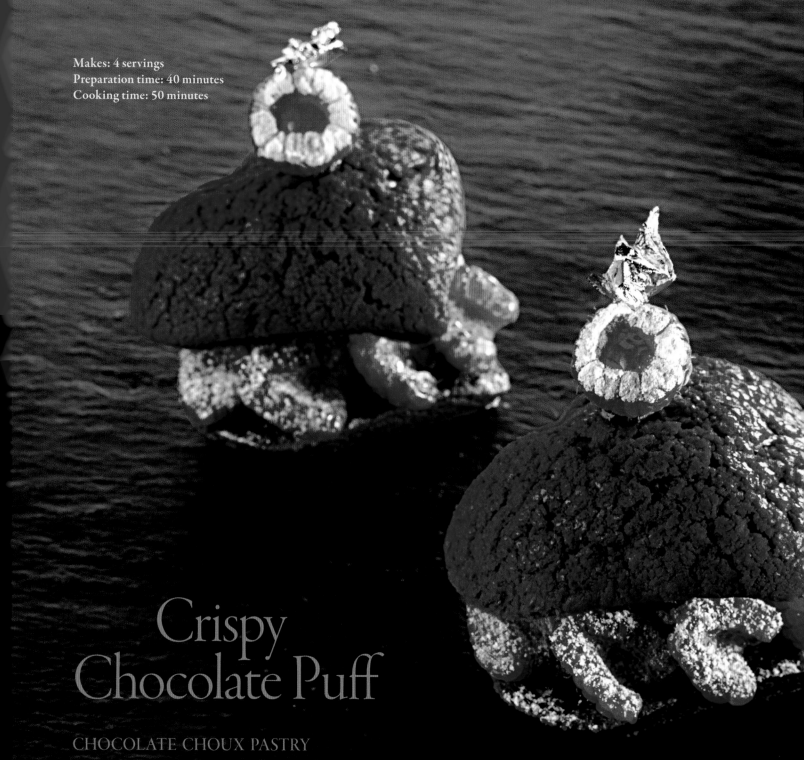

Makes: 4 servings
Preparation time: 40 minutes
Cooking time: 50 minutes

Crispy Chocolate Puff

CHOCOLATE CHOUX PASTRY

250 ml (8 fl oz) water

250 ml (8 fl oz) milk

10 gm (⅓ oz) salt

20 gm (⅔ oz) caster sugar

225 gm (8 oz) butter

250 gm (8¾ oz) plain flour, sifted

25 gm (⅞ oz) cocoa powder

10 eggs

Preheat the oven to 180°C (350°F).

Place the water, milk, salt, sugar and butter in a saucepan and over a medium heat bring to the boil. Stir well until all moisture has evaporated.

Remove the saucepan from the heat and stir in the flour and cocoa powder.

Return the saucepan to a low heat and whisk vigorously for 1 minute.

Pour the mixture into the bowl of a free-standing electric mixer and on a medium speed mix in the eggs one by one. Ensure each egg is fully incorporated before adding the next one.

Spoon the mixture into a piping bag and pipe out heart-shaped portions on a lined baking sheet.

Bake in the preheated oven for 20 minutes.

CRISP

100 gm (3½ oz) butter

125 gm (4½ oz) brown sugar

125 gm (4½ oz) plain flour, sifted

Preheat the oven to 180°C (350°F).

Place all the ingredients in the bowl of a free-standing electric mixer and using the whisk attachment, whisk on a medium speed until fully incorporated.

Remove the mixture from the bowl. Roll it out to a 2 mm (²⁄₂₅ inch) thickness and place it on a baking tray lined with baking paper.

Place the tray in the freezer to chill.

As soon as the mixture has frozen, use a cutter to cut out heart-shaped crisps.

Bake in the preheated oven for 20 minutes.

Allow to cool on a cooling tray.

CHOCOLATE PASTRY CREAM

250 ml (8 fl oz) milk

50 ml (1¾ fl oz) heavy cream, 38%, fresh

45 gm (1½ oz) egg yolks

35 gm (1⅓ oz) caster sugar

15 gm (½ oz) cornstarch

50 gm (1¾ oz) butter

100 gm (3½ oz) dark chocolate, melted†

Place the egg yolks, sugar and cornstarch in a bowl and whisk until thick and pale.

Place the milk and cream in a saucepan and over a medium heat bring to the boil.

Remove the saucepan from the heat and pour a little of the hot liquid into the egg mixture. Mix thoroughly.

Return the saucepan to the heat and pour the egg mixture into the saucepan, stirring constantly with a whisk until it thickens.

Allow the mixture to boil for 2 minutes, continually stirring so the cream does not stick to the bottom of the saucepan.

Slowly pour one third of the pastry custard cream into the melted chocolate, and mix vigorously with a spatula. Once incorporated, repeat with the remaining two thirds, a third at a time.

Pour the chocolate pastry cream into a bowl and wrap with plastic wrap. Ensure the plastic wrap touches the surface of the cream so that no skin forms.

ASSEMBLY

50 gm (1¾ oz) fresh raspberries, halved

100 gm (3½ oz) red cocoa butter

1 tsp icing sugar

Cut the choux puff in half; place a crisp on the bottom half.

Spray the top of the puff with red cocoa butter.

Spoon the pastry cream onto the bottom half of the crisp. Then place some raspberries, dusted with icing sugar, on the cream.

Take the top half of the choux, which has been previously sprayed with red cocoa butter, and place over the raspberries.

GARNISH

Decorate with whole raspberries (set using tempered chocolate); icing sugar and gold leaf.

† See Kitchen Techniques

Praline and Chocolate Cake

CHOCOLATE CAKE

130 gm (4½ oz) butter

135 gm (5 oz) caster sugar

35 gm (1 oz) almond powder

100 gm (3½ oz) eggs

40 ml (1⅓ fl oz) milk

175 gm (6⅕ oz) plain flour, sifted

5 gm (⅙ oz) baking powder, sifted

130 gm (4½ oz) dark chocolate, 64%, melted[†]

Preheat the oven to 150°C (300°F).

Place the butter and sugar in the bowl of a free-standing electric mixer and cream until pale and fluffy.

Gradually add the almond powder, eggs and milk. Continue beating.

Add the flour and the baking powder.

Pour the melted chocolate into the mixture.

Grease a rectangular cake tin, 20 cm (7⅘ inch) by 5 cm (2 inch), and pour in the mixture.

Bake in the preheated oven for 50 minutes.

Allow to cool on a cake tray to room temperature.

HAZELNUT PRALINE

260 gm (9¼ oz) hazelnuts

40 ml (1⅓ fl oz) water

155 gm (5⅓ oz) caster sugar

⅓ vanilla pod

80 gm (3 oz) dark chocolate, 53%

80 gm (3 oz) milk chocolate, 37%

70 ml (2½ fl oz) hazelnut oil

Make a praline[‡] with the hazelnuts, water, sugar and the vanilla pod. Allow to cool to room temperature.

Melt[†] the chocolates together and leave to cool to 33°C (91°F).

Mix the oil into the chocolate.

Gradually fold the praline into the chocolate. Set aside.

CHOCOLATE GLAZE

100 gm (3½ oz) dark chocolate

20 gm (⅔ oz) vegetable oil

Melt[†] the chocolate and stir in the vegetable oil. Remove from heat once the mixture reaches 35°C (95°F). It is ready for use.

ASSEMBLY

Cut the cake in half and spread the hazelnut praline evenly on the cut surface of the bottom half of the cake.

Place the top half of the cake on top of the praline and refrigerate for 1 hour.

Spread glaze over the top of the cake and allow to set.

GARNISH

Decorate with store-bought chocolate bells, chopped hazelnuts and gold leaf.

† See Kitchen Techniques
‡ See Basic Recipes

Makes: 4 servings
Preparation time: 30 minutes
Cooking time: 1 hour
Refrigeration time: 1 hour

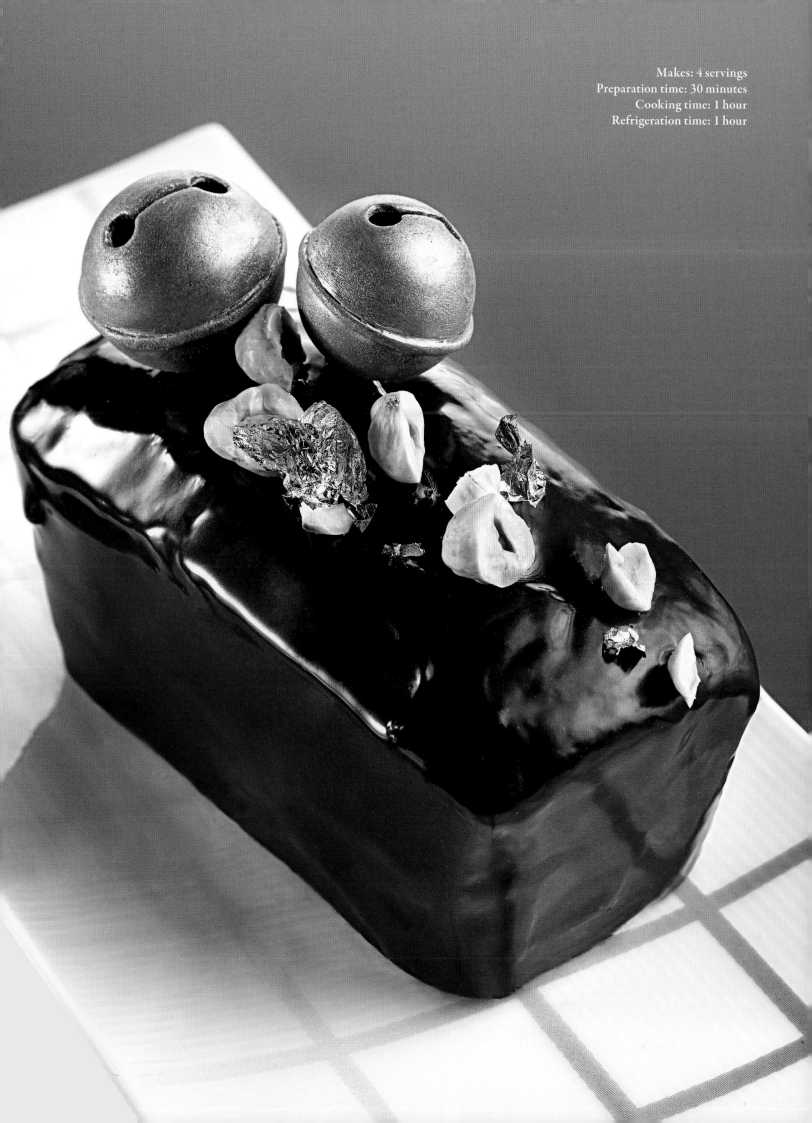

Makes: 4 servings
Preparation time: 2 hours
Cooking time: 1 hour
Refrigeration time: 24 hours

Gâteau Exotique

PÂTE À BOMBE

140 gm (5 oz) caster sugar

50 ml (2 fl oz) water

90 gm (3 oz) eggs

90 gm (3 oz) egg yolks

Place the sugar and the water in a saucepan and bring to a temperature of 118°C (244°F).

Place the eggs and egg yolks in the bowl of a free-standing electric mixer. Using a whisk attachment, start to whisk the eggs and egg yolks.

Pour the water and sugar over the egg mixture and continue whisking until completely cold.

MILK CHOCOLATE MOUSSE

300 gm (10⅔ oz) milk couverture, 43%

3 sheets gelatine

550 gm (17⅔ oz) heavy cream, 38%, fresh, whipped

Soften the gelatine in cold water and drain. Squeeze the excess water from the gelatine and mix it into the pâte à bombe.

Melt† the chocolate to 45°C (109°F).

Mix a quarter of the whipped cream into the chocolate.

Pour the chocolate and whipped cream mixture into the pâte à bombe.

Fold the remaining whipped cream into the chocolate pâte à bombe.

COCONUT DACQUOISE

125 gm (4½ oz) icing sugar

25 gm (⅞ oz) almond powder

100 gm (3½ oz) grated coconut

150 gm (5⅓ oz) egg whites

50 gm (2 oz) caster sugar

1 tsp egg white powder

Preheat the oven to 180°C (350°F).

Place the icing sugar, almond powder and coconut in a bowl and mix until combined.

In a separate bowl whisk the egg whites with the sugar and egg white powder until soft peaks form.

Using a plastic spatula, gradually fold the dry ingredients into the egg whites.

Spread the mixture on a non-stick baking mat and bake in the preheated oven for 15 minutes.

Allow the dacquoise to cool.

Once cool, cut into a circle 17 cm (6¾ inch) in diameter.

CHOCOLATE CRUMBLE

75 gm (2¾ oz) butter

75 gm (2¾ oz) brown sugar

75 gm (2¾ oz) almond powder

½ tsp salt

60 gm (2 oz) cake flour

25 gm (⅞ oz) cocoa powder

Preheat the oven to 160°C (325°F).

Place all the ingredients in the bowl of a free-standing electric mixer. Using the paddle attachment, process until little dough lumps start to form.

Once the dough lumps start to form, stop mixing and spread the crumble in a circular shape, 17 cm (16¾ inch) in diameter, on a non-stick baking mat.

Bake in the preheated oven for 12 to 15 minutes.

Allow to cool.

Once cool, place the crumble in the freezer – this will make it easier to handle when assembling the cake.

There will be a little crumble mixture left over. Cut it into 1 cm (¼ inch) cubes and roll the cubes in icing sugar. Reserve the cubes to use as decoration.

PASSION FRUIT CREAM

225 gm (7 oz) passion fruit purée

45 gm (1½ oz) egg yolks

25 gm (⅞ oz) eggs

225 gm (7 oz) butter, room temperature

1 sheet gelatine

Soften the gelatine in cold water, drain, and squeeze out the excess water.

Place all the ingredients, except the butter, in a saucepan and bring to a simmer, stirring constantly.

While stirring add the gelatine. Continue to stir until smooth. Once smooth remove the liquid from the heat and allow to cool.

Once cooled to 35°C (95°F), add the butter and emulsify using a hand-held immersion blender.

Immediately pour the mixture into a circular flexible baking mould 17 cm (16¾ inch) in diameter.

Place the flexible baking mould in the freezer to set the cream.

PASSION FRUIT GLAZE

120 gm (4½ oz) glucose

224 gm (7 oz) caster sugar

280 gm (10 oz) heavy cream, 38%, fresh

19 gm (⅔ oz) cornstarch

132 ml (4¾ fl oz) passion fruit juice

4 sheets gelatine

190 gm (6⅓ oz) white chocolate

Soften the gelatine in cold water and drain.

Cook the glucose and sugar to a caramel.

Once the caramel reaches 175°C (374°F), remove from the heat.

In a separate saucepan, heat the cream. Little by little, add the hot cream to the caramel.

Dissolve the cornstarch in a little passion fruit juice.

Pour the remaining juice into the caramel and then thicken with the cornstarch.

Return the saucepan to the heat and boil for 1 minute.

Melt† the chocolate.

Squeeze the gelatine dry and add to the chocolate; strain the caramel over the chocolate and gelatine.

Mix well with a hand-held beater.

Completely cover the glaze with plastic wrap and refrigerate overnight.

ASSEMBLY

Spoon the chocolate mousse into a piping bag with a 1½ cm (¾ inch) nozzle.

Place a metal ring frame, 19 cm (7½ inch) in diameter and 5 cm (2 inch) high, on a non-stick baking mat. Pipe the mousse into the frame.

Place the frozen passion fruit cream disc into the chocolate mousse so that the mousse rises around the side of the disc.

Pipe a thin layer of mousse on top of the frozen disc and stick the coconut dacquoise on top.

Pipe the last layer of mousse onto the dacquoise.

Place the crumble on top of the last layer of mousse.

Freeze the cake overnight.

Remove the cake from the freezer and heat the ring to remove it.

Place back in the freezer.

Before serving, pour the glaze on top and spread evenly. Allow the glaze to set.

GARNISH

2 chocolate sticks†

2 white chocolate sticks†

1 chocolate-coated coconut egg

2 edible flowers, violet

Decorate the cake with the crumble cubes, chocolate sticks, coconut egg and edible violets.

† See Kitchen Techniques

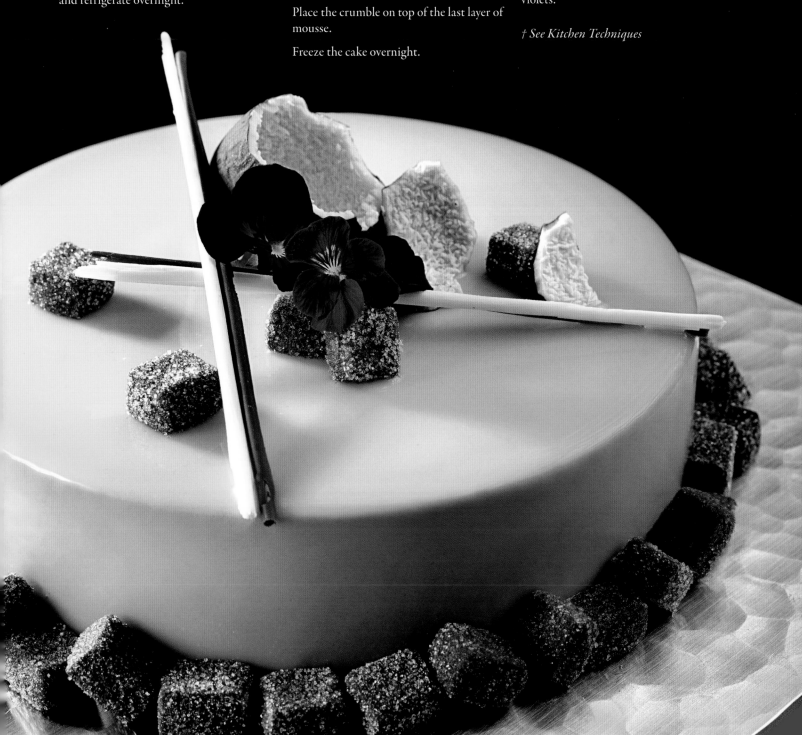

Chocolate Tropezienne Crumble

Makes: 30 pieces
Preparation time: 2 hours
Cooking time: 30 minutes
Refrigeration time: 12 hours

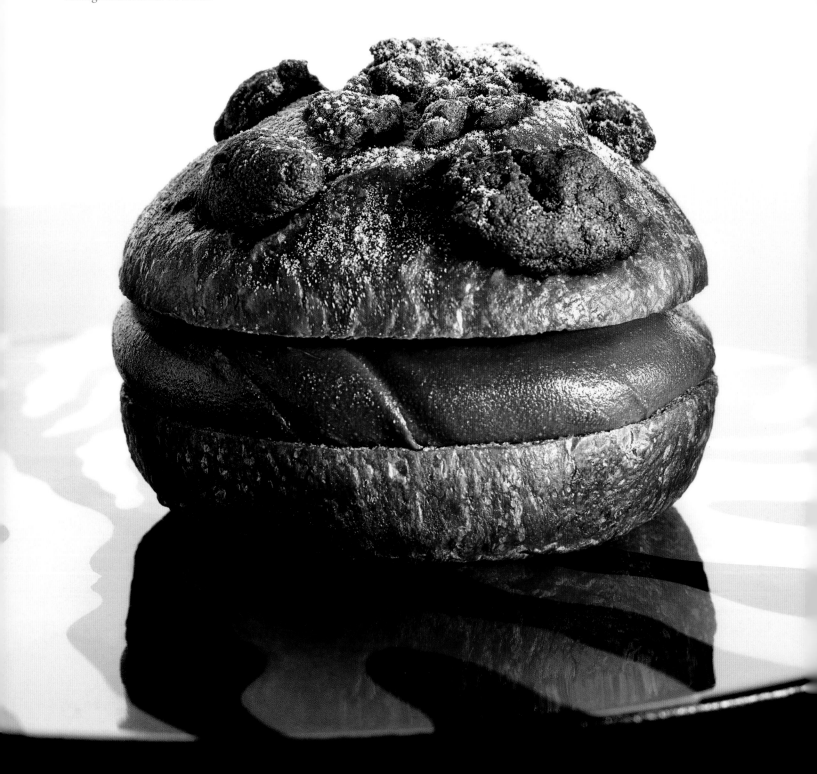

CHOCOLATE CRUMBLE

115 gm (4¼ oz) butter

115 gm (4¼ oz) caster sugar

200 gm (7¼ oz) all-purpose flour

25 gm (⅚ oz) cocoa powder

In a mixing bowl, combine the sugar, flour and cocoa powder.

Add the butter and mix until it forms a coarse, crumbly dough.

Use your fingertips to break up the dough into small pea-sized pieces.

Keep in an airtight container in the refrigerator until needed.

CHOCOLATE BRIOCHE

25 ml (⅚ fl oz) water, lukewarm

20 gm (⅔ oz) fresh yeast

5½ kg (12 lb) white bread flour, sifted

20 gm (⅔ oz) salt

40 gm (1½ oz) caster sugar

275 gm (10 oz) eggs

25 gm (⅚ oz) cocoa powder

350 gm (12⅓ oz) butter, divided into 4 parts

For egg wash

5 egg yolks

120 ml (4 fl oz) milk, fresh

Preheat the oven to 180°C (350°F).

Grease and flour muffin moulds. Set aside.

Combine lukewarm water, fresh yeast and two tablespoons of the sugar in a bowl. Cover and let stand for about 10 minutes, until mixture starts to bubble.

Place the flour, cocoa powder, salt and remaining sugar in the bowl of a free-standing electric mixer.

Add the yeast mixture and the eggs.

Using the dough hook attachment, mix the ingredients together on a low speed until a dough forms.

Beat the dough until it is smooth and shiny but sticky.

Add the butter by portion while continuing to knead the dough. Ensure each portion of butter is completely absorbed before adding the next portion. Continue kneading until all the butter is used.

Transfer the dough into a container thinly coated with oil or non-stick spray. Cover the dough with a lid or plastic wrap and let rise until it has doubled in size.

Press down the dough to deflate it and then divide it into 40 gm (1½ oz) balls.

Place the dough balls in the pre-prepared muffin moulds, brush with combined egg yolks and milk and allow to rise for a half hour.

Sprinkle the top of the brioche with chocolate crumble, then bake in the preheated oven for 15 minutes.

Unmould the brioche onto a wire rack and allow to cool completely.

CHOCOLATE CREAM

520 gm (1 lb 1 oz) heavy whipping cream, 38%, fresh

100 gm (3½ oz) egg yolks

55 gm (2 oz) caster sugar

400 gm (15 oz) dark chocolate

Place the cream in a saucepan and over a medium heat, bring to the boil. Remove from the heat and set aside.

Whisk together the egg yolks and sugar in a mixing bowl until light and fluffy.

Gradually pour the hot cream into the egg mixture while stirring briskly.

Place the mixing bowl on top of simmering water on low heat and cook the mixture to 84°C (183.4°F), stirring continuously with a rubber spatula.

Remove the saucepan from the heat, add the chocolate and stir until the chocolate has completely melted.

Set side and allow to cool to room temperature.

Refrigerate overnight.

ASSEMBLY

Slice the chocolate brioche in half horizontally.

Whip the chilled chocolate cream until smooth.

Place the chocolate cream in a piping bag and pipe a dollop of cream between the two pieces of brioche to make a sandwich, lightly pressing down to reach the edges of the brioche.

Dust the top of the brioche lightly with icing sugar before serving.

Makes: 20 servings
Preparation time: 3 hours
Cooking time: 1½ hours
Refrigeration time: 2 hours
Freezing time: 3 hours

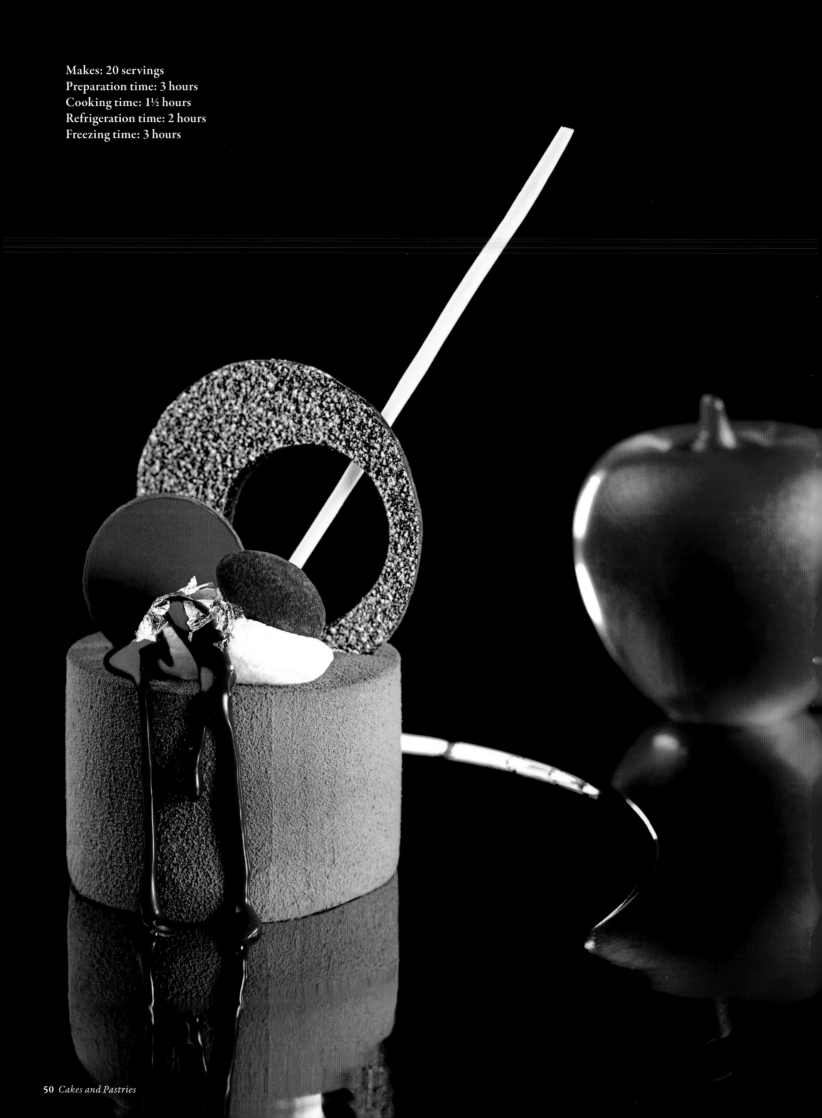

CINNAMON BAVAROIS

70 ml (2⅓ fl oz) milk

200 ml (6¾ fl oz) heavy cream, 38%, fresh

¼ vanilla pod

1 cinnamon stick

60 gm (2 oz) egg yolks

35 gm (1⅙ oz) sugar, granulated

1 sheet gelatine

Place the milk, cream, vanilla pod (sliced longways down the middle) and cinnamon stick in a saucepan and bring the liquid to a simmer.

Turn off the heat, cover the saucepan with a lid and let the liquid rest for 30 minutes.

In a separate bowl, mix the egg yolks and sugar.

Re-boil the cream and add in the egg yolk mixture through a strainer. Heat until the mixture reaches 80°C (176°F).

Place the gelatine in a separate bowl and cover with water.

Squeeze the water from the gelatine and stir it into the cream mixture.

Continue to stir until the liquid thickens.

Pour the liquid through a strainer into a half-moon shaped flexible baking pan (4 cm/1½ inch).

Place in a refrigerator to set for approximately 1 hour.

CHOCOLATE MOUSSE

90 gm (3 oz) egg yolks

72 gm (2½ oz) sugar, granulated

70 ml (2½ fl oz) water

225 gm (7 oz) dark chocolate, 75%

565 ml (19 fl oz) heavy cream, 38%, fresh

Place the egg yolks, granulated sugar and water in a bowl and whisk together until the sugar has just dissolved.

Melt† the chocolate and gradually stir in a third of the heavy cream to form a ganache.

Add the egg yolk mixture to the chocolate.

Whip the remaining heavy cream and gradually add it into the chocolate mixture.

Place in a refrigerator to set for 1 hour.

CARAMELISED APPLE

30 gm (1 oz) ghee (clarified butter)

50 gm (1⅔ oz) brown sugar

3 apples, peeled, cored and finely diced

10 gm (⅓ oz) Calvados (apple brandy)

Melt the ghee in a saucepan. Add the sugar. Once it caramelises, add the diced apples and sauté until they are coated with caramel.

Flambé with Calvados, spread on a non-stick baking mat and rest at room temperature.

BISCUIT DACQUOISE

150 gm (5⅓ oz) egg whites

40 gm (1⅓ oz) granulated sugar

100 gm (3½ oz) almond powder

100 gm (3½ oz) icing sugar

30 gm (1 oz) all-purpose flour

30 gm (1 oz) icing sugar

Preheat the oven to 190°C (370°F).

Mix the egg whites and granulated sugar to make a meringue.

Mix in the almond powder, 100 gm (3½ oz) of icing sugar and all-purpose flour. Mix with meringue until just blended.

Spoon the mixture into a pastry bag with a 1 cm (⅖ inch) nozzle.

Pipe the mixture onto a non-stick baking mat in 6 cm (2⅓ inch) wide discs.

Sift the 30 gm (1 oz) icing sugar over the disc surface twice.

Bake in the preheated oven for 20 minutes.

ASSEMBLY

Lay the biscuit dacquoise at the bottom of the base of a 6 cm (3 inch) wide and 4 cm (2 inch) high metal ring.

Place the cinnamon bavarois on top of the biscuit dacquoise.

On top of the bavarois, pipe a 1 cm (⅖ inch) layer of the chocolate mousse.

Add a layer of caramelised apple.

Pipe in more mousse to fill the ring to the top.

Smooth the top with a palette knife and freeze for 3 hours.

Take the ring out of the freezer and spray with chocolate for a velvety finish.

GARNISH

8 gm (⅓ oz) almonds, chocolate-coated

40 gm (1⅖ oz) chocolate ganache‡

20 white chocolate sticks†

½ tsp gold leaf

200 gm (7 oz) Chantilly cream

40 chocolate discs

Chantilly cream

200 gm (7 oz) heavy cream, 47%, fresh

16 gm (½ oz) sugar, granulated

Use an electric mixer to combine the cream and sugar. Whip until soft peaks form.

Chocolate discs

300 gm (10⅗ oz) milk chocolate, 35%, tempered†

Spread the tempered chocolate on a marble surface to a 2 mm (²⁄₂₅ inch) thickness.

Once the chocolate is almost set (but not hard), use different size ring cutters to cut out the chocolate rings.

Decorate each serving with a quenelle of Chantilly cream. Spoon the chocolate ganache over the cream. Add the chocolate discs and chocolate stick. Top with a chocolate-coated almond and gold leaf.

† See Kitchen Techniques
‡ See Basic Recipes

Makes: 10 servings
Preparation time: 1 hour
Cooking time: 45 minutes

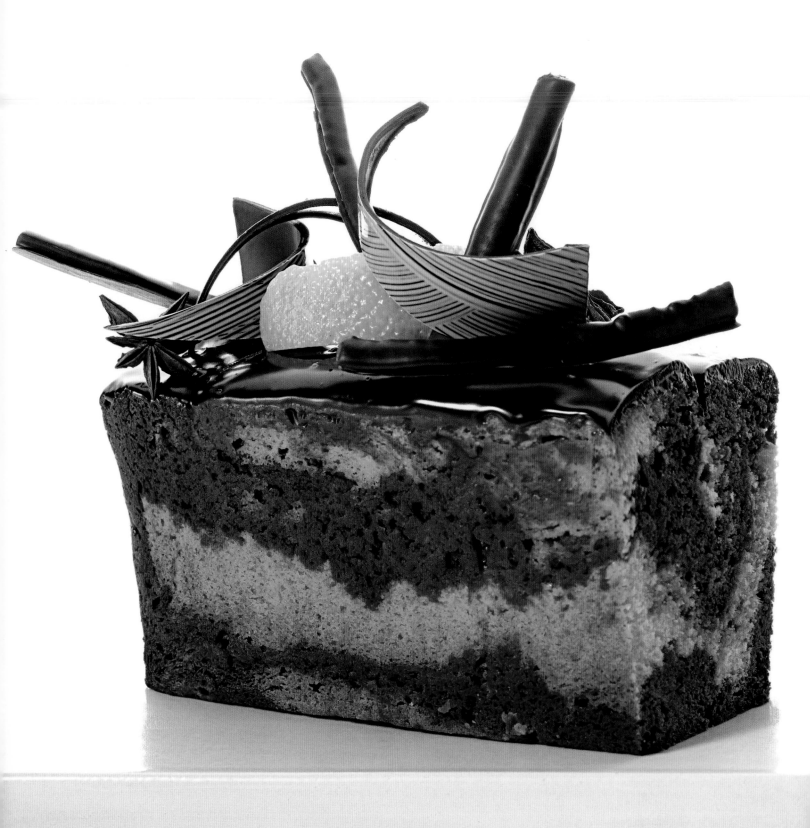

Chocolate and Orange Marble Cake

173 gm (6 oz) butter

180 gm (6½ oz) caster sugar

45 gm (1½ oz) almond flour

3 eggs

56 gm (2 oz) milk

233 gm (8 oz) plain flour

2 tsp baking powder

Zest of 1 orange

150 gm (5 oz) dark chocolate, 64%, melted†

Preheat the oven to 145°C (293°F).

In a bowl, cream the butter and sugar together until light and well combined.

Gradually add the almond flour, eggs and milk.

In a separate bowl, sift the plain flour and baking powder together and then add to the mixture. Mix well.

Pour one third of the batter into a separate bowl. Stir in the orange zest.

Pour the melted chocolate into the remaining mixture.

Grease a 23 cm (9 inch) square cake tin and pour one third of the chocolate batter into the tin.

Using a piping bag, pipe half the orange batter lengthways down the centre.

Cover with another third of the chocolate batter and pipe the remaining orange batter lengthways down the centre.

Cover with the remaining third of the chocolate batter.

Bake for 45 minutes.

Invert the cake onto a cooling tray and allow to cool.

GARNISH

300 gm (10½ oz) pâte à glacier (store bought)

1 chocolate shaving sheet, PCB-green coloured

Peel of 1 orange, fresh

10 gm (⅓ oz) star anise pods

10 gm (⅓ oz) chocolate curls†

Melt the pâte à glacier and dip the top of the cake into the chocolate. Allow the chocolate to set.

Decorate with chocolate shavings (pre-made from the chocolate shaving sheet), fresh orange peel, star anise seeds and chocolate curls.

† See Kitchen Techniques

Makes: 4 servings
Preparation time: 2 hours
Cooking time: 1 hour
Refrigeration time: 36 hours

Chocolate
Three Ways

MILK CHOCOLATE CHANTILLY CREAM

150 gm (5 oz) heavy cream, 38%, fresh

100 gm (3½ oz) milk chocolate, 40%

Place the cream in a saucepan and over a medium heat bring it to the boil.

Place the chocolate in a metal bowl and slowly pour a third of the hot cream over the top. Stir well to melt the chocolate.

Repeat this twice more with the remaining cream. Ensure the chocolate is fully incorporated.

Place the bowl in the refrigerator and chill for 24 hours.

The next day remove the cream from the refrigerator and whip until soft peaks form. Spoon into a piping bag with a thin nozzle. Set aside.

CHOCOLATE BISCUIT

215 gm (7⅙ oz) almond paste

65 gm (2⅙ oz) caster sugar

105 gm (3½ oz) egg yolks

75 gm (2¾ oz) eggs

125 gm (4½ oz) egg whites

65 gm (2⅙ oz) caster sugar

50 gm (1⅔ oz) cocoa paste, melted

50 gm (1⅔ oz) butter, melted

50 gm (1⅔ oz) cake flour, sifted

25 gm (⅞ oz) cocoa powder, sifted

20 gm (⅔ oz) hazelnuts, toasted

Preheat the oven to 160°C (325°F).

Place the almond paste and 65 gm (2⅙ oz) of sugar in the bowl of a free-standing electric mixer and mix together.

Gradually beat in the egg yolks.

Continue to dilute the mixture by adding in the eggs one at a time.

In a separate bowl, beat the egg whites with the remaining sugar.

In another bowl, place the melted cocoa paste and butter. Pour a little of the egg white mixture into the bowl and mix to smooth texture.

Add almond mixture to the melted cocoa paste and butter. Then fold through the flour and cocoa powder.

Lastly, add the remaining egg whites.

Spread the mixture in a 30 cm (11⅘ inch) by 40 cm (15¾ inch) by 6 cm (2⅖ inch) high baking tray lined with baking paper and bake in the preheated oven for 45 minutes.

Allow to cool on a cooling tray.

CHOCOLATE GANACHE

190 gm (6⅓ oz) heavy cream, 38%, fresh

1 vanilla pod, sliced lengthways

130 gm (4½ oz) dark chocolate, 53%

100 gm (3½ oz) dark chocolate, 70%

14 gm (½ oz) trimoline

35 gm (1⅙ oz) butter

Place the cream and vanilla pod in a saucepan and bring it to the boil.

Place the chocolate and trimoline in a bowl and pour the cream over the top.

Remove the vanilla pod.

Using a hand-held immersion blender mix the ingredients until the chocolate has melted. Monitor the temperature of the ganache.

When the ganache reaches 35°C (95°F) stir in the butter until the ganache is smooth and shiny.

WHITE CHOCOLATE RECTANGLES

20 gm (⅔ oz) white chocolate

Melt[†] the white chocolate, spread it onto a plastic sheet, keeping the chocolate to about a 1 mm (½₅ inch) thickness.

Once the chocolate hardens, cut it into rectangular pieces, 3 cm (1⅕ inch) by 12.5 cm (5 inch).

ASSEMBLY

Spread the chocolate ganache evenly on top of the cooled biscuit.

Place the tray in the refrigerator for about 12 hours.

The next day cut the biscuit into rectangles, 2½ cm (1 inch) by 12 cm (4½ inch).

Place a rectangular piece of white chocolate, slightly larger than the biscuit, on top of one biscuit rectangle.

Pipe the milk chocolate Chantilly cream on top of the white chocolate rectangle and cover with another white chocolate rectangle.

GARNISH

Decorate each plate with chocolate ganache[†], hazelnuts, gold leaf, chocolate buttons[†] and a chocolate stick[‡].

† See Kitchen Techniques
‡ See Basic Recipes

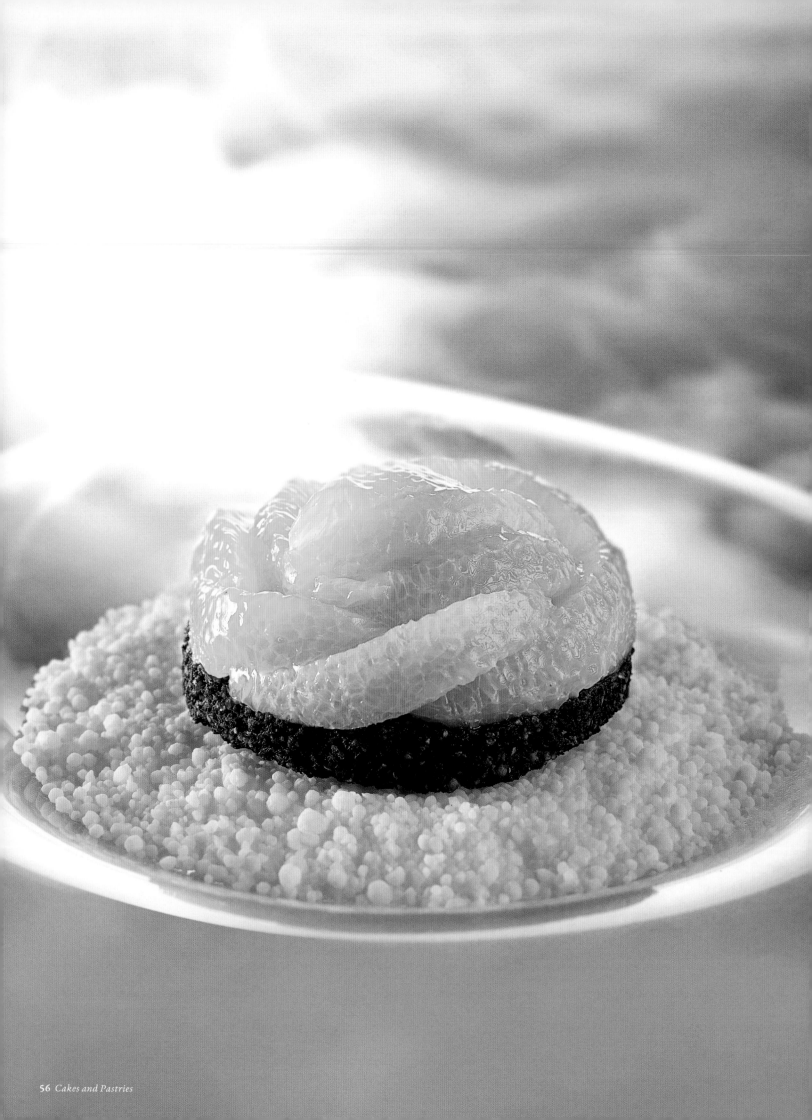

Makes: 4 servings
Preparation time: 2 hours
Cooking time: 20 minutes

Orange and Chocolate Sablé Tartelette

CHOCOLATE SABLÉ

50 gm (1½ oz) margarine

25 gm (¾ oz) icing sugar

7 gm (⅙ oz) egg

167 gm (½ oz) orange marmalade

60 gm (2 oz) wholewheat flour

7 gm (⅙ oz) cocoa powder, unsweetened

Preheat the oven to 170°C (354°F).

Place the margarine and icing sugar in the bowl of a free-standing electric mixer. Beat at medium speed until combined, then add the egg and orange marmalade. Continue to beat.

Add the wholewheat flour and the cocoa powder. Beat until just combined.

Remove the mixture from the bowl and roll it out on a lightly floured work surface to a 1 cm (½ inch) thickness.

Use a circle cutter 6 cm (3 inch) in diameter to cut 4 circles from the sablé.

Grease 4 tartelette moulds measuring 6 cm (3 inch) in diameter.

Drape the sablé dough over a rolling pin (this will allow you to position it correctly). Unroll the dough over each mould. Press down lightly with your thumbs so that the dough sticks to the sides of the mould.

Bake the sablé for 10 to 15 minutes.

Allow to cool and unmould.

CHOCOLATE PASTRY CREAM

70 ml (2¼ fl oz) soya milk

½ vanilla pod

18 gm (½ fl oz) egg yolk

18 gm (½ fl oz) brown sugar

7 gm (⅙ oz) cornstarch

6 gm (⅙ oz) cocoa powder

Place the soya milk and vanilla in a saucepan and, over a medium heat, bring the liquid to the boil. Remove the saucepan from the heat, put the lid on and allow the vanilla to infuse for 15 minutes.

Return the saucepan to the heat and bring the liquid to the boil again.

Strain the liquid into a clean bowl.

In a separate bowl, mix the eggs yolks and the brown sugar until combined.

Add the cornstarch to the egg mixture and stir. Then add the egg mixture to the strained milk.

Pour the combined mixture back into the saucepan and bring to the boil for 5 more minutes.

Add the cocoa powder and gently stir.

Pour the mixture into the bowl of a free-standing electric mixer and beat until the pastry cream cools to room temperature.

ORANGE SEGMENTS

4 oranges

Using a well-sharpened paring knife, peel the oranges. Make sure all the pith is removed.

Extract the segments.

Place the orange segments on a paper towel and gently pat dry.

ASSEMBLY

Using a spoon, fill each sablé tartelette shell with the chocolate pastry cream.

Arrange the orange segments on top of the pastry cream.

Chocolate and Hazelnut Brownie with Praline Fudge

CHOCOLATE AND HAZELNUT BROWNIE

240 gm (8½ oz) butter

140 gm (5 oz) caster sugar

185 gm (6½ oz) dark chocolate

220 gm (8 oz) eggs

280 gm (10 oz) caster sugar

240 gm (8½ oz) hazelnuts

155 gm (5½ oz) plain flour

A pinch of baking powder

A pinch of salt

Preheat the oven to 160°C (325°F).

Melt the butter, sugar (140 gm/5 oz) and chocolate over a bain-marie.

Place the eggs and sugar (280 gm/10 oz) in a bowl and whisk by hand.

Slowly add the melted ingredients to the egg mixture.

In a separate bowl, mix the hazelnuts, flour, baking powder and salt.

Pour the flour mixture into the egg and chocolate mixture and mix well.

Line a 30 cm (11⅘ inch) square cake tin with baking paper.

Pour the mixture into the cake tin and bake for 45 to 50 minutes.

Remove from the oven and allow the brownie to cool.

Unmould the brownie and remove the paper.

Flip the brownie upside down and scrape off uneven skin from the side that was not touching the cake tin.

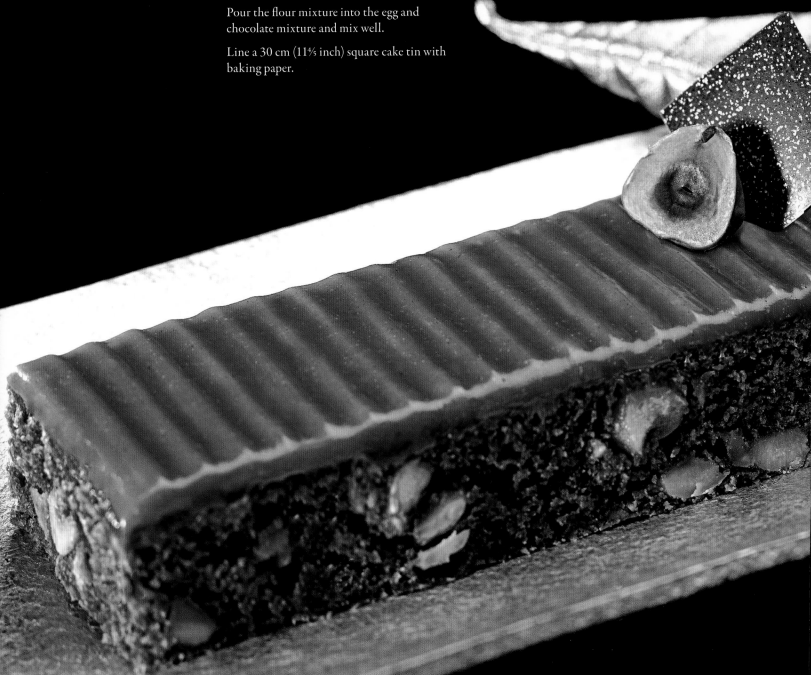

Makes: 12 servings
Preparation time: 40 minutes
Cooking time: 1 hour

PRALINE FUDGE

125 ml (4 fl oz) evaporated milk
125 gm (4½ oz) caster sugar
30 gm (1 oz) butter
⅛ tsp vanilla essence
A pinch of salt
45 ml (1½ fl oz) evaporated milk
85 gm (3 oz) praline⁺

Place 125 ml (4 fl oz) of evaporated milk and the sugar in a saucepan and heat until the mixture reaches 105°C (221°F).

Add in butter, vanilla essence and salt.

Continuously stir the mixture while it comes to the boil. When the mixture reaches 110°C (230°F) remove from the heat.

Add in 45 ml (1½ fl oz) of evaporated milk and the praline.

Stir vigorously for 30 seconds.

ASSEMBLY

Pour the fudge over the brownie and spread with a palette knife or a spatula.

Comb it with an icing comb.

Allow the fudge to cool before cutting into pieces.

Serve at room temperature.

GARNISH

Hazelnuts to garnish
12 chocolate squares, store-bought
Edible gold spray

Decorate each serving with hazelnuts and a chocolate square sprayed with edible gold spray.

ǂ See Basic Recipes

Makes: 4 servings
Preparation time: 20 minutes
Cooking time: 15 minutes

Chocolate Banana Mini Cake

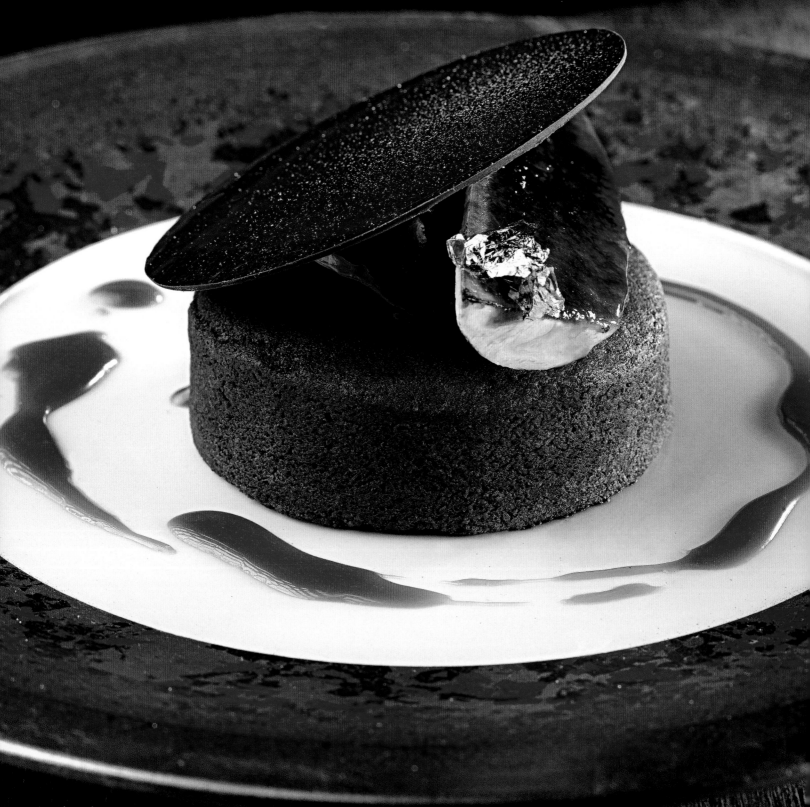

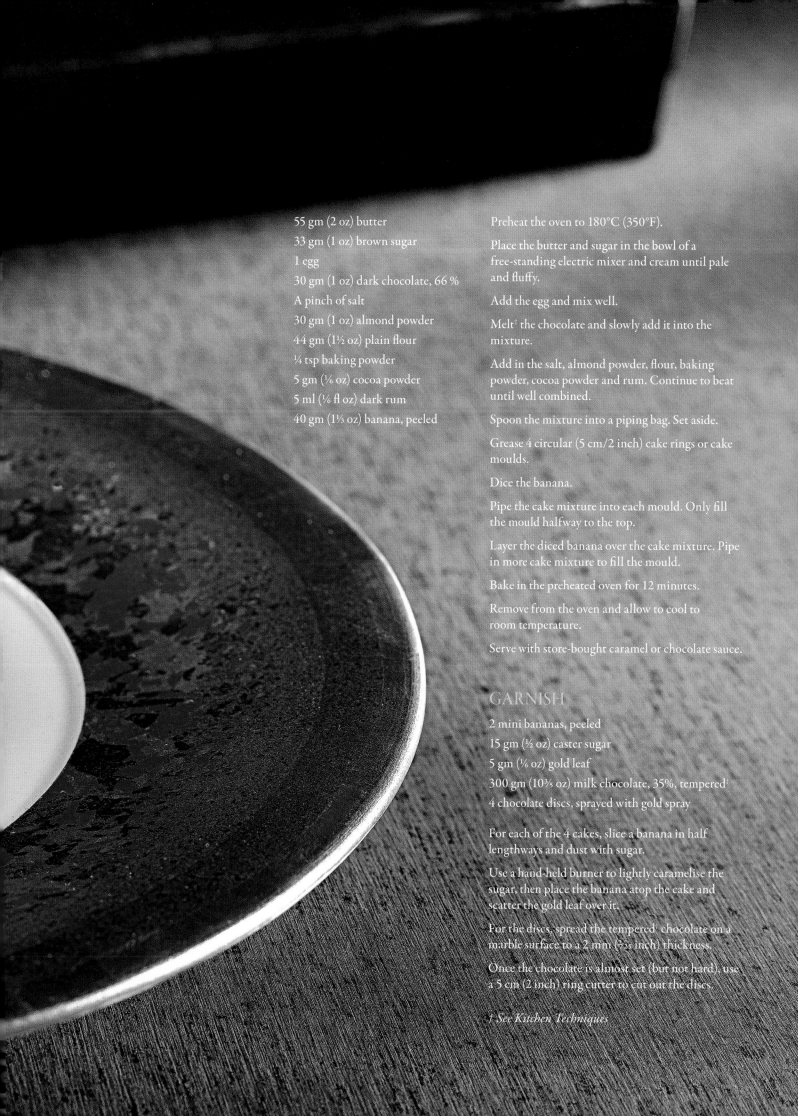

55 gm (2 oz) butter

33 gm (1 oz) brown sugar

1 egg

30 gm (1 oz) dark chocolate, 66 %

A pinch of salt

30 gm (1 oz) almond powder

44 gm (1½ oz) plain flour

¼ tsp baking powder

5 gm (⅙ oz) cocoa powder

5 ml (⅙ fl oz) dark rum

40 gm (1⅓ oz) banana, peeled

Preheat the oven to 180°C (350°F).

Place the butter and sugar in the bowl of a free-standing electric mixer and cream until pale and fluffy.

Add the egg and mix well.

Melt[1] the chocolate and slowly add it into the mixture.

Add in the salt, almond powder, flour, baking powder, cocoa powder and rum. Continue to beat until well combined.

Spoon the mixture into a piping bag. Set aside.

Grease 4 circular (5 cm/2 inch) cake rings or cake moulds.

Dice the banana.

Pipe the cake mixture into each mould. Only fill the mould halfway to the top.

Layer the diced banana over the cake mixture. Pipe in more cake mixture to fill the mould.

Bake in the preheated oven for 12 minutes.

Remove from the oven and allow to cool to room temperature.

Serve with store-bought caramel or chocolate sauce.

GARNISH

2 mini bananas, peeled

15 gm (½ oz) caster sugar

5 gm (⅙ oz) gold leaf

300 gm (10⅗ oz) milk chocolate, 35%, tempered[1]

4 chocolate discs, sprayed with gold spray

For each of the 4 cakes, slice a banana in half lengthways and dust with sugar.

Use a hand-held burner to lightly caramelise the sugar, then place the banana atop the cake and scatter the gold leaf over it.

For the discs, spread the tempered[1] chocolate on a marble surface to a 2 mm (⅟₂₅ inch) thickness.

Once the chocolate is almost set (but not hard), use a 5 cm (2 inch) ring cutter to cut out the discs.

1 See Kitchen Techniques

DESSERTS

A delicious dessert should be the crowning finale to every meal, the perfect conclusion that holds the company and extends the enjoyment of the moment. A chocolate dessert will never fail to please – the most seductive of all foods, almost universally liked and remarkably adaptable.

The Peninsula's chefs have been inspired by chocolate's amazingly nuanced taste profile. For the serious chocolate lover there is the rich Black Forest Delight or the intense Chocolate Tart. Some chefs have used citrus or spice to cut through chocolate's sweetness, to create the perfect sweet-savoury balance. Calorie counters have not been forgotten, with sugar-free spa-like delights.

Whether you need an intimate dessert for two or a show-stopping crowd pleaser, the *Naturally Peninsula* collection offers abundant choice.

Makes: 4 servings
Preparation time: 30 minutes
Cooking time: 1 hour

Chocolate Floating Island with Poached Pear and Lemon Zest

FLOATING ISLANDS

200 gm (7 oz) egg whites

100 gm (3½ oz) caster sugar

Preheat oven to 130ºC (250ºF).

Place the egg whites and sugar in the bowl of a free-standing electric mixer. Using the whisk attachment, beat on high speed until soft peaks form and the egg whites are firm and glossy.

Spoon the egg mixture into a piping bag with a star-shaped nozzle.

Line a baking dish with baking paper and pipe the egg mixture into it, in segments of approximately 4 cm (1⅗ inch) each in diameter.

Place the baking dish in a bain-marie and bake in the preheated oven for 50 minutes.

POACHED PEAR BALLS

200 ml (7 fl oz) water

85 gm (3 oz) caster sugar

½ vanilla pod

Zest of 1 lemon

10 ml (⅓ fl oz) pear liqueur

2 pears

Peel the pears and ball with a melon baller, to obtain 20 pear balls.

Place the water, sugar, vanilla, lemon zest and pear liqueur in a saucepan and bring to the boil over a medium heat.

Reduce the heat and place the pear balls in the liquid. Poach the pear balls for 15 minutes.

Remove from heat and set aside.

CHOCOLATE SOUP

250 ml (8 fl oz) milk

85 ml (2½ fl oz) heavy cream, 38%, fresh

Zest of 1 lemon

1 vanilla pod

85 gm (3 oz) dark chocolate, chopped

55 gm (2 oz) milk chocolate, chopped

Place the milk, cream, lemon zest and vanilla in a saucepan and bring to the boil over a medium heat.

Slowly add in the dark and milk chocolate and gently stir until it has melted. Remove from the heat and pour the liquid through a fine sieve into a clean bowl. Set aside.

ASSEMBLY

Pour the hot chocolate soup into a soup plate.

Remove the poached pear balls from the saucepan using a slotted spoon.

Add 5 pear balls to the soup plate and then add a floating island on top.

GARNISH

Garnish the plated dish with chocolate sticks[†], gold leaf and lemon zest.

† See Kitchen Techniques

Chocolate Entremet with Pecan Nut Brownie and Baileys Meringue Ice Cream

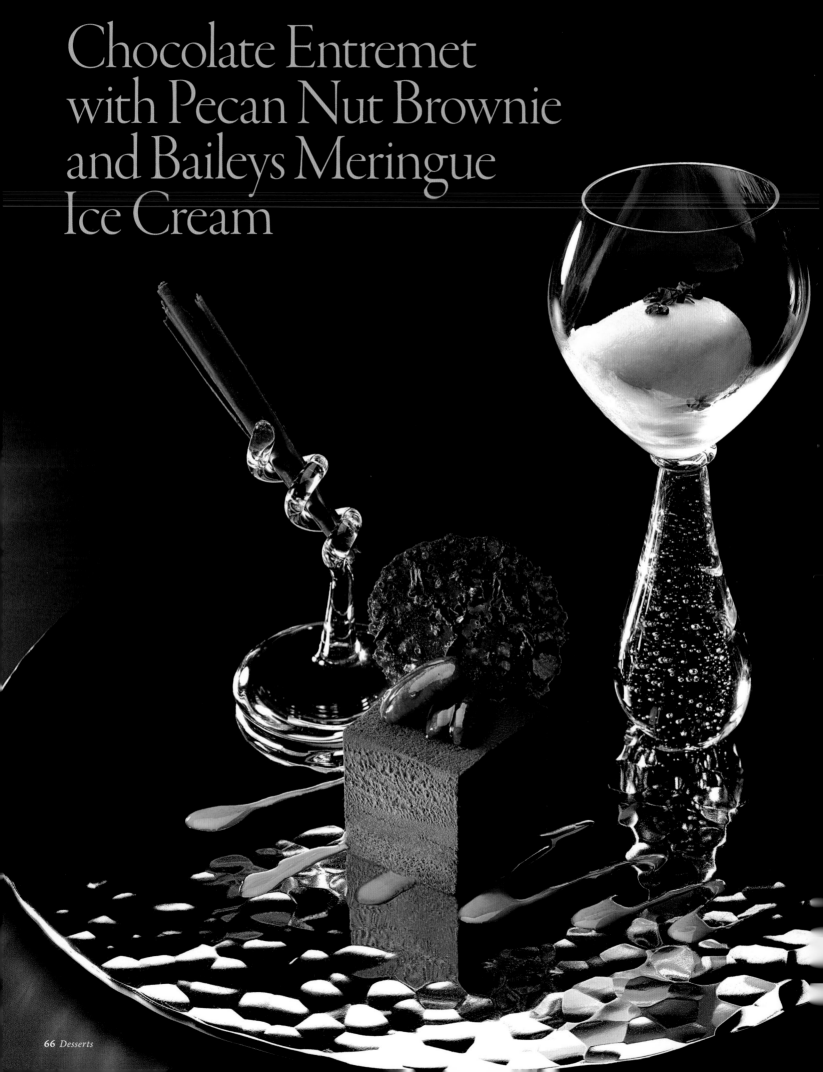

Makes: 6 servings
Preparation time: 1½ hours
Cooking time: 45 minutes
Refrigeration time: 3 hours
Freezing time: 2–12 hours

BROWNIE

22 gm (⅔ oz) dark chocolate, 70%

39 gm (1⅓ oz) butter, softened

15 gm (½ oz) egg white

26 gm (⅚ oz) egg yolk

38 gm (1⅓ oz) sugar, granulated

22 gm (⅔ oz) cake flour

22 gm (⅔ oz) pecan nuts

Preheat the oven to 170°C (338 °F).

Melt† the chocolate.

Place the butter and sugar in the mixing bowl of a free-standing electric mixer and beat.

Gradually add in the egg white and yolk; beat well after each addition.

Pour in the melted chocolate and continue to beat.

Gently fold in the flour and pecan nuts.

Pour into a rectangular mould, 20.3 cm (8 inch) by 30.9 cm (12 inch).

Bake for 30 minutes in the preheated oven.

Once baked, set aside and allow to cool. Do not unmould.

CHOCOLATE CREAM SAUCE

20 gm (⅔ oz) heavy cream, 38%, fresh

45 ml (1½ fl oz) milk

5 gm (⅙ oz) egg yolk

9 gm (⅓ oz) starch syrup

45 gm (1½ oz) dark chocolate, 64%, melted†

1 sheet gelatine

Place the milk and cream in a saucepan and bring to a simmer.

Place the egg yolk and starch syrup in a bowl and whisk well.

Pour milk and cream into the egg mixture and stir well.

Add the melted chocolate and gelatine.

Strain the mixture and allow it to chill in the refrigerator.

Once the sauce is cool, set aside.

MERINGUE

100 gm (3½ oz) egg whites

100 gm (3½ oz) sugar, granulated

100 gm (3½ oz) icing sugar

Preheat the oven to 80°C (176°F).

Make a meringue with the egg whites and the granulated sugar.

Blend the icing sugar into the meringue.

Spread the meringue thinly on a baking tray lined with baking paper.

Place in the preheated oven for 3 hours to dry.

Use in the preparation of the Baileys ice cream.

BAILEYS ICE CREAM

56 gm (2 oz) meringue

120 ml (4 fl oz) milk

56 gm (2 oz) heavy cream, 38%, fresh

11 gm (⅓ oz) Baileys Irish Cream liqueur

Place all the ingredients in a bowl and mix together.

Pour the liquid into an ice cream machine and freeze according to the manufacturer's instructions.

CHOCOLATE MOUSSE

11 gm (⅓ oz) egg yolk

14 gm (½ oz) sugar, granulated

11 ml (⅓ fl oz) water

44 gm (1½ oz) dark chocolate, 70%

72 gm (2½ oz) heavy cream, 38%, fresh

Simmer the water and sugar in a saucepan until the liquid reaches 116°C (240.8°F).

Place the egg yolk in the bowl of a free-standing electric mixer and beat on a high speed until they are pale in colour.

Gradually add the sugar and water into the beaten egg mixture.

Melt† the chocolate and gradually stir it into the egg and sugar mixture.

In a separate bowl, whip the cream until it is 80 per cent whipped.

Add the cream to the chocolate mixture and stir well.

ASSEMBLY

Pour the chocolate mousse into the mould on top of the brownie. Refrigerate for 3 hours to set.

Once the mousse has set, remove it from the refrigerator and cut the layered brownie and mousse into 6 pieces.

Pour the chocolate cream sauce around the brownie; serve with a quenelle of the Baileys ice cream.

GARNISH

Pecan nuts

20 gm (⅔ oz) pecan nuts

60 gm (2⅓ oz) sugar, granulated

20 gm (⅔ oz) starch syrup

In a saucepan, caramelise the sugar and starch syrup.

Add the roasted pecan nuts and mix well.

Spread the nuts on a non-stick baking mat and allow to dry.

6 chocolate sticks†

6 chocolate tuiles‡

Garnish with the pecan nuts and tuiles and place the chocolate sticks to the side.

† See Kitchen Techniques
‡ See Basic Recipes

Makes: 4 servings
Preparation time: 1 hour
Refrigeration time: 24 hours for the pineapple; 12 hours for the chilli chocolate mousse

Grilled Pineapple with Chilli Chocolate Mousse

GRILLED PINEAPPLE

500 gm (1 lb 1½ oz) pineapple, fresh
50 gm (2 oz) palm sugar, grated

Peel, trim and cut the pineapple into thin slices approximately 1½ cm (¾ inch) in height.

Place the pineapple in a baking tray and cover with grated palm sugar. Refrigerate overnight.

The next day, grill the pineapple in a lightly buttered frying pan, until the palm sugar slightly caramelises. Remove from heat and set aside.

CHILLI CHOCOLATE MOUSSE

100 gm (3½ oz) caster sugar
35 ml (1 fl oz) water
150 gm (5¼ oz) eggs
175 gm (6¼ oz) dark chocolate, 74%
50 gm (2 oz) butter, softened
1 sheet gelatine
250 gm (9¾ oz) heavy whipping cream, 38%, fresh
2 tsp chilli powder

Place the sugar and water in a saucepan and heat to 121°C (250°F).

Place the eggs in a separate bowl. Pour the sugar and water over the eggs and whip until completely cooled. Set aside.

Melt† the chocolate and butter in a bain-marie. Add the gelatine leaves into the chocolate and mix well.

Whip the cream and add half of the whipped cream into the chocolate.

Carefully fold the egg mixture and remaining cream through the chocolate.

Add the chilli powder to the mixture and gently mix it through.

Refrigerate for 12 hours.

ASSEMBLY

150 gm (5 oz) macadamia nuts, chocolate-coated (see Crunchy Macadamia Nuts, pg 18)

Place three slices of grilled pineapple on a plate.

Add a quenelle of chilli chocolate mousse on top of each slice.

Scatter chopped macadamia nuts on the plate.

GARNISH

8 chillies, red, fresh
2 tsp peppercorns, red
1 tsp mint, fresh
4 chocolate curls†
60 ml (2 fl oz) anglaise sauce‡

Garnish with red chillies, mint, peppercorns, chocolate curls and anglaise sauce.

† See Kitchen Techniques
‡ See Basic Recipes

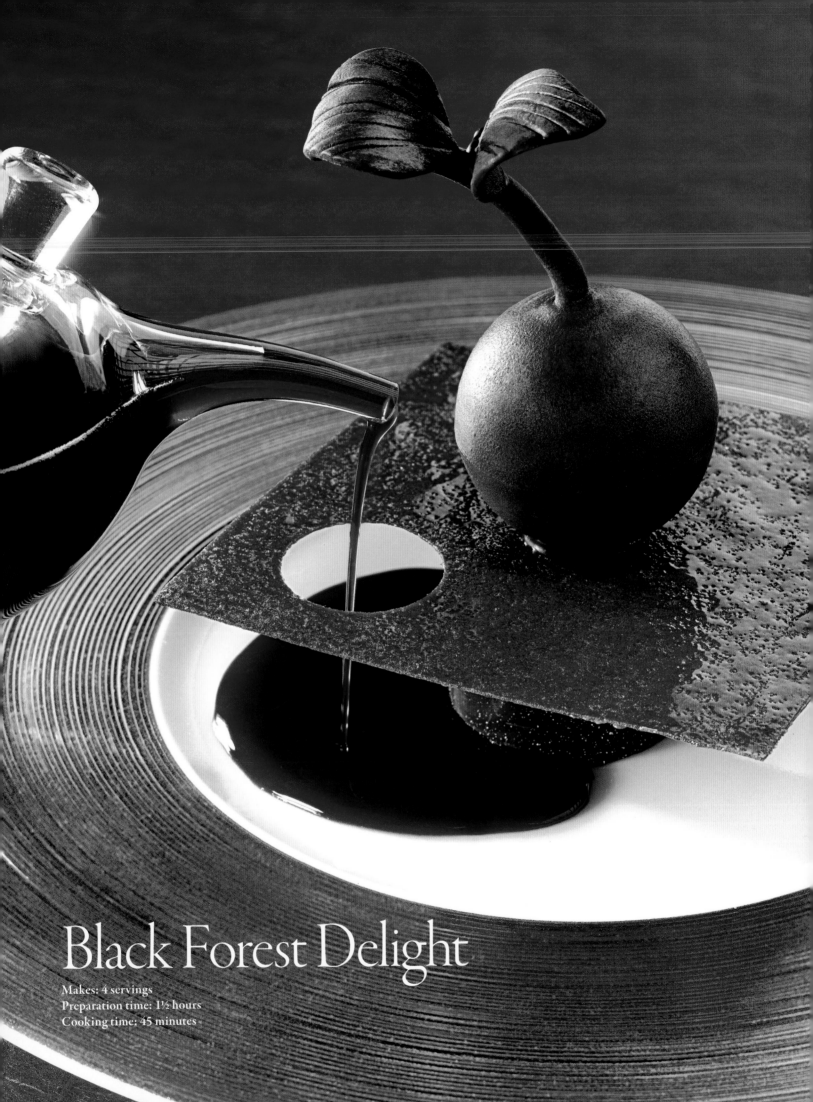

Black Forest Delight

Makes: 4 servings
Preparation time: 1½ hours
Cooking time: 45 minutes

FLOURLESS CHOCOLATE SPONGE CAKE

80 gm (2⅔ oz) dark chocolate, 70%, melted†

120 gm (4⅓ oz) egg yolks

65 gm (2⅙ oz) caster sugar

150 gm (5⅓ oz) caster sugar

65 gm (2⅙ oz) egg whites

Preheat the oven to 180°C (350°F).

Place the egg yolks and 65 gm (2⅙ oz) sugar in the bowl of a free-standing electric mixer and whisk well.

Fold in the melted chocolate.

In a separate bowl, mix 150 gm (5⅓ oz) sugar with the egg whites.

Fold the egg whites into the chocolate mixture.

Spread onto a baking sheet and bake in the preheated oven for 8 minutes.

SOUR CHERRY SAUCE

200 gm (7 oz) caster sugar

50 gm (1⅔ oz) white balsamic vinegar

375 gm (12 oz) cherries, tinned

Place the sugar in a saucepan and over a medium heat, cook to a blond caramel and then deglaze with vinegar.

Add strained cherry juice and reduce by half.

Add the cherries and simmer for 2 minutes, then blend and strain.

VANILLA AND KIRSCH CHANTILLY CREAM

250 gm (8 oz) heavy cream, 47%, fresh

25 gm (⅚ oz) caster sugar

Seeds of 1 vanilla pod

10 ml (⅓ oz) kirsch (cherry brandy)

Place all the ingredients in the bowl of a free-standing electric mixer and whisk the cream into stiff peaks.

Set aside until needed.

CHOCOLATE SHORTBREAD CRUMBS

125 gm (4½ oz) butter

45 gm (1½ oz) icing sugar

¼ tsp salt

105 gm (3⅝ oz) cake flour, sifted

10 gm (⅓ oz) cocoa powder, sifted

Preheat the oven to 160°C (325°F).

Whisk the butter, sugar and salt to a smooth paste.

Slowly add the cake flour and the cocoa powder.

Wrap the dough in plastic wrap and let it rest in the refrigerator for at least an hour.

Remove the dough from the wrap and roll to a thickness of 5 mm (¼ inch).

Cut the dough into 5 mm (¼ inch) cubes using a knife.

Place the cubes on a lined baking tray and bake in the preheated oven for 12 to 15 minutes.

Once cooked, remove the dough and allow it to cool.

Once cool, crumble the dough into small crumbs.

CHOCOLATE SIPHON

140 ml (5 fl oz) milk

25 gm (⅚ oz) heavy cream, 38%, fresh

¼ vanilla pod

60 gm (2 oz) dark chocolate, 66%

Place the vanilla pod (cut lengthways down the middle), milk and cream in a saucepan and over a medium heat, bring the liquid to the boil.

Place the chocolate in a bowl and pour the heated milk over the top.

Stir gently, then pass the liquid through a fine strainer.

Place the bowl with the chocolate in a bowl of ice water.

Pour the cooled liquid into a gas canister and charge with two gas cartridges.

Refrigerate until needed.

ASSEMBLY

4 pieces ready-made spring roll dough, 12 cm (4½ inch) squares

4 tsp caster sugar

4 ready-made chocolate tubes, 2 cm (1 inch) in diameter and 5 cm (2 inch) long

8 ready-made chocolate half-spheres

Preheat the oven to 200°C (400°F).

Line a baking tray with baking paper and place the spring roll dough pieces on the paper.

Sprinkle a teaspoon of caster sugar over each piece of spring roll dough.

Bake in the preheated oven for 1 to 2 minutes or until caramelised.

Fill the chocolate tubes with chocolate shortbread crumbs.

Fill the half-spheres with a layer of sponge cake, Chantilly cream and then the chocolate siphon.

Stick the filled half-spheres together.

Place the tubes onto plates, cover with a piece of spring roll dough.

Rest the sphere on top of the dough.

Pour the sour cherry sauce onto the side of the plate.

GARNISH

200 gm (7 oz) dark chocolate, 66%

Chop the chocolate and put it into a food processor. Process it until it turns into a fine powder.

Press the powder until it becomes soft and forms a ball. You can then work with it like modelling clay.

For the leaves, roll the chocolate to a 2 mm (²⁄₂₅ inch) thickness and cut out the shapes with a knife or a leaf-shaped cookie cutter.

For the stem, roll and shape the chocolate into a stick. Once it hardens, attach the leaves with tempered† chocolate and wait until the chocolate sets.

Attach to the top of the sphere with tempered† chocolate.

† See Kitchen Techniques

Makes: 6 servings
Preparation time: 40 minutes
Cooking time: 15 minutes
Refrigeration time: 30 minutes
Freezing time: 2–12 hours

Dark Chocolate Tart with Marinated Raspberries, Avocado Cream and Lemon Sorbet

DARK CHOCOLATE TART

110 gm (4 oz) dark chocolate, 64%

50 gm (1⅔ oz) butter

100 gm (3½ oz) sugar, granulated

25 gm (¾ oz) all-purpose flour

4 eggs

Melt the chocolate and the butter together in a bain-marie over medium heat.

In a separate bowl, whisk the eggs and the sugar together. Pour the egg mixture into the chocolate-butter mixture.

Add the flour.

Mix until it turns into a smooth batter.

Pour the batter into a clean bowl and refrigerate for at least 30 minutes before use.

Chef's tip: While waiting for the batter to become ready for use, prepare the lemon sorbet, *marinated raspberries, avocado cream and lemon crisp.*

Then place the chocolate batter in 6 non-stick moulds (5 to 6 cm/approximately 2 inch in diameter).

Bake for 8 minutes at 190°C (375°F).

LEMON SORBET

200 ml (7 fl oz) water

180 gm (6 oz) caster sugar

200 ml (7 fl oz) lemon juice

200 ml (7 fl oz) whole milk

Zest of 3 lemons

Place the water and sugar in a saucepan and bring to the boil over a medium to high heat. Make sure the sugar completely dissolves.

Once the sugar has dissolved remove the saucepan from the heat and allow the syrup to cool.

Mix the remaining ingredients into the syrup.

Pour the mixture into an ice cream machine and freeze according to the manufacturer's instructions.

If an ice cream maker is not available, place mixture in a clean bowl in the freezer and stir periodically as it freezes.

MARINATED RASPBERRIES

50 raspberries

5 ml (⅙ fl oz) best quality olive oil

½ vanilla pod

Juice of 2 oranges

Combine the raspberries, orange juice, olive oil, and the seeds of the vanilla pod in a bowl.

Gently mix the ingredients together.

Allow the raspberries to marinate for 15 minutes.

AVOCADO CREAM

1 ripe avocado

20 gm (⅔ oz) mango

20 gm (⅔ oz) caster sugar

5 ml (⅙ fl oz) water

Juice of ½ lemon

Place all the ingredients in a blender and blend until they are a fine purée.

Chill the purée.

LEMON CRISP

100 gm (3½ oz) brown sugar

100 gm (3½ oz) sugar, granulated

80 gm (3 oz) all-purpose flour

100 ml (3½ fl oz) juice of lemon

100 gm (3½ oz) butter

Preheat the oven to 90°C (375°F).

In a bowl, mix the brown and granulated sugars. Add the flour and then the lemon juice.

Melt the butter and combine with the rest of the ingredients.

Chill the batter in the refrigerator.

Line a 7½ cm (3 inch) by 15 cm (6 inch) rectangular baking tray with baking paper.

Chef's tip: Any size baking tray may be used, depending on the size and shape of the crisp required.

Once cooled, spread the batter thinly with a spatula onto the baking dish.

Bake for 5 minutes or until golden brown.

While still warm, shape the crisp with a rolling pin into the desired shape.

Allow to cool to room temperature.

ASSEMBLY

Arrange the marinated raspberries on the freshly baked chocolate tart.

Dress with avocado cream.

Arrange the lemon crisp on top, and serve with a scoop of lemon sorbet.

Makes: 4 servings
Preparation time: 30 minutes
Refrigeration time: 12 hours
Cooking time: 1 hour
Freezing time: 2–12 hours

Chocolate Crêpe Suzette with Grand Marnier Ice Cream

STRACCIATELLA GRAND MARNIER ICE CREAM

260 ml (9¾ fl oz) milk

60 ml (2¼ fl oz) heavy cream, 38%, fresh

80 gm (2¾ oz) caster sugar

55 gm (2 oz) egg yolks

55 gm (2 oz) Grand Marnier liqueur

30 gm (1 oz) dark chocolate, melted[†]

Place the milk and cream in a saucepan. Over a medium heat, bring the cream to the boil.

In a bowl, whisk the egg yolks with the sugar.

Pour about 3 tablespoons of the hot milk over the eggs and mix well. Pour the egg mixture into the saucepan.

Stir constantly and bring the liquid to a simmer, but ensure it does not boil.

Allow the custard to thicken to a consistency that will coat the back of a spoon (a finger drawn through the custard on the spoon should leave a clean path).

Once thickened, remove the custard from the heat and strain through a fine sieve into a clean bowl. Cool the bowl in an ice bath.

Once the mixture is cool, add the Grand Marnier and stir through.

Cover tightly with plastic wrap. Press wrap onto the surface of the mixture so a skin does not form.

Refrigerate overnight.

The next day, pour the mixture into an ice cream machine with the melted chocolate and freeze according to the manufacturer's instructions.

Store the ice cream covered in the freezer.

CHOCOLATE CRÊPES

50 ml (1⅔ fl oz) milk

110 gm (4 oz) dark chocolate, chopped

4 eggs

80 gm (2⅝ oz) caster sugar

60 gm (2 oz) plain flour, sifted

60 gm (2 oz) butter, melted

In a saucepan, bring the milk to the boil over a medium heat.

Place the chocolate in a bowl and pour the milk over the chocolate, stir until the chocolate is melted.

In a separate bowl mix the eggs, sugar and flour.

Slowly add the chocolate mix to the egg mixture, then slowly pour in the melted butter. Mix well.

Pour the mixture through a sieve into a clean bowl and allow to cool for 1 hour or until it reaches room temperature.

Heat a crêpe pan or 18 cm (17 inch) (base measurement) non-stick frying pan over medium heat.

Brush with melted butter to lightly grease.

Add 2 tablespoons of batter and tilt the pan in a circular motion, swirling the batter to cover the base. Cook for 2 minutes or until the edge begins to curl.

Turn and cook for a further 1–2 minutes or until light golden.

Transfer to a plate and cover with foil to keep warm. Repeat, in batches, with melted butter and the remaining batter.

SUZETTE BUTTER

Zest of 1 orange, finely grated

Zest of 1 lemon, finely grated

70 ml (2⅓ oz) Grand Marnier liqueur

250 gm (9 oz) caster sugar

100 ml (3⅓ fl oz) lemon juice

250 ml (8 fl oz) orange juice

70 gm (2⅓ oz) butter

4 oranges, in segments

Place the orange zest and lemon zest in a small bowl and cover with Grand Marnier. Allow to soak for 15 minutes.

Place sugar, juices, zests and Grand Marnier in a saucepan and warm over a low heat. Allow the sugar to dissolve.

Place the butter in the bowl of a free-standing electric mixer. Pour in the juice mixture and beat on a medium speed for 3 minutes. Set aside.

ASSEMBLY

Warm the crêpes and arrange them on the serving plates.

Pour the suzette butter over the crêpes.

Serve with a scoop of Grand Marnier ice cream and some orange segments.

† See Kitchen Techniques

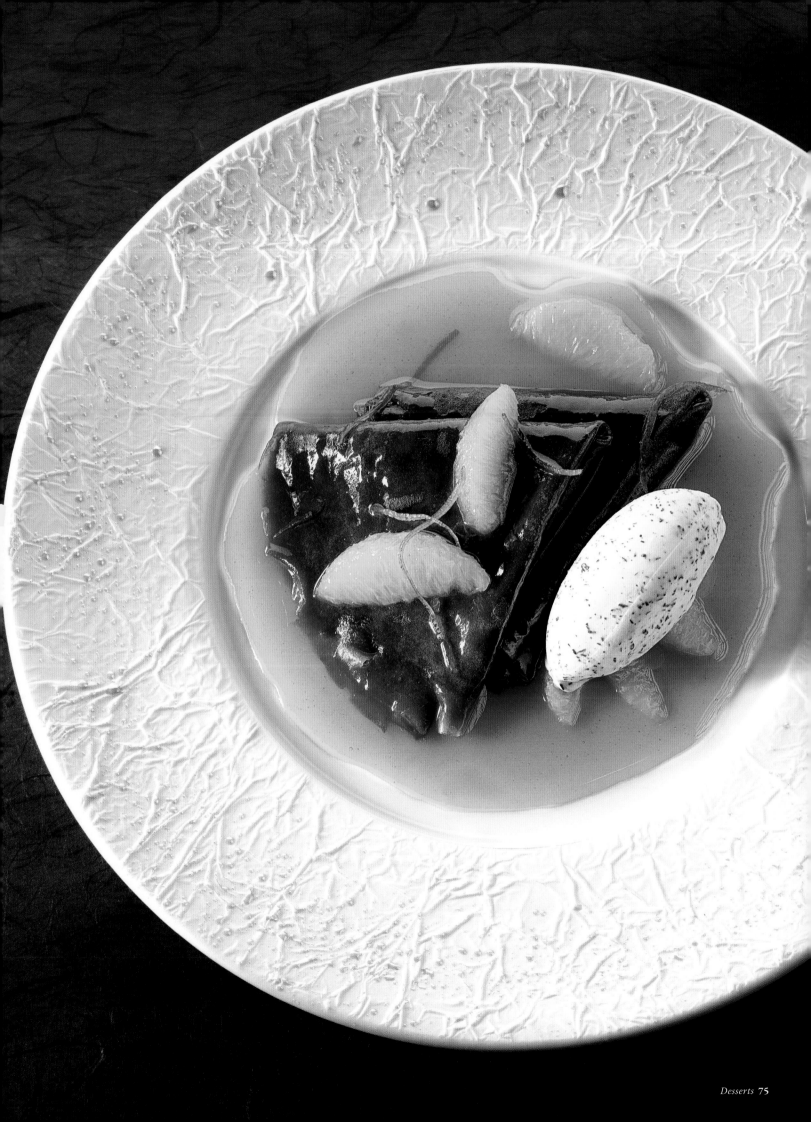

Makes: 8 servings
Preparation time: 1 hour
Cooking time: 1 hour
Freezing time: 12 hours

Warm Chocolate Tart with Raspberries

RASPBERRY CHOCOLATE ICE CREAM

750 ml (1⅓ pint) water

100 ml (3½ oz) heavy cream, 38%, fresh

110 gm (4 oz) caster sugar

57 gm (2 oz) trimoline

2 tsp raspberry liqueur

283 gm (10 oz) dark chocolate, 64%

198 gm (7 oz) raspberry pulp

Place the water, cream and sugar in a saucepan and bring to the boil over a medium heat.

Stir in the trimoline and raspberry liqueur. Reduce to a low heat.

Divide the chocolate into quarters.

Progressively stir in the chocolate, a quarter at a time.

Once the chocolate is melted, add the raspberry pulp.

Pour the mixture into an ice cream machine and freeze according to the manufacturer's instructions.

Store the ice cream covered in the freezer overnight.

CHOCOLATE CREAM

240 ml (8½ oz) heavy cream, 38%, fresh

170 gm (6 oz) raspberry purée

38 ml (1⅓ fl oz) glucose

378 gm (13⅓ oz) dark chocolate, 74%, melted†

110 gm (4 oz) butter

2 eggs

Place the cream, raspberries and glucose in a saucepan. Bring the liquid to the boil over a medium heat.

Place the melted chocolate and butter in a separate bowl.

Pour the cream mixture onto the chocolate and butter and stir well until combined.

In a separate bowl, beat the eggs until blended and then slowly add them to the chocolate mixture. Set aside.

TARTS

227 gm (8 oz) butter

453 gm (16 oz) plain flour

170 gm (6 oz) icing sugar

A pinch of salt

75 gm (2⅔ oz) almond powder

94 gm (3⅓ oz) eggs

¼ tsp vanilla powder

19 gm (⅔ oz) cocoa powder

Preheat the oven to 170°C (338°F).

Grease 8 shallow tart moulds, 7 cm (2⅘ inch) in diameter and 2 cm (⅘ inch) in height, with butter.

Sift the flour into a bowl and rub in the butter.

Stir in the sugar, almond powder, vanilla powder and cocoa powder.

Lightly whisk the eggs and add them to the dry ingredients. Mix together well to form a short dough.

Remove the dough from the bowl, wrap it in plastic wrap and chill in the refrigerator for 20 minutes.

Roll out the pastry to a thickness of 2 mm (²⁄₂₅ inch).

Use a circle cutter to cut the dough to fit the tart mould.

Bake blind (with weights) for 5 to 10 minutes or until firm. Remove the weights and return to the oven for a further 5 minutes.

Fill the tart shells with the chocolate cream and bake for approximately 6 to 8 minutes or until just set.

Do not overcook.

ASSEMBLY

Place the warm chocolate tart on the serving plate.

Serve with a quenelle of raspberry chocolate ice cream.

GARNISH

8 raspberries, fresh

8 chocolate tuiles‡

Decorate each plate with a raspberry and chocolate tuile.

† See Kitchen Techniques
‡ See Basic Recipes

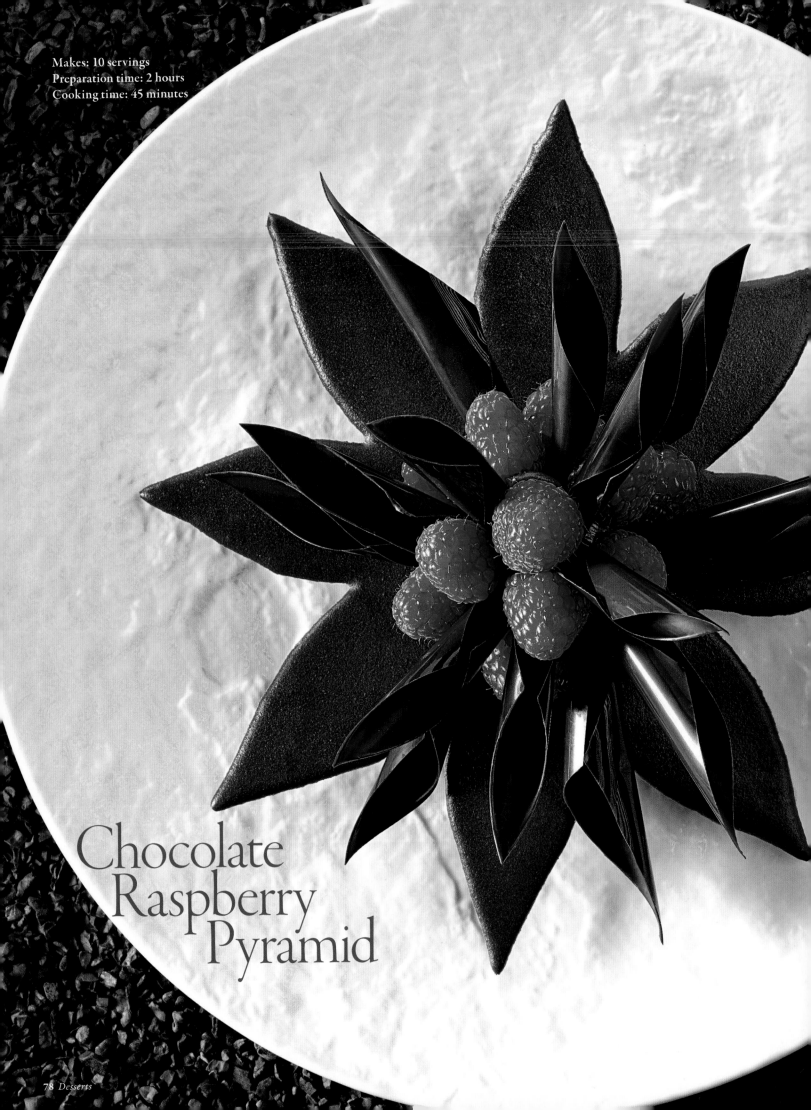

Makes: 10 servings
Preparation time: 2 hours
Cooking time: 45 minutes

Chocolate Raspberry Pyramid

CHOCOLATE TUILE

50 gm (1⅔ oz) icing sugar

55 gm (1⅞ oz) cake flour

12 gm (⅓ oz) cocoa powder

50 gm (1⅔ oz) egg whites

50 gm (1⅔ oz) heavy cream, 38%, fresh

Preheat the oven to 150°C (325°F).

Place all the dry ingredients in a bowl. Pour in the egg whites and cream and mix until well blended.

Keep the mixture covered in the refrigerator until set.

Make 8 tuiles per serving. For each tuile, cut out a diamond-shaped plastic template 4 cm (1⅗ inch) long by 2 cm (⅘ inch) wide and place it on a greased and floured baking tray.

Spread the tuile paste flat within the template, distributing it evenly.

Bake the tuile in the preheated oven for about 6 minutes.

Leave the tuile on the tray to cool, then transfer to an airtight container and keep in a dry place.

RASPBERRY MARMALADE

500 gm (1 lb 1½ oz) raspberries

140 gm (4 oz) caster sugar

2½ tsp pectin

In a small bowl, mix the pectin with half the sugar. Set aside.

With the remaining sugar, cook the raspberries in a small saucepan on medium heat for a few minutes until thick.

Add in the pectin-sugar mixture and stir until blended.

Let it simmer for a few more minutes.

Take the saucepan off the heat and let it cool down.

Store the marmalade in the refrigerator.

RASPBERRY JUICE

1 kg (2 lb 3 oz) raspberries, frozen

200 gm (7 oz) caster sugar

1 ltr (1⅗ pints) raspberry juice

2½ tsp pectin

15 gm (½ oz) caster sugar

Place the frozen raspberries and 200 gm (7 oz) of sugar together in a sealed plastic bag.

In a pot of simmering water, immerse the sealed plastic bag with the raspberries and cook until the raspberries have completely broken down.

Strain the cooked raspberries with a coffee filter to produce a clear juice.

In a small saucepan, bring the juice to the boil then add the pectin and 15 gm (½ oz) of sugar.

Cook the juice on a low heat and continue stirring until the mixture thickens.

Take the saucepan off the heat, set aside, and let the juice cool.

CHOCOLATE SHORTBREAD

200 gm (7 oz) butter, softened

200 gm (7 oz) caster sugar

180 gm (6 oz) almond powder

200 gm (7 oz) cake flour

8 gm (¼ oz) baking powder

40 gm (1⅓ oz) cocoa powder

A pinch of salt

Preheat the oven to 150°C (300°F).

Combine all the dry ingredients in a mixing bowl, rub in the butter and mix to a soft dough.

Knead lightly on a floured surface until smooth.

Roll out the dough to a 3 mm (⅒ inch) thickness. Cut out 10 circles, 8 cm (3¼ inch) in diameter. Place on a parchment-lined baking tray and bake in the preheated oven for 10 minutes.

Let it cool and set aside.

CHOCOLATE RASPBERRY CREAM

250 gm (9 oz) raspberry purée

250 gm (9 oz) heavy cream, 38%, fresh

200 gm (7 oz) egg yolks

50 gm (1⅓ oz) caster sugar

220 gm (7⅔ oz) dark chocolate, 66%

Place the cream and raspberry sauce in a saucepan and over a low heat, bring them to the boil.

In a mixing bowl, whisk the egg yolks and sugar until light in colour.

Pour the hot raspberry cream into the egg yolk mixture while whisking rapidly.

Place the mixing bowl over a pot of simmering water on low heat, stirring continuously with a rubber spatula until the mixture thickens slightly, coating the rubber spatula.

Take the bowl off the double boiler and add the dark chocolate.

Stir the mixture until the chocolate has completely melted.

Portion the cream into 10 ring moulds, each 8 cm (3¼ inch) in diameter, and fill up to 6 mm (¼ inch) high.

Let the mixture cool, then refrigerate.

FOLDED CHOCOLATE PETALS

500 gm (1 lb 1½ oz) dark chocolate, 66%, melted†, tempered†

Spread a thin layer of chocolate on a sheet of plastic film. When the chocolate is nearly set, cut 4 cm (1¾ inch) squares, but not cutting through the plastic film. Cut approximately 16 squares per serving.

Roll the plastic film to create the fold. Tape the end of the plastic film to hold its shape.

Once the chocolate petals are completely set, unroll the plastic carefully.

ASSEMBLY

500 gm (1 lb 1½ oz) raspberries, fresh

For each serving, arrange the 8 diamond-shaped tuiles on a plate and place a piece of chocolate shortbread on top. Pipe a small amount of raspberry marmalade between them to keep them in place.

Unmould a chocolate raspberry cream and place on top of the chocolate shortbread.

Spread a teaspoon of raspberry marmalade on the cream.

Arrange the fresh raspberries on the cream, forming a pyramid shape.

GARNISH

Arrange the folded chocolate petals among the raspberries.

Serve with the raspberry juice on the side.

† See Kitchen Techniques

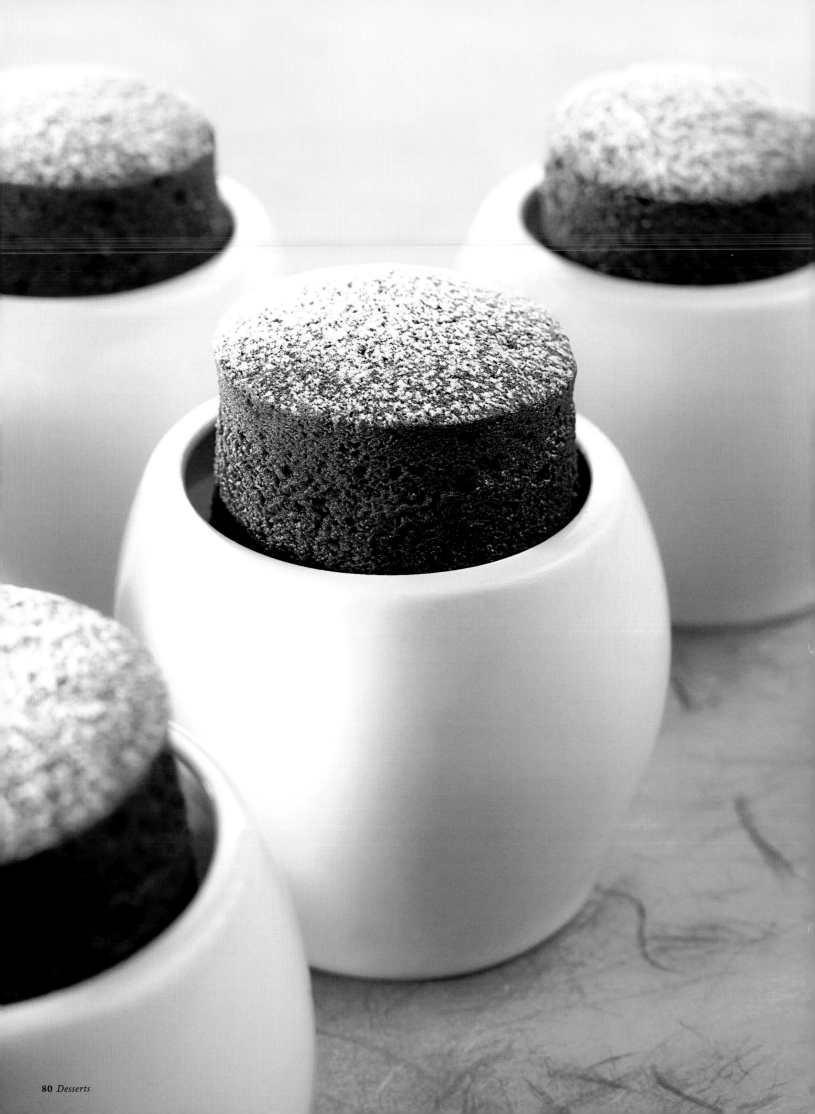

Choco-Banana Chestnut Pudding

Makes: 20 servings
Preparation time: 1 hour
Cooking time: 40 minutes
Refrigeration time: 1 hour

CHOCOLATE PUDDING

200 ml (7 fl oz) milk

30 gm (1 oz) sugar, granulated

25 gm (⅘ oz) cornstarch

20 gm (⅔ oz) cocoa powder

6 egg yolks

115 gm (6⅙ oz) dark chocolate, 75%, melted†

6 egg whites, whipped

100 gm (3½ oz) sugar, granulated

Preheat the oven to 140°C (284°F).

In a saucepan, bring the milk to a simmer.

Place 30 gm (1 oz) of the sugar, cornstarch and cocoa powder in the bowl of a free-standing electric mixer and mix for 5 minutes on medium speed.

Add the simmered milk to the mixing bowl. Blend for 1 minute.

Slowly add the egg yolks and blend.

Add the chocolate to the mixture and blend until combined.

Continue blending and slowly add the whipped egg whites. Once the mixture is well combined, set it aside.

Prepare a set of 20 cocottes, internal diameter 5.5 cm (2½ inch) and height 5.5 cm (2½ inch) each, by brushing melted butter on the internal surface.

Spoon the mixture into the cocottes, only filling half the cocotte.

Place the cocottes in a baking dish and fill the baking dish with enough water to come halfway up the exterior of the cocotte.

Bake in the preheated oven for 13 minutes.

CLASSIC CRÈME BRÛLÉE

200 gm (7 oz) heavy cream, 38%, fresh

250 ml (8 fl oz) milk

1 vanilla pod

150 gm (5¼ oz) sugar, granulated

140 gm (5 oz) egg yolks

20 pieces marron glacé

Preheat the oven to 160°C (320°F).

Place the cream, milk and vanilla pod in a saucepan over a low heat. Allow the cream to simmer for 3 minutes.

Add half the amount of granulated sugar and stir.

Remove the saucepan from the heat and allow it to stand for 20 minutes, or until it is room temperature.

In a separate bowl, mix the remaining granulated sugar with the egg yolks. Stir until well blended.

Return the milk mixture to a low heat and gradually stir in the blended egg yolk. Allow the custard to thicken enough to coat the back of a spoon. Remove the vanilla pod from the custard.

Take a new set of 20 cocottes, internal diameter 5.5 cm (2½ inch) and height 5.5 cm (2½ inch) each.

Place a marron glacé at the bottom of each cocotte, then pour the mixture in over the top. Only fill half the cocotte.

Bake in the preheated oven for 10 minutes.

Remove the cocottes from the oven and place them in a baking dish. Fill the baking dish with enough water to come halfway up the exterior of the cocotte.

Return to the oven and bake for a further 20 minutes.

Remove the cocottes from the baking dish and refrigerate for 1 hour or until they are cold.

ASSEMBLY

4 bananas

20 gm (⅔ oz) heavy whipping cream, 38%, fresh

Slice the banana into slices approximately 1.5 cm (¾ inch) in width.

Place 4 slices of banana on top of the crème brûlée.

Whip the cream and spoon on top of the banana.

Remove the chocolate pudding from its cocotte and place on top of the whipped cream.

GARNISH

Decorate with icing sugar.

† See Kitchen Techniques

Sugar-Free
Chocolate Panna Cotta

PANNA COTTA

3 sheets gelatine, bronze

200 ml (7 oz) milk

200 ml (7 oz) light cream, 18%, fresh

44 gm (1½ oz) sugar substitute

1 vanilla pod

2 tsp cocoa powder

20 gm (⅔ oz) sugar-free chocolate, melted[†]

Soften the gelatine in cold water and set aside.

Place the milk, cream, sugar substitute, and vanilla pod (sliced lengthways down the middle) in a saucepan and bring to the boil over a medium heat.

Whisk in the cocoa powder and melted chocolate.

Squeeze out excess water from the gelatine and add to chocolate mixture.

Remove the vanilla pod. Pour the chocolate mixture into 4 panna cotta glasses and refrigerate overnight.

CHOCOLATE CRUMBLE

100 gm (3½ oz) plain flour

100 gm (3½ oz) almond flour (or plain flour for a nut-free recipe)

20 gm (⅔ oz) cocoa powder

95 gm (3⅓ oz) sugar substitute

1 tsp sea salt

170 gm (6 oz) butter

Preheat the oven to 140°C (284°F).

Place all the dry ingredients in the bowl of a free-standing electric mixer and beat on a low speed for 5 minutes.

Add the butter to the mixing bowl and continue to beat on a slow speed until the mixture has the consistency of a crumble.

Place the bowl in the refrigerator and cool the mixture for 1 hour.

Spread the mixture on a baking sheet lined with baking paper, and bake in the preheated oven for 15 minutes, tossing the mixture every 5 minutes.

Let the crumble cool in a dry place.

ASSEMBLY

Once the crumble is cool, spoon a layer of the mixture, approximately 1.5 cm (¾ inch) thick, over the top of the panna cotta in each of the 4 glasses.

GARNISH

Garnish each serving with orange segments, lime zest and chocolate sticks[†].

† See Kitchen Techniques

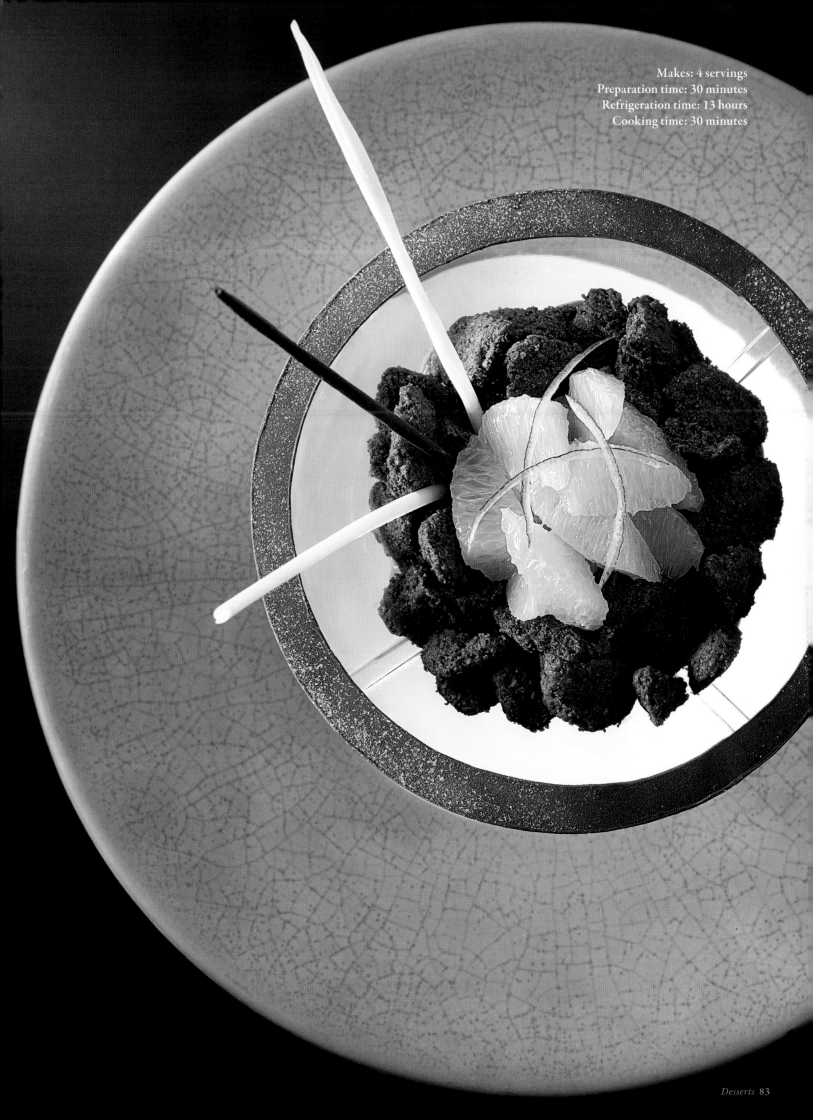

Makes: 4 servings
Preparation time: 30 minutes
Refrigeration time: 13 hours
Cooking time: 30 minutes

Crunchy Orange Praline Chocolate

Makes: 10 servings
Preparation time: 5 hours
Cooking time: 30 minutes

SUGAR DOUGH

600 gm (1⅓ lb) butter

380 gm (12 oz) icing sugar

120 gm (4½ oz) almond powder

3 tsp salt

2½ tsp vanilla essence

225 gm (8 oz) eggs

1 kg (2 lbs 3 oz) plain flour

Place the butter and icing sugar in the bowl of a free-standing electric mixer and, using the paddle attachment, beat until creamed.

Add the almond powder, salt and vanilla essence and continue to beat.

Add the eggs one by one. Ensure each egg is incorporated before adding the next one.

Add the flour and beat until combined.

Store in the refrigerator until needed.

CHOCOLATE SABLÉ

160 gm (5⅔ oz) milk chocolate, 43%

200 gm (7 oz) hazelnut praline†

40 gm (1⅓ oz) hazelnut paste

800 gm (1⅔ lb) sugar dough

1½ tsp salt

Preheat the oven to 160°C (325°F).

Melt† the chocolate and add the hazelnut praline and paste.

Place the sugar dough in the bowl of a free-standing electric mixer.

Use the paddle attachment to mix in the chocolate, hazelnut praline and paste mix.

Mix until a crumble forms.

Line a tray, 40 cm (15⅘ inch) by 60 cm (23 ⅗ inch), with baking paper and press the dough onto the tray to a ½ cm (¼ inch) thickness.

Bake in the preheated oven for 20 minutes.

Allow to cool on a cooling tray.

Once cool, cut the sablé into 6 cm (2½ inch) squares.

CHOCOLATE CRÉMEUX

1 ltr (1¾ pints) milk

350 gm (11 oz) egg yolks

100 gm (3½ oz) caster sugar

4 sheets gelatine

400 gm (14 oz) milk chocolate, 43%

250 gm (9 oz) dark chocolate, 66%

200 gm (7 oz) hazelnut paste

Make an anglaise sauce† with the milk, egg yolks and sugar.

Add the chocolate and place the mixture in a food processor.

Add the hazelnut paste little by little, processing the mixture after each addition.

Spoon the mixture into a piping bag and set aside until needed.

MIRLITON BISCUIT

220 gm (8 oz) eggs

90 gm (3 oz) egg yolks

180 gm (6 oz) almond powder

180 gm (6 oz) caster sugar

16 gm (½ oz) honey

16 gm (½ oz) cornflour

1 vanilla pod

Zest of 1 lemon

Zest of 2 oranges

Preheat the oven to 160°C (325°F).

Place all the ingredients in the bowl of a free-standing electric mixer and beat on a medium speed for 20 minutes.

Line a tray, 40 cm (15⅘ inch) by 60 cm (23⅗ inch), with baking paper and press the mixture onto the tray to a ½ cm (¼ inch) thickness.

Bake in the preheated oven for 10 minutes.

Allow to cool on a cooling tray.

Once cool, cut the biscuit into 6 cm (2½ inch) squares.

ORANGE MARMALADE

1.5 kg (3 lb 4½ oz) orange segments

225 gm (8 oz) caster sugar

240 ml (8½ oz) lemon juice

450 gm (16 oz) orange peel, finely sliced

15 gm (½ oz) pectin

30 gm (1 oz) caster sugar

Place the orange segments, sugar, lemon juice and orange peel slices in a large pot.

Cover with the lid and boil the liquid over a medium heat until the orange skin becomes transparent.

Remove the lid and let the liquid reduce until the marmalade darkens in colour.

Add the sugar and pectin. Keep boiling for 2 more minutes.

Allow to cool and store in the refrigerator.

MILK CHOCOLATE SQUARES

500 gm (1 lb 1½ oz) milk chocolate, 43%

Melt† the chocolate.

Spread the chocolate on a non-stick baking mat, and allow it to harden slightly.

Cut it into 7 cm (3 inch) squares.

ASSEMBLY

Place a square of milk chocolate on the plate.

Place a square of the chocolate sablé on the milk chocolate square and then another milk chocolate square on top.

Place the mirliton biscuit on top of the chocolate.

Pipe the chocolate crémeux in a square shape, 1 cm (½ inch) from the edge of the biscuit.

Place a spoonful of orange marmalade on the crémeux and top with another milk chocolate square.

GARNISH

Semi-dry orange

100 gm (3½ oz) orange peel

250 gm (9 oz) icing sugar

Preheat the oven to 90°C (194°F).

Cut the orange peel brunoise (small square diced pieces) and lay them on a baking tray lined with baking paper.

Dust with icing sugar.

Dry them in the preheated oven for approximately 30 minutes, or until dry.

Orange juice candy

400 ml (13 fl oz) lemon juice

150 gm (5⅓ oz) caster sugar

Zest of 2 oranges

Blanch the orange zest in boiling water.

Place the lemon juice and sugar in a saucepan and over a medium heat, bring to the boil. Stir to ensure the sugar is dissolved.

Add the orange zest to the saucepan.

Allow the liquid to simmer until it becomes a thick syrup.

Place a semi-dry orange brunoise on top of the plated dessert.

Drizzle the orange juice candy around the plate before serving.

† See Kitchen Techniques
‡ See Basic Recipes

GANACHE

115 ml (3¾ fl oz) milk

75 ml (2¼ fl oz) heavy cream, 38%, fresh

230 gm (8 oz) dark chocolate, 56%

42 gm (1½ oz) trimoline

45 gm (1½ oz) butter, unsalted

In a saucepan, simmer the milk and heavy cream.

Gradually add in the chocolate and stir using a flexible spatula until it melts.

Add in the butter and trimoline.

Remove from heat and blend the mixture with an immersion blender so that the mixture is smooth and perfectly emulsified.

Makes: 4 servings
Preparation time: 1 hour
Cooking time: 15 hour

CHOCOLATE GIANDUJA PAILLETÉ

24 gm (6/8 oz) milk chocolate, 40%

2½ tsp cocoa powder

150 gm (5¼ oz) gianduja pailleté

Place the milk chocolate and cocoa powder in a double boiler and melt them together over a low heat.

Add the gianduja pailleté and stir well.

CHOCOLATE SABLÉ

180 gm (6⅓ oz) cultured butter, unsalted

180 gm (6⅓ oz) sugar, granulated

18 gm (½ oz) egg yolk

215 gm (7½ oz) plain flour

70 gm (2⅓ oz) cocoa powder

Knead the butter and granulated sugar together.

Add the egg yolk and then add the flour and cocoa powder.

Cover with plastic wrap and press to 3 mm (¹⁄₁₀ inch).

Arrange in 4 circular moulds, each 8 cm (3⅓ inch) in diameter and 2 cm (⅘ inch) in height. Bake for 20 minutes in an oven at 160–170°C (320–338°F).

BISCUIT

300 gm (10 oz) egg whites

315 gm (10½ oz) sugar, granulated

200 gm (7 oz) egg yolks

90 gm (3 oz) cocoa powder

Preheat oven to 190°C (374°F).

Place the egg whites and granulated sugar in the bowl of a free-standing electric mixer. Using the whisk attachment beat the ingredients together until they reach meringue consistency.

Chocolate Tart

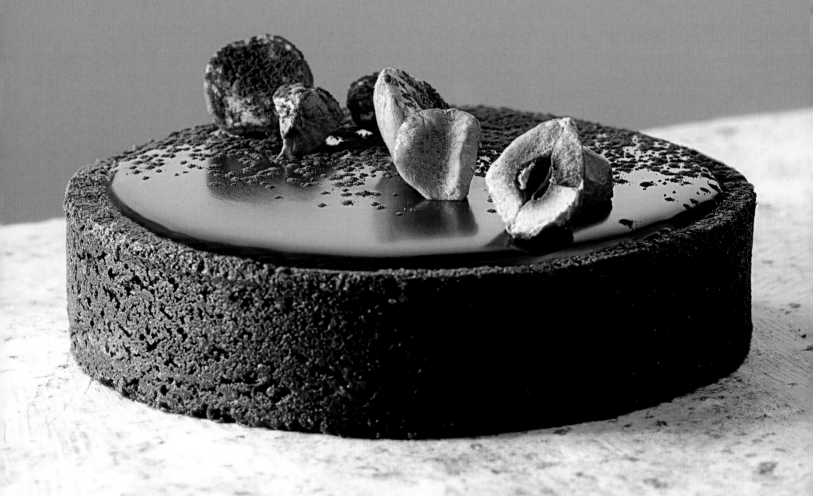

In a separate bowl, beat the egg yolks. Pour the egg yolks and sifted cocoa powder into the meringue. Stir very gently until just blended.

Grease 4 tart moulds, 8 cm (3½ inch) in diameter, and place the mixture in the moulds.

Bake in the oven for 15 minutes.

Once cooked, allow to cool to room temperature on a cooling tray.

ORANGE CONFIT

100 gm (3½ oz) orange segments
10 ml (⅓ fl oz) Grand Marnier

Place the orange segments in a bowl, cover with Grand Marnier and place the bowl in the refrigerator overnight.

CHANTILLY CREAM

200 gm (7 oz) heavy cream, 47%, fresh
16 gm (½ oz) sugar, granulated

Use an electric mixer to combine the cream and sugar. Whip until soft peaks form.

ASSEMBLY

Pour the chocolate giandujas pailleté into the baked chocolate sablé.

Sprinkle with orange confit and place the biscuit on top of it.

Fill up the mould with the ganache. Refrigerate until ready to serve.

GARNISH

1 mint leaf
¼ tsp orange zest
10 gm (⅔ oz) hazelnuts, chopped
¼ tsp cocoa powder

Garnish the tart with hazelnuts and a sprinkling of cocoa powder.

Serve with a quenelle of Chantilly cream, garnished with a mint leaf and some orange zest.

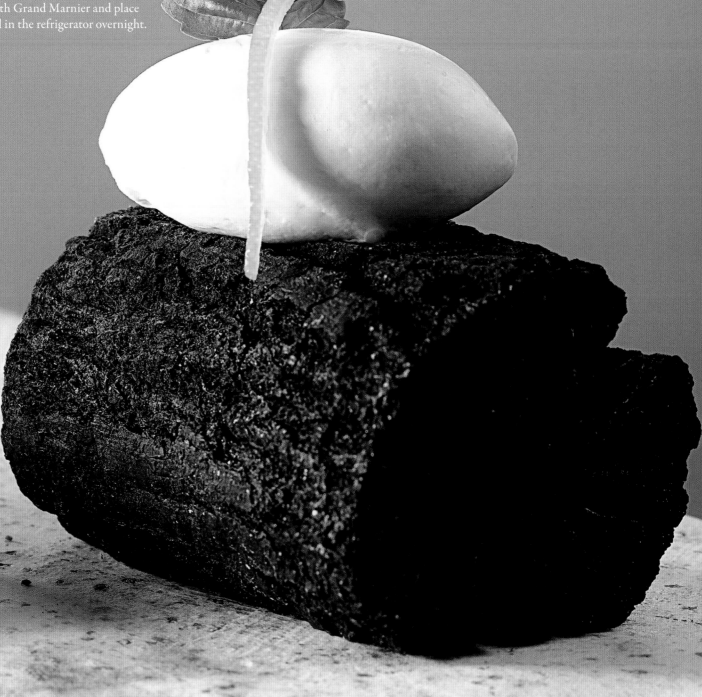

ICE CREAM, SORBET AND PARFAIT SUNDAES

The Italians call it *la dolce vita*, the sweet life. And as inventors of the world's favourite dessert, who could argue with them.

Chocolate with ice cream is a near-perfect combination of taste and texture. From creamy classics to melt-in-the-mouth sorbet and granitas, The Peninsula's chefs have chosen recipes that showcase the diversity of chocolate as an ice-cold flavour.

Twenty years ago it may not have been possible to make these recipes at home. Modern ice cream makers, however, make aerating, churning and freezing easy. It is worth investing in one, because these luxuriously light and fluffy treats will appeal all year round.

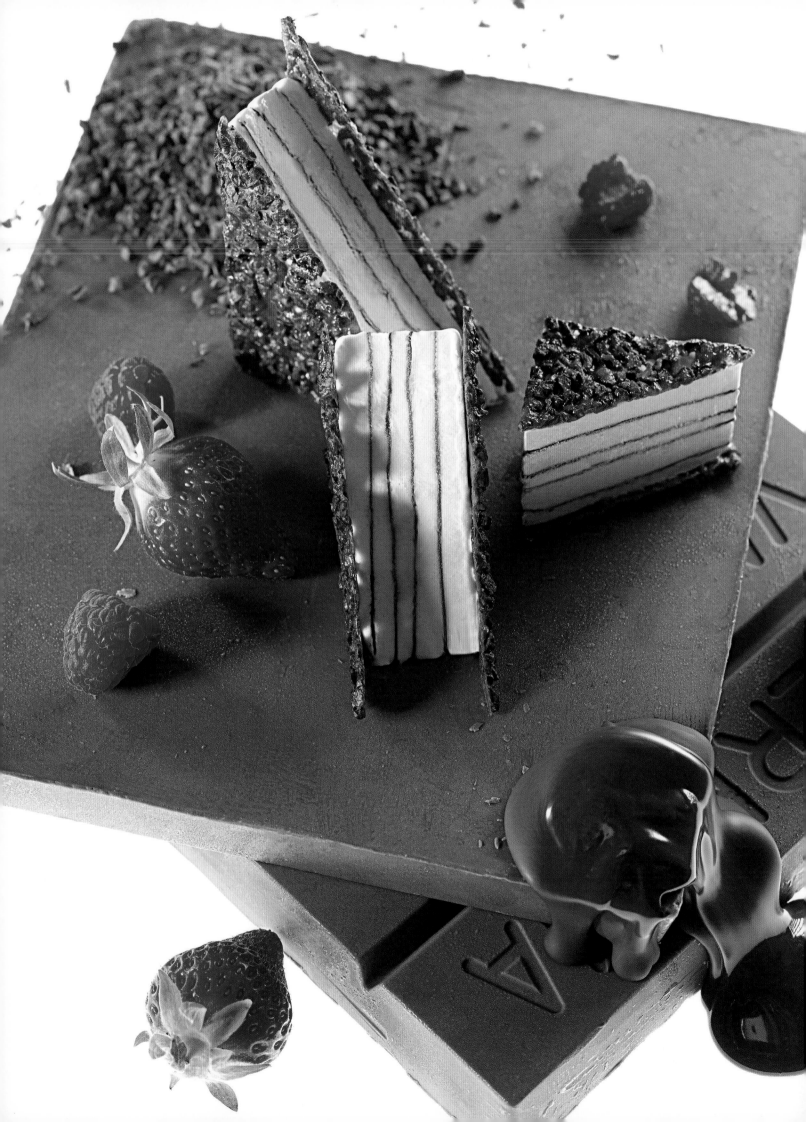

Soy'anilla and Chocolate Ice Cream Sandwich

Makes: 4 servings
Preparation time:
30 minutes
Refrigeration time:
24 hours
Cooking time:
20 minutes
Freezing time:
3–12 hours

LAYERED ICE CREAM

435 ml (14 fl oz) soya milk

1 vanilla pod

90 gm (3 oz) egg yolks

100 gm (3½ oz) brown sugar

1 tsp stabiliser

340 gm (12 oz) dark chocolate, 70.4%

67 gm (2½ oz) cocoa butter

Slice the vanilla pod in half.

Place the milk and vanilla pod in a saucepan and, over a medium heat, bring the liquid to the boil.

Remove the pan from the heat, cover it with a lid and let it sit and infuse for 15 minutes.

Add the stabiliser to the liquid and bring to the boil again.

In a separate bowl, whisk the egg yolks and the brown sugar and pour into the hot milk.

Allow the mixture to heat to 83°C (181°F).

Strain the mixture and allow it to cool to room temperature.

Rest the mixture for 24 hours in a refrigerator.

The next day, pour the liquid into an ice cream machine and freeze according to the manufacturer's instructions.

Spread a quarter of the quantity of the ice cream in a rectangular mould, 58 cm (22⅕ inch) long by 10 cm (4 inch) wide by 4 cm (1⅗ inch) high.

Melt† the chocolate.

Spread a third of the warm chocolate over the ice cream with a brush.

Repeat these steps, thrice for the ice cream and twice for the chocolate, to create a layered ice cream dessert with 4 layers of ice cream and 3 layers of chocolate.

Store in the freezer for 1 hour.

When ready to serve, remove the ice cream from mould. Slide a hot palette knife along the inside edge of the mould to help remove the ice cream.

Cut the ice cream into triangular wedges.

Keep in the freezer until ready to serve.

CRUNCHY COCOA NIB TRIANGLES

10 ml (¼ fl oz) milk, low fat

20 gm (⅔ oz) margarine

8 ml (⅕ fl oz) glucose

23 gm (¾ oz) caster sugar

½ tsp pectin NH

23 gm (¾ oz) cocoa nibs

Place the milk, glucose and margarine in a saucepan and bring to the boil.

Stir in the sugar and pectin and cook to 106°C (222.8°F).

Remove the saucepan from the heat and stir in the cocoa nibs until combined.

Pour the mixture between 2 sheets of baking paper.

Gently roll the mixture to a 2 mm (²⁄₂₅ inch) thickness and then place it in the freezer.

Preheat oven to 170°C (375°F).

Once the mixture is frozen, remove it from the freezer and bake it in the preheated oven for 12 minutes.

Cut into triangular pieces, the same size as the layered ice cream.

ASSEMBLY

Place each layered ice cream wedge between 2 crunchy cocoa nib triangles to form the ice cream sandwich.

GARNISH

15 gm (½ oz) raspberries

8 gm (⅕ oz) strawberries

20 ml (⅗ fl oz) chocolate sauce

Pour the chocolate sauce around the plated ice cream sandwich.

Garnish with fresh strawberries and raspberries.

† See Kitchen Techniques

Makes: 4 servings
Preparation time: 1 hour
Cooking time: 20 minutes
Freezing time: 2–12 hours

Pure Cocoa Sorbet

110 ml (3½ fl oz) water
20 gm (⅔ oz) brown sugar
30 gm (1 oz) honey, organic
15 gm (½ oz) cocoa powder, unsweetened
40 gm (1½ oz) chocolate, 70.4%

METHOD

Place the water, sugar and honey in a saucepan and bring to the boil.

Add the cocoa powder and chocolate to the liquid. Bring to the boil.

Allow the liquid to cool to room temperature.

Pour the liquid into an ice cream machine and freeze according to the manufacturer's instructions.

GARNISH

1 sprig mint, fresh
1 white chocolate curl†
500 gm (17⅔ oz) chocolate pearls, store-bought

Garnish each serving with fresh mint, a chocolate curl and chocolate pearls.

† See Kitchen Techniques

Dark Chocolate, Chilli and Pistachio Ice Cream

200 gm (7 oz) caster sugar

12 large egg yolks

1.25 ltr (2 pints) half-and-half (may be substituted with equal portions of cream and full cream milk)

1 gm (¼ tsp) chilli powder

45 ml (1½ fl oz) pistachio oil

100 gm (3½ oz) pistachios, toasted, chopped

150 gm (5⅓ oz) dark chocolate, 85%, chopped, melted[†]

Place half the sugar in a food processor and pulse until it becomes a coarse meal.

Whisk the egg yolks and remaining sugar in a large mixing bowl until the mixture is pale yellow and a ribbon trail forms when the whisk is lifted.

Place the half-and-half in a large saucepan and bring to the boil over a medium heat.

Remove the saucepan from the heat and pour the half-and-half into the egg yolk mixture. Whisk continuously.

Pour the combined mixture back into the saucepan and return to a low heat.

Stir the mixture constantly until a custard forms. The custard should thicken enough to coat the back of a spoon or until it reaches a temperature of 165°C (329°F).

Strain the custard through a fine sieve into a large bowl. Whisk in the chilli powder, pistachios and oil.

Allow the custard to cool slightly, then cover tightly with plastic wrap. Press wrap onto surface of custard so a film does not form. Refrigerate for 3 hours.

Pour the mixture into an ice cream machine. Add chocolate. Freeze according to the manufacturer's instructions.

GARNISH

Transfer to a serving bowl and garnish with pink peppercorns, sugar-coated pistachios, 2 chocolate sticks[†] and a chocolate leaf.

† See Kitchen Techniques

Makes: 6 servings
Preparation time: 25 minutes
Cooking time: 20 minutes
Refrigeration time : 3 hours
Freezing time: 2–12 hours

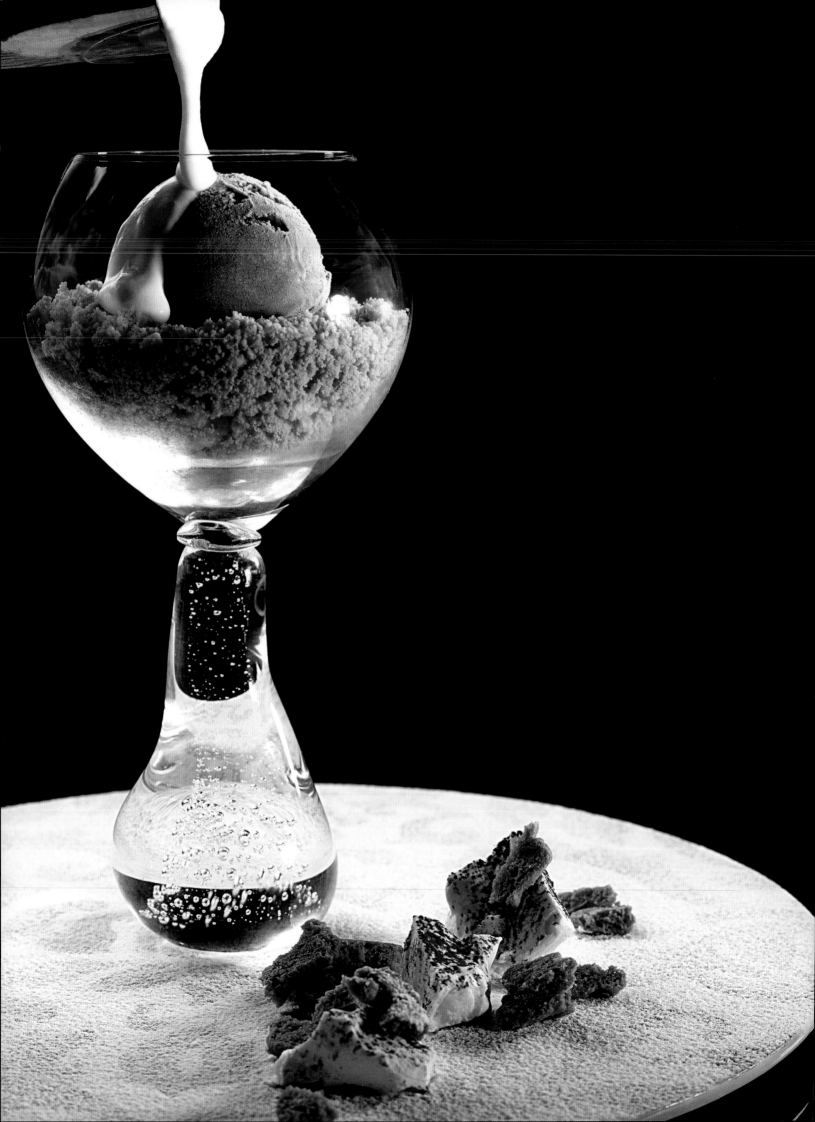

Makes: 15 servings
Preparation time: 1 hour
Refrigeration time: 12 hours
Cooking time: 45 minutes
Freezing time: 2–12 hours

Chocolate Cheesecake Ice Cream

CHOCOLATE CHEESECAKE ICE CREAM

850 ml (29 fl oz) milk

90 gm (3¹⁄₁₀ oz) cocoa powder

9 egg yolks

375 gm (13⅓ oz) caster sugar

750 gm (26½ oz) cream cheese, softened

Place the milk in a saucepan and bring it to the boil over medium heat. Add the cocoa powder and stir. Set aside.

Whisk the egg yolks and the sugar in a mixing bowl until light and fluffy. Gradually pour the hot milk into the yolk mixture. Stir quickly.

Place the mixing bowl over a pot of simmering water over low heat (be careful not to let the mixing bowl touch the water) and stir the liquid continuously with a rubber spatula until the mixture is thick enough to coat the spatula.

Add the cream cheese and stir until there are no pieces of cheese left in the mixture.

Set aside and let the liquid cool to room temperature.

Cover tightly with plastic wrap. Press wrap onto the surface of the mixture so a film does not form.

Refrigerate overnight.

The next day, pour the mixture into an ice cream machine and freeze according to the manufacturer's instructions.

Place the ice cream in a covered container. Store in the freezer.

PEANUT BUTTER STREUSEL

330 gm (11⅗ oz) butter, softened

50 gm (1⅘ oz) creamy peanut butter

500 gm (17⅗ oz) all-purpose flour, sifted

150 gm (5⅓ oz) icing sugar

Preheat the oven to 175°C (350°F).

Place the butter and peanut butter together in a small mixing bowl and stir until completely blended.

Add the flour and icing sugar, and mix until it forms a coarse, crumbly dough.

Use your fingertips to break up the dough into small pieces (no smaller than a pea) and place on a small baking dish lined with baking paper.

Bake in the preheated oven until the streusel starts to brown lightly at the edges. Set aside to cool.

CREAM CHEESE SAUCE

500 ml (17 fl oz) heavy cream, 38%, fresh

200 gm (7 oz) cream cheese

Salt and ground white pepper to taste

Place the cream and cream cheese in a saucepan and heat over low heat. Stir until the cheese has melted.

Add salt and pepper and stir.

Set the sauce aside to cool to room temperature, then refrigerate.

ASSEMBLY

Crumble the peanut butter streusel and place a thick layer on the bottom of a glass.

Scoop a medium-sized ball of ice cream on top.

Top with cold cream cheese sauce and serve immediately.

Makes: 15 servings
Preparation time: 1 hour
Cooking time: 45 minutes
Freezing time: 2–12 hours

Chocolate Coffee Cup

CHOCOLATE ICE CREAM

1 ltr (1⅗ pints) milk

200 gm (7 oz) caster sugar

100 gm (3½ oz) cocoa powder

200 gm (7 oz) dark chocolate, 61%, melted†

Place the milk and sugar in a saucepan and bring to the boil.

Stir in the cocoa powder and melted dark chocolate. Continue to stir until the mixture is smooth.

Strain the mixture through a sieve.

Pour the mixture into an ice cream machine and freeze according to the manufacturer's instructions.

COFFEE GRANITA

650 ml (22 fl oz) espresso coffee

350 gm (12⅓ oz) caster sugar

350 ml (12 fl oz) water

Make a simple sugar syrup by placing the sugar and water in a saucepan. Bring the liquid to the boil to dissolve the sugar.

Reduce the liquid to approximately 325 ml (11⅖ fl oz). Allow the sugar syrup to cool.

Combine the espresso and the sugar syrup in a shallow metal baking dish.

Place in the freezer to cool.

When partially frozen, stir the mixture with a fork and return to the freezer.

Repeat stirring every half hour until coarse ice crystals are formed.

Keep stored covered in the freezer until ready to use.

COFFEE-WHIPPED CREAM

20 ml (⅗ fl oz) heavy whipping cream, 38%, fresh

280 gm (100 oz) instant coffee powder

10 ml (⅓ fl oz) whipping cream

Dissolve the instant coffee powder into 20 ml (⅗ fl oz) of whipping cream.

Whip the coffee mixture with the remaining cream until soft peaks form. Keep chilled.

ASSEMBLY

Fill a martini glass halfway with the chocolate ice cream.

Cover with two heaped tablespoons of the coffee granita.

Top with the coffee-whipped cream.

GARNISH

Decorate with a store-bought chocolate square sprayed with edible gold spray, a chocolate curl† and a dusting of cocoa powder. Serve immediately.

† See Kitchen Techniques

Makes: 4 servings
Preparation time: 60 minutes
Freezing time: 2–12 hours

Barolo and White Chocolate Semifreddo

FIRST LAYER

50 ml (1¾ fl oz) Barolo (red Italian wine)

8 mm (⅓ inch)cinnamon stick

⅓ piece orange skin, cut into thick strips

⅓ piece lemon skin, cut into thick strips

43 gm (1½ oz) caster sugar

30 gm (1 oz) egg yolk

10 gm (⅓ oz) mascarpone

100 gm (3½ oz) heavy cream, 38%, fresh, softly whipped

Lightly oil a rectangular loaf tin, 25 cm (10 inch) long by 8 cm (3 inch) wide by 10 cm (4 inch) high, and line it with thick baking paper. Set aside.

Place the wine, cinnamon, orange and lemon skins in a saucepan and, over a medium heat, bring to the boil. Reduce the liquid to half.

Slowly pour in the sugar and stir well.

Once the sugar has dissolved, remove the pan from the heat and set aside.

To finish the sabayon, place the egg yolk in a separate bowl. Pour the wine into the bowl and use an electric beater on low speed to gently beat. Place the bowl over a saucepan of simmering water, making sure the bowl doesn't touch the water.

Whisk the mixture constantly until it thickens.

Allow the sabayon to cool to room temperature.

Mix in the mascarpone and soft cream.

Pour mixture into the pre-prepared mould and freeze for 6 hours.

Prepare the second layer after the first layer has frozen.

SECOND LAYER

30 gm (1 oz) egg yolk

15 ml (¼ fl oz) water

35 gm (1⅙ oz) caster sugar

25 gm (⅞ oz) white chocolate

15 gm (½ oz) mascarpone

80 gm (3 oz) heavy cream, 38%, fresh, softly whipped

Place the egg yolk, water and sugar in a bowl and whisk until combined.

Place the bowl over a saucepan of simmering water, making sure the bowl doesn't touch the water.

Melt† the chocolate.

Add the melted chocolate to the egg yolk mixture and stir well.

Once the mixture has thickened (it should coat the back of a wooden spoon), remove it from the heat and allow the sabayon to cool to room temperature.

Once cool, fold through the mascarpone and soft cream.

ASSEMBLY

Pour the second layer mixture onto the first layer of frozen semifreddo and freeze for another 6 hours.

To remove the semifreddo from the tin, wipe the outer edges of the tin with a wet, hot towel.

Gently lift the paper and place the frozen semifreddo on a cutting board or plate.

Remove the paper from the semifreddo. Cut the semifreddo into slices approximately 3 to 4 cm (1½ inch) wide.

GARNISH

Garnish the plate with blueberries, chocolate pearls, pistachios and chocolate curls†.

† See Kitchen Techniques

Makes: 5 servings
Preparation time: 2 hours
Cooking time: 1 hour
Refrigeration time: 24 hours
Freezing time: 2–12 hours

Ice Cream Parfait

CHOCOLATE ICE CREAM

100 ml (3⅓ fl oz) milk

10 gm (⅓ oz) heavy cream, 38%, fresh

½ vanilla pod

16 gm (¼ oz) egg yolk

15 gm (¼ oz) sugar, granulated

1½ tsp cocoa powder

10 gm (⅓ oz) trimoline

1 tsp stabiliser

25 gm (⅚ oz) dark chocolate, 53%

5 gm (⅙ oz) dark chocolate, 66%

Scrape the seeds from the vanilla pod and place them with all the other ingredients in a mixing bowl. Mix together.

Chill the mixture in the refrigerator.

Pour the liquid into an ice cream machine and freeze according to the manufacturer's instructions.

HAZELNUT ICE CREAM

66 ml (2⅕ fl oz) milk

66 gm (2⅕ oz) heavy cream, 38%, fresh

23 gm (⅚ oz) egg yolk

30 gm (1 oz) sugar, granulated

¼ vanilla pod

9 gm (⅓ oz) hazelnuts, minced

A pinch of salt

1½ tsp stabiliser

Place all the ingredients in a mixing bowl and mix together.

Refrigerate overnight.

The next day, strain the mixture.

Pour into an ice cream machine and freeze according to the manufacturer's instructions.

COFFEE JELLY

46 gm (1½ oz) sugar, granulated

2 tsp agar-agar

200 ml (7 fl oz) coffee

6 ml (⅕ fl oz) cognac

Use a hand-held whisk to whisk together the granulated sugar and agar-agar. Add the coffee and then immediately afterwards add the cognac.

Immediately pour the liquid into a ceramic bowl.

Once the liquid is firm, place the bowl in the refrigerator for 3 hours.

COFFEE PANNA COTTA

142 ml (5 fl oz) milk

36 gm (1⅙ oz) coffee beans

36 gm (1⅙ oz) heavy cream, 38%, fresh

21 gm (⅔ oz) sugar, granulated

1 sheet gelatine, softened in cold water

Place the milk, coffee beans and heavy cream in a pot and mix together. Let the mixture rest overnight in the refrigerator.

The next day, strain the liquid.

Place the liquid in a saucepan and, over a medium heat, bring to the boil.

Mix in the blended granulated sugar and softened gelatine. Allow to set in the refrigerator.

Chill with ice. When the mixture thickens, transfer it to a clean bowl and keep in the refrigerator.

CHOCOLATE FLAKES

300 gm (10⅔ oz) pailleté feuilletine

100 gm (3½ oz) almonds, blanched and diced

300 gm (10⅔ oz) milk chocolate, 40%

Mix the pailleté feuilletine and almonds.

Temper† the chocolate and add it to the mixture.

Spread the mixture over a non-stick baking mat and let it combine and harden.

CHOCOLATE SAUCE

345 gm (12 oz) heavy cream, 38%, fresh

117 ml (3¾ fl oz) milk

250 ml (8 fl oz) water

70 gm (2½ oz) cocoa powder

150 gm (5⅓ oz) sugar, granulated

345 gm (12 oz) dark chocolate, 70%

Place the cream, milk and water in a saucepan and, over a medium heat, bring to a simmer.

In a separate bowl, mix together the cocoa powder and granulated sugar.

Gradually pour the cocoa mixture into the heated milk.

Gradually pour in the chocolate, stir to emulsify.

ASSEMBLY

100 ml (3 fl oz) raspberry sauce, fresh

Put the raspberry sauce at the bottom of a tall ice cream glass.

On top of the sauce, layer the panna cotta and then the jelly.

On top of the jelly, place a scoop of both the ice creams, approximately 35 gm (1 oz) per scoop.

Top with chocolate sauce and flakes.

GARNISH

Garnish with store-bought chocolate plates.

† See Kitchen Techniques

Makes: 15 servings
Preparation time: 1 hour
Cooking time: 45 minutes
Refrigeration time: 12 hours
Freezing time: 2–12 hours

Chocolate Liégeois

CHOCOLATE ICE CREAM

1 ltr (1⅗ pints) milk

75 gm (2⅗ oz) cocoa powder

14 egg yolks

100 gm (3½ oz) caster sugar

250 ml (8 fl oz) heavy cream, 38%, fresh

40 gm (1⅖ oz) dark chocolate, 61%

Place the milk in a saucepan and bring to the boil over a medium heat. Add the cocoa powder and stir. Set aside.

Whisk the egg yolks and the sugar in a mixing bowl until light and fluffy. Gradually pour the hot milk into the yolk mixture. Stir quickly.

Place the mixing bowl over a pot of simmering water over low heat (be careful not to let the mixing bowl touch the water) and stir the liquid continuously with a rubber spatula. Add the cream and chocolate. Stir until the mixture is thick enough to coat the spatula.

Set aside and let the liquid cool to room temperature.

Cover tightly with plastic wrap. Press wrap onto the surface of the mixture so a film does not form.

Refrigerate overnight.

The next day, pour the mixture into an ice cream machine and freeze according to the manufacturer's instructions.

Store the ice cream covered in the freezer.

SPECULOOS COOKIES

100 gm (3½ oz) butter

125 gm (4½ oz) brown sugar

150 gm (5⅓ oz) plain flour

1 tsp baking soda

1 tsp salt

2 tsp cardamom powder

½ egg

Preheat oven to 180°C (350°F).

Place the butter and sugar in the bowl of a free-standing electric mixer and using the paddle attachment beat together until light and fluffy.

Beat in the egg.

Add in the flour, baking soda, salt and cardamom powder and beat on low speed until a dough forms. Remove the dough

from the mixing bowl, wrap in plastic wrap and refrigerate for at least 2 hours.

On a table lightly dusted with flour, roll out the dough to 5 mm (⅕₀ inch) thickness. Place on a non-stick baking mat. Prick the dough with a fork and bake for 12 to 15 minutes until the edges start to lightly brown.

While still warm, cut into square cookies.

Let the cookies cool on a cooling rack. Store in an airtight container in a dry place until ready to use.

COFFEE JELLY

250 ml (8 fl oz) espresso coffee, warm

1 sheet gelatine

Soak the gelatine sheet in iced water for at least 15 minutes.

Squeeze the excess water from the gelatine and add it into the warm espresso coffee.

Stir until the gelatine has completely dissolved.

Pour into a metal container and allow it to set in the fridge.

When the jelly is set, cut the jelly into small cubes.

MASCARPONE CHANTILLY

50 gm (1⅘ oz) mascarpone

5 ml (⅙ fl oz) heavy cream, 38%, fresh

12 gm (⅖ oz) caster sugar

½ egg

Combine all the ingredients in a small mixing bowl and whip until soft peaks form. Keep chilled.

ASSEMBLY

In a tall highball glass, place a medium scoop of chocolate ice cream.

Place some cookies and coffee jelly over the ice cream. Add another layer of ice cream, cookies and jelly.

Top with the mascarpone Chantilly.

GARNISH

Garnish with fresh mint leaves and serve immediately.

Makes: 4 servings
Preparation time: 30 minutes
Cooking time: 20 minutes
Freezing time: 2–12 hours

Chocolate Sorbet with Sea Salt and Raspberry Sauce

CHOCOLATE SORBET

1 ltr (1⅗ pints) water

300 gm (11 oz) caster sugar

140 ml (5 fl oz) glucose or corn syrup

400 gm (14 oz) dark chocolate, 72%

50 gm (2 oz) olive oil

2 tsp sea salt

Place the water, sugar and syrup in a saucepan and heat to a simmer.

Pour in the chocolate and stir until the chocolate has melted.

Add in olive oil and sea salt while continuously stirring.

Pour the mixture into an ice cream machine and freeze according to the manufacturer's instructions.

RASPBERRY SAUCE

100 gm (3½ oz) raspberry purée

30 gm (1¼ oz) caster sugar

2 vanilla pods

4 stems fresh thyme

Place the raspberry purée and the seeds of the vanilla pods in a saucepan and warm over a gentle heat.

Add in sugar and thyme stems and stir until the sugar is dissolved.

Remove from heat and remove the thyme stems.

ASSEMBLY

Serve a quenelle of sorbet with raspberry sauce.

GARNISH

1 tsp thyme leaves

4 edible flowers, pink

20 gm (⅔ oz) raspberries, fresh

1 tsp sea salt

Garnish plate with a sprinkling of thyme leaves, pink edible flowers, fresh raspberries and sea salt.

Makes: 8 servings
Preparation time: 40 minutes
Refrigeration time: 2 hours
Freezing time: 2–12 hours

Milk Chocolate and Jasmine Tea Sorbet

1 ltr (1⅗ pints) water, filtered, cold

3 Tbsp jasmine tea leaves

85 gm (3 oz) caster sugar

125 gm (4½ oz) glucose

30 gm (1 oz) trimoline

100 gm (3½ oz) milk chocolate, 35%

SORBET

Place the water in a saucepan and bring it to the boil. Remove the saucepan from the heat, add the tea and let it stand/infuse for 15 minutes.

Add the sugar, glucose and trimoline to the saucepan.

Return the saucepan to the heat and bring the liquid to the boil for 1 minute.

Pour the liquid through a sieve (to strain the tea leaves) into a bowl and allow it to cool to 60°C.

Add the chocolate to the liquid and stir well.

Allow the mixture to cool to room temperature.

Pour the mixture into an ice cream machine and freeze according to the manufacturer's instructions.

JASMINE TEA JELLY

8 sheets gelatine

800 ml (1⅖ pints) hot water

60 gm (2 oz) jasmine tea leaves

Soak the gelatine sheets in cold water until soft.

Boil the water and infuse the tea leaves; discard half the leaves after 5 minutes, leaving the rest for visual effect.

Add the softened gelatine to the still hot tea.

Pour into an oval-shaped silicone mould, or any shape you like, and set in the fridge for 2 hours.

ASSEMBLY

Place the jasmine tea jelly on a plate and top with a quenelle of the sorbet.

SAVOURY DISHES

Chocolate is no longer the preserve of decadent desserts; for cutting-edge chefs it has become a key ingredient in savoury dishes. It is chocolate, but not as we know it.

Chocolate adapts to innumerable ingredients. It lends itself to game meats – enhancing the rich, complex flavours – but works equally well with chicken or fish.

The Peninsula chefs have also paired chocolate with salt and seafood. Salt enlivens the chocolate flavour, and it cuts the dairy so the butter doesn't taste as heavy.

Each dish has been thoughtfully composed to balance the sweet with the bitter, to smooth out spicy notes and to enrich contrasting flavours. Taste sensations, every one guaranteed to stimulate and sate your appetite in their own spectacular and characteristic way.

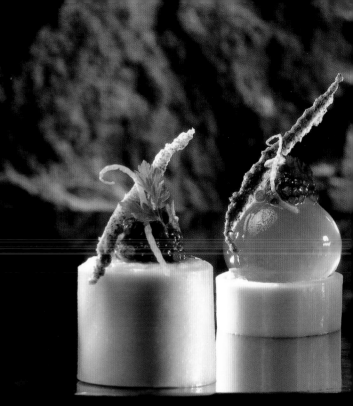

Makes: 4 servings
Preparation time: 30 minutes
Cooking time: 2½ hours

White Chocolate with Crab and Caviar

CRAB

1 kg (2 lb 3 oz) crab, live

Steam the crab for 12 to 14 minutes, then refresh in ice water.

Remove all the meat from the shells and reserve.

Keep the shells for the crab jus.

CRAB JUS

Crab shells, chopped
50 gm (2 oz) butter
20 gm (⅔ oz) stem ginger, peeled
150 gm (5⅓ oz) white wine
200 gm (6⅔ oz) fish stock
250 gm (8 fl oz) heavy cream, 38%, fresh
Salt and pepper to taste
Lemon juice to taste

Sauté the crab shells in butter until they lighten in colour.

Add the ginger and sweat.

Add the white wine and simmer for 3 minutes, then add the fish stock and cream.

Cook for 12 minutes, season, and strain through a fine sieve.

Reserve 380 ml (12 fl oz) for the ganache and jelly sheet.

WHITE CHOCOLATE GANACHE

180 ml (6 fl oz) crab jus
100 gm (3½ oz) white chocolate
Zest and juice of 1 lime
2 sheets gelatine, soaked in cold water
200 gm (6⅔ oz) crab meat
Salt and cayenne pepper to taste
50 gm (2 oz) fennel, finely diced
50 gm (2 oz) courgette, finely diced

Place the crab jus in a saucepan and bring to the boil.

Place the chocolate in a bowl and pour the crab jus over it. Mix to a smooth paste.

Squeeze the excess water from the softened gelatine.

Add the lime and gelatine to the chocolate. Stir well to ensure the gelatine is dissolved.

Add the crab meat, seasoning, fennel and courgette.

Spoon the mixture onto plastic wrap in a thin rectangular shape and carefully fold the wrap to form a long, thick sausage.

Place in the refrigerator to set.

CRAB JELLY

200 ml (6⅔ fl oz) crab jus
3 sheets gelatine, soaked in cold water

Heat the crab jus with the gelatine and pour into a flat tray to a 1.5 mm (1/16 inch) thickness.

Place in the refrigerator to set, then cut into 12.5 cm (5 inch) squares.

CRAB ROLLS

Remove the white chocolate ganache from the plastic wrap and place it on the jelly. Roll the jelly around the ganache, so that it forms a casing.

Cut it into 2.5 cm (1 inch) long rolls and refrigerate.

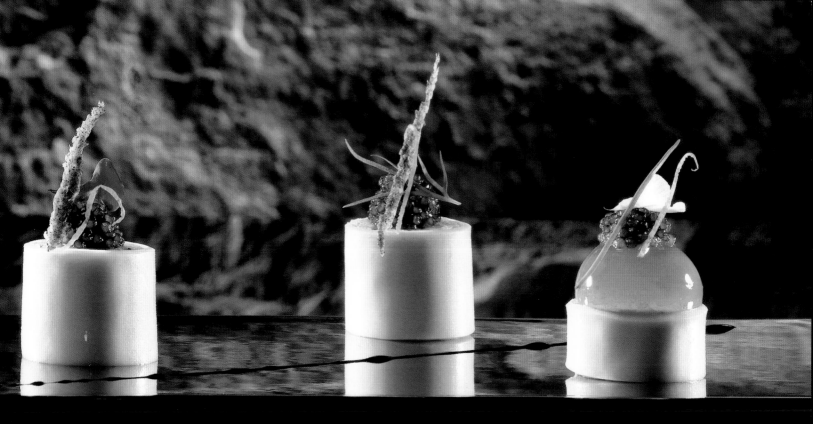

CRAB CONSOMMÉ JELLY BALLS

2.5 kg (6⅓ lb) crab
200 gm (7 oz) onion
300 gm (10⅔ oz) carrot
100 gm (3½ oz) shallot
175 gm (6 oz) green onion
100 gm (3½ oz) fennel
7 cloves garlic
150 gm (5 oz) ginger
180 gm (6 oz) mushroom
600 ml (1 pint) white wine
150 ml (4½ fl oz) cognac
4.5 ltr (9½ pints) water
10 gm (⅓ oz) parsley
10 gm (⅓ oz) thyme
2½ tsp tarragon
100 gm (3½ oz) tomato
10 gm (⅓ oz) rock salt
1 tsp orange peel
3 sheets agar-agar

Preheat the oven to 150°C (300°F).

Remove the lung of the crab and the shell. Cut the crab meat into 4–5 cm (approximately 2 inch) pieces.

Put the crab meat pieces in the oven to dry. Bake slowly to ensure the meat doesn't burn.

Put the sliced vegetables and rock salt (except the tomato and herbs) into a large pot. Add a bit of water and cover with the lid.

Over a medium heat, slowly cook the vegetables.

Add the dried crab pieces and gently stir them in.

First add the cognac, then the white wine. Turn the heat to high and bring the liquid to the boil.

Add the tomato and water while the liquid is boiling, then reduce the heat.

Add the herbs and let the liquid simmer for 1 hour.

Check the taste and then strain the liquid.

Slice the orange peel and add it to the consommé.

Return the liquid to the pot and bring it back to the boil.

Remove the pot from the heat.

Remove the orange peel from the consommé and reserve for the garnish.

Add the agar-agar to the crab consommé.

Pour into ball-shaped moulds, approximately 2 cm (¾ inch) in diameter.

Keep it in the refrigerator to set.

ASSEMBLY

Place the crab rolls upright on the serving plate.

Place the jelly balls on top of the crab roll.

GARNISH

40 gm (1⅓ oz) caviar
Zest of 1 lime
Zest of 1 lemon
Edible flowers to garnish, white/purple
Dill to garnish
Chives to garnish

Makes: 4 servings
Preparation time: 24 hours
Cooking time: 3 hours

Chocolate, Beef and Mushroom Cannelloni with Lemon Turbot

BRAISED BEEF CHEEK

2 kg (4 lbs 6 oz) beef cheek, grass-fed

300 ml (10 fl oz) red wine

5 garlic cloves, peeled

3 bay leaves

3 sprigs rosemary, fresh

70 gm (2½ oz) carrot

55 gm (2 oz) celery

70 gm (2½ oz) onion

55 gm (2 oz) leek

Salt and coarse black pepper to season

Plain flour to dust

60 ml (2 fl oz) olive oil

30 gm (1 oz) tomato paste

55 gm (2 oz) organic dark chocolate, 74%

15 gm (½ oz) rosemary, fresh, chopped

Clean the beef cheek. Remove the tissue and trim the fat.

Wash the carrot, celery, onion and leeks, then cut into mirepoix size.

Marinate the beef cheeks with garlic, bay leaves, rosemary, mirepoix vegetables and red wine overnight.

Season the beef cheeks with salt and pepper and dust with flour.

Heat the olive oil in a braising pan and sear the beef cheeks on each side until brown. Remove and set aside.

In the same braising pan sauté the mirepoix vegetables until golden brown.

Add the tomato paste to the pan and cook briefly.

Deglaze with the liquid from the marinade and reduce until it achieves a syrup-like consistency.

Place the seared cheeks back in the pan and cover with brown stock.

Bring the liquid to a simmer, place the lid on the saucepan and cook in the oven until tender (approximately 2½ hours).

Remove beef cheeks and strain the sauce.

Heat the sauce to reduce it to a pouring consistency (when poured onto a plate it should form a circle and not run).

Whisk the dark chocolate and chopped rosemary into the sauce.

Add the cheeks to the sauce to prevent the meat from drying out.

Set aside until needed.

CHOCOLATE PASTA DOUGH

30 gm (1 oz) organic dark chocolate, 74%

A pinch of salt

100 gm (3½ oz) semolina

70 gm (2½ oz) plain flour

3 egg yolks

1 egg

10 ml (⅓ fl oz) olive oil

Finely grate the dark chocolate.

Place the semolina, flour, salt and chocolate in a bowl and mix together.

In a separate bowl, mix the egg yolks with the whole egg.

Combine the egg mixture with the semolina mixture, add the olive oil and knead for 5 minutes.

Wrap the dough in plastic wrap and allow to rest for at least 6 hours in the refrigerator.

WILD MUSHROOM CUSTARD

30 gm (1 oz) porcini mushroom

30 gm (1 oz) morel mushroom, fresh

70 gm (2 oz) bottom mushroom

70 gm (2 oz) portobello mushroom

30 gm (1 oz) shallot

10 gm (⅓ oz) garlic

10 ml (⅓ fl oz) olive oil

15 gm (½ oz) butter

60 ml (2 fl oz) white wine

125 ml (4 fl oz) heavy whipping cream, 38%, fresh

Salt and coarse white pepper to season

2 egg yolks

30 gm (1 oz) Parmesan cheese, grated

Clean mushrooms and cut into cubes.

Finely chop the shallots and garlic.

In a saucepan, heat the olive oil and sauté the shallots and garlic for 1 minute.

Add butter and the mixed mushrooms and fry until golden brown in colour.

Deglaze with white wine. Reduce the white wine for 2 minutes.

Add the cream and cook for 5 minutes or until the cream is thickened.

Season with salt and pepper.

Place the hot mixture in a food processor and pulse 3 times until it develops a coarse texture.

Let the mixture cool to room temperature. Add the egg yolks and Parmesan cheese, mix well and pour into a heatproof baking tray. The height of the mixture should not be more than 1 cm (½ inch).

Cover the tray with plastic wrap and poach in a steamer at 100°C (212°F) for 15 minutes or until cooked.

Allow the custard to cool in the refrigerator until needed.

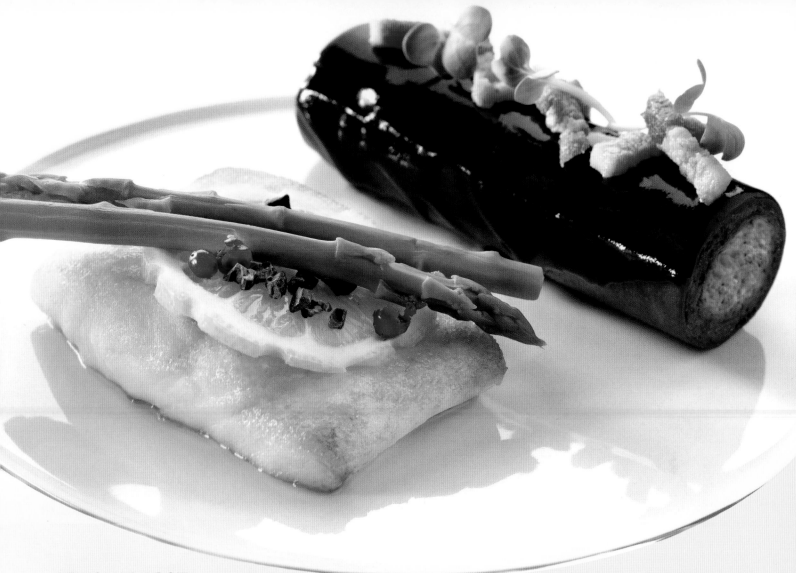

LEMON TURBOT

600 gm (1 lb 4½ oz) turbot fillet

15 ml (½ fl oz) virgin olive oil

Salt and white pepper to taste

10 ml (⅓ oz) lemon juice

30 gm (1 oz) butter

2 sprigs thyme

2 cloves garlic

Dry the cleaned turbot with kitchen paper and season with lemon juice, salt and pepper.

Place the olive oil, butter, thyme and garlic clove in a fry pan and heat to medium-high heat, or until the butter is sizzling.

Add the fish and fry until golden brown on both sides. While cooking, spoon the butter liquid over the fish so it takes on the scent of the herbs.

ASSEMBLY

170 gm (6 oz) chocolate pasta dough

125 gm (4½ oz) braised beef cheek

125 gm (4½ oz) wild mushroom custard

90 ml (3 fl oz) beef cheek sauce

20 gm (⅔ oz) organic chocolate, 74%, finely chopped

Roll the pasta dough to 1 mm (½₅ inch) thickness and blanch in a pot of boiling water to al dente; the dough yields a total of 4 portions, rolled out to 12 cm (4⅗ inch) square sheets.

Freshen the cooked pasta dough sheets in iced water and trim into 10 cm (4 inch) squares.

Flake the braised beef cheek.

Mix the poached mushroom custard and beef cheek flakes. Season if required, and place the mixture in a piping bag.

Place a chocolate pasta square on a piece of plastic wrap and drizzle with olive oil.

Pipe the mushroom-beef mixture onto the pasta and roll it into a cylinder-shaped cannelloni, 1.5 cm (3/4 inch) in diameter and 10 cm (4 inch) long.

Tighten plastic wrap at both ends, making sure no air remains in the roll.

Poach the cannelloni for 6–8 minutes in a hot water bath.

Heat the beef cheek sauce and whisk in the chocolate. Allow the sauce to become syrupy.

Transfer the hot cannelloni to a cutting board and cut off a slice close to the end of the roll. Using the back of the knife, gently push the stuffed pasta roll out of the plastic wrap and trim the other end.

Position the cannelloni on a plate so that the side with the overlapping pasta is not seen.

Once the fish is cooked, discard the garlic and thyme, and place the fish on the plate next to the cannelloni.

GARNISH

45 gm (1½ oz) preserved lemon, sliced

3 green asparagus shoots, blanched

1 tsp red peppercorn

10 gm (⅓ oz) cocoa nibs

20 gm (⅔ oz) crispy bacon bits

20 gm (⅔ oz) microgreens

Place the lemon slices and then the asparagus on top of the fish.

Sprinkle with the red peppercorns and cocoa nibs.

Spoon the chocolate-beef cheek sauce over the cannelloni and garnish with crispy bacon and microgreens.

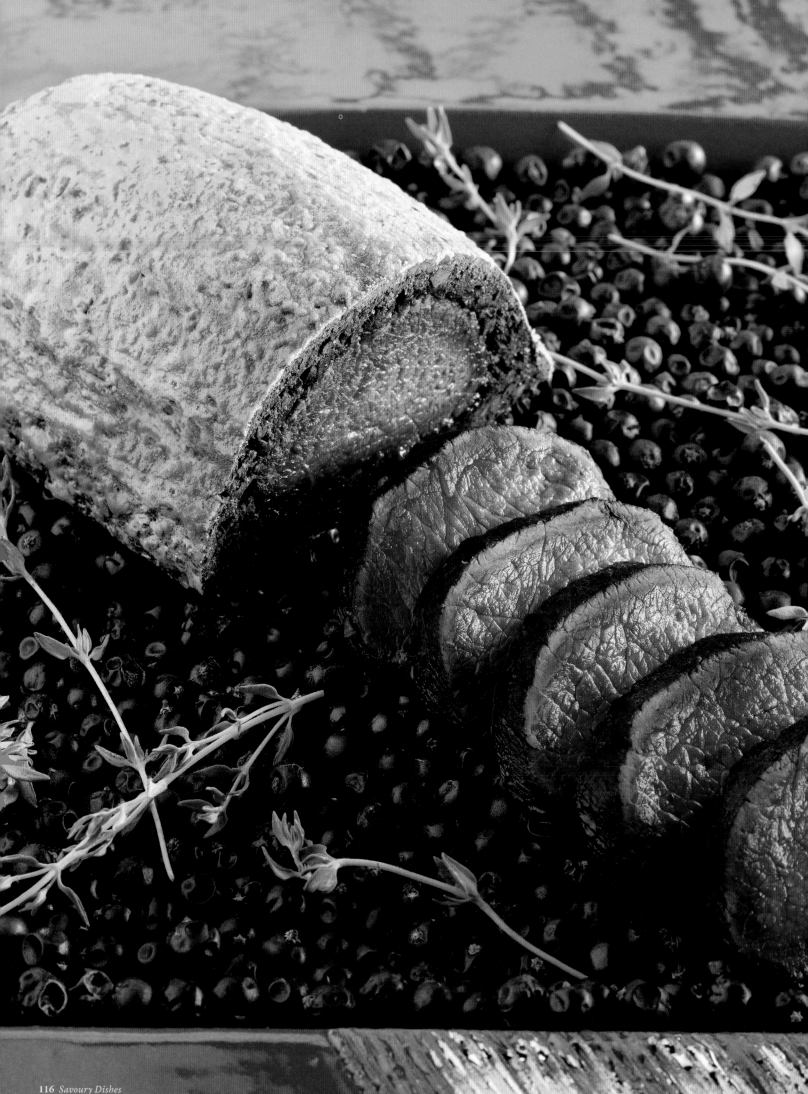

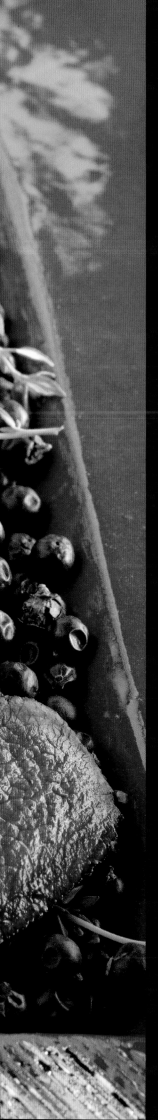

Makes: 4 servings
Preparation time: 40 minutes
Cooking time: 30 minutes

Venison Saddle Baked in Bitter Chocolate and Cocoa Nibs

VENISON MARINADE

650 gm (1½ lb) venison saddle

150 ml (5 fl oz) red wine

50 ml (1¾ fl oz) red port

2 juniper berries, ground

A pinch of fresh ground pepper

50 ml (1¾ fl oz) vegetable oil

25 gm (⅚ oz) butter

Trim and clean the venison and place on a tray.

Place the red wine and port in a stainless steel pan and over a medium heat reduce to a glaze. Turn off the heat and allow the glaze to cool slightly.

Brush the wine glaze evenly on the venison. Season with juniper and pepper.

Heat vegetable oil in a separate saucepan and sear the venison on all sides.

Finish by adding the butter.

Remove the venison from the pan, drain, chill, then roll again in the marinade, and reserve.

CHOCOLATE NIB PASTRY

100 gm (3½ oz) table salt, fine

100 gm (3½ oz) cocoa nibs, unsweetened

50 gm (2 oz) cocoa powder

75 gm (2½ oz) plain flour

100 gm (3 oz) egg whites

Combine all dry ingredients in the mixing bowl of a free-standing electric mixer. Using a dough hook attachment, mix until evenly distributed.

Add the egg whites and knead into the dough.

Remove the dough from the bowl and on a lightly floured surface, roll to a large rectangle, approximately 1 cm (½ inch) in width. Leave at room temperature.

ASSEMBLY

Preheat the oven to 260°C (500°F).

30 minutes prior to cooking, cut the chocolate pastry into two rectangles (one slightly larger than the other).

Place the smaller piece of pastry on a baking tray and brush with egg yolk.

Place the chilled venison in the centre. Place the larger pastry on top of the venison and press it against the meat. Ensure all the meat is in contact with the pastry and that no air pockets have formed.

Trim and square the edges of the pastry and brush heavily with an egg wash (made with 5 eggs and 10 Tbsp water).

Decorate with cocoa nibs and sea salt.

Bake in the preheated oven for 8 minutes.

Remove from the oven and keep in a warm place to continue cooking for about 15 minutes.

Place the tray back in the hot oven for 2 minutes.

Open the crust at the table and serve immediately.

GARNISH

Garnish with juniper berries and thyme sprigs.

Chef's tip: Serve this dish with sweet potato purée, parsnips, roasted apple and bacon.

Roast Duck with Chocolate Orange Sauce and Soya Milk Cocoa Flan

ROASTED DUCK BREAST

300 gm (10 oz) duck breast

Cook the skin side of the duck in a hot pan.

Bake in the oven for 6 minutes at 180°C (356°F).

STEWED DUCK LEG

200 gm (7 oz) duck leg

Salt and pepper to taste

40 gm (1⅖ oz) onion

10 gm (⅖ oz) carrot

10 gm (⅖ oz) celery

1 pod garlic

500 ml (7 fl oz) red wine

Butter to taste

Place the duck leg on a pan, add salt and pepper and brown the meat.

Cook and brown the seasoning vegetables.

Put the browned duck leg in a pot, add red wine and simmer.

Add the seasoning vegetables.

Simmer for 2 hours on a low flame.

Pierce the meat with a skewer and check if it is tender enough, then remove from the pot.

Strain the stew sauce. Add salt, pepper and butter and reserve.

BRAISED ENDIVES

8 oranges

2 Belgian endives

10 ml (⅖ fl oz) lemon juice

Salt and pepper to taste

Zest an orange and reserve the zest for garnish.

Squeeze the oranges to produce approximately 300 ml (10⅗ fl oz) of juice.

Line the endives in a flat-bottomed pot. Add the orange juice, lemon juice, salt and pepper. Cover the top of the pot with cooking paper, then place the pot lid on top, and simmer on a low heat for 25 minutes.

Remove the endives and reserve for plating.

Use the juice in the preparation of the chocolate orange sauce.

CHOCOLATE ORANGE SAUCE

100 ml (3½ fl oz) duck/chicken bouillon

80 gm (2⅘ oz) chocolate, unsweetened

10 gm (4⅕ oz) cocoa mass

50 gm (1⅘ oz) butter

Salt and pepper to taste

10 ml (⅖ fl oz) orange vincotto

Boil the orange juice used to braise the endives, add the bouillon and reduce to half.

Add the chocolate, cocoa mass, butter, salt, pepper and the orange vincotto.

SOYA MILK COCOA FLAN

200 ml (7 fl oz) soya milk

10 gm (4⅕ oz) cocoa mass

20 ml (⅗ fl oz) honey

80 gm (2⅘ oz) egg yolks

Simmer the soya milk at 80°C (176°F), add the cocoa mass, honey and egg yolks and stir well.

Strain once.

Pour into a flan mould and steam at 78°C (172.4°F) for 20 minutes.

FLAN SAUCE

80 ml (2⅘ fl oz) soya milk

10 ml (⅖ fl oz) honey

2½ tsp cornstarch

Add the honey to the soya milk and bring slowly to the boil; take off immediately, add cornstarch and stir until it thickens.

ASSEMBLY

Place the duck leg on a plate and ladle the stew sauce over it.

Spoon the chocolate orange sauce onto another section of the plate, and arrange slices of the roasted duck breast over it.

Place the flan on the plate, and dress with the flan sauce.

Arrange the braised endives on the side.

GARNISH

Brussels sprouts

120 gm (4½ oz) Brussels sprouts

Take off the outer leaves and blanch. Halve the Brussels sprouts and cook until browned.

Carrot chips

20 gm (⅔ oz) carrot

Peel the carrot, cut into thin slices, 5 cm (2 inch) in length and 0.5 mm (¹⁄₅₀ inch) thick, and lightly fry until crisp.

Garnish the plate with the orange zest, carrot chips and the Brussels sprouts halves and leaves.

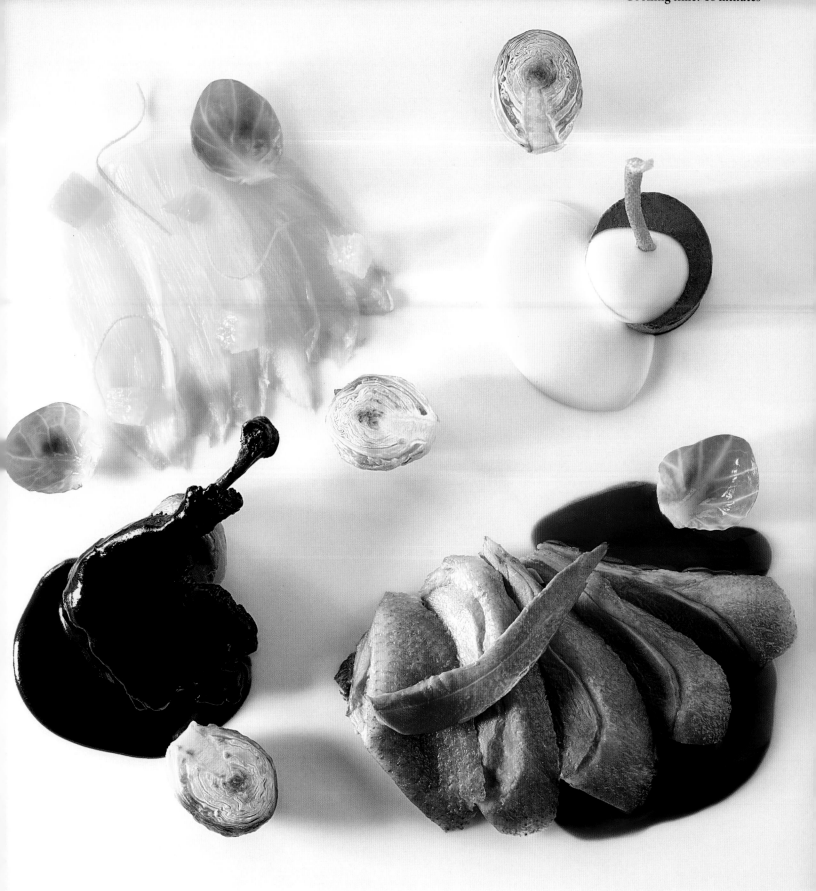

Makes: 1 serving
Preparation time: 1 hour
Cooking time: 40 minutes

Makes: 1 serving
Preparation time: 5 minutes
Cooking time: 15 minutes

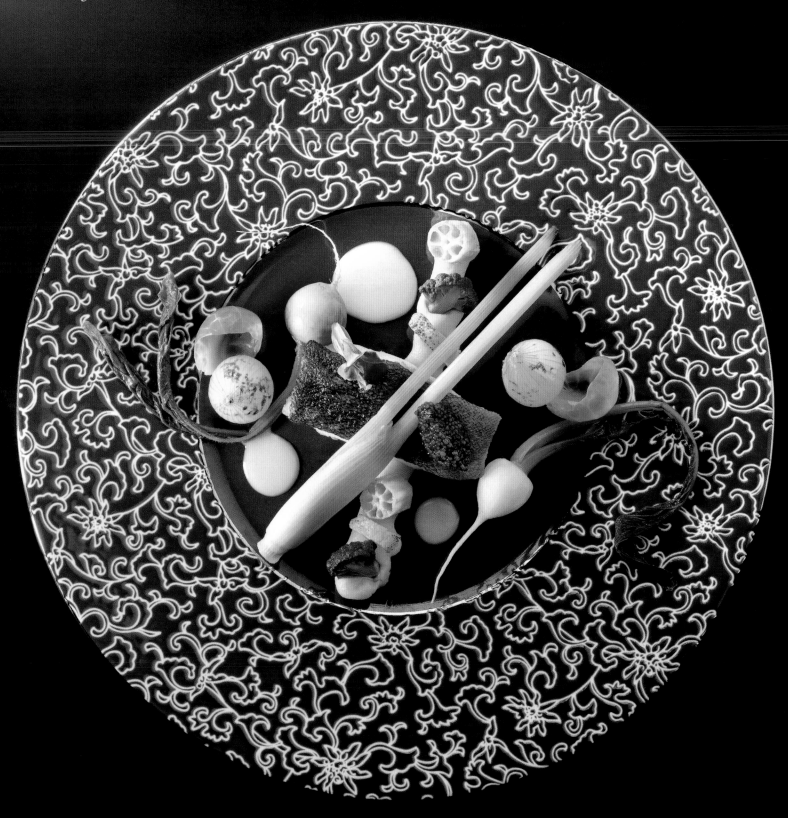

Sake Black Cod with White Chocolate Sauce

BLACK COD

180 gm (6 oz) black cod

200 ml (7 fl oz) sake

Salt and pepper to taste

Place the black cod, skin side up, in a shallow sauté pan.

Fill the pan with sake to just below the skin of the fish.

Season with salt and pepper.

Place the pan in a broiler, or an oven on a broiler setting, to allow the skin to crisp.

Allow the poaching liquid to reach 55°C (131°F); cook for 8 minutes.

Remove the fish from the pan and allow to rest for 5 minutes. The poaching liquid will keep the fish moist.

RADISH AND SPROUTS

1 baby radish, red

1 baby radish, white

2 leaves of a Brussels sprout

10 gm (⅔ oz) caviar

1 edible flower, purple

Cook the baby radishes in boiling salted water for 4 minutes, then take them out and sauté in a pan with a little butter, not to colour, just to give a shine.

Season to taste.

For the Brussels sprout leaves, blanch for 5 seconds, and toss in the same pan as the radishes for a few seconds.

POTATO MOUSSELINE

200 gm (7 oz) Yukon Gold potato

90 gm (3 oz) heavy cream, 40% or greater

42 gm (1½ oz) extra virgin olive oil

Peel and quarter the potato, then place it in a small pot filled 5 cm (2 inch) with water.

Boil the potato for 35 minutes.

Place the cream in a separate saucepan and bring to a simmer.

Push the potato through a food mill into a bowl and then whisk in the hot cream.

Once the cream is incorporated, whisk in the olive oil.

Season to taste.

CARAMELISED CAULIFLOWER

2 florets cauliflower, white

2 florets cauliflower, purple

14 ml (½ fl oz) virgin olive oil

28 gm (1 oz) butter

Salt and pepper to taste

Heat and maintain a sauté pan at medium heat.

Put the oil and butter into the hot pan.

Season the cauliflower florets with salt and pepper.

Add the florets to the hot pan and sauté until all sides are seared. Add more butter if needed.

Reserve for plating.

GLAZED CIPPOLINI

2 cippolini onions

900 ml (31⅓ fl oz) water

180 gm (7 oz) caster sugar

2 star anise pods

1 clove

Place the water, star anise, clove and sugar in a small pot and bring to the boil.

Allow the liquid to boil for 5 minutes to infuse the flavour into the water.

Add the cippolini onions and reduce to a simmer, allowing to cook through, for approximately 5 minutes.

Remove the onions and reserve for plating.

Reduce the liquid until it resembles a syrup and reserve to use as a sauce.

GINGER INFUSED WHITE CHOCOLATE SAUCE

400 gm (14 oz) heavy cream, 38%, fresh

170 gm (6 oz) white chocolate

35 gm (1¼ oz) ginger

1 tsp lemon zest

Peel and quarter the ginger.

Place the cream and ginger in a saucepan and bring to a simmer.

Reduce the cream to 125 ml (4 fl oz) and remove from the heat.

Allow the cream to steep for 15 minutes, then strain it.

Place the white chocolate in a bowl and slowly whisk the cream into it.

Once the cream is incorporated into the chocolate, add the lemon zest and reserve in a warm place.

LOTUS ROOT CHIPS

150 gm (5⅓ oz) baby lotus root

224 ml (7⁹⁄₁₀ fl oz) canola oil

Salt and pepper to taste

Slice the lotus root into 2 mm (²⁄₂₅ inch) slices.

Place the oil in a saucepan and bring to 162°C (324°F)

Carefully fry the sliced lotus root for approximately 1 minute or until crispy.

Reserve on a napkin/paper towel and season.

POACHED BABY FENNEL

900 ml (31⅓ fl oz) water

1 star anise pod

1 clove

1 baby fennel

A pinch of salt

Place the water, star anise, clove and salt in a small pot and bring to the boil.

Allow the liquid to boil for 5 minutes to infuse the flavour into the water.

Add the baby fennel to the water for approximately 2 minutes.

Allow to cook through, remove and season.

Reserve for plating.

ASSEMBLY

Pipe the potato mousseline in a rectangular shape across the centre of the plate.

Sear the fish until cooked and gently place it in the centre of the mousseline.

Place the cooked purple and white cauliflower on the ends of the piped potato.

Add the fried lotus chips, and the small onions to the side.

Top the fish with the poached fennel, and scatter the coloured radish and sprouts around the plate.

Lastly, spoon on the white chocolate sauce and serve.

Poussin with Chocolate Chinese Pear

Makes: 4 servings
Preparation time: 40 minutes
Cooking time: 1½ hours

CHOCOLATE STOCK

50 gm (2 oz) crue de cacao

250 gm (9 oz) crushed ice

250 ml (8 fl oz) water

60 gm (2 oz) brown sugar

1 vanilla pod

Melt† the crue de cacao in a bain-marie.

Add the ice and water to the melted crue de cacao and bring it to the boil.

Pass the mixture through a fine sieve and then stir in all the remaining ingredients.

Bring the liquid to the boil again.

POUSSIN

4 poussin (young chicken, 4–6 week old) legs

4 poussin breasts, skinless, lightly seasoned with low sodium salt

1 Chinese pear

4 whole chillies, red, approximately 2½ cm (1 inch) each

4 sprigs rosemary

80 ml (2½ fl oz) chocolate stock

Peel the pear and cut it into quarters.

Take 4 small (70 ml/2⅓ fl oz) preserving jars. In each, place 1 poussin leg and breast, a quarter of the pear, a chilli and a sprig of rosemary.

Pour the chocolate stock into each jar. The stock should cover the ingredients.

Close the lid and steam the jars in a 72°C (144°F) steam oven for 45 minutes.

GARNISH

Serve the poussin leg in the jar and the breast on a white plate with a banana leaf, rosemary sprig and chilli to decorate.

† See Kitchen Techniques

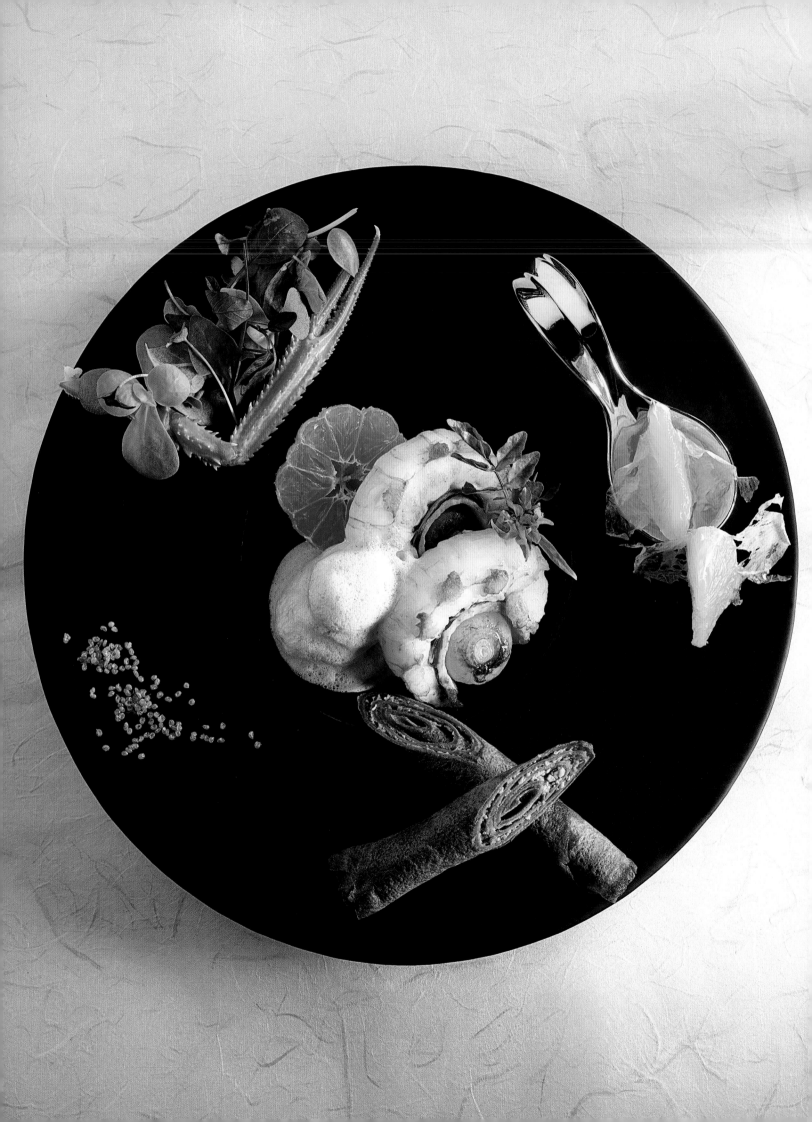

Makes: 4 servings
Preparation time: 1 hour
Cooking time: 15 minutes

Langoustine with Chocolate Cappuccino

LANGOUSTINE

4 langoustines, 100 gm (3⅓ oz) each

20 gm (⅔ oz) savoy cabbage

8 slices pancetta

4 petit onions

25 gm (⅚ oz) butter

Remove the shells from the langoustines. Keep the shells and set aside.

Remove the coral (brains) from the langoustine head. Store the heads with the shell and place the coral in a separate container.

Cut the savoy cabbage into 1½ cm (1 inch) by 10 cm (4 inch) strips. Place the cabbage in a saucepan and cover it with water. Boil the cabbage until it softens.

Cut the pancetta into 1.5 cm (1 inch) by 10 cm (4 inch) strips.

Roast the petit onions in a 170°C (338°F) oven for 10 minutes.

Layer the pancetta, cabbage and petit onions (in that order) inside the belly side of the langoustine.

Tie the ends of the langoustine together (to create a circle) with a bamboo stick.

Sauté in butter on both sides until golden brown, for approximately 6 minutes.

CHOCOLATE CAPPUCCINO

4 langoustine heads and shells, previously set aside

300 ml (10 fl oz) milk

20 gm (⅔ oz) dark chocolate, 70%

Place the langoustine heads and shells in a pot, crush them and then cover them with water.

Over a medium heat, bring the water to a simmer.

Simmer for 10 minutes on a medium heat or until there is no more water in the pot.

Add the milk to the pot and cook over a low heat for 30 minutes.

Add the chocolate and stir through. When the chocolate has melted, put the mixture through a sieve to remove all the shells.

Whip the strained mixture with a hand-held beater until it becomes a frothy foam.

IYOKAN CONFIT

3 iyokans

1 tsp olive oil

A pinch of salt

Preheat the oven to 90°C (194°F).

Peel two iyokans and cut them in half.

Peel the third iyokan and remove all the pith.

Place all three on an oven sheet and sprinkle with salt and olive oil.

Bake the halved iyokans for 45 minutes in the preheated oven.

Bake the whole iyokan for 30 minutes in the preheated oven.

Chef's tip: Iyokans are a Japanese citrus fruit; they can be substituted with small, ripe pomelos in this recipe.

CHOCOLATE CRÊPE CIGAR

60 gm (2 oz) plain flour

2½ tsp cocoa powder, unsweetened

15 gm (½ oz) sugar, granulated

50 gm (1⅔ oz) eggs

120 ml (4 fl oz) milk

10 gm (⅓ oz) butter

80 gm (3 oz) mushroom

Coral from 4 langoustines (previously set aside)

Salt and pepper to taste

Place the flour, eggs, cocoa powder and granulated sugar in the bowl of a free-standing electric mixer and mix well.

Gradually add in the milk and melted butter.

Mince the mushrooms, place them in a frying pan and, over a medium heat, sauté until there is no moisture left in the pan.

Take the langoustine coral and push it through a fine sieve.

Add the strained coral to the sautéed mushrooms and season with salt and pepper.

Add the mushrooms to the crêpe mixture and cook in a non-stick crêpe pan.

Once the crêpe sets on one side, flip it over and cook the other side.

Take the pan off the heat and roll the crêpe like a cigar.

SALAD BOUQUET

3 tsp watercress

3 tsp amaranth

10 gm (⅓ oz) lamb's lettuce

1 tsp purple basil

1 tsp microgreens

1 tsp chives

½ tsp tarragon

½ tsp broccoli sprouts

ASSEMBLY

Place the halved iyokans on the plate.

Place the sautéed langoustine next to them and dress with the cappuccino foam.

Place the chocolate crêpe cigar, whole iyokan and salad bouquet on the plate and dress with olive oil.

Note: Langoustine claw is an optional garnish.

Makes: 4 servings
Preparation time: 1 hour 20 minutes
Cooking time: 20 minutes

Maple Syrup Veal Tenderloin with Chocolate Macaroon

MAPLE SYRUP MARINATED VEAL

400 gm (14 oz) veal tenderloin

30 ml (1 fl oz) maple syrup

1 Tbsp butter

80 gm (2⅖ oz) burdock

60 gm (2 oz) carrot

Cut the veal tenderloin into 100 gm (3½ oz) pieces.

Marinate the veal pieces in 30 ml of maple syrup for 2 hours.

Preheat the oven to 180°C (350°F).

Place the butter in a heated pan and fry the veal until it is brown on all sides, for about 5 minutes.

Place the veal in the preheated oven and cook until desired (rare/medium/well done).

Baton-cut the vegetables and blanch them in boiling water.

Place the vegetables in the frying pan used to cook the veal and sprinkle with salt and sugar.

Heat the vegetables until they are shiny.

SWEETBREADS

80 gm (3 oz) veal sweetbreads

120 gm (4½ oz) shallot

60 ml (2 fl oz) veal stock

1 Tbsp butter

Place the veal sweetbreads (whole) in a bowl of water and allow them to soak for 1 hour (this cleans them of impurities).

Remove the sweetbreads from the water. Place them in a clean saucepan and cover with fresh water.

Bring the water to a simmer and cook the sweetbreads for 20 minutes.

Remove the sweetbreads from the saucepan and remove the veins. Slice the sweetbreads into 1 cm (½ inch) pieces.

Chop the shallots.

Place the sweetbread pieces in a separate pan with the butter and chopped shallots. Add the veal.

Bring the liquid to simmer and allow it to reduce to a third in approximately 15 minutes.

RAVIOLI

100 gm (3½ oz) plain flour

1 tsp salt

1 Tbsp olive oil

1 egg

Place the flour, salt and olive oil in the bowl of a free-standing electric mixer and using the dough hook, beat until a dough forms.

When fully mixed, wrap the dough in plastic wrap and place it in the refrigerator to rest for 2 hours.

Then roll the dough out to a 1 mm (½5 inch) thickness, using a pasta machine.

Use a circle cutter to cut out circular shapes in the pasta, approximately 7 cm (3½ inch) in diameter.

Place 30 gm (1 oz) of veal sweetbreads in the centre of a pasta circle.

Place another pasta circle on top and using your fingers, gently press the edges of the two circles together to seal it.

Place the filled ravioli circles on a drying rack to dry for an hour.

Fill a deep saucepan with water and add a pinch of salt. Bring the water to the boil.

Drop the ravioli into the boiling water and cook for 2 minutes.

Remove the ravioli from the water with a slotted spoon.

CHOCOLATE MACAROON

10 gm (⅖ oz) cocoa powder

20 ml (⅔ fl oz) heavy cream, 38%, fresh

20 gm (⅔ fl oz) butter

20 gm (⅔ oz) almond powder

60 gm (2 oz) egg whites

10 ml (⅖ fl oz) maple syrup

Preheat the oven to 130°C (250°F).

In a bowl, mix together the cocoa powder, heavy cream, melted butter, almond powder and maple syrup.

Slowly add egg whites and whip well.

Spoon the mixture into a piping bag.

Pipe the mixture in 5 cm (2 inch) circles onto a baking tray lined with baking paper.

Bake in the preheated oven for 20 minutes.

MAPLE SYRUP CARAMEL SHEET

50 ml (1⅔ fl oz) maple syrup

10 ml (⅓ fl oz) maple vinegar

A pinch of salt

Preheat the oven to 160°C (325°F).

In a saucepan, simmer the maple syrup until it reduces to approximately 15 ml (½ fl oz)

Add 10 ml (⅓ fl oz) of maple vinegar and then add a pinch of salt. Gently stir.

Pour the liquid onto a cooking sheet and bake in the preheated oven for 5 minutes. Cut out in a shape you prefer.

VEAL SAUCE

20 gm (⅔ oz) veal stock

50 ml (1⅔ fl oz) dark chocolate, 80%, melted[†]

A pinch of cocoa mass

Place the veal stock in a saucepan with the melted chocolate and bring to the boil.

Once boiled, remove from the heat and stir in the cocoa mass.

ITALIAN PARSLEY SAUCE

20 gm (7⁄10 fl oz) Italian parsley

50 ml (1⅔ fl oz) olive oil

A pinch of salt

Place the parsley in a saucepan and cover with a small amount of water. Bring to the boil.

Place the water and parsley in a blender with the olive oil and salt. Process until well combined.

ASSEMBLY

Arrange the vegetables on the plate.

Drain off the water and place the boiled ravioli on the plate.

Place the cooked veal on the plate, with the macaroon on the top.

Pour the veal sauce and Italian parsley sauce on the side.

Break the caramel sheet into a size of your preference and stick it in the macaroon.

Makes: 4 servings
Preparation time: 1 hour
Cooking time: 30 minutes

Seafood Puff with White Chocolate Beurre Blanc

PUFF PASTRY

1 sheet puff pastry, fresh

1 egg

Sea salt for seasoning

Preheat the oven to 180°C.

Cut the puff pastry sheet into 4 rectangles approximately 6.5 cm (2½ inch) by 10 cm (4 inch) in size.

Lightly beat the egg and, using a pastry brush, brush it onto the tops of the pastry cases.

Season the cases with sea salt and place into the preheated oven.

Bake for 12 to 15 minutes or until golden and crispy.

Once cooled, lay the pastry cases out on a serving plate.

WHITE CHOCOLATE BEURRE BLANC

45 gm (1½ oz) shallot, sliced

250 ml (8 fl oz) white wine

250 ml (8 fl oz) lemon juice

8 sprigs thyme, fresh

160 ml (8⅓ fl oz) heavy cream, 48%, fresh

100 gm (3½ oz) butter, unsalted, chilled

150 gm (5⅓ oz) white chocolate, high cocoa content

200 ml (6⅔ fl oz) milk (used in Assembly)

Salt and freshly ground black pepper for seasoning

In a small non-reactive saucepan add the shallots, wine, lemon juice and thyme. Bring the liquid to the boil and then reduce the heat. Simmer until the liquid has reduced by two thirds.

In a separate saucepan add the cream. Bring the cream to the boil. Lower the heat and allow the cream to simmer. Reduce the cream by a third.

While the liquids are reducing, cut the butter into small pieces.

Once the liquids have reduced, remove them from the heat. Strain the shallot, thyme and lemon mixture and add it to the cream.

Keep the saucepan warm. Slowly whisk in the butter, only adding 1–3 pieces at a time. Continue to whisk.

Whisk in the white chocolate until fully incorporated. Season with salt and pepper. Set the sauce aside.

SEAFOOD

45 ml (1½ fl oz) extra virgin olive oil

30 gm (1 oz) shallot, chopped

15 gm (½ oz) garlic, chopped

125 gm (4½ oz) sea scallops

8 prawns, peeled

125 gm (4½ oz) lobster meat

4 lobster claws

125 gm (4½ oz) white fish fillet

125 gm (4½ oz) salmon

125 gm (4½ oz) tuna

Salt and freshly ground black pepper for seasoning

Clean the seafood and season with salt and pepper.

Set a frying pan over a high heat and add the olive oil, shallots and garlic.

Once heated, add the seafood and cook for 2–3 minutes. Set aside on paper towels.

GARNISH

50 gm (2 oz) Mesclun salad mix

2 each edible flowers, purple, red and pink

20 ml (⅔ oz) olive oil

250 gm (9 oz) baby artichoke, fresh

30 gm (1 oz) green peas, fresh

Fish roe to garnish

Sauté the artichokes with the green peas.

Toss the Mesclun salad mix leaves and flowers in olive oil.

ASSEMBLY

Place the tossed salad in the centre of the plate.

Mix the seafood into the warm sauce and bring to the boil.

Divide the seafood between the pastry cases, then add some beurre blanc sauce.

Arrange the artichoke, peas and fish roe around the pastry cases.

Bring the milk (from the white chocolate beurre blanc recipe) to the boil in a pan and add a little of the beurre blanc sauce.

Blend the liquid with a hand-held blender until frothy. Spoon the froth around the plate just before serving.

Chef's tip: The puff pastry can be cut into fish-shaped cases.

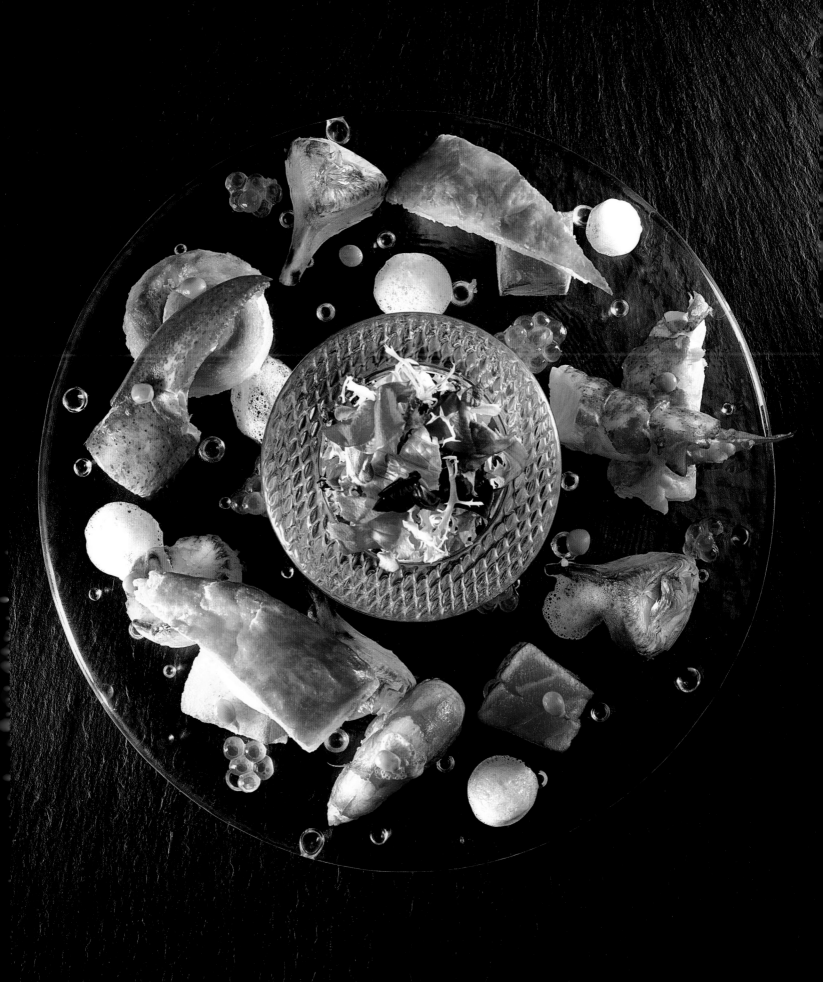

Makes: 4 servings
Preparation time: 3 hours
Cooking time: 10 minutes
Refrigeration time: 3 hours

Seared Tuna with Chilli and Chocolate Coulis

TUNA LOIN

25 ml (1 fl oz) sunflower oil

350 gm (11 oz) tuna loin, cleaned and trimmed, sushi grade

A pinch of dried chilli flakes

A pinch of fresh ground pepper

2½ tsp cocoa powder

Heat the sunflower oil in a skillet over a medium heat.

Place the tuna in the skillet and sear it on all 4 sides (20 seconds per side).

Remove the tuna and pat off the excess fat.

Mix the chilli, pepper and cocoa on a plate and roll the tuna evenly in the spices.

Wrap the tuna tightly in plastic wrap.

Refrigerate for at least 3 hours.

CHOCOLATE COULIS

25 gm (⅚ oz) brown sugar

25 gm (⅚ oz) red wine vinegar

80 ml (2½ fl oz) milk

20 gm (⅔ oz) praline[‡]

100 gm (3½ oz) dark chocolate, 64%

1 lime

Place the sugar in a saucepan and caramelise until golden brown. Deglaze the pan with red wine vinegar.

Pour the milk into the saucepan and bring to the boil.

Remove the saucepan from the heat and add the praline and chocolate. Stir the mixture until it becomes a smooth, glossy cream.

Zest and juice the lime, then gently stir the zest and juice into the mixture.

Reserve at room temperature.

ASSEMBLY

Slice the tuna and arrange on plates. Drizzle chocolate coulis around the tuna slices.

GARNISH

75 gm (2½ oz) red bell pepper, peeled and diced

20 gm (⅔ oz) cocoa nibs

4 wasabi leaves

8 kinome leaves

8 amaranth stalks with leaves

‡ *See Basic Recipes*

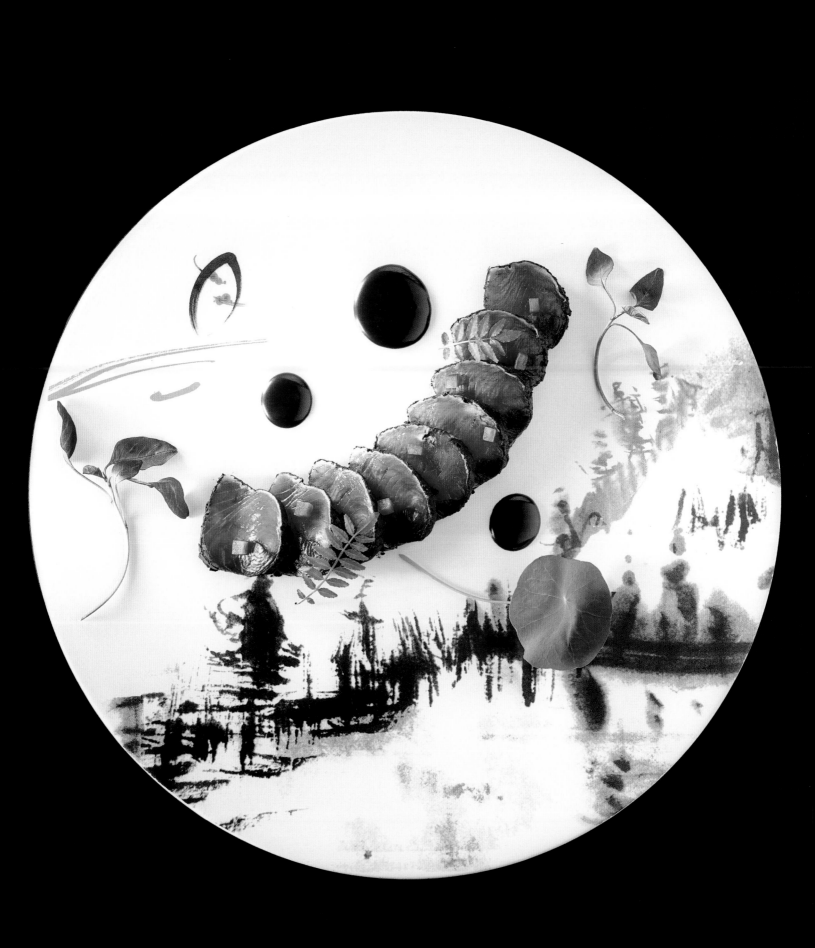

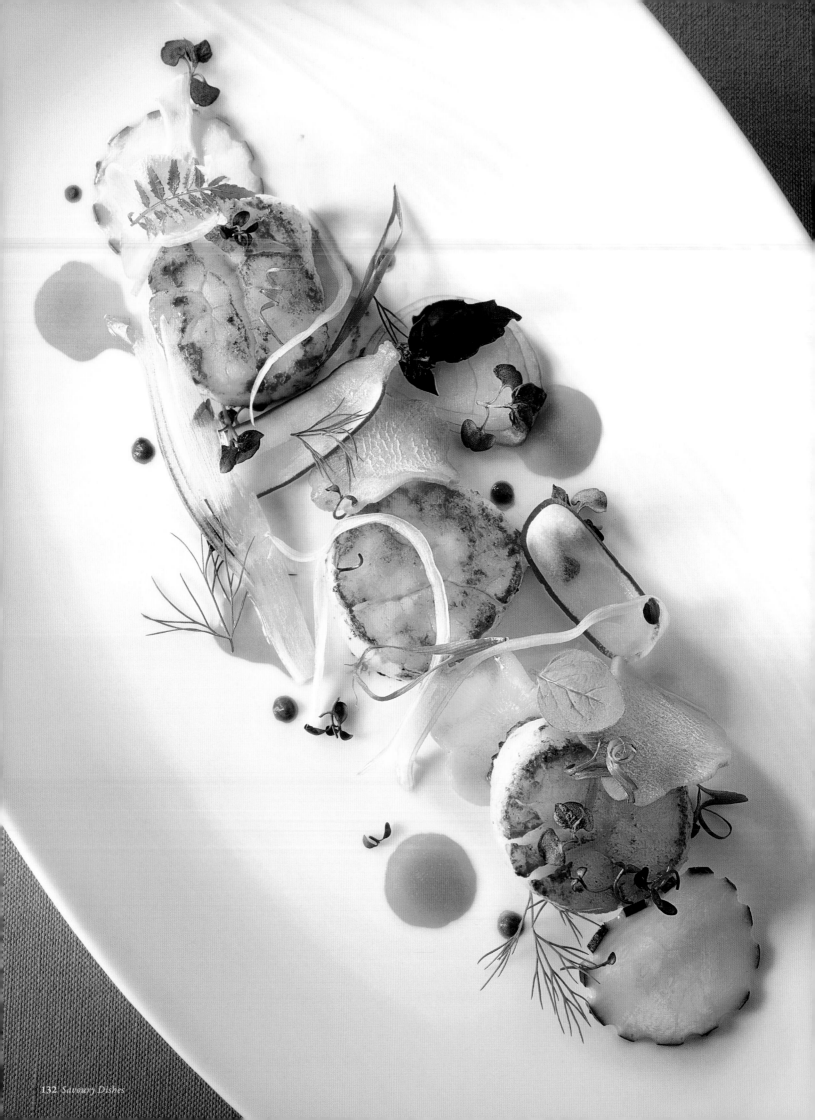

Makes: 4 servings
Preparation time: 1 hour
Cooking time: 10 minutes

Scallops Sautéed in Cocoa Butter with Tangy Vegetable Salad

TANGY VEGETABLE SALAD

2 oranges

1 lemon

1 lime

150 ml (5⅓ fl oz) extra virgin olive oil

Salt, caster sugar and cayenne pepper to taste

80 gm (3 oz) courgette, finely sliced

100 gm (3½ oz) yellow carrot, sliced

100 gm (3½ oz) orange carrot, sliced

80 gm (3 oz) fennel, finely shaved

40 gm (1½ oz) shallot, finely sliced

Zest and juice the oranges, lemon and lime.

Pour the juice into a saucepan.

Over a medium heat, reduce the juice by two thirds.

Add all the zest to the juice and bring to the boil. Remove from the heat.

Pour the liquid over the olive oil and seasoning.

When the marinade is warm to touch, pour it over the prepared vegetables and allow them to marinate for 30 minutes.

SCALLOPS

12 scallops, fresh

50 gm (2 oz) cocoa butter, finely grated

Salt and pepper to taste

Lightly dust the scallops with the cocoa butter and set aside.

Heat a frying pan with a drop of oil, place scallops in the pan and cook for 3–4 minutes. Lightly season with salt and pepper.

Deglaze with a tablespoon of the marinade and serve.

GARNISH

1 sprig dill

1 tsp purple basil

1 tsp myoga (ginger leaf)

2 tsp purple shiso leaves

1 red radish, thinly sliced

Arrange the tangy vegetable salad on plates, place scallops on top and drizzle with the salad marinade. Garnish with dill, basil, myoga, shiso and the radish slices.

DRINKS

Liquid chocolate dates back to the Mayan civilisation. Here, The Peninsula's chefs celebrate its original form with a repertoire that caters to any special occasion.

Hot chocolate is undeniably one of winter's saving graces. There are three *Naturally Peninsula* versions. Two are diet-be-damned indulgences – mercilessly rich and dark, best taken in dainty sips from china cups – as well as The Peninsula's Spa Chocolate, a lighter, yet equally decadent treat.

When circumstance calls for something stronger, the frothy White Mayan or the Chocolate Tiramisu Martini, with a 66 per cent chocolate coin, is the perfect libation. But be forewarned: the Snickers Vodka is more lethal than its dainty taste and high-art looks suggest.

Makes: 1 serving
Preparation time: 2 minutes
Cooking time: 10 minutes

The Peninsula Spa's Chocolate

125 ml (4½ fl oz) skimmed milk

40 gm (1¼ oz) sugar-free chocolate, grated

8 gm (¼ oz) cocoa powder

Place the milk in a saucepan and bring to a simmer.

Add the chocolate and cocoa powder and stir until the chocolate is melted.

Pour into a latte glass.

Note: Can be served hot or cold.

Chocolate Tiramisu Martini

14 ml (½ fl oz) dark crème de cacao liqueur
14 ml (½ fl oz) Kahlúa coffee liqueur
14 ml (½ fl oz) limoncello
1 chocolate coin, 66%
30 gm (1 oz) cocoa powder, in shaker or shifter

Place the crème de cacao, Kahlúa and limoncello
in a cocktail shaker and shake well for 1 minute.

Pour into a martini glass.

Drop in the chocolate coin.

Dust with cocoa powder.

GARNISH

Place a chocolate curl† at an angle on one side of
the glass, slightly submerged in the martini.

† See Kitchen Techniques

Makes: 1 serving
Preparation time: 10 minutes
Cooking time: 20 minutes

Hot Chocolate

100 gm (3⅓ oz) heavy cream, 38%, fresh

100 ml (3⅓ fl oz) soya milk

50 gm (2 oz) cocoa powder

50 gm (2 oz) sugar, powdered

50 gm (1⅔ oz) milk chocolate

Place the cream and soya milk in a saucepan and bring to a simmer.

Whisk in the cocoa powder and sugar, and simmer for 3 minutes, stirring occasionally.

Turn off the heat and add the milk chocolate.

Stir until the chocolate has melted.

Once combined, pour into a cup.

GARNISH

Serve with a chocolate stick†, sheet and shaving.

† See Kitchen Techniques

Makes: 1 serving
Preparation time: 20 minutes
Refrigeration time: 1 week

Snickers Vodka

50 gm (1⅔ oz) Snickers bar, finely chopped
90 ml (3 fl oz) vodka

Using a funnel, place the Snickers pieces in an empty screw-top bottle.

Pour the vodka into the bottle, over the top of the Snickers.

Shake and store in a refrigerator.

Shake daily for one week.

Strain the Snickers pieces from the liquid and return the liquid to the bottle until ready for use.

Serve in a martini glass.

GARNISH

Decorate with a Snickers bar and peanuts.

Makes: 1 serving
Preparation time: 10 minutes

Choco-licious

1 scoop passion fruit ice cream
1 scoop chocolate ice cream
40 ml (1⅓ fl oz) banana liqueur
20 ml (⅔ fl oz) chocolate syrup
20 ml (⅔ fl oz) chocolate sauce
½ banana, peeled

Place one scoop of passion fruit ice cream into a martini glass and set aside.

Place all the remaining ingredients in a blender and blitz for 20 seconds or until smooth. Pour over the passion fruit ice cream.

GARNISH

Decorate with chocolate plates.

Note: Chocolate syrup is syrup with chocolate, water and sugar. Chocolate sauce is sauce with chocolate, milk and sugar. Both products are readily available in retail outlets.

Makes: 1 serving
Preparation time: 10 minutes
Cooking time: 10 minutes

White Chocolate and Raspberry Frappé

180 ml (6 fl oz) milk
100 gm (3½ oz) white chocolate
375 ml (6 fl oz) ice, crushed
2 shots espresso coffee
30 gm (1 oz) caster sugar
30 gm (1 oz) raspberries

Place the milk and white chocolate in a saucepan and heat until the chocolate has melted. Allow to cool to room temperature.

Place the combined melted chocolate and milk, ice, espresso coffee, sugar and raspberries in a blender and blitz until smooth.

GARNISH

15 ml (½ fl oz) heavy cream, 38%, fresh, whipped
6 pink biscuits

Garnish with whipped cream and pink biscuits.

PINK BISCUIT GARNISH (10 PIECES)

1 egg
30 gm (1 oz) cake flour
30 gm (1 oz) sugar, granulated
A pinch of red colouring powder

Preheat the oven to 160°C (325°F).

Separate the egg yolk and egg white.

Place the granulated sugar and the egg white in a bowl and whisk until well combined.

Whisk in the egg yolk.

Melt the red colouring in a teaspoon of water and add it to the mixture.

Add the cake flour and mix well until it forms a dough.

Roll the dough into a long, thin rectangle and place it on a baking sheet.

Bake in the oven for 10 minutes.

Remove and allow to cool. Once cool, cut the biscuit into a shape of your preference and use as garnish.

Makes: 1 serving
Preparation time: 5 minutes
Cooking time: 20 seconds

Chocolate Kiss

40 ml (1⅓ fl oz) white cacao liqueur

50 ml (1⅔ fl oz) vodka

10 ml (⅓ fl oz) chocolate syrup

14 ml (½ fl oz) chocolate sauce

2 tsp cocoa powder

1 tsp chocolate nibs

Note: Chocolate syrup is syrup with chocolate, water and sugar. Chocolate sauce is sauce with chocolate, milk and sugar. Both products are readily available in retail outlets.

Place all the ingredients in a blender and process for 20 seconds, until well incorporated and smooth.

Pour the drink into a rock glass and decorate with some chocolate nibs.

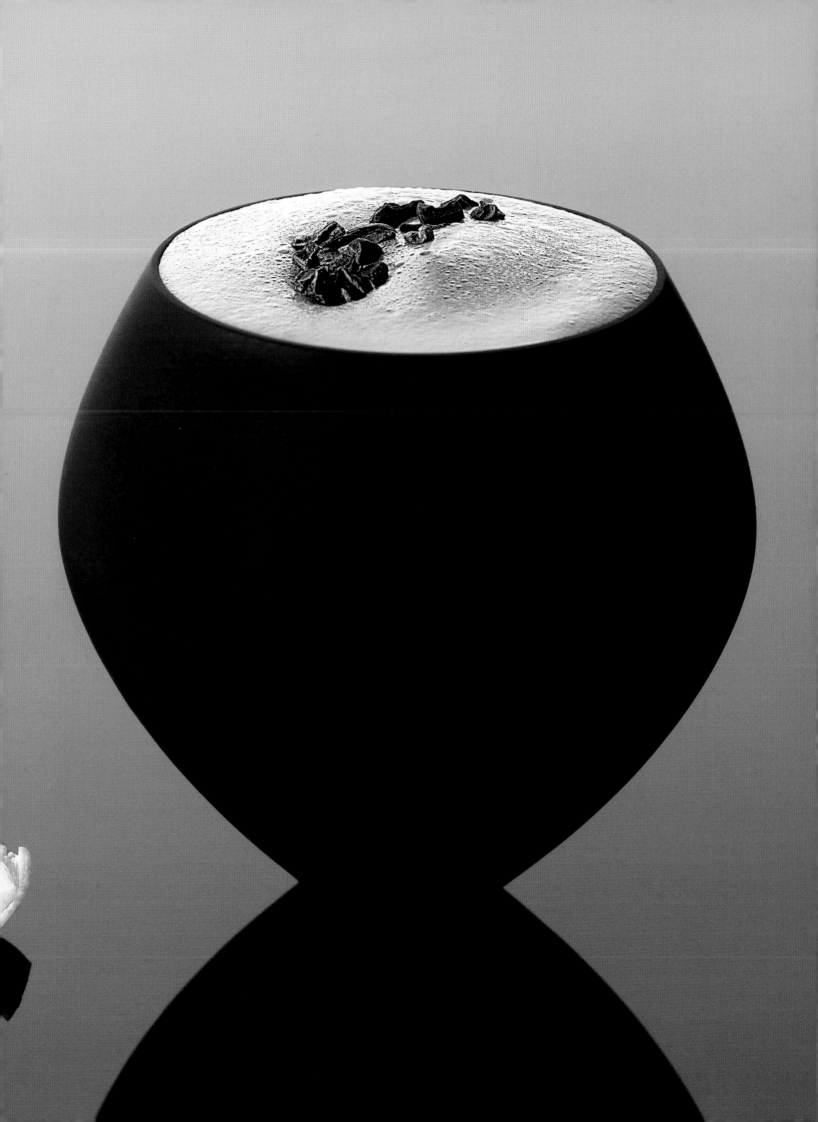

Chocoluxe Martini

CARAMEL CREAM

200 gm (7 oz) caster sugar
50 gm (1⅔ oz) glucose
250 ml (8 fl oz) heavy cream, 38%, fresh
50 ml (1⅔ fl oz) caramel syrup
250 gm (8 oz) whipped cream, firm

Place the sugar and glucose in a saucepan and heat over a medium heat until golden brown.

Remove the saucepan from the heat.

Carefully stir in the cream.

Add the caramel syrup and gently stir.

Allow the liquid to cool to room temperature.

Once the liquid is cool, fold through the whipped cream. Set aside.

ASSEMBLY

40 ml (1⅓ fl oz) vodka
30 ml (1 fl oz) Kahlúa coffee liqueur
10 ml (⅓ fl oz) Baileys Irish Cream liqueur
10 ml (⅓ fl oz) crème de cacao, brown
10 ml (⅓ fl oz) chocolate liqueur

Pour the cooled caramel cream and the other ingredients into a cocktail shaker and shake well.

GARNISH

Pour the drink into a glass and top with foamed cream and a chocolate leaf.

White Mayan

60 ml (2 fl oz) cocoa tequila

50 ml (1½ fl oz) coffee liqueur

1 shot espresso

125 gm (4 oz) ice

1 Tbsp heavy cream, 38%, fresh, whipped

Place the tequila, coffee liqueur and espresso in a cocktail shaker. Shake well.

Crush the ice in a blender and place in a rocks glass (tumbler).

Pour the combined alcohol over the ice.

Float the whipped cream.

GARNISH

Decorate with chocolate sauce, cocoa powder and fresh mint.

Makes: 1 serving
Preparation time: 20 minutes
Cooking time: 20 minutes

Sago Chocolate Tea

SAGO

100 ml (3⅓ fl oz) boiling water

10 gm (⅓ oz) sago pearls

Place the water and sago pearls in a saucepan and bring to a simmer. Simmer for 5 minutes or until ready.

The pearls will be ready once they are chewy and jelly-like all the way through.

CHOCOLATE TEA SHAKE

10 ml (⅓ fl oz) Oolong tea

35 gm (1⅙ oz) dark chocolate, 70%

180 ml (6 fl oz) coconut milk, unsweetened

Seeds of ¼ vanilla pod

25 gm (⅚ oz) caster sugar

Place the hot tea in a bowl and add in the chocolate. Stir until the chocolate melts.

Place the melted chocolate liquid and the remaining ingredients in a blender. Blitz until smooth.

ASSEMBLY

Place the sago pearls at the bottom of a glass.

Pour the chocolate tea shake over the pearls.

GARNISH

Top with whipped cream and chocolate curls†.

† See Kitchen Techniques

All About Chocolate

VODKA LIQUEUR

40 ml (1⅓ fl oz) vodka

25 ml (⅘ fl oz) Kahlúa coffee liqueur

30 gm (1 oz) ice

Place the vodka and Kahlúa in a cocktail shaker and shake well.

BAILEYS CAVIAR

100 ml (3⅓ fl oz) Baileys Irish Cream liqueur

100 gm (3⅓ fl oz) algin mix

Drizzle Baileys into the algin mix to form small droplets. Refresh in ice water. Set aside.

MILK CHOCOLATE ESPUMA

400 ml (13 fl oz) heavy cream, 38%, fresh

60 ml (2 fl oz) chocolate syrup

200 ml (6⅔ fl oz) milk chocolate, grated

Place the cream and chocolate syrup in a saucepan and bring to the boil.

Place the chocolate in a bowl and pour the cream and syrup mixture over the chocolate. Mix well and then cool in ice water.

Pour the mixture into a gas canister and charge with two gas cartridges.

Store in the refrigerator until needed.

ASSEMBLY

Pour the liqueur and ice into a glass, add the Baileys caviar and finish with the espuma.

The Peninsula's Hot Chocolate

45 gm (1¼ oz) cocoa powder

180 ml (6 fl oz) milk

35 gm (1⅕ oz) milk chocolate 43%

2 Tbsp milk foam (frothed milk)

30 gm (1 oz) heavy cream, 38%, fresh, whipped

15 gm (½ oz) cocoa nibs

Place the cocoa powder and milk in a saucepan and, using a steam wand, heat the liquid to make a frothy chocolate milk.

Pour the heated chocolate milk into a teapot and set aside.

Melt† the chocolate and pour it into a cup.

To serve, pour the chocolate milk from the teapot, into the cup, add the milk foam.

GARNISH

Top with whipped cream and cocoa nibs of your choice. Add sugar, if desired.

† See Kitchen Techniques

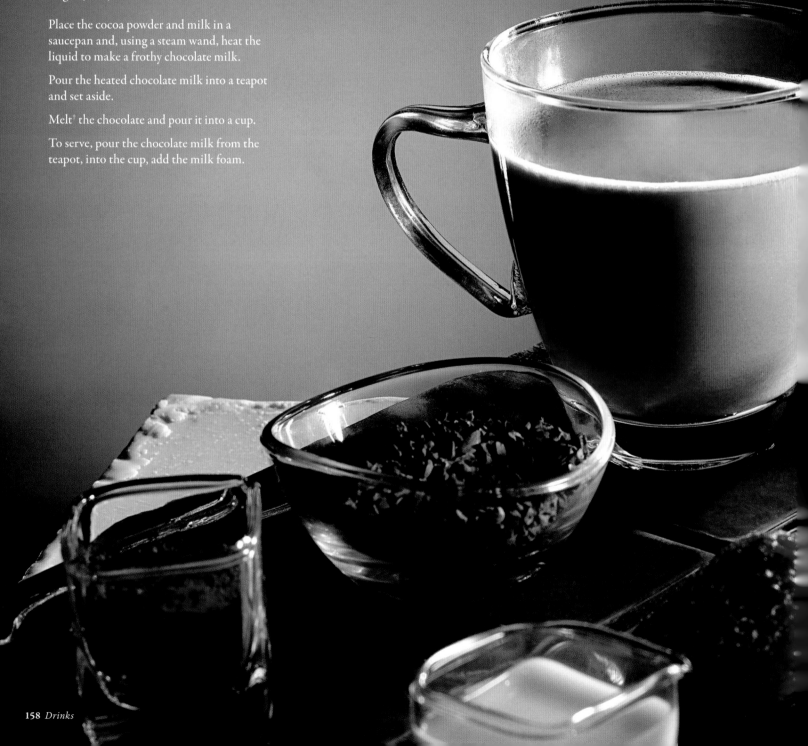

Makes: 1 serving
Preparation time: 15 minutes
Cooking time: 10 minutes

CHOCOLATE
FOR KIDS

Kids love chocolate. They love shopping for it, cooking it and eating it. At The
Peninsula, we believe there is no such thing as "children's food". Good food
should be shared by all. That is why in this chapter you will find recipes that
use only the highest quality ingredients – albeit with techniques that are easier
for little fingers.

From the simple, three-step Chocolate-Covered Popcorn to the more complex
Chocolate Grissini with Hazelnut Spread, there is a recipe to suit all levels
of budding gourmands. Several of these recipes are taught at The Peninsula's
Kids Academy, so we understand how to engage children with food in a
creative way. For parents, there are delicious advantages to nurturing a child's
love of cooking. Just sit back and wait to be served.

Makes: 20 pieces
Preparation time: 1 hour
Cooking time: 1 hour
Refrigeration time: 30 minutes

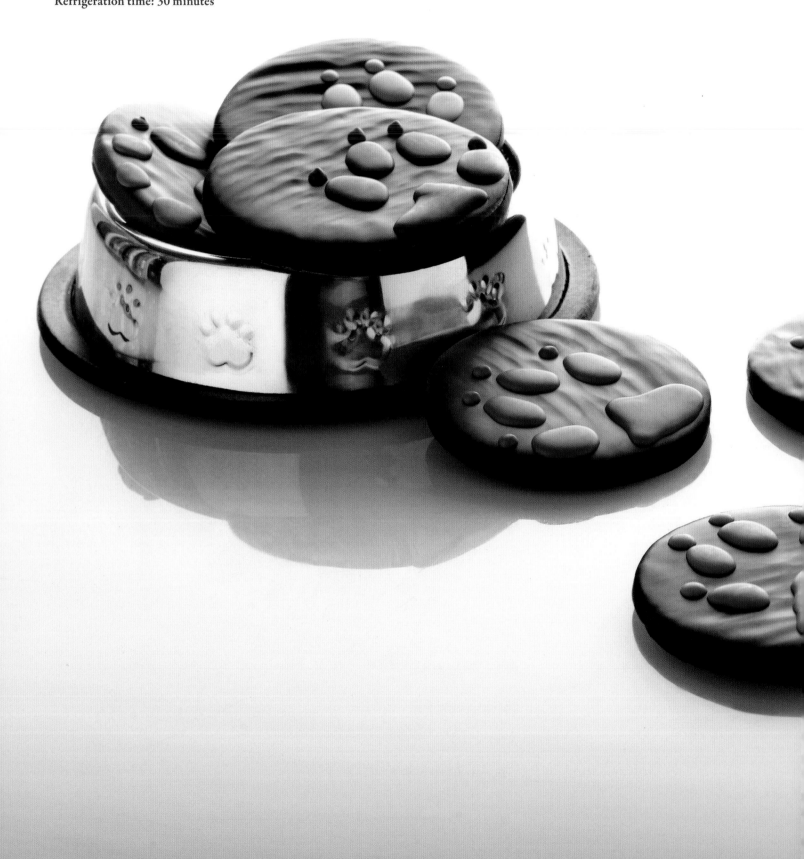

"My Puppy" Shortbread Biscuit

135 gm (4¾ oz) butter

120 gm (4½ oz) caster sugar

2 tsp salt

55 gm (2 oz) egg yolks

180 gm (6 oz) plain flour, sifted

2 tsp baking powder, sifted

100 gm (3½ oz) dark chocolate, 61%

100 gm (3½ oz) milk chocolate, 43%

Place the butter, sugar and salt in the bowl of a free-standing electric mixer and whisk to a smooth paste.

Slowly add the egg yolks until incorporated.

Fold in the cake flour and baking powder. Beat until combined.

Remove the mixture from the bowl and wrap in plastic wrap. Refrigerate for half an hour.

Preheat the oven to 160°C (325°F).

Roll out the dough on non-stick baking paper or a lightly floured surface until 6 mm (¼ inch) thick. Cut out the dough using a 7 cm (2⅔ inch) round cookie cutter and place the biscuits on a non-stick baking mat on a baking tray. Bake for 12 to 15 minutes or until golden brown.

Allow the shortbread biscuits to cool on the trays.

Temper† the dark chocolate, then dip† the biscuits into it.

Melt† the milk chocolate and use it to design a dog paw print on each biscuit.

† See Kitchen Techniques

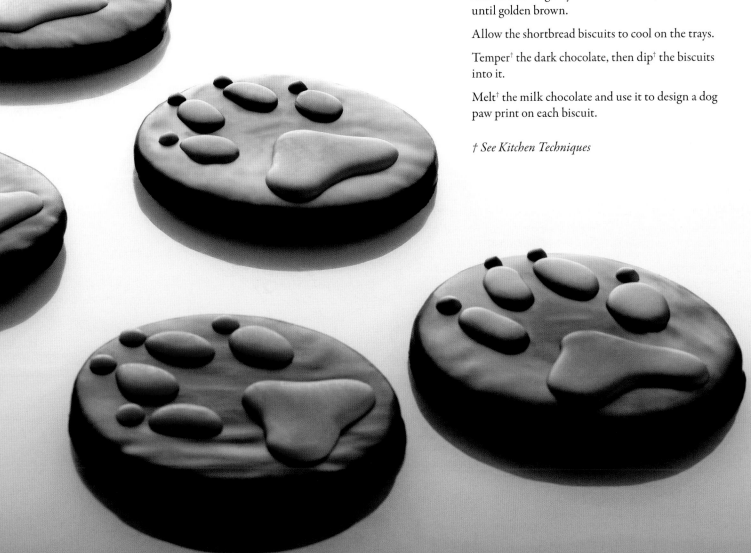

Crunchy Cookie Lollipop

Makes: 20 pieces
Preparation time: 15 minutes
Cooking time: 35 minutes

125 gm (4½ oz) butter

75 gm (2¾ oz) brown sugar

50 gm (1⅘ oz) caster sugar

1½ tsp salt

50 gm (5 oz) eggs

150 gm (1 oz) plain flour

30 gm (⅛ oz) cocoa powder

2½ tsp baking soda

125 gm (12⅓ oz) dark chocolate, 70%

350 gm (12⅖ oz) chocolate chips

Preheat the oven to 160°C (325°F).

Place the butter, brown sugar, caster sugar and salt in the bowl of a free-standing electric mixer. Beat to a smooth paste.

Slowly add the eggs until incorporated, then fold in the flour, cocoa powder and baking soda.

Melt† the chocolate together with the chocolate chips and incorporate into the flour mixture.

Use an ice cream scoop to portion the dough and shape into balls. Pierce each ball with a a skewer. Place the balls onto a tray lined with baking paper and bake in the preheated oven for 12 to 15 minutes.

Allow to cool on a baking tray.

CHOCOLATE GLAZE

100 gm (3½ oz) dark chocolate, 64%

20 ml (1¼ fl oz) vegetable oil

Melt† the chocolate and stir in the oil.

Cool the mixture to 35°C (95°F).

ASSEMBLY

Dip† the lollipops in the glaze and leave to set before serving.

† See Kitchen Techniques

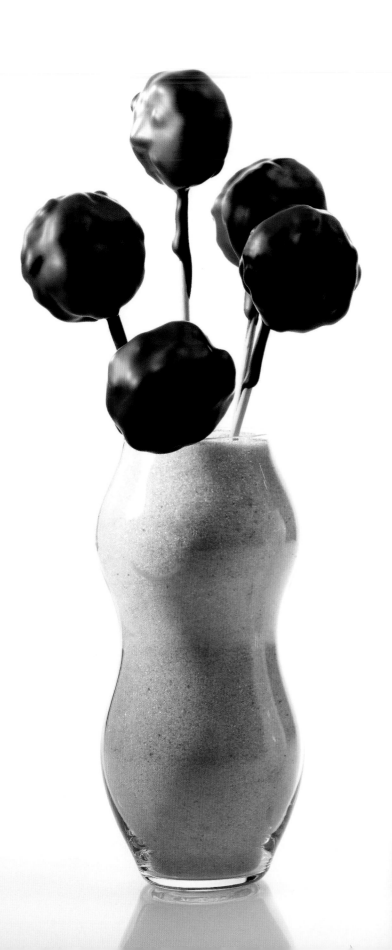

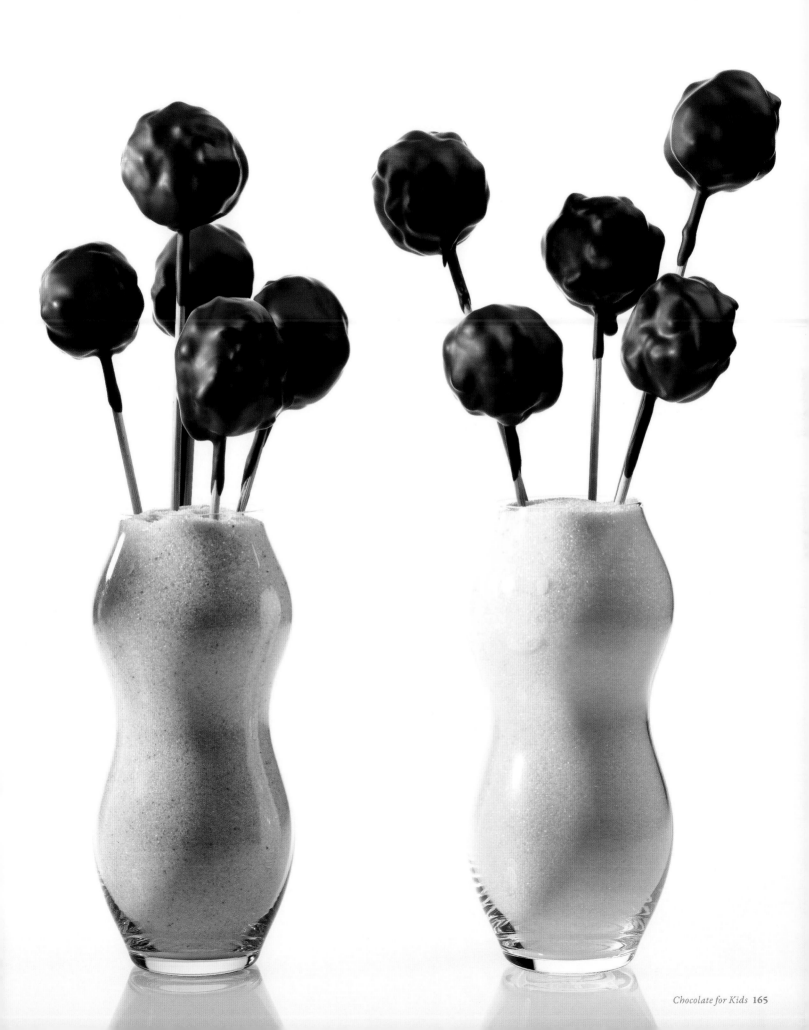

Makes: 30 pieces
Preparation time: 10 minutes
Cooking time: 20 minutes

Chocolate Brownie

80 gm (3 oz) dark chocolate, 70%, chopped

150 gm (5¼ oz) butter

130 gm (4⅗ oz) eggs

200 gm (7⅕ oz) caster sugar

35 gm (1¼ oz) plain flour, sifted

15 gm (½ oz) cocoa powder, sifted

80 gm (2⅖ oz) pecans, chopped

Preheat the oven to 170°C (338°F). Grease a 26 cm (9 inch) square baking tray.

Melt the chocolate and butter over a bain-marie.

In an electric mixer, whisk the eggs and sugar on high speed. Slowly incorporate all the remaining ingredients into the mixer.

Pour mixture into baking tray.

Bake in the preheated oven for 20 minutes.

Set aside to cool, and then cut the chocolate brownie into even square shapes.

Chocolate Marshmallow Lollipop

CHOCOLATE MARSHMALLOW LOLLIPOPS

227 gm (8 oz) caster sugar

71 gm (2½ oz) trimoline

121 gm (4½ oz) water

3 sheets gelatine

100 gm (3½ oz) dark chocolate, 70%, melted

100 gm (3½ oz) trimoline

600 gm (1 lb) dark chocolate, 70%

Makes: 20 pieces
Preparation time: 20 minutes
Cooking time: 1 hour
Refrigeration time: 12 hours

Place the sugar, 71 gm (2½ oz) of trimoline and water in a saucepan and heat to 120°C (248°F).

Soak the gelatine in cold water. Once it is softened, place it in a mixing bowl with 100 gm (3½ oz) of trimoline.

Pour the hot liquid into the mixing bowl and whisk continuously for 15 minutes or more, until the mix resembles a meringue.

Once the meringue has formed, melt† the 100 gm (3½ oz) of chocolate and gently fold it through the meringue.

Immediately spoon the chocolate marshmallow mixture into a piping bag and pipe into 2.5 cm (1 inch) wide silicone rubber moulds.

Leave to set in the refrigerator for at least 12 hours.

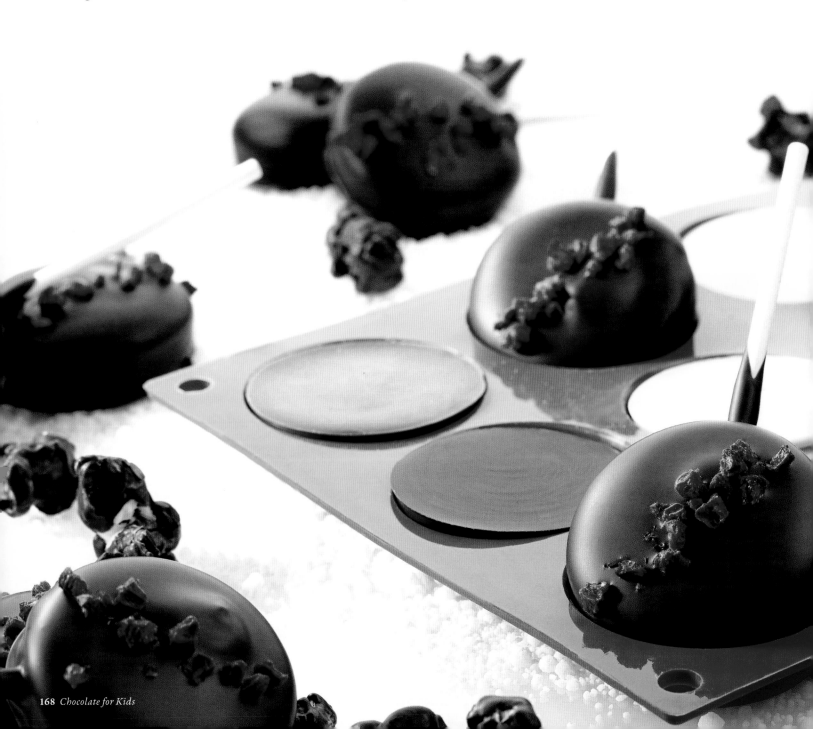

and Chocolate-Covered Popcorn

Remove the marshmallows from the moulds. Insert a lollipop stick into the side of each marshmallow disc.

Temper† the 600 gm (1 lb) of chocolate. Dip and coat each marshmallow lollipop in tempered chocolate.

Place the lollipops on a tray lined with baking paper and allow them to set.

GARNISH

Dried raspberries to garnish

Just before the chocolate has set, decorate the lollipops with dried raspberries.

CHOCOLATE-COVERED POPCORN

100 gm (3½ oz) microwave popcorn

600 gm (1 lb) dark chocolate, 53%

Microwave the popcorn according to the packet instructions. Once cooked, open the packet and spread popcorn onto a tray. Allow popcorn to cool.

Temper† the chocolate. Place tempered chocolate in a mixing bowl.

Gather 5 to 6 pieces of popcorn and dip them together into the chocolate, to form a cluster.

Once fully coated, place each popcorn cluster on a tray lined with baking paper. Allow clusters to set.

Store in an airtight container until served.

† See Kitchen Techniques

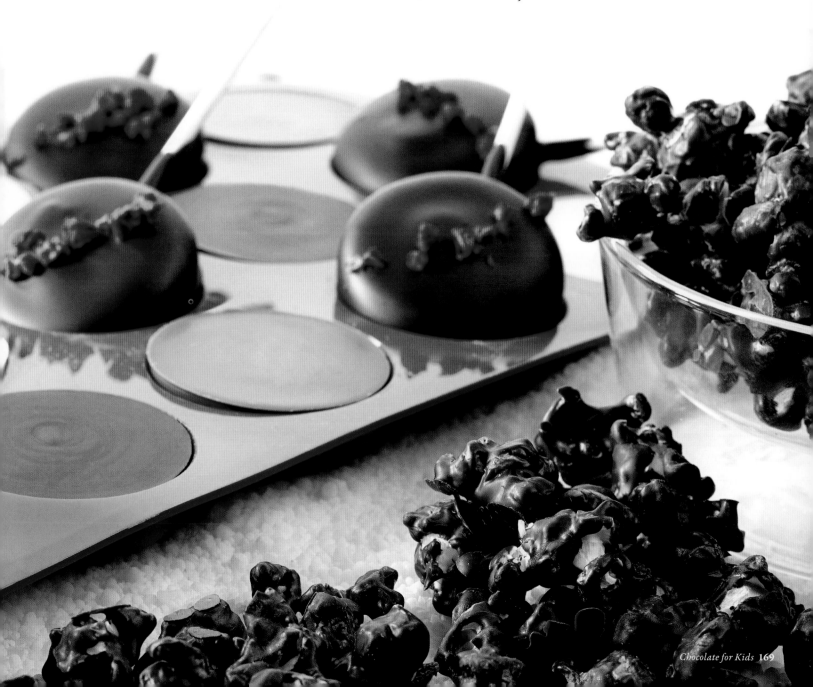

Makes: 16 pieces
Preparation time: 20 minutes
Cooking time: 20 minutes
Refrigeration time: 12½ hours

Chocolate Cupcake

CUPCAKES

113 gm (4 oz) eggs

400 gm (16 oz) caster sugar

151 ml (5½ fl oz) vegetable oil

66 gm (2½ oz) yoghurt, plain, full-fat

125 gm (4½ oz) sour cream

200 ml (7 fl oz) milk

226 gm (8 oz) plain flour

9 gm (⅓ oz) baking soda

103 gm (3½ oz) cocoa powder

Preheat the oven to 160°C (325°F). Line a muffin tray with paper cases.

Mix eggs, sugar, oil, yoghurt, sour cream and milk.

Sift the flour, baking soda and cocoa powder. Mix this into the egg mixture.

Pipe or spoon the mixture into the paper cases.

Bake the cupcakes for approximately 15 to 20 minutes.

Place on a cooling rack until cold.

WHIPPED GANACHE

112 gm (4 oz) heavy whipping cream, 38%

14 gm (½ oz) glucose

190 gm (6½ oz) dark chocolate, 70%

450 gm (15 fl oz) heavy cream, 38%, cold

Combine the whipping cream with the glucose in a saucepan. Bring to the boil. Once bubbling, pour in the chopped dark chocolate.

Mix until all the chocolate has melted; pour in the cold cream. Place in the refrigerator and leave for at least 12 hours.

Take the chocolate cream and whisk to a firm consistency.

ASSEMBLY

Spoon the cream into a piping bag and pipe onto the cupcakes.

The cupcakes may be served at this stage or further decorated with coloured discs and fruit.

GARNISH

Coloured chocolate discs

100 gm (3½ oz) orange cocoa butter

100 gm (3½ oz) pink cocoa butter

100 gm (3½ oz) green cocoa butter

300 gm (10⅔ oz) white chocolate, 38%

Melt the cocoa butter and, using an airbrush spray, spray the cocoa butter onto cellophane sheeting.

Allow the cocoa butter to dry, then coat it with a thin layer of chocolate.

Once the chocolate has hardened, cut discs in three different sizes, then layer on top of the cupcake with ganache in between.

Fruit

40 gm (1⅓ oz) pineapple

40 gm (1⅓ oz) kiwi

40 gm (1⅓ oz) mango

15 gm (½ oz) raspberry

Place a piece of fruit on top of the top disc of each cupcake (match the colour of the fruit to the colour of the disc).

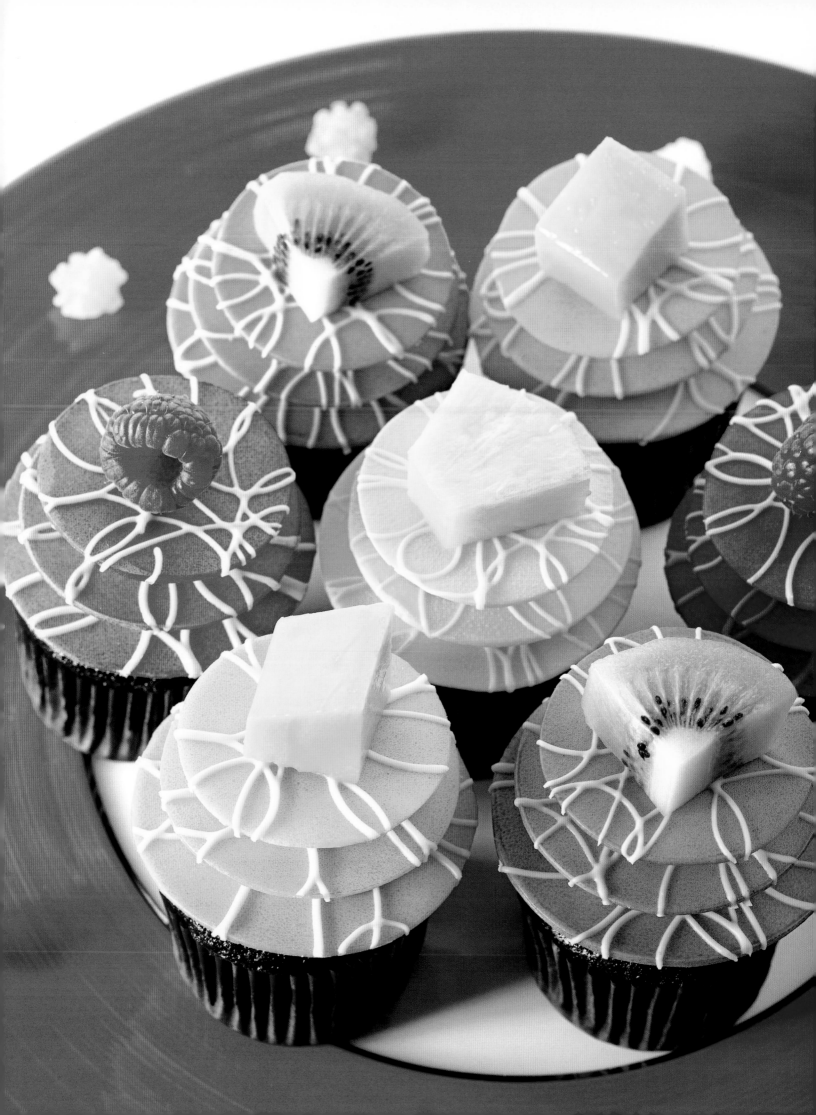

Makes: 12 pieces
Preparation time: 2 hours
Cooking time: 30 minutes

Chocolate Cornetto

CORNETTO BASE

60 gm (2 oz) cocoa butter, divided in 3 portions

½ tsp red colour powder

½ tsp yellow colour powder

½ tsp green colour powder

200 gm (7 oz) white chocolate, 28%

Melt 1 portion of the cocoa butter and mix well with the red colour powder, using a hand-held beater.

Repeat for the yellow and green colour powders.

Splash the coloured cocoa butter onto plastic cornetto moulds.

Melt† the white chocolate and pour it into the cornetto moulds to create the cornetto base.

Once the chocolate is set, take it out of the moulds.

BUTTER CREAM

10 gm (⅓ oz) egg white

30 gm (1 oz) caster sugar

10 ml (⅓ fl oz) water

¼ tsp salt

67 gm (2½ oz) margarine, soft

58 gm (2 oz) dark chocolate, 70.4%

6 gm (⅕ oz) cocoa powder

Place the egg white and salt in a mixing bowl of a free-standing electric mixer with a whisk attachment. Set aside, do not start whisking.

Place the sugar and the water in a saucepan and bring to the boil, stirring well.

When the syrup reaches 115°C (239°F), start to whisk the egg white.

Once the syrup reaches 118°C (244.4°F) pour it into the egg white and continue to whisk until a meringue forms.

Keep whisking until the mixture is at room temperature.

Once the mixture has cooled add the soft margarine.

Next, add the chocolate and the cocoa powder. Mix well.

Spoon the mixture into a piping bag with a star nozzle.

GARNISH

30 gm (1 oz) kiwi

30 gm (1 oz) raspberry

30 gm (1 oz) blueberry

30 gm (1 oz) pineapple

ASSEMBLY

Pipe the cream into the chocolate cornetto base.

Top with freshly cut fruit.

† See Kitchen Techniques

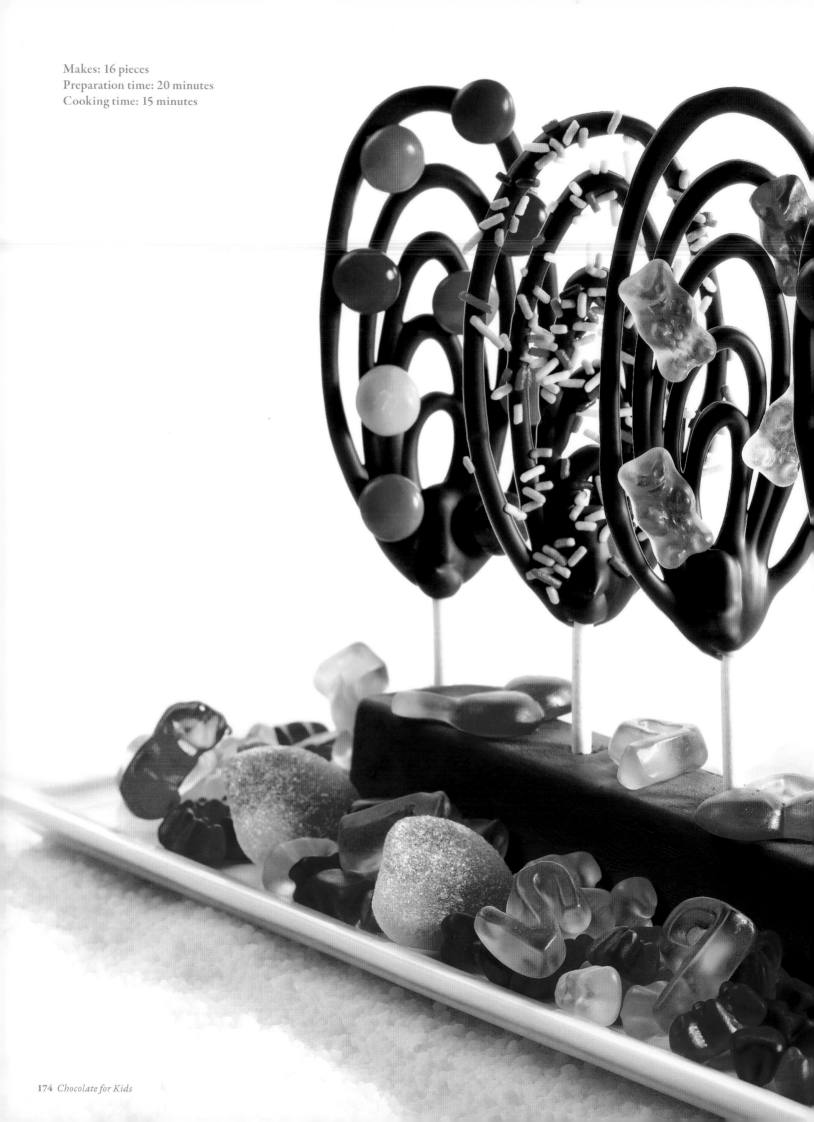

Makes: 16 pieces
Preparation time: 20 minutes
Cooking time: 15 minutes

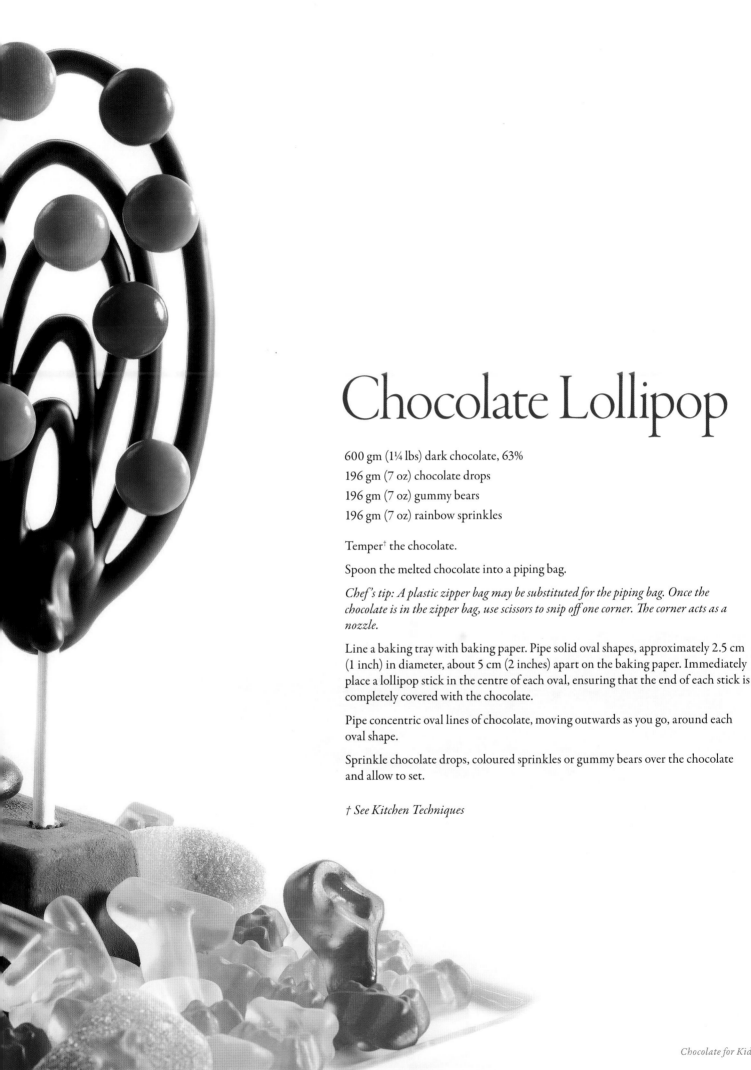

Chocolate Lollipop

600 gm (1¼ lbs) dark chocolate, 63%

196 gm (7 oz) chocolate drops

196 gm (7 oz) gummy bears

196 gm (7 oz) rainbow sprinkles

Temper† the chocolate.

Spoon the melted chocolate into a piping bag.

Chef's tip: A plastic zipper bag may be substituted for the piping bag. Once the chocolate is in the zipper bag, use scissors to snip off one corner. The corner acts as a nozzle.

Line a baking tray with baking paper. Pipe solid oval shapes, approximately 2.5 cm (1 inch) in diameter, about 5 cm (2 inches) apart on the baking paper. Immediately place a lollipop stick in the centre of each oval, ensuring that the end of each stick is completely covered with the chocolate.

Pipe concentric oval lines of chocolate, moving outwards as you go, around each oval shape.

Sprinkle chocolate drops, coloured sprinkles or gummy bears over the chocolate and allow to set.

† See Kitchen Techniques

Makes: 60 pieces
Preparation time: 10 minutes
Cooking time: 1 hour
Refrigeration time: 2 hours

Crispy Rice Lollipop

30 gm (1 oz) butter

220 gm (7⅓ oz) marshmallow

160 gm (5½ oz) rice crispies/rice bubbles

70 gm (2½ oz) hazelnut paste

40 gm (1¼ oz) marshmallow, cut into small cubes

500 gm (1 lb 1½ oz) milk chocolate

100 gm (3½ oz) cocoa butter

Place the butter in a saucepan and melt over a medium heat.

Add the 220 gm (7⅓ oz) of marshmallow, rice crispies and hazelnut paste to the saucepan and stir well.

Once the marshmallow has melted and the ingredients are well combined remove the saucepan from the heat and add the marshmallow cubes.

Line the base and sides of a 23 cm (9 inch) square cake tin with baking paper.

Pour the mixture into the cake tin and allow to set in the refrigerator.

Once set, cut into cubes approximately 2.5 cm (1 inch) square.

Pierce each cube with a bamboo skewer or lollipop stick.

Melt† the milk chocolate and cocoa butter and combine them in a bowl.

Dip† each cube in the chocolate and sit on a baking tray lined with baking paper.

Allow the chocolate to set.

† See Kitchen Techniques

Makes: 16 pieces
Preparation time: 15 minutes
Cooking time: 15 minutes
Refrigeration time: 12 hours

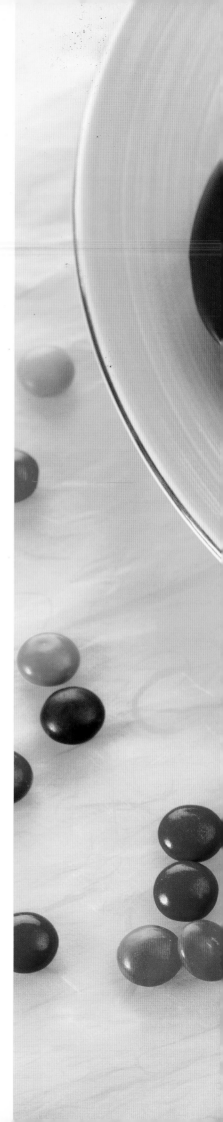

Cheerful Chocolate Cookie

100 gm (3½ oz) margarine, soft

180 gm (6½ oz) brown sugar

1 tsp salt

6½ ml (⅕ fl oz) vanilla extract

65 gm (2⅓ oz) eggs

225 gm (8 oz) wholewheat flour

10 gm (⅓ oz) baking powder

Place the margarine, brown sugar, salt and the vanilla extract in the bowl of a free-standing electric mixer.

Mix with the paddle attachment at a low speed.

Add the eggs slowly.

Add the sifted flour and baking powder. Mix until combined.

Remove the mixture from the bowl and wrap in plastic. Keep overnight in the refrigerator.

The following day, preheat the oven to 150°C (300°F).

Roll out the dough on non-stick baking paper or a lightly floured surface until 5 mm (¼ inch) thick. Cut out the dough using a 7 cm (2⅔ inch) round cookie cutter and place the cookies on a non-stick baking mat on a baking tray. Bake for 9 to 12 minutes or until golden brown.

Cool on cooling trays.

COATING AND DECORATION

100 gm (3½ oz) chocolate, 70% or 34% or white

10 gm (⅓ oz) cocoa butter

100 gm (3½ oz) coloured button-shaped chocolate candies

Melt† the chocolate of your choice and mix in the cocoa butter.

Temper† the chocolate.

Immediately coat the cookies with chocolate.

Decorate each cookie with 2 drops of white chocolate for the eyes, and 3 button-shaped candies for eyeballs and a nose.

† See Kitchen Techniques

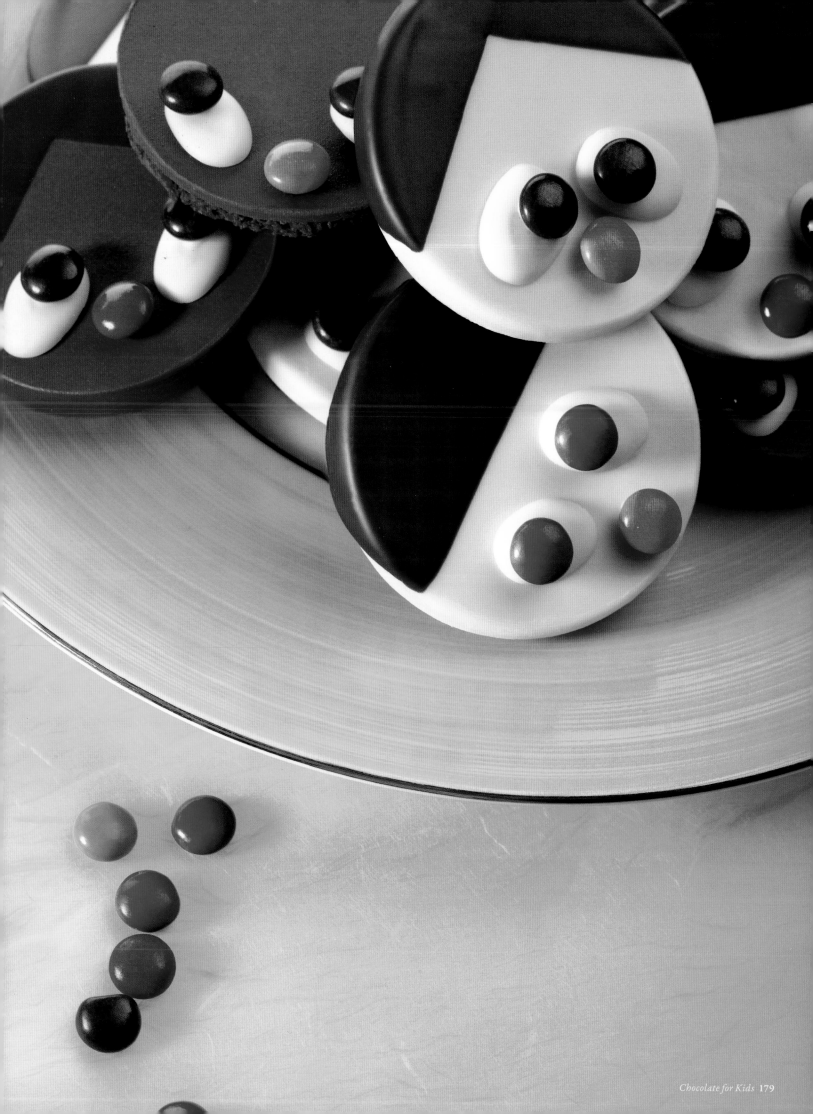

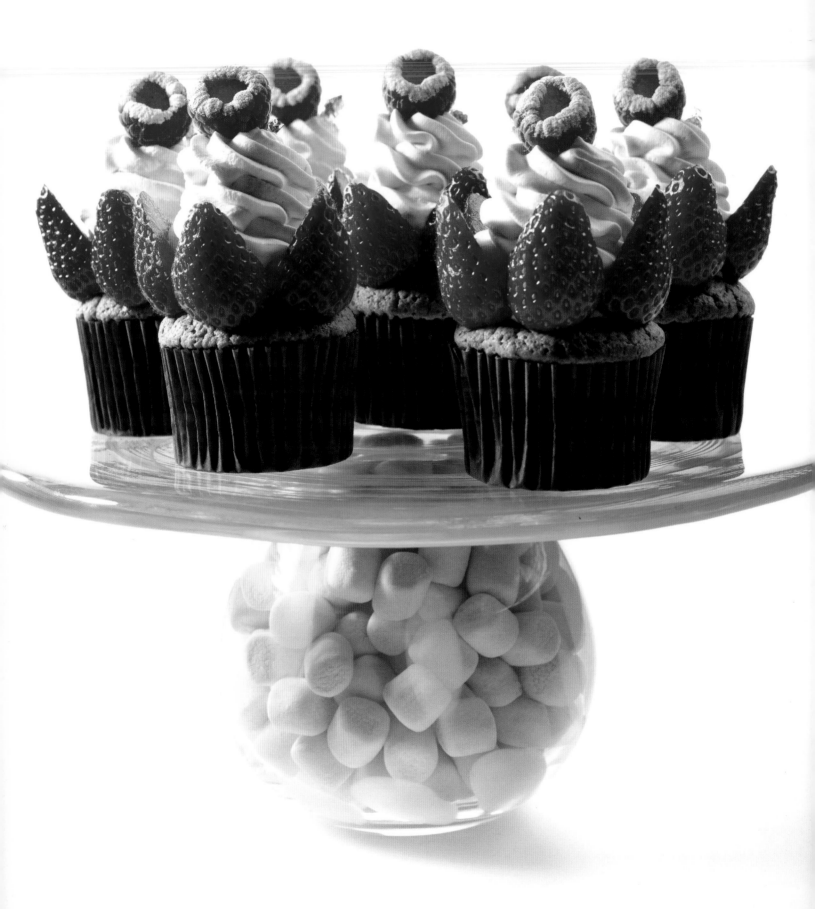

Makes: 12 pieces
Preparation time: 1 hour
Cooking time: 1½ hours
Refrigeration time: 12 hours

Chocolate and Strawberry Cupcake

CHOCOLATE CUPCAKES

90 gm (3 oz) almond powder

90 gm (3 oz) brown sugar

50 gm (1¾ oz) eggs

20 gm (⅔ oz) egg yolk

40 gm (1½ oz) plain flour, sifted

A pinch of baking powder, sifted

60 gm (2 oz) dark chocolate

70 gm (2½ oz) butter

90 gm (3 oz) egg whites

A pinch of salt

Preheat the oven to 150°C (300°F).

Place the almond powder, sugar, eggs, egg yolk, flour and baking powder in the bowl of a free-standing electric mixer and use the whisk attachment to whisk for 5 minutes on medium speed.

Melt† the chocolate and butter and pour into the mixing bowl.

In a separate bowl whisk the egg whites and salt.

Slowly fold the egg whites into the chocolate mixture.

Line a muffin tray with paper cases.

Bake in the preheated oven for 50 minutes.

STRAWBERRY JAM

250 gm (8 oz) strawberries

75 gm (2¾ oz) caster sugar

10 ml (⅓ fl oz) lemon juice

Cut strawberries in quarters and mix with sugar and lemon juice; leave overnight in the refrigerator.

The next day, lightly mash the strawberries.

Place the strawberry mixture in a saucepan and bring to a simmer. Cook for about 20 minutes. Allow to cool.

VANILLA CHANTILLY CREAM

250 gm (9 oz) heavy cream, 47%, fresh

24 gm (1 oz) caster sugar

1 vanilla pod

Slice the vanilla pod longways through the centre and scrape out the seeds. Whisk the cream with the sugar and vanilla seeds, until it forms firm peaks. Spoon into a piping bag.

ASSEMBLY

Create a hollow in the cupcake with a spoon.

Pour a teaspoon of strawberry jam into the hollow.

Pipe the vanilla Chantilly cream on top.

GARNISH

12 fresh strawberries, quartered

½ tsp gold leaf

4 fresh raspberries

1 tsp icing sugar

Decorate with strawberries, gold leaf and raspberries dusted with icing sugar.

† See Kitchen Techniques

Vanilla and
Chocolate Marshmallow

Makes: 4 servings
Preparation time: 10 minutes
Cooking time: 1 hour

250 gm (8⅘ oz) caster sugar

75 ml (2⅔ fl oz) water

50 gm (2 oz) glucose

75 gm (2⅔ oz) egg whites

13 gm (½ oz) caster sugar

4 sheets gelatine

2 vanilla pods

50 gm (1⅔ oz) icing sugar

50 gm (1⅔ oz) cornstarch

600 gm (1¼ lbs) dark chocolate, 64%

Heat the 250 gm (8⅘ oz) of sugar, water and glucose on a high flame, stirring until the syrup reaches 121°C (250°F).

Place the egg whites in the bowl of a free-standing electric mixer. Use the whisk attachment to whisk the egg whites on medium speed. Add the 3 gm (½ oz) of sugar as the egg whites are being whisked.

Pour the sugar syrup into the egg whites and continue to whisk for 10 minutes or until cold. At this point the marshmallow should keep its shape when you lift a bit from the bowl. It should also look silky.

Soak the gelatine in water to soften it, then squeeze the excess water from it.

Whisk in the softened gelatine and the seeds from the vanilla pods; incorporate well.

Pour mixture into a piping bag. Using a round nozzle, pipe the marshmallow onto a non-stick baking mat.

Sprinkle icing sugar and cornstarch over the marshmallow and leave to set.

Temper† the dark chocolate.

Once the marshmallow has set, coat† it in the tempered dark chocolate.

† See Kitchen Techniques

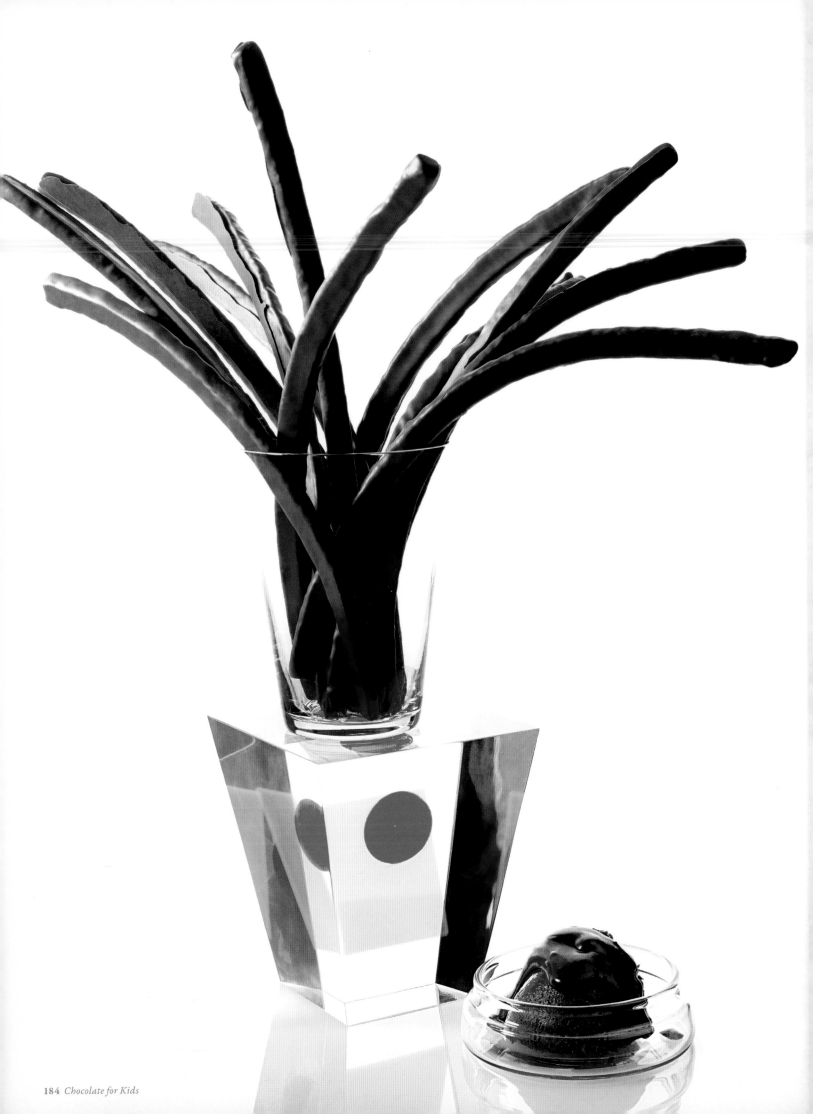

Makes: 60 pieces
Preparation time: 1½ hours
Cooking time: 1 hour

Chocolate Grissini with Hazelnut Spread

GRISSINI

Step 1

375 gm (12 oz) plain flour

260 ml (9⅕ fl oz) water, lukewarm

10 gm (⅓ oz) yeast, powdered

2½ tsp salt

50 gm (1¾ oz) caster sugar

Combine all the Step 1 ingredients in the bowl of a free-standing electric mixer. Use the dough hook attachment to mix the ingredients into a smooth dough.

Remove the dough from the mixing bowl, place on a lightly floured work surface and cover with a tea towel. Leave the dough to rest at room temperature for one hour. The dough should double in size.

Step 2

37 ml (1⅓ fl oz) water

60 ml (2 fl oz) olive oil

120 gm (4½ oz) plain flour

100 gm (3½ oz) cocoa powder

Preheat oven to 200°C (392°F).

Put the dough from Step 1 back into the mixer and add the Step 2 ingredients. Mix well with the dough hook until the mixture becomes a smooth dough.

Immediately roll the dough to a 0.5 cm (⅕ inch) thickness and cut into strips 0.5 cm (⅕ inch) wide by 25 cm (9⅘ inch) long.

Place the strips onto a greased baking tray and shape them into curves, or as desired.

Leave the grissini to rest for 10 minutes; they will rise into a slightly curved shape.

Bake in the oven for 7 minutes.

HAZELNUT SPREAD

260 gm (9⅕ oz) hazelnuts

40 ml (1⅖ fl oz) water

155 gm (5½ oz) caster sugar

⅓ vanilla pod

85 gm (3 oz) dark chocolate, 53%

85 gm (3 oz) milk chocolate, 37%

68 ml (2½ fl oz) hazelnut oil

Make a praline‡ with the hazelnuts, water, sugar and the seeds of the vanilla pod. Allow to cool to room temperature.

Melt† chocolates together and cool to 33°C. Mix the oil into the chocolate.

Add the praline to the chocolate mixture and fold through.

Leave to set.

Note: Place the grissini in a jar and serve the hazelnut spread as a dip. The hazelnut spread should be at room temperature.

† See Kitchen Techniques
‡ See Basic Recipes

Basic Recipes

ANGLAISE SAUCE

300 ml (10 fl oz) milk

200 ml (6⅘ fl oz) heavy cream, 38%, fresh

⅕ vanilla pod

140 gm (5 oz) egg yolk

65 gm (2⅓ oz) sugar, granulated

Put the milk, heavy cream and vanilla pod (seeds scraped) in a pot and bring to the boil. Turn off the heat and cover with a lid. Let it rest at room temperature for 1 hour.

Put the egg yolk and granulated sugar in a bowl and whisk.

Add the boiled milk, cream and vanilla pod and mix with a whisk.

Transfer to a pot, place over a low heat and stir with a wooden spatula. When it reaches 80˚C, pour rapidly into an iced bowl to cool.

Store refrigerated in a container with a lid.

CHOCOLATE PASTRY CREAM

520 gm (1 lb 1 oz) heavy whipping cream, 38%, fresh

100 gm (3½ oz) egg yolks

55 gm (2 oz) caster sugar

400 gm (15 oz) dark chocolate

Place the cream in a saucepan and, over a medium heat, bring to the boil. Remove from the heat and set aside.

Whisk the egg yolks and sugar together in a mixing bowl until light and fluffy.

Gradually pour the hot cream into the egg mixture while stirring briskly.

Place the mixing bowl on top of simmering water on a low heat and cook the mixture to 84˚C, stirring continuously with a rubber spatula.

Remove the saucepan from the heat, add the chocolate and stir until the chocolate has completely melted.

Set side and allow to cool to room temperature, then refrigerate overnight.

CHOCOLATE TUILE

50 ml (1¾ fl oz) water

100 gm (3½ oz) caster sugar

100 ml (3½ fl oz) glucose

45 gm (1½ oz) cocoa paste

Place the water, sugar and glucose in a saucepan and cook to 156ºC (313º F) to form a syrup.

Pour onto the cocoa paste and mix to make a smooth paste.

Roll the paste between 2 non-stick baking mats to as thin a width as possible.

Place the non-stick baking mat in a 180ºC (350º F) oven and cook until soft (approximately 20 seconds).

Remove from the non-stick baking mat.

Pull the tuile into the desired shape and form.

Store in a sealed container, preferably with a desiccant such as silica gel crystals.

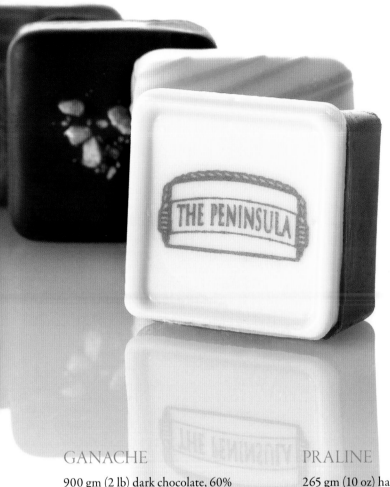

GANACHE

900 gm (2 lb) dark chocolate, 60%

568 ml (1 pint) pouring cream

Melt† the chocolate in a large bowl, using a bain-marie.

Bring the cream to the boil.

Slowly pour the cream over the melted chocolate, stirring continuously with a hand-held whisk to combine. If the cream is not mixing in easily, stop pouring and stir until smooth, then continue adding the cream a little at a time.

Allow the ganache to cool, then store in an airtight container and refrigerate.

Leave to rest overnight before using.

† See Kitchen Techniques

PRALINE

265 gm (10 oz) hazelnuts/almonds/walnuts or 160 gm (5⅔ oz) pistachios

50 ml (2 fl oz) water

160 gm (5⅔ oz) caster sugar

⅓ vanilla pod

Preheat the oven to 160°C (320°F).

Roast the nuts for approximately 6 minutes (the cooking time depends on the size of the nuts, for example, pistachios need less time to roast than hazelnuts).

Place the water, sugar and vanilla pod (seeds scraped) in a saucepan and boil to 110°C (230°F). Add the roasted nuts.

Once the sugar around the nuts starts crystallising, caramelise them slowly until golden-brown; then spread them onto a baking sheet and leave to cool down.

Place the cool nuts in the bowl of a food processor and process them into a smooth paste. Ensure they are processed long enough to form a smooth and liquid paste. Leave the praline to cool down before using.

SABAYON

160 ml (5⅗ fl oz) white wine, dry or sweet

65 gm (2⅓ oz) caster sugar

360 ml (12⅗ oz) egg yolks

Place the wine and sugar in a large, heatproof bowl, and then whisk until combined. Once combined, whisk in the egg yolks.

Set the bowl over a pan of gently simmering water (make sure the bottom of the bowl doesn't touch the water) and whisk vigorously until the mixture becomes thick, pale and stiff. You can slow down the speed, but if you need to stop whisking it, remove the bowl from the pan for as brief a time as possible.

The sabayon is ready when the mixture is thick and a ribbon trail forms when the whisk is lifted.

Kitchen Techniques

Working with chocolate has long been surrounded by mystique, implying the process needs vast knowledge and much experience. It is true that working with chocolate is technical; it involves precision and demands care and attention. Yet, once the basic techniques are mastered, it is not difficult and can even be great fun. Throughout this book, the same procedures are used repeatedly in different recipes. It is important to follow these procedures. This will achieve the best – and most consistent – results.

Melting Chocolate

The golden rule when melting chocolate is not to cook it. There are a few ways to melt chocolate.

In a bain-marie

The best way to melt chocolate is over hot water. Chop the chocolate on a chopping board (or use other forms of chocolate such as buttons, fèves or pistoles). Place the chocolate in a heat-resistant bowl (glass or metal) or in the top of a double boiler over a saucepan of simmering water. Make sure the base of the bowl containing the chocolate is not touching the water, as this can cause the chocolate to burn. Be sure also that no steam or water comes into contact with the chocolate as this causes the chocolate to seize into a hard lump which can't be re-melted. Allow the chocolate to melt while stirring it constantly so that it melts evenly.

In a microwave oven

Place the chocolate in a microwave-safe bowl. Heat at 500 W maximum for one minute, remove from the oven, stir with a flexible spatula, and return to heat for 30 seconds. Mix again and repeat the process as many times as necessary, until the chocolate has melted completely.

Over direct heat

Chocolate can be melted over direct heat when it has been combined with other ingredients like butter or cream. The heat should be low and the mixture should be stirred constantly during the melting process.

Tempering Chocolate

Tempering chocolate involves putting it through a cycle of temperatures (heating–cooling–heating) that professionals call the tempering curve.

Dark chocolate

Melting: 45°C (131°F)
Cooling down: 27°C (81°F)
Heating up/using: 31°C (88°F)

Milk chocolate

Melting: 45°C (131°F)
Cooling down: 26°C (79°F)
Heating up/using: 30°C (86°F)

White chocolate

Melting: 40°C (109°F)
Cooling down: 25°C (77°F)
Heating up/using: 29°C (84°F)

Chocolate needs to be tempered to transform it from one form to another, such as from a chocolate bar into coating for a praline. Without tempering, chocolate loses its gloss. It will not snap properly or melt gently in the mouth.

We advise buying a kitchen thermometer (preferably an instant-read one), which will allow you to follow the tempering curve precisely throughout the process. While there are several ways to temper chocolate, we recommend using a tempering stone.

Tempering using a tempering stone

1 Chop chocolate and melt it slowly over a bain-marie. If you are using dark or milk chocolate stir until it reaches 45°C (131°F). If you are using white chocolate, stir until the chocolate reaches 40°C (109°F).

2 Remove the bowl from the bain-marie and pour two thirds of the chocolate onto a marble slab. Keep the remaining third warm, either over a bain-marie or in a warm place, but not over direct heat.

3 Spread the chocolate and move it around with the help of a scraper and palette knife. Keep spreading and turning the chocolate until the following temperatures are reached:
 • 27°C (81°F) for dark chocolate
 • 26°C (79°F) for milk chocolate
 • 25°C (77°F) for white chocolate

4 Place the melted, worked chocolate in a mixing bowl. Gradually pour in the warm chocolate (previously set aside) until it reaches a temperature of:
 • 31°C (88°F) for dark chocolate
 • 30°C (86°F) for milk chocolate
 • 29°C (84°F) for white chocolate
 If the chocolate is too cold, it can be heated a little with the help of a hot air blower. If it is too warm, pour half of it back onto the marble slab to cool down.

5 Once the chocolate has reached the right temperature, it is ready to use.

6 If you are not sure the tempering process has worked, take a spatula and place a little chocolate on it. Leave it for 1–2 minutes to see if it begins to set. If it sets then the chocolate has been correctly tempered.

Moulded Chocolates

Preparing the mould

Heat the moulds with a hot air blower and clean them with cotton wool. Allow the moulds to cool down.

1 If the recipe calls for it, spray the moulds with tempered coloured cocoa butter (ensure the moulds are cool before spraying, if they are not cool the cocoa butter will heat up and lose its shine).
2 Allow the cocoa butter to set, then remove the excess with a scraper.

Casting the mould

1 Pour tempered chocolate into a piping bag and completely fill the prepared moulds. Ensure all surfaces are covered. Tap the side of the mould to remove air bubbles.
2 Turn the mould upside down to remove the excess chocolate (hold the mould above the tempered chocolate bowl so the excess runs off into the bowl). Tap the side of the mould with the scraper to ensure the shell left in the mould is thin.
3 Place the mould on its side to let the chocolate start setting.
 Once the chocolate starts to set, scrape the top with a scraper so the edges are neat and trim.
4 Do not wait too long to level the edges. This increases the risk of the chocolate shells breaking.

Filling the mould

1 Moulded chocolates can be filled with a huge variety of centres including ganache, praline or gianduja.
2 Always use a piping bag to fill moulded chocolates.
3 Fill to about 1 mm (¹⁄₂₅ inch) from the top of the mould.
4 Place the mould in the refrigerator to allow the filling to set. It will take approximately 30 minutes for the filling to set. Do not leave the mould in the refrigerator for any longer as it may ruin the chocolate shell.

Closing the mould

1 Once the filling is set in the refrigerator, the moulded chocolates can be closed. Heat the surface of the mould with an air blower to slightly melt the side of the chocolate and the filling. This will ensure the bottom layer of chocolate sticks well to the filling.
2 Pour one layer of tempered chocolate onto the base of the mould. Remove the excess chocolate with a scraper and leave the chocolate to set slightly.
 Repeat a second time to get an even and straight bottom.

De-moulding the mould

1 Once the mould has been closed, place it back in the refrigerator for a few minutes to let the chocolate set. This makes the chocolate shrink and will help it slip out of the mould.
2 Take the mould out of the refrigerator and turn it upside down on a marble slab.
3 Gently tap the side of the mould.
4 If the chocolate was tempered properly, the chocolates should fall out on their own.

Hand-dipped Chocolates

Preparing the filling

1 Hand-dipped chocolate fillings are usually made in a confectionary frame (available at specialty cooking stores and online). The frame should be placed on a non-stick baking mat or baking sheet. Once the filling (e.g. praline or ganache) is ready, pour it into the frame. Chef's tip: If you don't have a confectionary frame it is possible to use a brownie dish or baking tray. The tray must be deep enough to pour in the ganache to a thickness of 1 cm (½ inch).
2 Spread the filling out evenly with a spatula so that it fits the frame.
3 Place the frame in a cool area (approximately 15°C to 18°C/59°F to 64°F) for 12 hours or overnight to allow the filling to set. Do not place the frame in the refrigerator, as it will be too cold for the chocolate.

Undercoating

Some fillings for hand-dipped chocolates need to be undercoated. Undercoating provides a protective layer over the filling so the filling doesn't melt when it comes into contact with heat.

4 Carefully remove the frame around the filling.

5 Using a spatula, spread a thin layer of tempered chocolate over the surface of the uncut filling.

6 Cover the chocolate with baking paper. This undercoated side becomes the bottom of the hand-dipped chocolate. The undercoat will prevent the filling from sticking while it is cut or melting while it is dipped.

7 Once the undercoat has set, remove the baking paper. Place the baking paper back onto the filling (it does not have to sit in exactly the same position as it was in before).

8 Turn the filling over, onto the baking paper and remove the baking mat.

9 Cut the filling as the recipe directs (e.g. square, rectangular or round).

Hand-dipping or coating

1 Place the undercoated side of one piece of filling (e.g. praline or ganache) on the tongs of a dipping fork.

2 Lower the fork into a bowl of tempered chocolate. Immerse the filling completely.

3 Use the fork to lift the filling out of the chocolate.

4 Dip it three or four times to give the filling a thin coat. On the final dip allow the excess chocolate to run off the fork.

5 Place the hand-dipped chocolate on a baking sheet.

Decorating hand-dipped chocolates

Hand-dipped chocolates can be decorated either immediately after dipping or after they have set, depending on what kind of decoration is required.

Making Decorations

Before chocolate hardens (crystallises) it will take on whatever shape it is given. While making decorations, it is important not to let the chocolate harden as it will become unworkable.

Chocolate sticks

1 Spread out the tempered chocolate on a cool working surface to a thickness of just under 2 mm (²⁄₂₅ inch).

2 When it begins to set (the texture is just right when your finger can indent the chocolate easily), push a triangular metal pastry scraper through the chocolate. Push it away from you, pressing hard.

3 The chocolate will roll over itself, creating a curled stick.

4 Repeat the procedure as many times as necessary. If the chocolate hardens you will not be able to continue.

5 Scrape up the hardened chocolate and spread out some freshly tempered chocolate to continue.

6 Leave the sticks for 30 minutes before using.

7 For thicker sticks, after spreading out the tempered chocolate, let it cool and harden.

8 Cut strips to form the sticks.

Chocolate curls

1. Pour tempered chocolate on top of a pre-cut film and spread.

2. Roll up the film to form curls.

3. Let the chocolate set, then gently remove from the film.

Moulded decorations

(e.g. chocolate buttons)

Many objects can be used to create a mould. Following are instructions to make a mould for chocolate buttons. However, the buttons could be replaced with another object to create a mould in the shape of your choice.

1 Place small plastic buttons on a plate.

2 Place slightly larger rings (these can be made out of either plastic or metal e.g. circular biscuit-cutters) around the buttons. Stick the ring to the plate with tempered chocolate or edible sugar glue (either will work).

3 Mix a batch of food-grade silicon rubber according to the manufacturer's instructions.

4 Pour a layer of silicone over the buttons and leave overnight to set.

5 Remove the rings and the buttons from the silicone.

6 Pour some tempered dark chocolate into the button moulds and leave to set.

7 Once set, remove the buttons from the mould and decorate the buttons with some gold powder.

8 Stick the buttons onto the pralines, using some tempered chocolate as glue.

Weights and Measures

Quantities for this book are given in Metric and Imperial measures. Standard American (spoon and cup) measurements used are: 1 teaspoon = 5 ml/2 gm, 1 tablespoon = 15 ml/6 gm, 1 cup = 250 ml/100 gm. All measures are level unless otherwise stated.

Liquid and volume measures

Metric	Imperial	American
5 ml	⅙ fl oz	1 teaspoon
10 ml	⅓ fl oz	1 dessertspoon
15 ml	½ fl oz	1 tablespoon
60 ml	2 fl oz	¼ cup (4 tablespoons)
85 ml	2½ fl oz	⅓ cup
90 ml	3 fl oz	⅜ cup (6 tablespoons)
125 ml	4 fl oz	½ cup
180 ml	6 fl oz	¾ cup
250 ml	8 fl oz	1 cup
300 ml	10 fl oz	(½ pint) 1¼ cups
375 ml	12 fl oz	1½ cups
435 ml	14 fl oz	1¾ cups
500 ml	16 fl oz	2 cups
625 ml	20 fl oz (1 pint)	2½ cups
750 ml	24 fl oz (1⅕ pints)	3 cups
1 litre	32 fl oz (1⅗ pints)	4 cups
1.25 litres	40 fl oz (2 pints)	5 cups
1.5 litres	48 fl oz (2⅖ pints)	6 cups
2.5 litres	80 fl oz (4 pints)	10 cups

Dry measures

Metric	Imperial
30 grams	1 ounce
45 grams	1½ ounces
55 grams	2 ounces
70 grams	2½ ounces
85 grams	3 ounces
100 grams	3½ ounces
110 grams	4 ounces
125 grams	4½ ounces
140 grams	5 ounces
280 grams	10 ounces
450 grams	16 ounces (1 pound)
500 grams	1 pound, 1½ ounces
700 grams	1½ pounds
800 grams	1¾ pounds
1 kilogram	2 pounds, 3 ounces
1.5 kilograms	3 pounds, 4½ ounces
2 kilograms	4 pounds, 6 ounces

Oven temperature

	°C	°F	Gas Regulo
Very slow	120	250	1
Slow	150	300	2
Moderately slow	160	325	3
Moderate	180	350	4
Moderately hot	190/200	370/400	5/6
Hot	210/220	410/440	6/7
Very hot	230	450	8
Extremely hot	250/290	475/550	9/10

Length

Metric	Imperial
½ cm	¼ inch
1 cm	½ inch
1½ cm	¾ inch
2½ cm	1 inch

Abbreviation

tsp	teaspoon
Tbsp	tablespoon
gm	gram
kg	kilogram
ml	millilitre
ltr	litre
cm	centimetre
oz	ounce
lb	pound
fl oz	fluid ounce

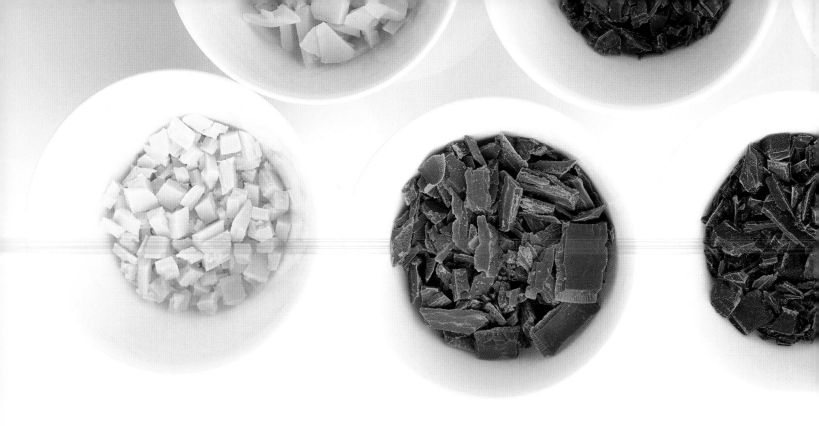

Glossary

CHOCOLATE

Dark couverture chocolate

Bittersweet or unsweetened dark couverture contains 66 per cent or more cocoa. Semi-sweet dark chocolate contains 55 per cent cocoa and a small quantity of sugar. These chocolates need sweetening when used in baking. Semi-sweet dark couverture is best for cooking with, melting for shaping as well as coating or piping. It needs to be tempered (see Kitchen Techniques) before moulding and coating.

Milk couverture chocolate

Milk couverture chocolate contains milk in a dried and powdered or concentrated form. It also contains more sugar than dark couverture, lessening the significance of the cocoa. The milk in this chocolate makes it difficult to use for cooking and baking, as it is less able to tolerate heat. It is best used for mousses and glazes, which only require minimal heat.

White chocolate

Referred to by some as the chocolate imposter, because it contains no chocolate liquor. The best white chocolate is ivory in colour – the colour of cocoa butter. The cocoa percentage of white chocolate consists entirely of cocoa butter. The other ingredients are sugar and powdered milk.

Compound chocolate

Compound chocolate is an inferior chocolate to couverture, but is very easy to use. It doesn't burn as easily as real chocolate because most, if not all, of the cocoa butter has been replaced by palm oil or soybean oil.

Cocoa powder

After the extraction of cocoa butter from the cocoa liquor a solid mass remains in the press. This is then pulverised to make cocoa powder. The powder contains between 10 and 24 per cent cocoa butter and no sugar. Two types of cocoa powder are available: alkalised (also known as Dutch-processed) or naturalised (non-alkalised). Cocoa that has been alkalised has a low acidity and a rich colour and flavour. When cooking, do not substitute sweetened cocoas or hot chocolate mixes for cocoa.

SUGARS

Brown sugar

Brown sugar contains small amounts of molasses, which gives it its characteristic brown colour and rich flavour. In general, the lighter the brown sugar, the more delicate the flavour. Very dark brown sugar has a more intense molasses flavour. Molasses is able to hold water from its surrounding environment, which makes cakes and biscuits made with brown sugar characteristically moist.

Caster sugar

Caster sugar is a very fine white sugar created from granulated sugar. It dissolves more quickly than regular white sugar so is especially useful in baking. Caster sugar can be created by grinding white sugar in a food processor. It is also known as superfine sugar.

Granulated sugar

Granulated sugar is white refined sugar, made by dissolving and purifying raw sugar then drying it to prevent clumping. Granulated sugar comes in a variety of crystal sizes including coarse-grained (such as decorating sugar), normal (for table use), fine-grade (such as caster sugar) and powdered (such as icing sugar).

Pectin

Pectin is a naturally occurring substance (heteropolysaccharide) found in the cell walls of plants. Apples, berries and citrus peels contain high amounts of pectin. When pectin is combined with sugar and heated it becomes a thickening agent. It is used to set (or gel) fruits to give them a spreadable texture. Commercial pectin is made by extracting pectin from apples or citrus peels (a by-product of juice production). The resulting extract is then precipitated, washed and dried.

Powdered sugar

Powdered sugar (also known as confectioner's sugar or icing sugar) is granulated sugar

ground to a smooth powder and then sifted. It contains approximately 3 per cent cornstarch to prevent caking. Powdered sugar is ground into three different degrees of fineness. The confectioner's sugar available in supermarkets is the finest of the three and is used in icing, confectionary and whipping cream.

Trimoline
Trimoline (also known as invert sugar) is created when sucrose is split into its two component sugars (glucose and fructose). The process is called inversion. Commercial trimoline is a mixture of glucose and fructose. It helps to reduce sugar crystallisation during the cooking process, thereby increasing the shelf life of bakery items.

FRUIT AND VEGETABLES

Apricot paste
Apricot paste is a sweet, thick paste typically made from softened, mashed apricots and sugar. Similar to fruit preserves, apricot paste can be spread on toast, stirred into tea as a sweetener, or served as part of an appetizer. Chefs may also add it to sauces and pastry recipes to give them flavour and texture. Apricot paste may be purchased in jars from specialist grocery stores or made at home.

Broccoli sprouts
Broccoli sprouts are three-four days old broccoli plants that look like alfalfa sprouts, but taste more like a radish. The sprouts are very delicate with a light watery crunch. They are often added to salads or used as a raw garnish. Like their mature form, broccoli, broccoli sprouts are high in vitamin C and vitamin E.

Kinome
Kinome (also known as Japanese pepper leaf or prickly ash leaves) refers to the baby leaves of the prickly ash tree. The small serrated leaves have a minty aroma and flavour, with a lingering heat. They are often used as a garnish or herb in Japanese cooking. They should be stored in a tightly sealed bag and will last for three to four days.

Microgreens
Microgreens are a tiny form of edible greens produced from the seeds of vegetables, herbs or other plants. They range between 2.5–5 cm (1–2 inch) in length, including the stem and leaves. Microgreens can have surprisingly intense flavours considering their small size, though not as strong as mature greens and herbs. Microgreens are not the same as sprouts, and have much more developed flavours, colours and textures than sprouts.

Purple cauliflower
Purple cauliflower is a hybrid of the standard white cauliflower. Its flavour is milder, nuttier and free of the bitterness sometimes found in the white variety. The plant's purple colour is due to the presence of the antioxidant, anthocyanin, which can also be found in red cabbage and red wine. The colour is naturally occurring and is not due to scientific manipulation.

PLANTS AND FLOWERS

Agar-agar
Agar-agar is a gelatine substitute suitable for vegetarians, produced from a variety of seaweed vegetation. It is sold in health food stores in both flake and powder varieties, and can be used in dairy-free and vegan recipes as a stabilising and thickening agent for custards, puddings and sauces.

Amaranth
The miniscule seeds of the amaranth plant are rich in protein, calcium and fibre. The plant is an annual herb, yet it is often considered part of the grain family because of its grain-like appearance. The seed closely resembles a mustard seed, but has a mild, malt-like taste, with nut undertones. Amaranth is gluten-free and an excellent alternative to rice or couscous. It can be popped or cooked.

Edible flowers
Edible flowers are flowers that can be consumed safely. They can be used in drinks, jellies, salads, soups, syrups and main dishes.

THE PENINSULA
HOTELS

The Peninsula Hong Kong

The Peninsula Manila

The Peninsula New York

The Peninsula Beverly Hills

The Peninsula Bangkok

The Peninsula Chicago

The Peninsula Beijing

The Peninsula Tokyo

The Peninsula Shanghai

The Peninsula Paris (2013)

The Peninsula Hong Kong
Salisbury Road, Kowloon
Hong Kong, SAR, People's Republic of China
Telephone: (852) 2920 2888 Facsimile: (852) 2722 4170
E-mail: phk@peninsula.com

The Peninsula Beverly Hills
9882 South Santa Monica Boulevard
Beverly Hills, CA 90212, United States of America
Telephone: (1-310) 551 2888 Facsimile: (1-310) 788 2319
E-mail: pbh@peninsula.com

The Peninsula Beijing
8 Goldfish Lane, Wangfujing
Beijing 100006, People's Republic of China
Telephone: (86-10) 8516 2888 Facsimile: (86-10) 6510 6311
E-mail: pbj@peninsula.com

The Peninsula Manila
Corner of Ayala & Makati Avenues
1226 Makati City, Metro Manila, Philippines
Telephone: (63-2) 887 2888 Facsimile: (63-2) 815 4825
E-mail: pmn@peninsula.com

The Peninsula Bangkok
333 Charoennakorn Road, Klongsan
Bangkok 10600 Thailand
Telephone: (66-2) 861 2888 Facsimile: (66-2) 861 1112
E-mail: pbk@peninsula.com

The Peninsula Tokyo
1-8-1 Yurakucho, Chiyoda-ku
Tokyo, 100-0006, Japan
Telephone: (81-3) 6270 2888 Facsimile: (81-3) 6270 2000
E-mail: ptk@peninsula.com

The Peninsula Paris (2013)
19 Avenue Kléber
75016 Paris, France
E-mail: ppr@peninsula.com

The Peninsula New York
700 Fifth Avenue at 55th Street
New York, NY 10019, United States of America
Telephone: (1-212) 956 2888 Facsimile: (1-212) 903 3949
E-mail: pny@peninsula.com

The Peninsula Chicago
108 East Superior Street (at North Michigan Avenue)
Chicago, IL 60611, United States of America
Telephone: (1-312) 337 2888 Facsimile: (1-312) 751 2888
E-mail: pch@peninsula.com

The Peninsula Shanghai
No 32 The Bund, 32 Zhongshan Dong Yi Road
Shanghai 200002, People's Republic of China
Telephone: (86-21) 2327 2888 Facsimile: (86-21) 2327 2000
E-mail: psh@peninsula.com

For more information, please visit us at **www.peninsula.com**

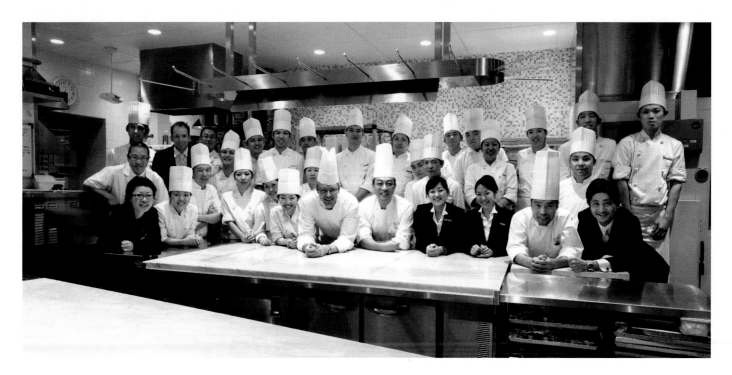

Project Coordination
Paul Tchen and Lisa Lum

Culinary Coordination
Florian Trento, Adam Mathis, Shigeru Nojima

Project and Recipe Contributors
Chiharu Arakichi, Dustin Baxter, Kimiko Berten, Marc Bouchard, Patrick Boucher, Hsing Chen, Sebastien Cocquery-Beraud, Marijn Coertjens, David Couch, Terrence Crandall, Lisa Crowe, Ludovic Douteau, Richard Glaze, Masayuki Haeiwa, Yasuharu Izumita, Mari Kamata, Maiko Kasahara, Romain Lenoir, Kai Lermen, Samuel Linder, Yoann Mathy, Mitsunao Negase, Chris Pitts, Cornel Ruhland, Mike Wehrle, Chi Ping Xu, Hynn Yam, Hayato Yamada, Tim Yu and Dominic Zhu

Photoshoot Location
The Peninsula Tokyo

The Hongkong and Shanghai Hotels, Limited
8th Floor, St. George's Building, 2 Ice House Street, Central, Hong Kong
www.hshgroup.com

The Hon. Sir Michael Kadoorie, Chairman
Ian D. Boyce, Deputy Chairman
Clement K. M. Kwok, Managing Director and Chief Executive Officer
Peter C. Borer, Director and Chief Operating Officer
Neil J. Galloway, Finance Director and Chief Financial Officer

Peninsula Merchandising Limited
The Peninsula Hong Kong, Salisbury Road, Tsim Sha Tsui, Kowloon, Hong Kong
www.peninsulaboutique.com

Paul Tchen, General Manager

Special Thanks to
Noritake Co., Limited, Sugahara Glassworks Inc., Schott Zwiesel Japan, Tousyougama Produced by Marukatsu, Yamaguchi Ceramics Shop Co., Ltd., Y.J. Incorporation

Managing Editor	Ardyn Bernoth
Editor	Sarah Wormwell
Assistant Editor	Shweta Moogimane
Project Manager	Christine Clarke
Design and Art Direction	Timmy Ho
Photography	Edmond Ho, Jambu Studio
Text	Ardyn Bernoth, Sarah Wormwell and Peninsula Merchandising Limited
Recipe Testing	The Peninsula Tokyo, Sally Arnell and Fiona Thomson

Copyright © 2012 Peninsula Merchandising Limited
A subsidiary of The Hongkong and Shanghai Hotels, Limited

Published by PPP Company Limited, Hong Kong
www.ppp.com.hk

All rights reserved
ISBN 978-988-8151-51-6

Printed by Magnum Offset, Hong Kong

Naturally Peninsula

"To live well is to eat well"

These chocolate roses are handmade, with pink-coloured white chocolate. The chocolate is tempered, spread on a marble surface until semi-set, then delicately moulded into petals. The petals are combined to make the roses, ready to be used on our wedding cakes at The Peninsula.